DIS

PHOTOGRAPHIC PRESIDENTS

PHOTOGRAPHIC PRESIDENTS

MAKING HISTORY FROM
DAGUERREOTYPE TO DIGITAL

CARA A. FINNEGAN

UNIVERSITY OF
ILLINOIS PRESS
Urbana, Chicago, and Springfield

Library of Congress Cataloging-in-Publication Data
Names: Finnegan, Cara A., author.
Title: Photographic presidents : making history from
 daguerreotype to digital / Cara A. Finnegan.
Description: Urbana : University of Illinois Press,
 [2021] | Includes bibliographical references and
 index.
Identifiers: LCCN 2020040736 (print) | LCCN
 2020040737 (ebook) | ISBN 9780252043796
 (cloth) | ISBN 9780252085789 (paperback) | ISBN
 9780252052699 (ebook)
Subjects: LCSH: Presidents—United States—Portraits.
 | Portrait photography—United States—History. |
 Portraits, American.
Classification: LCC E176.5 .F56 2021 (print) | LCC E176.5
 (ebook) | DDC 973.932092/2—dc23
LC record available at https://lccn.loc.gov/2020040736
LC ebook record available at https://lccn.loc.gov/
 2020040737

For John Murphy, with love

Contents

PART IV. THE SOCIAL MEDIA PRESIDENT

Color images follow page 108

Acknowledgments

Strange as it may seem, John Quincy Adams became something of a muse for me as I wrote this book. I think it had something to do with reading his diaries in his own hand, filled with ruminations about everything from his health to the state of his garden and the quality of the sermons he heard on Sundays. I grew to have sympathy for this iconic man's affections, curiosities, and frustrations. And so I open this long list of acknowledgments with his words. "Gratitude," Adams wrote, "fills the soul to overflowing, and scarce leaves room for any other sentiment or thought."

I'm grateful for institutional support of all kinds. In its earliest stages, this project was nurtured by my University of Illinois colleagues Nancy Abelmann and Maria Gillombardo of the Office of Research Advising and Project Development. Their detailed and insightful feedback on my early research proposals gave me the confidence to commit to this project at a time when I needed it most. On campus, a grant from the University of Illinois Campus Research Board, funding from a Conrad Professorship and a University Scholar award, and a teaching release from the Center for Advanced Study enabled visits to archives and time for research. A 2016–2017 National Endowment for the Humanities Fellowship for University Professors provided me with much-needed time for focused writing.

I'm grateful for the rotating team of graduate students who served as research assistants at every stage of this project: Donovan Bisbee, Chelsea Butkowski, Daniel DeVinney, Katie Irwin, John Moist, Matt Pitchford, and Jillian Klean Zwilling. Thanks especially to Daniel DeVinney and Joseph DeVinney for collaborating on the World's Most Beautiful and Useful Image Spreadsheet, and to John Moist for heroic efforts to secure image files and permissions during a global pandemic (literally).

I'm grateful for archives and archivists. I spent an engaging afternoon with David Eisenman in my current hometown of Champaign, Illinois, where he shared highlights of his personal archive of stereographs with me. Beverly Brannan and the staff at the Prints and Photographs Division of the Library of Congress helped me navigate the wide world of presidential imagery, as did Sarah Ickow at the Smithsonian's National Portrait Gallery. That so many of the images in this book come from these two places is a testament to their value as cultural institutions that preserve and share—for free or at minimal cost—our nation's visual treasures.

I'm grateful for the support of those who study and practice visual politics. At the George Eastman Museum, photographic process historians Mark Osterman and Nick Brandreth trained me in nineteenth-century photographic practices. Michael Shaw of *Reading the Pictures* models how visual critics should engage in the public sphere; our collaboration on the *Chatting the Pictures* webcast gives me a valued space to talk about contemporary visual politics and sharpen my critical eye. Pete Souza kindly reached out over email, answered a few lingering questions about the Obama Flickr site, and offered hugely helpful feedback on my treatment of White House photography.

I'm grateful for the many opportunities to share my work in progress and learn from questions, feedback, and conversations. A generous invitation from Dianne Harris, then-director of the Illinois Program for Research in the Humanities, gave me an early chance to talk about the project at the 2015 Chicago Humanities Festival. I refined my ideas in talks at Georgia State University, University of Iowa, Texas A&M University, University of St. Thomas, Indiana University, Penn State University, Wayne State University, DePauw University, Northwestern University, University of Southern California, and the Print Matters conference at the New York Public Library. Thanks to the many colleagues who made these visits possible.

I'm grateful to be working again with the outstanding folks at University of Illinois Press, especially Danny Nasset, who took an early interest in a different kind of book and helped me shape it into something that would appeal to multiple audiences. The generous reviewers of the proposal and manuscript offered helpful feedback that made the final product better, and the Press's design, production, and marketing staff showed me once again that they are the best of the best.

I'm grateful to have Debbie Hawhee and Vanessa Beasley as beloved friends, colleagues, and role models. These two incredible women inspire me every day with their smarts and their hearts. Our shared meals, writing camaraderie, travel adventures, and virtual check-ins keep me going.

Finally, and most importantly, I'm grateful that John Murphy loves me for my enthusiasms and my curiosities, because god knows this book is chock-full of them. He is the best of husbands and the best of men. My soul overflows indeed.

Introduction

The election of Barack Obama opened a new chapter in the history of the U.S. presidency and transformed the visual practices of the office. Just a few months after the 2009 inauguration, the Obama administration announced it would use the popular social media site Flickr to share White House photographs with the public. Previous administrations employed official White House photographers to chronicle each president's time in office with an eye toward posterity, but Obama expanded presidential photography into an unprecedented, real-time social media strategy. By the time he left office, the White House Flickr photostream contained more than six thousand images that offered viewers a carefully curated behind-the-scenes look at the president of the United States. These photographs continue to circulate widely today as visual exemplars of presidential leadership. By communicating his visual image to the public in ways that bypassed traditional media almost entirely, Barack Obama changed the history of presidential image making and, in the process, became a key player in a dramatic transformation in the history of photography itself.

But Obama was not the first president to shape photography in the public sphere. Throughout U.S. history, presidents have participated in photography as subjects, producers, and consumers of photographs. They have posed for portraits, been captured in snapshots, orchestrated photo opportunities,

and in at least one memorable case threatened to punch a photographer. *Photographic Presidents* tells a history of photography through stories of how presidents shaped and participated in transformative moments in the history of the medium: the rise of the daguerreotype portrait after 1839, the dawn of the "halftone era" in the late nineteenth century, the emergence of so-called candid camera photography in the late 1920s, and the digital revolution of the early twenty-first century. From daguerreotypes to selfies, from the earliest photographs printed in newspapers to online slide shows, the technological developments I chronicle here transformed our practices of photography and introduced new visual values to the medium. These new visual values became the evaluative standards by which photography would be judged moving forward. Thus, as photography itself changed, so too did the way its practitioners and consumers understood its significance, impact, and role in the culture. Because presidential photographs represented elite leaders who symbolized the nation, they became prominent contexts in which the implications of these new visual values played out in public, often clashing with existing social and cultural norms.

Stories of presidents' participation in photography offer a compelling lens through which to study how photography shapes public experience. I begin with George Washington, who, more than fifty years after his death, emerged as a crucial subject for early photography in a nation eager to consume portraits of elite leaders. Subsequent chapters feature stories of presidents' engagements with key moments of transformation in photography: John Quincy Adams, who in the early 1840s lamented in his diary his failure to get a good daguerreotype ("all hideous," he said); William McKinley, whose 1901 assassination set off a morbid race to find and publish the dead president's "last photographs"; Herbert Hoover and Franklin Roosevelt, each vexed by encounters with "candid cameramen" who had the capacity to catch their subjects unaware; and Barack Obama, whose use of social media photography embodied the tensions inherent in early twenty-first-century digital photography.

The president of the United States is a singular citizen who at the same time symbolically represents the nation; in short, the president's image is the nation's image.[1] Yet no one has examined the 180-year relationship between U.S. presidents and photography in any depth.[2] This lack of attention is surprising, given that photography emerged as a public art early in the nation's history, that presidents participated in photography from its beginnings, and that strategic use of photography helped to elect

leaders from Lincoln to Kennedy and beyond.[3] Presidential biographies and memoirs of White House photographers offer intriguing yet frustratingly brief anecdotes about presidential encounters with the camera.[4] Histories of presidents' relationships with the press may mention photography in passing but are more interested in the institutional features of the White House press operation than in presidential photography specifically.[5] Political communication researchers typically treat photography as a tool that politicians use to build an image, get elected, or wield authority; furthermore, they usually ignore the nineteenth and early twentieth centuries in favor of the decades after the dawn of television.[6] Overall, while a few people have studied what photography can tell us about a few presidents, no one yet has asked what studying presidents' relationships with photography tells us about the history of photography itself.

Photographic Presidents tells that story. In our present moment, when former Obama White House chief photographer Pete Souza has garnered two million Instagram followers for his pointed visual criticism of President Donald Trump, and photographs of presidents past and present circulate endlessly via online news, social media, and memes, the time is ripe for a history of presidents' relationships with photography. I bring together primary sources such as diaries, letters, newspapers, magazines, images, and memes with scholarship from the fields of communication, political science, media, literature, and art history to tell a new story about a medium and an institution that have largely grown up together. My goal is to move beyond the popular but narrow characterization of presidential photography as a political tool. Because I want to think more broadly about how presidents participate in the visual public sphere, I treat the presidents I discuss in a somewhat unconventional manner. While they are key characters in my story, they do not by themselves drive the plot. This is not a book about the presidency as an institution, nor does it focus closely on the relationship between presidents and the press. The reader will not find presidential biographies or tales of policy victories and defeats. In fact, some of the presidents I take up were not even serving in that role during the time periods I discuss. For example, John Quincy Adams was a congressman decades beyond his presidency when he was first photographed, and both George Washington and William McKinley were dead for most of the chapters that focus on them. By flipping the conventional script from "presidential photography" to "photographic presidents," I invite readers to picture the visual past in a new way.

In addition, the story I tell reminds us that every era grapples with the opportunities and challenges of its own new media. By studying moments of technological transformation across the history of the medium, I show how not only presidents but all Americans have made sense of the changing visual values through which we experience and engage one another. Each moment of technological change I take up in the book—the daguerreotype, the news photograph and snapshot, the candid camera image, social media photography—activated lively public conversations about the social and cultural implications of these new visual values. Was photography a suitable medium for the depiction of the nation and its leaders? Could photography be relied upon to communicate both accurate and instantaneous news to the public? Was photography's increasing capacity to make private moments public a blessing or a curse? And how, in the age of endlessly circulating digital photographs, can twenty-first-century citizens control their image in a hypermediated culture of sharing and remixing? Using photographic presidents as a historical and critical lens, I identify and track these conversations and questions across a landscape that stretches from the founding of the nation to the present.

Structure of the Book

The book is structured in paired chapters that alternate short narratives about the history of photography in a particular time period with longer, substantive stories about specific photographic presidents. The short chapters are there to provide the reader with sufficient historical and cultural context for understanding each photographic president's story in the longer chapters. I begin by asking why George Washington emerged as a subject of early photography after its introduction in the United States in 1839. Unavailable to be photographed from life (he had died fifty years before), Washington's image nevertheless circulated in daguerreotypes of busts and painted portraits. The urge to photograph Washington illustrated the immediacy with which photography and the presidency became linked in the public mind.

Portraiture was a vital art of national character in the early American republic. The daguerreotype brought to portraiture new visual values that highlighted the nascent medium's paradoxical capacity to produce images of perfect fidelity to reality and astounding wonder. In Washington, DC, itinerant daguerreotypists and, later, permanent studios became integrated

into the social life of the U.S. capital as photographers sought out the nation's elites to photograph. John Quincy Adams sat for upward of fifty daguerreotypes between 1842 and his death in 1848. Adams wrote about his experiences with photography in his diary, experiences that were mostly frustrating. My analysis of his writings reveals a thoughtful, anxious public figure grappling with the question of what photography's capacity to produce images that Adams called "too true to the original" might mean for building a visual record of national memory. The medium introduced new visual values of fidelity and wonder to the culture, but Adams doubted whether photography was the best art for producing what he termed "true portraiture of the heart"—portraits that were, in his words, "worthy of being preserved" as images of and for the nation.

The next pair of chapters brings the reader from the daguerreotype era of fidelity and wonder to the beginning of the twentieth century, which featured the new visual value of timely photography. This period included the rise of printed, reproducible photographs; the introduction of amateur cameras (and subsequent anxieties about how they would be used); and the so-called halftone revolution that made it possible to print photographs in newspapers and magazines. With these developments in mind, I explore photographs of William McKinley published in the wake of his 1901 assassination at the Pan-American Exposition in Buffalo, New York. After the president's death, editors rushed to publish what they defined as the "last photographs" of President McKinley, images made while he toured the exposition in the days before his death. These "last photographs"—which did not include actual images of the shooting—were sought after in part because they represented photography's recently developed capacity for capturing timely news events. The new visual value of timeliness that dominated the halftone era of the snapshot and news photograph produced often unreasonable expectations for images that could capture a single historic moment in time.

Moving from the early twentieth century to the 1930s, the next two chapters explore the period "between the Roosevelts," from Theodore to Franklin. This era was marked by the rise of photo agencies designed to circulate news photographs widely, the publication of photo-heavy sections in newspapers and magazines, the increasing professionalization of photojournalism, and, beginning in the late 1920s, the rise of miniature photography, also known as "candid camera" photography. I examine how Herbert Hoover and Franklin Roosevelt engaged with the new visual value

of candidness that was grounded in the access, intimacy, and energy offered by the new miniature cameras. The candid camera gave viewers insight into processes of political deliberation that previously had been invisible to them, yet it also posed risks for politicians who worried that they might fall victim to the candid camera's prying eyes. The new visual value of candidness clashed with fragile norms of presidential decorum that had developed since the beginning of the twentieth century.

The next pair of chapters brings the reader from the mid-twentieth century to our present digital era, which brought with it yet another group of new visual values: those of sharing and remixing. I explore the impact on photography of television and the internet, examine the push-pull relationship between the visual press and the president, outline the history of the job of official White House photographer, and highlight the impact of Web 2.0 on presidential communication. I then turn to the visual archive built when the Obama White House chose to make official White House photographs available to the public via the social media photography site Flickr. The Obama White House Flickr photostream—still preserved in its original form today—constituted a discrete, real-time social media photography archive and also operated as an axis around which other social media practices and public debates about photography circulated. Social media privileges the visual values of sharing and remixing, and my analysis of the Obama Flickr site shows how those visual values were often in tension with the administration's desire for image control.

The presidents I study in this book—from John Quincy Adams, the daguerreotype president, to Barack Obama, the social media president—are photographic presidents not only because they participated in photography but also because they engaged the medium at precisely those moments when its visual values were in flux. New visual values like fidelity, wonder, timeliness, candidness, sharing, and remixing emerged at moments of technological change in the new medium and activated new relations between presidents and the public. Adams's frustrating encounters with the fidelity and wonder of the daguerreotype, McKinley's contradictory representations in the context of timely news photography, Hoover's and Roosevelt's struggles with the candid camera, and Obama's desire for control amid a culture of sharing and remixing: these stories all serve as a powerful lens through which to explore the history of photography and its changing visual values.

PART I

The Daguerreotype Presidents

CHAPTER 1

Photographing George Washington

In February 1839 the *Boston Daily Advertiser* published news from France of a "curious invention lately made by M. Daguerre; for making drawings." The writer noted that while "the manner in which the camera obscura produces images of objects, by means of a lens, is well known," Louis-Jacques-Mandé Daguerre's contribution was "a method of fixing the image permanently" that did so "by the agency of the light alone." The article went on to explain that Daguerre's "machine" could make "accurate drawings" of "any object indeed, or any natural appearance may be copied by it." One man who had observed Daguerre's efforts compared the new technology "to a kind of physical retina as sensible as the retina of the eye."[1]

As the *Daily Advertiser*'s choice to publicize Daguerre's efforts illustrates, Americans were keenly interested in the idea of photography. Some enthusiasts in the late 1830s were experimenting with "photogenic drawing," the process of exposing objects to light-sensitive paper pioneered by William Henry Fox Talbot in England.[2] But it was Daguerre's invention that most captured the American imagination. In 1839 a few Americans who had read about Daguerre's experiments before the entire process was made available to the public tried to make the images but without documented success.[3] Famed inventor Samuel Morse experimented with proto-photographic processes for years, visited France to promote his own invention of the

telegraph, and met Daguerre in early 1839.[4] Months before the French officially presented the daguerreotype to the public, Morse wrote a letter about the process to his brothers, who circulated it to U.S. newspapers. In it, he called Daguerre's invention "Rembrandt perfected."[5]

After the French government formally presented the daguerreotype to the public in August 1839, copies of European newspapers describing how to perform the new process made their way across the Atlantic to the United States.[6] Once on American shores, the daguerreotype quickly became an open-source, commercially viable technology. For his part, Morse publicized and supported Daguerre's new invention in the United States while at the same time downplaying the simultaneous photographic discoveries of Talbot in England.[7] The daguerreotype quickly took off in the United States, eclipsing other nascent modes of photography.

A daguerreotype is a one-of-a-kind, fixed photographic image made by the action of light upon a plate sensitized by chemical solutions. According to photo process historian Mark Osterman, a copper plate is coated with light-sensitive silver, the plate is exposed in the camera, and then the hidden image is revealed "by allowing the fumes of heated mercury to play upon the silver." The daguerreotype is then washed in a fixing solution to make the image permanent and, finally, "toned with a solution containing gold chloride."[8] The resulting image, which could come in a variety of sizes depending on the plate used, is a "highly polished silver mirror" that, when manipulated by the hand, alternately reveals the highlights and shadows of its fixed image.[9]

Almost as soon as Americans started making daguerreotypes, they made daguerreotypes of George Washington. The fact that he was unavailable to be photographed from life was no obstacle. Though he died in 1799—a full forty years before photography's invention—the nation's first president nevertheless appeared as a subject in daguerreotypes of busts, painted portraits, and prints, ironically making daguerreotypes of Washington's image some of the earliest presidential photographs. Take, for example, a daguerreotype of Gilbert Stuart's famous, yet unfinished, 1796 "Athenaeum" portrait of George Washington. Roughly three inches tall by two and a half inches wide and easily held in one hand, the lightly tarnished, quarter-plate daguerreotype of Washington is preserved behind glass and a gilded mat, cushioned by red velvet, and protected by a worn wooden and leather hinged case. But its mirrored surface still clearly offers up Washington's painted gaze, one that is familiar to us today in large part because we carry it in our wallets on the U.S. dollar bill.

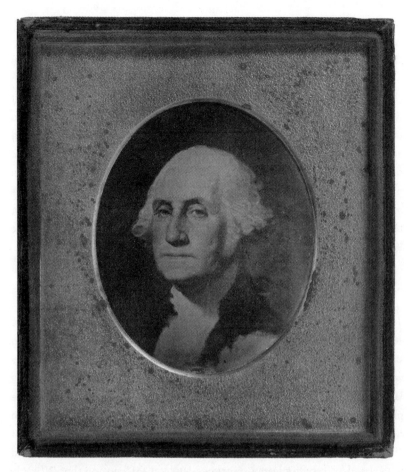

Figure 1.1: John Adams Whipple, daguerreotype of portrait of George Washington by Gilbert Stuart, 1847. (National Portrait Gallery, Smithsonian Institution; gift of Helen Hill Miller.)

When the case is opened, a message appears opposite the Washington image. In embossed letters on a red velvet background, a tiny brass plate reads:

<div align="center">

DAGUERREOTYPED BY

JOHN A. WHIPPLE

NOV. 15TH 1847.

</div>

The daguerreotype and its tiny brass plate invite several questions. What, precisely, has been "daguerreotyped" here? At first glance, the answer would seem simple: Whipple has made a daguerreotype of a famous painting of George Washington. But why? To share Stuart's famous portrait with others

who might not otherwise see it? As an experiment or practice for a photographer continually honing his craft? To illustrate to potential customers Whipple's own prowess in the art of the daguerreotype? To tap into (and perhaps profit from) mid-nineteenth-century Americans' obsession with the iconic founder? Or perhaps the choice of Stuart's Athenaeum portrait was one of mere convenience; the portrait got its name because it was held in Boston's Athenaeum, the local library, so it theoretically would have been accessible to the photographer.[10] There are no definitive answers to these questions. Nevertheless, the practice of photographing George Washington offers a helpful point of entry into this book's exploration of how presidents have helped to shape photography across its history. Because it turns out that once Americans got photography, they needed a photographic George Washington.

Whipple's Washington

John Adams Whipple worked as a photographer in Boston starting in the 1840s, and by the 1850s he was a well-known and well-regarded practitioner. Whipple grew up with an interest in chemistry and came to photography while working as a supplier of photographic chemicals in Boston.[11] By the late 1840s Whipple ran a studio with his partner, James Black, where he participated in most aspects of the photographic trade. The 1848–1849 *Boston Directory* listed him as one of twenty-two sellers and producers of "Daguerreotype Miniatures" in the city.[12] An ad in that same publication advertised "Whipple's Daguerreotypes—BY STEAM," noting that Whipple had successfully integrated steam power into the production of his images, enabling him to "furnish my customers with BETTER MINIATURES IN LESS TIME THAN FORMERLY, ESPECIALLY BEAUTIFUL LIKENESSES OF LITTLE CHILDREN, Which I will warrant to make satisfactory to parents, If they will call upon me between the hours of 11 and 2, when the sky is clear."[13] For an art of "sun-painting" that relied on the exposure of its subject to a light-sensitive medium, a clear sky was essential.

Today Whipple is remembered for his contributions to the science of photography and the photography of science. For example, in 1850 Whipple and Black patented a process for making paper prints from glass negatives— what they called "crystalotypes"—which opened the door to the printing of photographs on paper in later decades.[14] During this period Whipple

also experimented with photographing the moon and stars using a large telescope at the Harvard College Observatory. After several failures over the span of three or so years, he finally succeeded in making a spectacular daguerreotype of the moon in 1851.[15]

Closer to the subject of his Washington daguerreotype, Whipple also showed interest in the photography of art and in images related to the nation's founders.[16] In what may have been one of his early experiments with the crystalotype, Whipple made and printed on paper a vibrant image of a classically themed statue of a male and female pair walking together.[17] Later, in 1854, Whipple contributed images to a book called *Homes of American Statesmen*, a nearly five-hundred-page compendium of patriotic biographies of the nation's founders. Such publications were common during this period. Merry Foresta writes, "In America the nineteenth century was a great period of taking stock, of retrospection and recovery as well as expansion, and photography was considered the truest agent for listing, knowing, and possessing, as it were, the significance of events."[18] Each statesman's profile was accompanied by facsimiles of his letters and engravings of his home, many of which originated as daguerreotypes. The George Washington chapter featured an engraving of a Cambridge, Massachusetts, house that Washington lived in during the Revolution, based upon a daguerreotype by Whipple.[19] Each book was sold with a photographic frontispiece of John Hancock's Boston home by Whipple; printed directly on paper, the image was, according to a publisher's note in the book, "somewhat of a curiosity, *each copy* being an *original sun-picture* on paper."[20] The frontispiece constituted perhaps one of the earliest examples of a photograph being printed in or with a book.

The daguerreotype of the Washington painting was thus far from unusual for its creator. In many ways it embodied what we know of Whipple's overarching interest in the art and science of photography and his commitments to technical and aesthetic experimentation with the photography of art objects. Perhaps his choice to photograph Washington was also tied to a patriotic and commercial investment in telling visual narratives of the nation's founders. If so, Whipple was not alone.

George Washington as Visual Icon of the Nation

For nearly all of the nineteenth century, George Washington was *the* visual icon of the nation, its metaphorical father figure and shaper of national

character. This status emerged during Washington's own life as he took command of the Continental forces during the Revolution and then later assumed the presidency. Publicly circulated visual images played a central role in the emerging iconicity of Washington. The culture more broadly was interested in new topics for visual representation, as the later eighteenth century brought with it a shift from public interest in portraits of religious figures to more secular figures such as soldiers and politicians.[21] In the case of George Washington, those new images came in a dizzying variety of forms, everything from pictures in books and magazines to prints suitable for framing and even sheet music. Writes Wendy Wick Reaves, "Never before in America had a single subject produced such a quantity of visual material over an extended period of time."[22] Many images came with Washington's explicit cooperation. For if Washington in his Cincinnatus guise was a famously reluctant general and later a reluctant president, he does not appear to have been reluctant to pose for portraits or busts.[23] His fame and his own interest in visual representation led the most famous artists of the day to seek him out. Washington sat for upward of twenty-eight portrait painters, some more than once.[24] When the images were completed, many of them stayed in the Washingtons' possession. Furthermore, the president displayed images of himself in his home at Mount Vernon and was known to proudly show them off to visitors.[25]

In life, and as captured by some of the finest painters and sculptors of the day, Washington's body was already understood to be a national body that embodied American values.[26] Washington's status as a visual icon only grew after his death. Barry Schwartz writes that between 1800 and 1860, "American writers produced at least 400 books, essays, and articles on Washington's life. During this time, Washington's image was not that of a mere celebrity, it was sacred."[27] Dramatic illustrated prints such as John James Barralet's 1802 *Apotheosis of Washington*, which featured Washington being elevated to divine status by allegorical figures representing Father Time and Immortality, used familiar iconology to confirm and perform that sacred status.[28] Later the 1820s and 1830s brought the rise of the illustrated celebrity biography, followed around 1840 by the first illustrated history books chronicling the founding of the nation.[29] Not surprisingly, Washington's image repeatedly circulated in these contexts.[30] By the 1840s, when photography was just appearing on the national scene, the profusion of images of Washington continued, even including his likeness on household

wares like textiles and buttons. Yet despite the diversity of places where one could find images of Washington circulating, the images themselves did not differ all that much from one another.[31] The source images used for this wide variety of material were likely to be a small handful of increasingly accepted canonical images of Washington.

Here Whipple's choice to make a daguerreotype of Stuart's Athenaeum portrait comes into sharper focus, for that image became *the* image of Washington in the nineteenth century and it remains as one of the most visible today.[32] For example, one popular illustrated biography, John Frost's 1844 *Pictorial History of the United States*, affirmed for readers Washington's national paternity by featuring an engraved reproduction of the Athenaeum portrait in which Washington was surrounded by other symbols of the nation, including Lady Liberty, an American eagle, the flag, and the Constitution.[33] In 1847, the year Whipple made his Washington daguerreotype, the government released its first stamps, which featured images of Ben Franklin and George Washington; the latter's image was based on Stuart's Athenaeum portrait.[34] In fact, the Athenaeum portrait became so widely reproduced, in so many forms, that literary and art critic John Neal claimed in 1868, "If Washington returned to life and stood side by side with this portrait and did not resemble it, he would have been rejected as an impostor."[35]

In good republican fashion, however, the Athenaeum portrait was not merely coronated as the preferred portrait; it had to be argued for, repeatedly. In the process of authorizing commissions for paintings and sculptures of Washington in the 1820s and 1830s, Congress debated more than once which images of George Washington were the best likenesses. One commission gave the chosen artists freedom to construct their works as they saw fit but decreed that the head must be Stuart's.[36] This provision produced a series of counterarguments by those who claimed that the images of Washington by Rembrandt Peale were in fact more faithful likenesses. Throughout much of the nineteenth century, the dispute continued between those who favored Peale and those who favored Stuart, carried on largely through family members invested in securing the aesthetic and commercial value of their ancestor's legacy. As late as the nation's centennial celebrations in 1876, for example, Stuart's daughter Jane still worked publicly to convince Americans that her father's images of Washington were the most authentic.[37] Yet she need not have worried. Stuart's Athenaeum painting

continued to dominate. As an 1889 magazine article declared, "The household Washington of the world is Stuart's Washington."[38]

But Peale and Stuart had something more important in common than disputes about whose likeness of Washington was the "truest." The disputes happened in the first place because each had painted the man from life. Thus it would be assumed that their images would be closest to a faithful depiction of Washington the man. Arguably that fidelity gave the Athenaeum portrait much of its rhetorical traction as a vehicle for communicating Washington's symbolic status. Washington likely sat for Stuart in Philadelphia in April 1796 as a part of a commission to paint both the president and his wife.[39] The portrait, however, was never finished; furthermore, Stuart never even gave it to the Washingtons, despite the fact that they had commissioned it and that Martha Washington requested it from the artist after her husband's death.[40] While working on the heads, Stuart received a lucrative commission to create a full body portrait of Washington that ultimately became known as the "Lansdowne" portrait.[41] Stuart set aside the unfinished portrait of the president but likely copied the head for the new commission.[42] The image known today as the Athenaeum portrait—famously unfinished but regularly and routinely copied by the artist and others in his studio—was given to the Boston Athenaeum after Stuart's death in 1828. The original unfinished portrait was copied at least seventy-five times during the artist's lifetime.[43]

The portrait was especially ripe for daguerreotyping because it was known to be painted from life. If one could not directly photograph Washington, the logic might go, one could at least photograph an image known to be painted from life—especially one conveniently hanging in the local Boston library. That would give one's daguerreotype something close to the status of what the new medium promised: fidelity to its subject, a perfect likeness. Furthermore, the specific visual qualities of the Athenaeum portrait conformed to the evolving norms of photographic portraiture, which themselves had come from portrait painting. After the Revolution the nation needed a new mode of visual representation for its leaders, and Stuart's Washington fit that bill.[44] Paul Staiti points out that Washington's expression in the painting embodied "prudence, self-control, and sincerity, a premeditated presentation of an ideal self" that found later echoes in the norms of daguerreotype portraiture in the United States.[45] Stuart's image from life depicted its subject with a "sense of dignity, of seriousness, even melancholy."[46] Whether viewed in its original unfinished state or in its

myriad painted "finished" copies, the Athenaeum portrait was not all that different in tone from the daguerreotype portraits photographers were making of elites in the 1840s: clear, crisp, and austere.[47]

Which brings us back to the act of photographing George Washington. Whipple was not the only Bostonian who thought to photograph the Athenaeum portrait. One of Whipple's Boston competitors, the studio of Southworth and Hawes, created at least six daguerreotypes of the Athenaeum portrait in the early 1850s.[48] Like Whipple, Southworth and Hawes regularly copied art objects and advertised the quality of their copies.[49] The daguerreotype, Albert Southworth wrote, "is admirably adapted to the copying of sculptures, crayons and engravings, and also to paintings, many of which can be well done." Writing specifically of the Athenaeum portrait, he continued, "The most of Stuart's portraits lose nothing in character by daguerreotype, and are far more perfect than any engraver could represent them."[50]

At least one visitor to Southworth and Hawes agreed. The photographer and writer Marcus Aurelius Root visited the studio in 1855 and offered his impressions in an article published in the August issue of the *Photographic Art-Journal*, one of a small crop of photography journals that appeared after 1851.[51] Root praised the work of Boston daguerreotypists as among the very best, writing that they "occupy a higher place of intelligence, energy and personal reputation, than those of any other city in the United States."[52] He singled out the work of Southworth and Hawes, in particular "a photographic copy of Gilbert Stuart's original portrait of Washington, full size, and decidedly the best photographic copy of that celebrated portrait I have ever seen."[53] Root's statement implied that he had seen and examined others, hinting at the broader practice of photographing Washington.[54]

Southworth and Hawes did not only copy the Stuart portrait by itself, however. Following the path of earlier photographers with more allegorical interests, they also used a finished copy of the painting in an original daguerreotype composition. A whole-plate daguerreotype made by Southworth and Hawes in the early 1850s features a young woman gazing at the painting behind her. She is turned three-quarters toward the viewer but gazes over one shoulder at the Athenaeum Washington. The direction of her gaze, coupled with the nearly perfect eyeline match between painted subject and live subject, seems to invite the viewer to gaze along with her.[55] Echoes of the familial connotation of founding father and child may also be found in earlier daguerreotypes that juxtaposed Washington with live

subjects. One dated to the mid-1840s pictures what looks to be a mother and daughter. The mother looks out at the viewer while the daughter gazes down upon a print of George Washington resting in the mother's lap; closer inspection reveals it to be a print of the Athenaeum portrait.[56] New York photographer Gabriel Harrison posed his children with busts of Washington to construct heavy-handed allegories of patriotism.[57] Harrison earned public acclaim in 1845 for a daguerreotype portrait he made of his son in which the young boy, aptly named George Washington Harrison, gazes upward while hugging a white marble bust of the founding father.[58] Ten years later Harrison made a similar daguerreotype of his daughter with a different bust of Washington. Laura Wexler argues that images like these constituted the

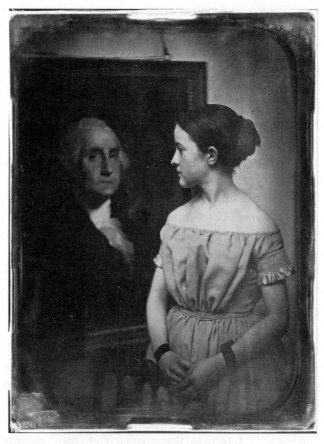

Figure 1.2: Southworth and Hawes, girl with portrait of George Washington, ca. 1850. (Metropolitan Museum of Art; gift of I. N. Phelps Stokes, Edward S. Hawes, Alice Mary Hawes, and Marion Augusta Hawes, 1937.)

nation as a family, with Harrison's children as loving proto-citizens, literally wrapping their arms around the father of the nation.[59] Other scholars suggest that Harrison used the busts and portraits of Washington to add "visual interest."[60] Harrison's portraits tapped into conventions of theater to tell allegorical, patriotic stories of good citizens properly worshiping the father of their national family.[61]

Figure 1.3: Unknown maker, American mother and daughter with print of George Washington, ca. 1845–1848. Daguerreotype, half-plate, 5 1/2 x 4 1/2 inches (14 x 11.4 cm). (Nelson-Atkins Museum of Art, Kansas City, Missouri; gift of Hallmark Cards Inc., 2005.27.70. © Nelson Gallery Foundation. Image: Thomas Palmer.)

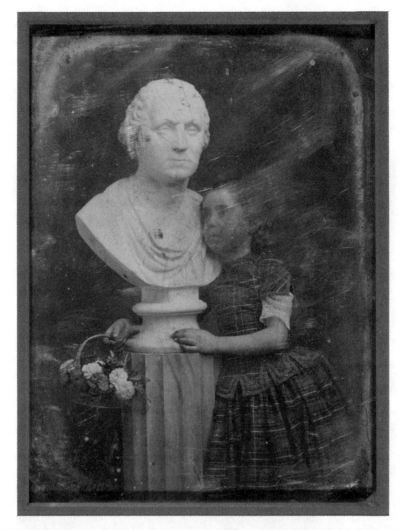

Figure 1.4: Gabriel Harrison, Helia Harrison with bust of George Washington, ca. 1855. (Courtesy of George Eastman Museum.)

Harrison's daguerreotypes prompted one writer to reflect upon the relationship between the Washington of the daguerreotype and the viewer of it. A terribly overwritten poem published in the *Photographic Art-Journal* in 1851 by Eliza C. Hurley includes these two verses: "Look up,—Look up, 'tis Washington! Oh! fix on him thy gaze, His noble, his heroic mind Fill'd Nations with amaze! / Strain every nerve to reach the mark, The height to which he soar'd; Who proved the glory of his day By the whole world

ador'd."[62] The writer urged the child to look up, to not only see but to emulate George Washington as well. To "photograph" Washington, then, meant to recognize both his patriarchal greatness and the requirement for the daguerreotype's viewer to "fix" her own gaze, to aspire to that same character, to "strain every nerve to reach the mark."

Returning now to my original set of questions about Whipple's choice to photograph the Athenaeum portrait—instead of asking why George Washington emerged as a subject of early photography, it may be more appropriate to ask *Why wouldn't he?* The visual icon of the nation symbolically transformed from the national body of the revolutionary and presidential periods to something akin to a white national father. Furthermore, at least in his Athenaeum portrait form, Washington was also the ideal representative for daguerreotype portraiture, a kind of aesthetic touchstone for carrying the presidential image forward into the photographic age. He was both of the past and relentlessly present. Washington's own bearing, combined with Stuart's skill, offered mid-nineteenth-century viewers a serious, calm presence to emulate, an image made from life and a model of citizenly gravitas.

Daguerreotyping the Revolution and Early Republic

The need for models of citizenship seemed especially urgent because photography appeared precisely at the moment when the generation of the American Revolution and early republic was dying out. While George Washington, John Adams, and Thomas Jefferson were long gone, James Madison's widow, Dolley Madison, lived long enough to be photographed, as did John Quincy Adams, a literal child of the Revolution and himself a former president. Photographers were so eager to get a daguerreotype of an elderly and ill Andrew Jackson before his death in 1845 that they more or less staged a months-long (and eventually successful) stakeout at his home in Tennessee.[63] Perhaps the best products of that desire for a direct link to the Revolution and early republic are the daguerreotypes of Dolley Madison, who more than anyone stood as a living symbol of them. Newly returned to living in the nation's capital in the 1840s, she remained a celebrity. The apocryphal story of her rescue of Gilbert Stuart's portrait of George Washington from the British army descending upon the White House in 1814 still circulated, fanning the flames of her fame.[64] She was

given her own seat on the floor of the House of Representatives, and when she died in 1849 she received a state funeral.[65]

Daguerreotypes made by Mathew Brady in 1848 of Madison posing alone and with her niece Anna Payne suggested both continuity and change. In her portraits, Madison wore the very-out-of-fashion turban of her earlier era of national prominence, her dress in sharp contrast with that of her younger, more fashionable niece. Madison's symbolic continuity with the nation's founding is perhaps best illustrated in a group photograph likely made in the summer of 1846 at the President's House (as it was called then). The daguerreotype made by the painter George P. A. Healy recorded what might have been a chance, and certainly fortuitous, photo opportunity at the Polk White House. The photograph condensed into one image the nation's past represented by a somewhat out of focus yet still clearly identifiable Madison, its present represented by the current president, James Polk, and his wife, Sarah, and its future in the form of then–Secretary of State James Buchanan, who would become president less than a dozen stormy years later.[66]

Figure 1.5: Mathew Brady, daguerreotype of Dolley Madison, 1848. (Library of Congress.)

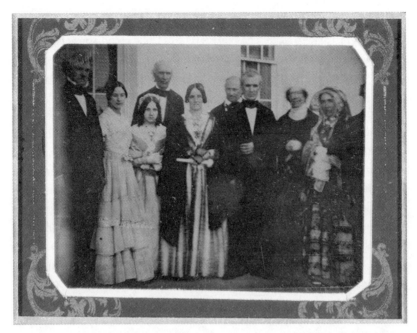

Figure 1.6: George P. A. Healy, Dolley Madison with two presidents on the south portico of the White House, 1846–1847. (Courtesy of George Eastman Museum.)

The Madison daguerreotypes were both similar to and different from photographs of Washington in painted or sculpted form. They also provided citizens with visual memories of the founding, but as images of living people they offered a poignant, bodily connection to the earliest years of the nation. The desire to capture elite figures for posterity drove early portraiture in the United States, especially in the nation's capital. An 1845 editorial in the Washington, DC, *National Intelligencer* extolled the virtues of the work of the photographers Edward Anthony and J. M. Edwards, who had spent the last few years trying to photograph every member of Congress, along with other dignitaries, from a makeshift studio inside the U.S. Capitol: "We can hardly imagine an exhibition more attractive to the public than the accurate likenesses of all, or nearly all, the eminent individuals of our country."[67] The writer recognized the future value of the images as well, adding, "It must also soon be of great value, as one and another of those who have lived long enough to attain celebrity are passing from this stage of life. How priceless would be a good daguerreotype of Washington, Franklin, or any of the fathers of our country."[68] Implicit in the editorial's lamentation about the impossibility of ever having a "good daguerreotype" of Washington and

others was the recognition that photography made it possible to preserve figures for history. To make a daguerreotype of Dolley Madison was in many ways to photograph the Revolution itself.

Daguerreotypes in the Washington Monument

Beyond the desire to capture the image and spirit of the Revolution, the urge to photograph George Washington exemplified the immediacy and intensity with which photography and the presidency came together in the public mind. Perhaps no single event of the 1840s illustrated this blending more clearly than the public celebrations surrounding the laying of the cornerstone of the Washington Monument. On July 4, 1848, after many decades of deliberation, partisan wrangling, and often ineffectual fund-raising, the cornerstone of the Washington Monument was laid in an elaborate ceremony in Washington, DC.[69] Just as the group daguerreotype of Dolley Madison with a current and future president bridged the nation's past and future, the laying of the cornerstone served as a symbolic bridge between the eighteenth and nineteenth centuries. Newspapers reported that a procession some forty-five minutes long brought President Polk, members of Congress, justices of the Supreme Court, and special guests to the monument site, where an estimated fifteen to twenty thousand people gathered for the event.[70] Eighty-year-old Dolley Madison was joined as a special guest by ninety-one-year-old Eliza Hamilton, widow of Alexander, and they rode together in the procession to the ceremony. Both women, along with Louisa Adams, the widow of the recently deceased John Quincy Adams, had helped with fund-raising efforts for the monument.[71] (Months earlier, Adams himself had been invited to give the oration at the event but turned down the request because of ill health.[72]) In keeping with the intergenerational nature of the event, a young, new congressman from Illinois, Abraham Lincoln, was also in attendance.[73]

The masonic ceremony opened with a prayer and an oration, and then came the main event:

> The brethren came under the masonic arch into the excavation, and surrounded the corner-stone during the speaking. After which the various plates, books, pamphlets, newspapers, maps, charts, &tc., having been deposited in the stone, Major French came down and a hymn was sung. He then

poured the oil, and corn, and wine, emblems of prosperity and happiness, into the stone, and after the usual examination of the order, pronounced it "true and trusty"; had the cap-stone let down, and the stone sealed up; and the clapping of hands . . . finished the work.[74]

Dozens of artifacts and objects were deposited inside the cornerstone as a kind of time capsule. These objects recalled aspects of Washington's life, chronicled the history of plans for the monument, and described aspects of the present day. Copies of the Constitution and Declaration of Independence were placed inside, along with a book of presidential messages and copies of current magazines and that day's newspapers. Among the items the writer above termed "&tc." were a "portrait of Washington, from Stuart's painting, Faneuil Hall" and "Daguerreotype likenesses of General and Mrs. Mary [sic] Washington; with a description of the Daguerreotype process by John S. Grubb, Alexandria, Va."[75] The choice of these particular items is telling. When the Washington Monument committee decided what it wanted to communicate to posterity about George Washington and about the United States in 1848, it chose an image of Washington, one of Stuart's that recycled the famous head of the Athenaeum portrait.[76] And it chose to feature the new relatively technology of photography. Furthermore, in choosing to place daguerreotypes in the cornerstone, it chose not portraits of living Americans—the very feature that made this miraculous new art so miraculous—but "daguerreotype likenesses" of portraits of two people dead for some fifty years. In 1848 the nation still needed Washington, but so, apparently, did photography: to authorize its value, to connect it to the nation's past and present, and to establish its own norms of portraiture for decades to come.

Early Daguerreotypes in the U.S. and the Nation's Capital

How did a medium still in its relative infancy in 1848 end up so important to the nation's conception of itself that instructions for making a daguerreotype were entombed in the cornerstone of the Washington Monument? The answer lies in part in the way photography enmeshed itself into the social and political life of American elites in the 1840s, especially in the capital city of Washington, DC. Detailed accounts of the daguerreotype appeared in New York by the end of September 1839, and information about the process circulated via newspapers so quickly that it did not take long for amateurs to begin trying it out.[1] By the end of November, a man named François Gouraud arrived in New York from France. Gouraud served as an agent for the company that "held the exclusive franchise in France for Daguerre's apparatus and materials and now hoped to expand their enterprise in America." He showed samples of daguerreotypes and offered lectures that performed, step by step, how to make them.[2] Describing Gouraud's samples, the *New-York Commercial Advertiser* wrote:

> Most beautiful they are—most exquisitely beautiful—and that is all we shall say about them; for it is utterly beyond the power of language to describe their perfections, and equally impossible for one who has not seen them to derive from language a just conception of the wonderful effects produced.

We might write an hour, and to those who have examined the pictures our words would seem feeble and inexpressive, while they who have yet to examine them would cudgel their brains to no purpose in endeavoring to fancy what they are. There is but one thing to do—go and see them, choosing a bright day for the purpose.[3]

Ironically taking dozens of words to pronounce the images "beyond the power of language," the writer conveyed something of the excitement the new art aroused in those seeing it for the first time. Daguerreotypes were "exquisitely beautiful," they produced "wonderful effects," but remained difficult to "cudgel" one's brain around. A writer for the *Madisonian* offered more detail about what one actually saw in this account of viewing Gouraud's examples: "The views and copies, which compose his collection, exceed in beauty, exactness, and minuteness of finish any thing that we had been led to expect. They are perfect miniature transcripts of the originals. It would baffle the most laborious engraver to present objects with such inimitable nicety and fidelity." Getting to the heart of what made the images distinctive, the *Madisonian* zeroed in on two qualities that came to dominate descriptions of daguerreotypes: their fidelity to their "originals" and their "wonderful effects," things that not even a master engraver could achieve. The writer concluded, "We are amply convinced that it is one of the greatest inventions of the age, and will mark a new era in the history of art."[4] These twin aspects of daguerreotypy—fidelity and wonder—marked this "new era" as key visual values by which the exciting new medium would be judged.

Gouraud developed a series of lectures on how to make daguerreotypes, which he offered to audiences in New York, Philadelphia, and Baltimore in early 1840.[5] Describing one of those lectures in early February, a writer for the *New-York Commercial Advertiser* enthused, "The lecture was eminently practical, the entire process being performed, from the polishing of the plate to the ultimate washing which fixes the drawing. . . . The process took up somewhat more than two hours. The drawing was perfect, and Mr. Gouraud announced his intention of presenting it to the President of the United States, as the first perfect specimen of the Daguerreotype produced in this country."[6] In addition to his displays and demonstrations, Gouraud charged for daguerreotype lessons and sold full kits for making daguerreotypes. One account of such a sale in early 1840 stated that the

aspiring photographer paid fifty-four dollars for everything needed to get started, about fifteen hundred in today's dollars.[7] While Gouraud's claim that his daguerreotype was "the first" made in America was false (though perhaps its "perfect" qualities are what he was claiming as "the first"), his comment on sharing the image with the president was noteworthy.[8] France offered the new technology freely to Americans. Gouraud cast himself as a kind of official emissary from France, though he was not in fact a representative of the government. Yet his dramatic statement highlighted the new medium's appeal and recognized its potential public value. To present a daguerreotype to the president would be to engage in a transnational act of friendship. For Gouraud, bringing French technology to American soil was about much more than sharing an individual scientific achievement. It also highlighted the hopes of practitioners that the new art was potentially so valuable as to be worthy of national attention from the country's elites.

The basic institutional structures of daguerreotype photography in the United States were established by early 1840.[9] With photographers came the necessary introduction of sellers of photographic equipment and chemicals, the latter of which had begun to set up shop in major U.S. cities early in the new year.[10] Daguerre famously suggested that he did not think his process would be amenable to portraiture, largely because of the long exposure times required to make a good image.[11] In December 1839 the editor of *The Knickerbocker* agreed: "The daguerreotype will never do for portrait painting. Its pictures are quite too natural, to please any other than very beautiful sitters."[12] But in the United States, experiments with portraiture began almost immediately, and American photographers made improvements to the process that reduced exposure times and made portraiture more feasible. In May 1840, photographers John Johnson and Alexander Wolcott received the first U.S. patent in photography for their development of a high-quality daguerreotype camera suitable for studio use.[13] A few months earlier the two men had opened a daguerreotype studio in New York, the first commercial one in the world. Their innovations allowed the pair to dramatically reduce exposure times to between three and five minutes.[14] Outside of big cities, traveling or itinerant daguerreotypists began to move throughout the country in search of paying customers.[15] By the end of 1840, access to the daguerreotype was widespread for those who had five dollars to pay for one.[16]

From the beginning, the commercial practice of daguerreotypy was sold as an art of memory and recollection that preserved the subject's likeness and, in doing so, had the seeming capacity to collapse time itself. Photography made the past present in the faces of lost loved ones and offered the opportunity for those pictured to visually revisit their own past selves later in life. An advertisement by Rochester, New York, photographer I. N. Bloodgood captured these qualities as it enumerated the value of the daguerreotype to the average citizen:

> How many have lost Father, or Mother, or a little child, without a shadow of resemblance to recall their features. . . . How much more valuable would be a well-executed Daguerreotype of the loved and lost! Should you reach the years of maturity, what would you not give for a true likeness of yourself, taken when a child? It would show the effects of time, and call up many pleasant recollections. This satisfaction you can now afford your children. And should they be snatched from your embrace by the cold hand of Death, your possession of their Daguerreotype Likeness, if taken by a good artist, will afford sweet consolation.[17]

Advertisements like this one illustrated how the daguerreotype became a recognizable and powerful cultural product, one that offered viewers an experience of both fidelity (a "true likeness") and wonder (collapsing "the effects of time").

Marcy Dinius points out that as the new art form became more integrated into antebellum society, the daguerreotype came to be popularly understood in three ways: as a democratic art, as a representation of its subject's character, and as a metaphor for truth or realism.[18] Unlike painting, the daguerreotype freed the hand of the painter from the representation, turning portraiture into an art of fidelity whose qualities appeared more democratic than those images painted by the fawning hand of a well-paid artist.[19] African American orator and activist Frederick Douglass was the most photographed person of the nineteenth century and a frequent visitor to the daguerreotypist himself. Celebrating photography's democratic qualities, he proclaimed, "What was once the special and exclusive luxury of the rich and great is now the privilege of all."[20] Because of their seeming capacity to offer a "truer" representation than other visual modes of portraiture, daguerreotypes were also said to be better communicators of their subjects' moral character—a position

one of the earliest photographic presidents, John Quincy Adams, would contest, as I show in chapter 3. Well before photography was invented, portraits were understood to be sources of information about character, a belief amplified by the popularity of the pseudosciences of phrenology and physiognomy, which argued that one's bodily attributes predicted one's morality and intellectual abilities.[21] As an accurate representation of the sitter, the daguerreotype seemed to be especially good at making visible its subject's moral qualities. Finally, the term "daguerreotype" came to function as both a noun and a verb in ways with meaning beyond photography itself.[22] "To daguerreotype" something came to metaphorically mean providing an accurate, truthful description. According to Marcy Dinius, the term also "came into fashionable figurative use as a metaphor for a lasting impression made by a person, place, or event on one's memory, for a writer's ability to bring characters, events, or scenes to life in the reader's mind, and for a comprehensive perspective on a moment in time provided by newspapers, magazines, and histories."[23] This is why Frederick Douglass would write in the early 1850s of Harriet Beecher Stowe, "So much has been said and written about Mrs. Stowe, that it is hardly worth while [sic] for us to give our daguerreotype impression of her."[24] As a medium communicating visual values of fidelity and wonder, the daguerreotype came to stand not only for the technology that produced it but also for the cultural power of those visual values themselves.

Daguerreotypes in the Capital City

By early 1840 both the material object and the visual values of the daguerreotype had arrived in the nation's capital. In March 1840 a local newspaper, the *National Intelligencer*, announced an exhibit of "sun-painted pictures," and as many news outlets felt compelled to do in the early days of photography, it attempted to explain what visitors would see: "The images seen in the Camera Obscura are made permanent on plates of silver by the agency of light. *All* stationary objects preserve their forms, in the most minute detail, with perfect exactitude. The effects of linear perspective, and the gradations of tone depending upon aerial perspective, are presented with wonderful delicacy on these pictorial duplications of Nature."[25] As in the earlier announcements of the daguerreotype, the writer highlighted the

daguerreotype's capacity for detail and "exactitude" as well as its capacity for wonder. A couple of days later, the paper's editors wrote of the exhibition conducted by a man named Seixas: "This is the first opportunity that the Washingtonians have had of becoming practically acquainted with the almost magical effects produced by this most interesting art, of which it is difficult to say whether it is most to be wondered at or be admired. We have ourselves examined some of the plates executed by Mr. Seixas, and they are certainly, as far as we can judge, beautiful impressions of the objects which they represent."[26]

By June 1840 a daguerreotypist named John Stevenson had temporarily set up shop in Washington with this advertisement announcing his plans: "Daguerreotype Likenesses: Mr. Stevenson would inform the citizens of Washington and the District that he has taken rooms at Mrs. Cummings', on Pennsylvania avenue, a few doors from the Capitol, where he is prepared to take miniature likenesses by the Daguerreotype every fair day, from 10 A.M. till 4 P.M." Stevenson appears to have stayed in the capital until July.[27] About six months later, in January 1841, photographers Justus Moore and a man known only to posterity as Captain Ward took rooms in a Washington, DC, hotel. They announced in the newspaper that they were in town "for a few days, where they will be prepared to take Daguerreotype likenesses in a superior style, which, being the reflected forms of the objects themselves, far surpass in fidelity of resemblance any thing which can be accomplished by the eye and hand of the artist."[28] Despite downplaying in the ad their own skill and artistry, the photographers achieved some success and recognition. They even secured a portrait session with the new president, William Henry Harrison. In mid-March the *National Intelligencer* reported that Moore and Ward had "for some weeks past been successfully engaged at the Capitol in obtaining likenesses of the President, of several Members of Congress, and other distinguished personages."[29] President Harrison, according to a Philadelphia newspaper, apparently "was delighted with the result."[30] Harrison died within a month of his inauguration and that portrait session; the daguerreotype likely survived him but is now lost to history. As for Moore and Ward, they too moved on and by June were working in St. Louis for a brief time before moving on yet again.[31]

It is unclear when the nation's capital got its first permanent resident photographer. By 1843 at least two were working in the city. The 1843 city

☞ NOTICE.—The Young Men's Total Abstinence Society will meet this (Monday) evening, at 8 o'clock, in the 4th Presbyterian Church, on 9th street, when the Rev. Mr. Clary, agent of the Maryland State Temperance Society, will address the Society on the subject of temperance.

The members of the Society and the Public generally are invited to attend. june 29

DAGUERREOTYPE LIKENESSES.—Mr. STEVENSON would inform the citizens of Washington and the District that he has taken rooms at Mrs. Cummings', on Pennsylvania avenue, a few doors from the Capitol, where he is prepared to take miniature likenesses by the Daguerreotype every fair day, from 10 A. M. till 4 P. M. june 29—1w

MAYOR's OFFICE, WASHINGTON, JUNE 18, 1840.
VEGETABLE STALLS.—On Monday, the 6th of July next, I shall rent all the ·Vegetable Stalls in the West Market-house to the highest bidder, for one year, commencing the 1st day of July. .
Renting to commence at 7 o'clock A. M.

Figure 2.1: Daguerreotype advertisement, *National Intelligencer*, June 29, 1840.

directory listed a "George West, photographer" on E Street; West and his partner, Charles Page, would photograph sitting congressman and ex-president John Quincy Adams twice, in April and May of 1843.[32] In addition, a lithographer named Philip Haas was making daguerreotypes out of a studio on Pennsylvania Avenue near the Capitol.[33] He would photograph Adams a handful of times beginning in 1843.[34] One of those daguerreotypes was lost to history for nearly 175 years until it reappeared seemingly out of nowhere in 2017.

The Daguerreotype President

In August 2017 Sotheby's announced that it was putting up for auction a newly discovered original daguerreotype of John Quincy Adams made in March 1843 in Washington, DC, by Philip Haas. National Portrait Gallery senior curator Ann Shumard reported to *Washingtonian* magazine that in December 2016 she received an email from someone claiming to have a daguerreotype of John Quincy Adams. The National Portrait Gallery already held an image of Adams known to be the oldest existing photograph of a U.S. president: a small, sixth-plate daguerreotype made in August 1843 in Utica, New York.

Figure 2.2: Philip Haas, daguerreotype of John Quincy Adams, March 1843. (National Portrait Gallery, Smithsonian Institution. Acquired through the generosity of the Secretary of the Smithsonian and the Smithsonian National Board, the Burnett Family Fund, Carl and Marilynn Thoma, Connie and Dennis Keller, Tim Lindholm and Lucy Gaylord Lindholm, Mr. and Mrs. John W. McCarter Jr., Mr. and Mrs. Ronald J. Gidwitz, Ellen G. Miles and Neil R. Greene, Ronnyjane Goldsmith, David D. Hiller, Richard and Janet Horwood, and Mary Martell.)

Shumard was accustomed to occasional communications from earnest amateur historians who thought their attic finds must be someone important, but Shumard told reporter Rob Brunner that this email "seemed different."[35] Brunner wrote, "A man had found a daguerreotype in a desk drawer at his parents' house after they died in 1991. He'd always figured it was probably his great-great-grandfather Horace Everett, a Vermont congressman from 1829 to the early 1840s. Interesting, he thought, but not hugely significant. Back into the drawer it went. But about a decade ago, the man said, he'd started doing some research online, and the person in the image appeared to be John Quincy Adams."[36]

Shumard studied the photograph and confirmed that it was indeed Adams. And not a copy daguerreotype either but an original. And not just an original but one that predated the earliest-known daguerreotype owned by the National Portrait Gallery. Just like that, the nation got a new oldest existing photograph of a president. After the Everett descendant (who asked not to be named) consigned the daguerreotype to auction with Sotheby's, it was sold in 2017 to the Smithsonian's National Portrait Gallery for $360,500 and put on display for the public to see in the National Portrait Gallery's "America's Presidents" exhibition.[37]

Adams was not the first president to be photographed. That distinction goes to Moore and Ward's long-lost 1841 daguerreotype of William Henry Harrison. But the extant daguerreotypes of Adams currently are the oldest that we have of any president of the United States.[38] For that reason alone, John Quincy Adams occupies a key place in the history of presidential engagements with photography.[39] Adams is also important because he not only sat for photographs; he also wrote about his experiences with them. He kept a detailed daily diary for most of his life, leaving hundreds of words chronicling his experiences sitting for daguerreotypes. The diary entries offer the most substantive records of his photographic activities (i.e., when and where he was photographed, and by whom), and as the next chapter explores, they describe in detail what he thought about these encounters and this strange new medium of fidelity and wonder.

John Quincy Adams and National Portraiture

On August 1, 1843, seventy-six-year-old ex-president and sitting congress-man John Quincy Adams visited the photography studio of Dr. Leverett Bishop and Alonzo Gray on Genesee Street in Utica, New York. His old friend, the former congressman Ezekiel Bacon, accompanied him. Adams reported later in his diary that "four Daguerreotype likenesses of my head were taken, two of them jointly with the head of Mr. Bacon." His assessment of the images: "All hideous."[1] Adams was not a man who minced words.

Adams's disappointing visit to the local daguerreotypist took place in the midst of a busy twenty-four hours for the supposedly vacationing con-gressman. On the previous evening a "committee representing the coloured citizens of Utica" paid a visit to Adams to thank him "for my efforts in protecting the right of petition, and promoting the abolition of slavery." Ad-ams reported in his diary that one of the visitors "addressed me in a short, formal speech, modest and well delivered." The former Boylston Professor of Rhetoric at Harvard then replied to his fellow citizens with "equal brevity, thanking them for their kind attentions to me."[2] The *Utica Gazette* reported that in those remarks Adams had, among other things, wished his visitors "a successful issue out of all the afflictions and injustice under which they and their brethren now in bondage of various kinds had so long labored."[3]

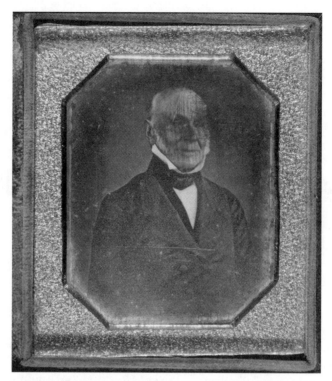

Figure 3.1: Bishop and Gray, daguerreotype of John Quincy Adams, August 1843. (National Portrait Gallery, Smithsonian Institution; gift of John D. Duncan and an anonymous donor.)

The next morning, Adams visited Utica Female Academy, where he met teachers and students and was "addressed on behalf of the trustees of that institution by Mr. Spencer in a manner so affecting that it made a child of me." Spencer had included in his remarks excerpts from Abigail Adams's letters to her husband and to her son John Quincy. Adams got emotional: "I actually sobbed as he read, utterly unable to suppress my emotion. Oh! My mother! Is there anything so affecting to me as thy name?" Adams reported in his diary that he quickly pulled himself together to offer a few brief remarks in response but confessed, "My thoughts were all upon my mother. My heart was too full for my head to think, and my presence of mind was gone." After this emotionally affecting experience, Adams was ushered to an outdoor stage where his friend Bacon offered him a formal welcome on behalf of the citizens of Utica, which Adams then responded to "in a speech of about half an hour." Adams wrote in the diary that "the

shaking of some hundred hands then followed."[4] Only after this did he head off to the daguerreotypist.

One would think that being formally welcomed, delivering speeches, shaking so many hands, and sitting for daguerreotypes would be enough to fill one's day, especially for an increasingly frail septuagenerian. But Adams was just getting started. After the daguerreotype sitting, he visited a celebrity described in his diary as "the dwarf C. S. Stratton, called General Tom Thumb." The great American showman P. T. Barnum had partnered with Charles Sherwood Stratton's father to exhibit Stratton as a stage performer. Adams's encounter with him took place during the child performer's first tour, which took the young Stratton to parts of New York and Canada in the late summer of 1843.[5] Though Stratton was only five years old at the time, Barnum advertised the child as age eleven so as to better play up the spectacle of his small stature. Adams must have believed the humbug, for he reported in his diary that General Tom Thumb was "11 years old. 25 inches high; weighing 15 pounds. Dressed in military uniform, mimicking Napoleon."[6] After a meal hosted by Adams's nephew Alexander B. Johnson, he visited a congressional colleague, John M. Niles, who was hospitalized. From there he proceeded to the York Mills Cotton Factory, where he gave another speech. His address was followed by gifts of cotton, which the antislavery Adams was careful to note in his diary he "declined accepting." Only after these final events of the day did John Quincy Adams return to his nephew's house for an "elegant evening party and supper."[7]

Most Americans in 1843 did not spend their vacations like this. Nor were they greeted at nearly every stop along the way with what one newspaper described as "a brilliant torchlight procession, preceded by music, and followed by an immense concourse of the people generally."[8] But John Quincy Adams was not most Americans. Adams held a singular place in American history. As an eight-year-old, the white, privileged son of a founding father and mother had watched firsthand some of the first shots fired in the American Revolution. That child grew up to be an international diplomat, U.S. senator, secretary of state, rhetoric professor, president, congressman, and passionate antislavery advocate. He boasted fluency in several classical and modern languages, championed science through his advocacy for the establishment of the Smithsonian Institution, and kept a diary that chronicled nearly every day of his adult life.[9] No surprise, then, that John Quincy Adams's appearances in the towns and cities of western New York

in the summer of 1843 constituted major public events, equaling, perhaps, even the spectacles of Barnum himself. The *National Intelligencer* summed up the former president's travels this way: "In each city and town that he has passed through, or rested in, the spontaneous evidences of the personal respect which his long life of honor has induced for him among the people have been very numerous and gratifying."[10]

As a person of national prominence, John Quincy Adams was one of the most visually depicted figures of his age. He sat for dozens of portraits during his lifetime, in multiple media.[11] The most important portrait artists of the day painted him, including John Singleton Copley, Charles Willson Peale, and Gilbert Stuart—the same men who had painted Adams's mother and father, George Washington, and other elites of the Revolution and early republic. Like this earlier generation, John Quincy Adams was the subject of countless engravings, silhouettes, and lithographs as well, affordable images that citizens in the U.S. and abroad could buy, sell, and display. Toward the end of his life, he confided to his diary, "I question whether another man lives who has been so woefully and so variously bedaubed as I have been. There is no picture of my childhood but from the age of 16, when I was caricatured in crayons by Mr. Schmidt for four ducats, down to this my 77th year, when Mr. White has lampooned me in oil, scarcely a year has passed away, without a crucifixion of my face and form by some painter engraver or sculptor."[12] Despite his characteristic grumpiness, Adams cared deeply about art, and he liked to spend time with artists. In addition to numerous accounts of sittings with painters, his diary reported evening hours spent in the pleasant company of artists such as the sculptor Horatio Greenough and the painter Charles Bird King, and he often mentioned browsing the visual collections of friends and neighbors whom he visited.[13]

Given Adams's lifetime of experiences with visual representation, it makes sense that he would be curious about the new medium of photography. According to data culled from entries in Adams's diary, the Utica trip was his seventh visit to a daguerreotypist in less than a year. By the time he sat for Bishop and Gray in Utica, Adams already had sat for roughly twenty daguerreotypes. Most of those sittings, he reported in his diary, failed to produce a quality image. Adams would sit for and write about somewhere around fifty daguerreotypes before his death in February 1848.[14] As a sought-after photographic subject and lover of technology with a lifetime of

experience being "bedaubed," Adams occupied a singular cultural position from which to wrestle with the implications of the strange and wonderful new medium. His diary reveals him to be a thoughtful, anxious public figure grappling with the question of what this new visual medium might mean for national life. Adams recognized photography's unique representational power, but his interest in photography did not amount to a wholehearted endorsement. The new medium's visual values of fidelity and wonder worried him. He lamented photography's capacity to produce images that were, as he put it, "too true to the original," ones that depicted with too much clarity his aging body and face.[15] More broadly, Adams also worried about whether the daguerreotype in all its mirrored wonder was the best art for producing what he termed "true portraiture of the heart"—portraits that were, in his words, worthy of being "transmitted to the memory of the next age."[16] Adams was ambivalent about the new visual values emerging from inside the place he called "the shadow shop."[17] The reasons why not only tell us about Adams's own experiences but also provide insight into how daguerreotypes became part of the visual culture at large.

"Wretched portraits far inferior to the silhouette"

Despite the publicity given to the new art of the daguerreotype in 1840 and the fact that the president, members of Congress, and other local elites sat for daguerreotypes made by itinerant photographers located close to the U.S. Capitol, John Quincy Adams does not appear to have availed himself of the services of a photographer until the fall of 1842. Adams must have been aware of the new medium, because the daguerreotype demonstrations described in the previous chapter were publicized and reviewed in his preferred Washington, DC, newspaper, the *National Intelligencer*. Adams did not report in the diary that he attended any of these demonstrations or saw early daguerreotype displays in the nation's capital. Given his propensity for documenting all of his daily activities in his diary, the absence of documentation suggests he likely did not partake of them. Adams did continue his regular practice of taking in other visual representations during this period, however. For example, several days before Seixas's daguerreotype demonstrations in March 1840, Adams noted in his diary that on his way to the Capitol he had stopped at the studio of a sculptor named Bettrich to look at "his statues and busts."[18]

Given that Adams famously enjoyed learning about new technology and loved science, it is unclear why he eschewed the opportunity to sit for a daguerreotype before then.[19] One plausible explanation is that his calendar during this period was filled with nationally consequential work that likely crowded out other activities. During late 1840 and early 1841, for example, Adams obsessively prepared for his argument before the Supreme Court on the *Amistad* case, which would cement his reputation as "old man eloquent" and fuel the abolitionist movement.[20] In early 1842 Adams embroiled himself yet again in a bitter and sometimes nearly violent congressional argument against the so-called gag rule, which since 1836 had banned antislavery petitions from being discussed on the floor of the House.[21] Yet it was perhaps only a matter of time before one of the nation's best-known and public of citizens climbed the stairs to a daguerrean's studio and took his own turn before the camera.

Congressman Adams had been home in Quincy, Massachusetts, for just over a week in late September 1842 when he drove into Boston with some relatives. "I went for the aid of a dentist," he wrote in his diary, and found one Dr. Gray, who "gave me what aid he could by sealing off the tartar, and tying up one of the loose ones with a thread." Adams found the visit a painful reminder of his aging body, writing that his teeth were "all past surgery, and serve me but as perpetual warnings to make ready for my final dissolution." After suffering through an hour and a half of this dental work, Adams recorded that the procedure "gave me no relief."[22]

A short time after leaving the dentist, Adams stopped in at the National Daguerrian Gallery on Court Street, an establishment belonging to John Plumbe. Adams reported in his diary that he "had been invited by a printed card from him to take a photographic miniature likeness of me." The photographer told Adams he was too busy and unable to photograph the former president just at that moment: "He was so much engaged that he could not take it now, but [I] engaged to go in again, next Tuesday the 27th at 10 o'clock A.M. which he minuted down on a book and is then to take it." Despite having not been able to get in a sitting, Adams must have browsed the gallery while he was there, for he observed in his diary of Plumbe, "He has a very large collection of photographs but this wonderful invention of Daguerre's yields but wretched portraits far inferior to the silhouette."[23] "Wonderful" but "wretched": paradoxical words from a man who knew a thing or two about being visually depicted.

At first glance the choice to compare the daguerreotype to the silhouette seems strange. Why, for example, would Adams not compare the daguerreotype portrait to the painted portrait? They were similar in look and goals: the creation of a suitable and artful likeness of (in Adams's case, at least) an elite public subject. The silhouette, by contrast, constituted one of the "low forms" of portraiture.[24] Silhouettes (also known as "shades") became a popular mode of portraiture in the late eighteenth and early nineteenth century. To create a silhouette, the outline of a subject, often in profile, was drawn or cut out of a sheet of paper and pasted onto a contrasting background (usually black pasted onto white).[25] The best silhouettes could be works of art unto themselves and offered good representational accuracy in terms of the tracing of the shape of the subject's head, profile, or in some cases the entire body. Even so, it is difficult to see how the silhouette would compare favorably to the daguerreotype portrait's capacity to produce an accurate likeness.

Yet the daguerreotype and the silhouette shared several features. First, both practices involved machines. The daguerreotypist used the camera to focus an image and expose the plate, while the silhouette artist might use a physiognotrace or "profile cutter" to mechanically trace a sitter's profile.[26] In addition, both visual objects could be made quickly and cheaply compared to other modes of portraiture. Penley Knipe explains, "As opposed to portrait miniatures made with precious pigments on ivory or vellum and housed in expensive cases, shades were often simply snipped from paper for a few pennies. The speed with which one could get a portrait taken was also a great advantage. Only one sitting was required, as compared to numerous sittings needed for more complex forms of portraiture."[27] This speed and affordability also ensured ease of circulation. Multiple copies of a silhouette could be produced at the same time, and they were easy to store in albums or put into the mail.[28] In this way, silhouettes were more portable and commercially viable than the daguerreotype, which was a unique, comparatively bulky, and unreproducible object. Finally, the silhouette and the daguerreotype shared a visual grounding in the play of light and shadow. A silhouette revealed a subject's visual features differently because it was a negative portrait. Similarly, the mirror-like daguerreotype offered both a positive and a negative image, depending upon how it was manipulated by the hand.[29] The hyper-accuracy of representation typically ascribed to early photography was only part of the attraction of the daguerreotype;

equally fascinating to viewers of the period was the ineffable, almost magi-
cal way that the daguerreotype's chemical play of light and shadow worked
to both reveal and hide its subject. This quality might have worked against
the daguerreotype as far as Adams was concerned; perhaps for Adams the
silhouette seemed to be a more stable and accurate "shade" than the wonder
of the daguerreotype's continuously vanishing and reappearing image.

Adams's long experiences with the silhouette might also have played
a significant role in his initial assessment of photography. Beginning in
1809, Adams sat for some of the most important "shade men" of the time,
including William James Hubard and, much later, Auguste Edouart, the
latter internationally known as one of the finest silhouette artists.[30] Ed-
ouart appears to have spent much of the first part of 1841 in Washington,
taking out an advertisement in late January announcing that "for a short
time only" he had opened "for inspection his extraordinary collection of
upwards of 85,000 Silhouette likenesses, taken by himself, amongst which
are some of the first characters of Europe and America." The ad listed prices
for any customers who wanted their own silhouette made, but noted that
any members of Congress or "Principal Officers of the Government" who
would "have the goodness to allow him a sitting" would not have to pay.[31]
Adams reported in his diary that Edouart visited him in Washington on
March 11, 1841, and made his silhouette:

> Mr Edouart is a Frenchman who cuts out profiles in miniature on paper,
> and came and took mine. He says he has a collection of them 85000 in
> number. He took one also of my father from a shade taken in 1809 which
> with those of my mother, my wife, myself, and our sons George [sic] then
> boys of 8 and 6 years of age, we have under a glass in one frame. He gave
> me a full length profile of President Harrison, in the attitude of delivering
> his inaugural address.[32]

Adams's diary entry highlighted yet another similarity between the silhou-
ette and the daguerreotype: both created a desire to make, collect, and share
or sell images of important national figures. Edouart took the silhouette
he made of Adams that day, superimposed it onto a sketched background
of the kind of library one might have in one's home, and then had Adams
himself sign and date it.[33] Edouart's production of Adams's silhouette and
his gift of President Harrison's silhouette to Adams illustrate the mecha-
nisms of visual exchange that were common to this popular art form.[34] In
addition, Adams's reference to his own collection of silhouettes highlighted

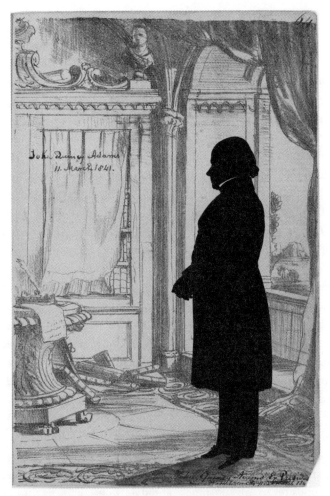

Figure 3.2: Auguste Edouart, silhouette of John Quincy Adams, 1841. (National Portrait Gallery, Smithsonian Institution; gift of Robert L. McNeil Jr.)

the role the so-called lower art form played in family life. One would gather silhouettes into family albums much like one did with photographs in later eras. It was common to purchase albums specifically designed to house silhouettes. Families also preserved them by framing them, as Adams indicated his family had done.[35]

Edouart made a return visit to Adams a few months later, in June 1841: "In the Evening Mr Edouart the man of shades, came and left with me full length profiles of my father, President Tyler, and myself."[36] Adams later favored Edouart at least twice with visits to his collection. A few days after

Edouart's June visit to him, Adams returned the visit, writing in his diary, "On my way to the Capitol I stop'd at Mr Edouart's lodgings and viewed his collection of silhouettes or full length miniature shades. He has a curious collection of the figures of many distinguished men of this country assembled together and stand in one hall in relative positions to each other forming a very pleasant tableau, and many of them striking likenesses."[37] Given that Adams himself knew most of the "distinguished men of this country," he could comment on the fidelity of their likenesses. Two years later, during his summer 1843 trip to New York, he also mentioned in the diary a visit to Edouart in Saratoga Springs, where the artist had moved to follow the elites who summered there.[38]

For Adams, the art of the silhouette offered a familiar and pleasurable form of portraiture that provided the opportunity to appreciate the public men of his own time as well as remember family members and loved ones no longer with him. In addition, both the old art of the silhouette and the new one of the daguerreotype provided Adams with useful metaphors for describing political character. When a visitor to his home in April 1843 asked Adams to comment upon "the prospects of the approaching Presidential elections" of 1844, Adams did not have much positive to say about any of the potential candidates. He reported later in the diary that he told his visitor that James Buchanan "is the shadow of a shade, and General [Winfield] Scott is a Daguerreotype likeness of a candidate—all sunshine, through a camera obscura."[39] Adams implied that Buchanan was the shadow side of the silhouette, dark and perhaps unknowable; one might study him closely yet not get insight into his character. Scott, according to Adams, seemed to be the opposite: an "all sunshine" candidate whose light might paradoxically blind the viewer and therefore also limit his knowability. Neither form, Adams implied, seemed amenable to offering the viewer knowledge of one's character. But this did not stop Adams from taking advantage of both popular forms of portraiture. Despite his initial assessment that the daguerreotype did not live up to the silhouette, he nevertheless kept his appointment with John Plumbe in Boston. He would leave there disappointed.

"I dozed and the picture was asleep"

Because the practice of photography was so new, most daguerreotypists of Adams's time had started out in another trade, often a scientific one. Plumbe was no exception. John Plumbe Jr. was born in Wales and came

to the United States in 1821.[40] Plumbe started out as an engineer. He reportedly took up photography in 1840 after encountering the itinerant photographer John Stevenson in Washington, DC, and by 1841 he had set up his own studio in Boston.[41] An enterprising entrepreneur, Plumbe established some of the earliest daguerreotype galleries years ahead of the later, better-known Mathew Brady galleries of the 1850s.[42] By 1845 Plumbe had fifteen branch galleries; he eventually owned a chain of twenty-three multicity galleries that he called the "National Daguerrian Gallery."[43] A few months after Adams's visit, Plumbe advertised the collection that Adams described as "large" but "wretched" in a Boston newspaper, declaring it "the largest collection of daguerreotypes in the world." Plumbe advertised that "colored likenesses" were "taken every day, at three dollars each, and a duplicate gratis."[44] Despite Adams's dismissals of the work, business was good.

During the week between taking in Plumbe's offerings and sitting for his own daguerreotype, Adams kept busy by fishing with friends, partaking of tea and meals with state legislators, and rejoicing in the flourishing of his garden and trees. He also shared a strange but friendly visit with an elderly man who had shown up at Adams's home simply "for the pleasure of having it to say that he had once in his life seen a President of the United States."[45] Adams returned to Boston on September 27 to keep the appointment to sit for his portrait. He wrote in the diary:

> I went immediately to Mr. Plumbe's Daguerrian gallery to have my photograph taken. They took me forthwith up to the top of the house where a sort of round house has been erected, with windows like those of a green house, and with a door opening to let in the Sun. I took a seat at the corner of a settee so that the light of the Sun came obliquely on the side of my face. There was a small telescope nearly in front of me pointed directly at me, and at a corresponding angle on the other side a mirror. A tin or metallic plate was fitted into the telescope, and on that metallic plate the photographic impression was made.[46]

Photographers needed natural light and lots of it in order for a daguerreotype portrait to be successful. As Adams's diary account illustrated, daguerreotype studios like Plumbe's tended to be on the top floors of buildings where tall windows and skylights could flood a space with natural light. The photographer and perhaps an assistant would have set up the scene and also, as Adams reported, manipulated the former president's body so that Adams would be positioned to take full advantage of available light.

The "small telescope" Adams described was the daguerreotype camera, into which a plate treated with light-sensitive chemicals was inserted.

Adams's analogies to the greenhouse and telescope echoed others' accounts of early daguerreotype sittings, as sitters worked to describe this strange new experience. Marcy Dinius notes that the practice of making analogies was common to early discussions of photography, "a familiar pattern: the oscillation between assimilating and differentiating the known and the unknown, old and new."[47] Adams knew the power of analogy. In his *Lectures on Rhetoric*, published some thirty years before, Adams wrote, "The great foundation of figurative language rests on the association of ideas. When a word has in the first instance been appropriated to any particular thing, and is afterwards turned or converted to the representation of some other thing, its new signification must arise from some association with the old."[48] In his public advocacy for the sciences, Marlena Portolano notes, "This method of arguing through similitude was a favorite of Adams's."[49] Telescopes and greenhouses were an understandable rhetorical move for a man in his mid-seventies.

The diary entry describing his visit to Plumbe's studio went on to describe the process of photographing the subject:

> Not more than two minutes were required for each impression to be taken during which I was required to keep my head immovable, looking steady at one object. They kept me there an hour and a half, and took seven or eight impressions, all of them very bad for an exposition of sleep came over me, and I found it utterly impossible to keep my eyes open for two minutes together. I dozed and the picture was asleep. I gave it up in despair. How the impression is taken came upon the plate [sic] is utterly inconceivable to me.[50]

Adams's lamentation not only described what the process was like; it also highlighted the emotional aspects of his experience of being photographed: his frustration with the bodily challenges the process posed and his ignorance of the process. He sat for "seven or eight impressions," each of which he said required two minutes of exposure time. If Adams's self-report can be trusted, then that meant a total of roughly fifteen minutes of sitting completely still over the course of an hour and a half. For someone used to sitting for painted portraits, where one might relax and chat amiably with the artist (many who painted his portrait reported that he was an excellent conversationalist), this stricture alone must have been a challenge.[51] Despite

attempts to comply with instructions and "look steady at one object" during the exposures, Adams could not help himself and began to fall asleep, causing the picture to "fall asleep" as well. Furthermore, the experience was ruined not only by Adams's inability to control his body but also by his lack of understanding of the process itself. Tellingly, the diary turned to passive voice at that moment. "The photographic impression was made," Adams wrote, and in an imprecise fumbling for words not usually present in the diary, he admitted he had no idea how it was "taken came upon the plate." It was "utterly inconceivable." The whole experience must have been disconcerting, not only for Adams but for Plumbe and his staff as they tried to capture a waking image of the somnolent ex-president. After all, Adams was a dignitary whom they had specially invited to their place of business, surely the most eminent of any they had photographed up to that point. Ultimately, Adams's first attempt at sitting for a daguerreotype was defined on all sides by failure and despair.

Of the approximately fifty daguerreotypes that Adams's diary mentions, he recorded that about a dozen of them failed or were not successful.[52] What constituted a "successful" daguerreotype in the early 1840s depended upon many things. As a highly technical process subject to everything from the weather to the photographer's ability to properly prepare the plate, operate a camera, pose a sitter, and develop the resulting image, early accounts of daguerreotypy tended to treat success or failure in purely instrumental terms: Did one manage to fix a visible image on the plate or not? Only later did photographers turn to improving the quality of images themselves.[53] For example, in early 1840, newspapers were still reporting as news the fact that individual would-be photographers had successfully created a daguerreotype image.[54]

Of the potential for technical failure Sarah L. Thwaites writes, "Daguerreotypy was a risky business: the process was delicate, expensive and dangerous. The silvered copper plates were costly, the process required unpredictable exposure times, bulky equipment and, moreover, profitable daguerreotypy necessitated the dexterous, and somewhat intuitive, manipulation of a number of elements."[55] For early photographers it seemed that failure lurked around every corner. Until lenses for cameras improved in their capacity to capture light, photographers emphasized that sitters needed to come on bright, sunny days; a couple of Adams's diary entries mentioned that photographers were concerned about whether too much

sun or not enough sun might produce an unacceptable image.[56] While Adams did not detail specific causes of daguerreotype failure, the frequent references to failure illustrate how even amid the joys of photographic fidelity and wonder, the new art and science was a highly contingent, sometimes accident-prone venture.

"A very good one"

Despite giving it all up in despair, Adams was willing to try again. Back in Washington, DC, six months later, Adams managed to keep a few pictures awake. This time the photographer was Philip Haas. Born in Germany, Haas came to the United States in 1834 and ultimately ended up in Washington, DC, where he worked as a printer and lithographer.[57] Little of Haas's photographic work remains today, and in the early 1840s he was primarily known as a lithographer. Even so, as the previous chapter mentioned, he is recognized as one of the first resident photographers in Washington, DC, where the city directory of 1843 listed a misspelled "P. Hass, lithographer" with an address on Pennsylvania Avenue.[58]

Adams came to Haas for the same reason he went to Plumbe's in Boston: he was invited. On March 7, 1843, Adams wrote in his diary, "Mr. Haas a German who takes Daguerreotype likenesses in the Pennsylvania Avenue [studio near] the capitol had engaged me to come and sit to his camera obscura and I went this afternoon. But Mr Haas said the morning would be a more favourable time and I promised to call again to-morrow before noon."[59] (Mornings were better because the sun would be more suitably situated, improving the possibilities for a good exposure.) The next day, Adams returned and wrote an account of the sitting in his diary:

> I walked this morning to Mr. Haas's shop, and he took from his camera obscura three Daguerreotype likenesses of me—the operation is performed in half a minute, but is yet altogether incomprehensible to me. Mr. Haas says it is a chemical process upon mercury, silver, gold and iodine. It would seem as easy to stamp a fixed portrait from the reflections of a mirror; but how wonderful would that reflection itself be, if we were not familiarised to it from childhood.[60]

As in the September 1842 account, with this second sitting Adams attempted to understand the unfamiliar through the lens of the familiar.

Adams's reference to Haas's camera as a "camera obscura" improved upon the previous telescope analogy, though technically it too was not quite correct. The camera obscura was a precursor to the technologies of photography. Latin for "dark room," the camera obscura gained popularity during the Renaissance and the scientific revolution as a way to produce accurate renderings of objects. It was an optical device into which light would pass through a lens in such a way as to display an image of an object; that image could then be traced to produce a rendering of it.[61] Haas's daguerreotype camera likely looked like the camera obscura with which Adams would certainly have been familiar; its purpose of accurate rendering was also similar. Despite the analogy, Adams recognized that there was a difference between the camera obscura, which projected but could not fix an image, and the "daguerreotype likeness" he procured from Haas. His mention of the "chemical process" using "mercury, silver, gold and iodine" suggests that during the encounter Adams must have asked questions of the operator about how the image, as a previous diary entry had wondered, "came upon the plate." Whatever education Haas might have offered the congressman, however, ultimately Adams lamented that what he termed "the operation" was "yet altogether incomprehensible to me." Despite having experienced the process more than once, Adams still did not fully understand what happened during that brief period when the exposure was made.

Adams's experience with Haas also prompted a fascinating meditation on the nature of photography itself. Where his September 1842 diary account focused on his despair at dozing off and creating images that were "asleep," in the March 8 entry Adams reflected upon the "wonderful" implications of the resulting images themselves: "It would seem as easy to stamp a fixed portrait from the reflections of a mirror; but how wonderful would that reflection itself be, if we were not familiarised to it from childhood." For Adams, the experience of viewing a daguerreotype was like looking at oneself in a mirror. This was literally true, of course, because the mirrored surface of the daguerreotype not only offered the viewer an image of its subject, but as Marcy Dinius points out, it also reflected "one's own image . . . on the surface that holds the image," enabling the viewer to actually see herself "in another's portrait."[62] This feature of the daguerreotype, Dinius argues, "allows for a moment of visual identification" between viewer and subject.[63] Furthermore, daguerreotypes are laterally reversed images of their subjects. Mark Osterman explains that they "appear backwards,

capturing the subjects as they see themselves in a mirror, not how they are seen by others."[64] Adams's own daguerreotype would thus appear to Adams the same way that he would appear while looking at himself in a mirror.

Continuing this line of thought, Adams wrote, "If we were not familiarised to it from childhood"—familiarized to our own reflection in the mirror, that is—"how wonderful would that reflection itself be." What made the daguerreotype potentially "wonderful" (full of wonder) was its capacity to not merely capture the image of a person but to also literally reveal the reflections of others to the viewer. Adams recognized that the daguerreotype could provide citizens with a new mechanism for seeing others as they saw themselves, a particular kind of fidelity that would seem to offer a new mode of public subjectivity. Yet if that capacity was the ultimate value of this "wonderful" new mode of portraiture, it was not easy to achieve. As Adams's earlier comments about the "wretchedness" of the daguerreotype for portraiture hinted, the possibility for seeing one another differently could be hampered by technical problems or, in Adams's own case, the bodily failures of the sitter.

Three days after the March 8 sitting, Adams stopped in at Haas's studio to pick up his daguerreotype. He was pleased with what he saw: "Call[ed] at Haas's shop and took the Daguerreotype likeness of me—a very good one."[65] While the diary does not report what specifically Adams thought was "very good" about the image, perhaps it was enough that the process had actually worked. In any case, that Haas had managed to produce a pleasing image seems to have warmed Adams's view of photography as a whole, and he chose on his own to stop by Haas's studio at least two more times during the following week. On March 15, in the middle of a cold, snowy week during which the diary reported that Adams was not feeling well ("Another restless, hacking, wracking night I awoke coughing before 3"), Adams "walked to the shop of Mr. Haas where I found a young man with two ladies[—]his wife and her companion whose likenesses he took in a group while I was there. He attempted also to take me, but did not succeed because he said there was too much light of the sun; and I promised to come again tomorrow or the first fair day between 8 and 9 of the morning."[66]

Adams returned as promised the next day. His March 16 diary entry began by noting the weather and his health: "Deep snow. The progress of my catarrh [a buildup of mucus in the nose or throat] continues with increasing severity."[67] Despite his illness, Adams kept his appointment with Haas:

"According to promises I walked up to Mr. Haas's shop about 9 my hands in woolen gloves bitterly pinched with cold. Found Horace Everett there for the same purpose of being facsimilead [*sic*]. Haas took him once, and then with his consent took me three times[,] the second of which he said was very good—for the operation is delicate, subject to many imperceptible accidents, and fails at least twice out of three times."[68] Horace Everett, a friend and congressional colleague of Adams who represented Vermont from 1829 to 1843, appears to have graciously let Adams cut ahead of him in line. In that image Adams appears to be grasping his hands both to keep them still and warm them up on a morning when they were "bitterly pinched with cold." (See figure 2.2.)

According to the diary, Haas made a total of six daguerreotypes of Adams at the March 8 and March 16 sittings. Adams reported that one March 8 image was "very good." On March 16 he reported that of the three exposures that Haas took, Haas told him "the second" was "very good." Of these March 1843 images, two daguerreotypes exist today: the daguerreotype now at the Smithsonian and a second, copy daguerreotype held at the Metropolitan Museum of Art. While it is impossible to know whether any of the "very good" daguerreotypes were the ones that have come down to us today, it is now assumed that the March 16 one (fig. 2.2) is the Everett daguerreotype. Adams likely gave the daguerreotype to Horace Everett sometime after Everett encountered Adams (and let him cut ahead of him in line) at Haas's studio on that cold March day, making that image the one described in chapter 2.[69]

The March 1843 Haas sittings are important not only because they produced what we now know is the earliest extant daguerreotype of an American president but also because they offer specific insight into John Quincy Adams's engagements with photography and the subsequent circulation of his photographic image. Despite going on to be photographed dozens more times until the end of his life, the Haas daguerreotypes are the only images Adams confessed in the diary to actually liking. We cannot know precisely what caused Adams to pronounce the March 8 and March 16 daguerreotypes as "very good." Was it simply that they had not failed, as the ones made at his September 1842 sitting had, or was it Adams's evaluation of how he felt the images represented him? It is easy to see why Adams might have liked the March 16 picture. The daguerreotype depicts not an old man in his "final dissolution" but a sharp-eyed, decorous, dynamic statesman seated

in a homelike, scholarly setting of fireplace and books. Adams's gaze marks the daguerreotype as what Gunther Kress and Theo van Leeuwen call a "demand image," in which the subject of the photograph stares directly out from the image at the viewers, visually engaging them on equal (or perhaps even confrontational) terms.[70] Indeed, the very awake Adams seems just about to respond to a congressional opponent with a well-timed, damning verbal rebuke. Keeping in mind Adams's remarks about how the daguerreotype could reveal to the viewer how the subject saw himself in a mirror, perhaps Adams responded to this image positively because it depicted him as he wanted to see himself: vital, scholarly, a force very much still to be reckoned with, a man still fighting for what was right in the Supreme Court and in Congress. That was Adams's idea of fidelity. Yet in his experience, the daguerreotype failed to achieve it more often than not.

The Visual Lives of the Haas Daguerreotypes

In 1937 the Metropolitan Museum of Art in New York City acquired a collection of several dozen daguerreotypes that came from the famous mid-nineteenth-century Boston photography studio Southworth and Hawes. Among the daguerreotypes was an image of John Quincy Adams. Posed against the same homelike interior featured in the Everett daguerreotype, this daguerreotype features Adams sitting with a body posture and facial expression that are almost identical to the Everett image. But while in the Everett image Adams's bare hands grasp onto one another, hovering over his lap in a slight blur of movement (fig. 2.2), in the Met daguerreotype Adams's clasped hands rest quietly on top of a handkerchief on his lap. (See fig. 3.3.) Comparison of the two images shows them to be nearly identical, from the exact placement of the chair upon the patterned rug, to the books on the table, to Adams's bodily comportment. But slightly different (though equally imposing) facial expressions and the relative presence and absence of the handkerchief suggests they were different exposures made at the same sitting.

Yet no one knew this in 1937, because they had nothing with which to compare the Met's daguerreotype. When the Met acquired the group of Southworth and Hawes daguerreotypes, experts assumed that it and all the other daguerreotypes in the collection had been made by Southworth and Hawes themselves.[71] Furthermore, a catalog of the images published in

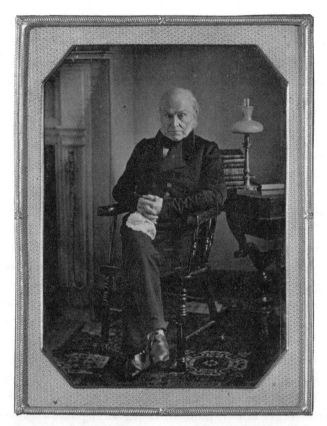

Figure 3.3: Southworth and Hawes, copy daguerreotype of John Quincy Adams (from original daguerreotype by Philip Haas, March 1843), ca. 1850. (Metropolitan Museum of Art; gift of I. N. Phelps Stokes, Edward S. Hawes, Alice Mary Hawes, and Marion Augusta Hawes, 1937.)

1939 stated that the daguerreotype of Adams had been made in his home in Quincy, Massachusetts, even though it would have been nearly impossible for Adams's home to have offered indoor lighting conditions conducive to the successful production of such an image. Years later, other writers repeated the error that not only had Southworth and Hawes made the daguerreotype but that it was made in Adams's own home in Quincy.[72] In the late 1970s photography historian Beaumont Newhall challenged these interpretations. He had come across a daguerreotype of Ohio congressman Joseph Ridgway; its paper mat listed 1843 as the date it was made and "P. Haas" as the photographer.[73] Comparing the background of the Ridgway

daguerreotype to the Met's Adams daguerreotype, Newhall quickly saw that they were the same: the same rug, the same chair, the same fireplace mantle and lamp. The only difference was that Ridgway's daguerreotype contained no books and was a laterally reversed image of the Met's Adams daguerreotype: the table with lamp was on the left side of the image rather than on the right side. Newhall's physical study of the Met's daguerreotype further revealed that the plate had a manufacturer's mark dating it to the early 1850s, too late for it to have been inside the camera in a room with John Quincy Adams.[74] Newhall concluded that what the Met held was a daguerreotype produced in the 1850s by Southworth and Hawes but one that was a *copy* of an original Haas daguerreotype made in Washington, DC, in 1843. The evidence provided by the studio backdrop, plate, and reversal of the image suggested that Southworth and Hawes likely made its own copy of an original Haas daguerreotype of Adams in the years after the ex-president's death.

Haas's daguerreotypes lived on in nonphotographic forms as well. Haas the daguerreotypist was also Haas the lithographer who invited Adams to visit his studio and pose. Like Edouart the "shade man" and other visual artists of the time, Haas likely wanted not only to photograph the great man but also to publicize his photograph and sell images. In keeping with the landscape of visual commerce of the era, Haas turned at least one of the daguerreotypes he made in those March 1843 sittings into a lithograph for sale and copyrighted it in 1843.[75] Because the lithograph repeated the visual motif of the chair, the rug, and the general body position of the subject, Newhall relied on this image as further evidence that the Southworth and Hawes daguerreotype was a copy of an original Haas image. Despite the visual similarities, however, Haas's lithograph did not perfectly transcribe the daguerreotype poses. In the lithograph Adams looks off to the side rather than directly at the viewer. In addition, his facial expression, while still stern, suggests a touch of a worried smile. And Adams holds a book in his hand, his index finger marking his spot; no such book appears in either the Met copy daguerreotype or the original Everett one. Did the lithograph represent an entirely different, third pose based on an original Haas daguerreotype that is currently lost to us today? Or did Haas the lithographer take some liberties with the work of Haas the photographer? Lithographs did not have to be entirely faithful to their source images; lithographers were artists in their own right who interpreted images as much as they duplicated them.[76] The Haas lithograph, for example, features not only the

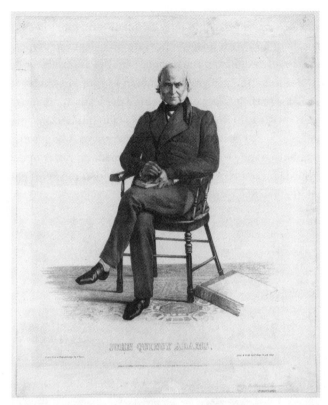

Figure 3.4: Philip Haas, lithograph of John Quincy Adams taken from a daguerreotype by Haas, 1843. (Library of Congress.)

book in Adams's hand but also a more conceptual sketch of a large book at his feet on the floor. The size of the book suggests that it was not present in any original daguerreotype but added later. Perhaps the lithographer used it to suggest the book that is in Adams's hand, or (much as Edouart's library setting for his Adams silhouette) to point more generally to the great man's learned qualities. Throughout his life, Adams was often pictured holding a book.[77]

In addition to adding visual elements or embellishments, lithographers also borrowed from one another in ways that seem like intellectual property theft today but were common at the time.[78] For example, after Adams's death a lithographer named Benjamin Franklin Butler produced a hand-tinted lithograph based on Haas's 1843 lithograph.[79] In this image produced to memorialize Adams after death, the scant smile on Adams's face in the Haas lithograph was transformed into a full-blown one, which

left Adams looking less like "old man eloquent" and more like an impish, grandfatherly figure. Such images illustrate how daguerreotypes of elites like Adams circulated during the period. Like the affordable, popular art form of the silhouette, lithography made images of elite public men like Adams available to the masses. While some Americans in urban areas could visit daguerreotype galleries to view images of famous citizens, many more could purchase cheap paper prints for display at home. Adams's experiences with early photography reveal how the new medium never operated in a vacuum. The daguerreotype was bound up with other modes of portraiture that circulated in a lively visual culture.

Figure 3.5: Benjamin Franklin Butler, lithograph of John Quincy Adams after Haas lithograph, 1848. (National Portrait Gallery, Smithsonian Institution.)

"Requesting me to come"

On the same bitterly cold day that Adams met Horace Everett at Haas's studio on Pennsylvania Avenue, he had yet another encounter with a photographer. After taking care of some business inside the Capitol building, Adams reported in his diary, "Thence I went into the military committee room of the Senate where I found J. M. Edwards, another Daguerreotype likeness taker. I had received last evening a note from him, requesting me to come this day or tomorrow between 9 and 3, as he wanted my likeness for a large picture of the Senate chamber, which he has projected and in which the senators, judges of the Supreme Court, the President, and his cabinet and others may all be assembled."[80] Jonas Edwards and his partner, Edward Anthony, planned to work with an engraver to produce a giant "collective portrait" of political elites, a kind of fantasy mashup that would display national leaders of the era (including a few women, such as Dolley Madison) visually gathered together in the Senate chamber.[81] The first step was to photograph as many of them as they could. In order to do that, the photographers set up a daguerreotype studio in a borrowed committee room of the Senate. Despite responding to Edwards's invitation to visit him at the Capitol, Adams initially chose not to participate in the project. He reported in the diary that Edwards "said he could not take my likeness this day, but asked if I could not stop to be taken at New York on my way home [where Edwards and Anthony had a studio]. I declined, and on inspecting many samples of the faces he had taken I was glad to be released from being taken by him at all."[82] Perhaps after his more positive experiences with Haas, Adams was coming to realize that some photographers were better than others. Or perhaps a stop in New York City on his way from Washington to Boston was too onerous for the aging congressman.

Despite Adams's experiences with all manner of daguerreotype failure—that of photographers as well as himself as a sitter—he continued to sit for daguerreotypes until his death. Despite his criticism of their images, Adams eventually did return to Edwards and Anthony to sit for a daguerreotype earmarked for their grand project. On March 1, 1844, Adams wrote that he "went into the chamber of the military committee of the Senate, where Edwards took two Daguerreotype likenesses of me," and on April 12 he wrote,

Figure 3.6: Thomas Doney, United States Senate Chamber, print after Anthony and Edwards daguerreotypes, 1846. (National Portrait Gallery, Smithsonian Institution.)

"At the request of J. M. Edwards and Anthony, I sat also in their room while they took three larger Daguerreotype likenesses of me, than those they had taken before. While I was there President Tyler and his son John came in, but I did not notice them." (Given Adams's animosity toward Tyler, it is safe to assume that when Adams said he "did not notice them," he meant that he chose not to acknowledge their presence.[83]) One of these sittings likely produced the profile daguerreotype that was eventually incorporated into the collective portrait.[84]

When the daguerreotypes were combined with the art of mezzotint engraving, Michael Leja argues, what emerged was "hybrids of the two media . . . having the identity of both photograph and print, each fortified by the other."[85] The Edwards and Anthony daguerreotypes' "fortified" image was published as a large mezzotint engraving by Thomas Doney in 1846.[86] Like the Adams lithographs, Edwards and Anthony's collective portrait offered another example of how the early daguerreotype participated in the era's visual politics. In March 1845 Adams noted in the diary that he ran into Edwards near the Capitol, and the daguerreotypist invited him in to see the latest daguerreotypes they had made, including "two of the new President Polk—one

in a breast-pin reduced from the other, and bespoken for Mrs. Polk."[87] A few months later, in May, Edwards called on Adams "and invited me to visit their establishment where they exhibit a collection of several hundreds, persons of notoriety of all descriptions. He told me that Mr Anthony was going to England to carry with him and exhibit there his whole gathering of noted persons of this country, and to procure and bring back a similar collection of European notorieties to exhibit here."[88] Edwards and Anthony mobilized their daguerreotypes of "great men" to build their business, exhibit American greatness abroad, and (as in the example of the pin for Mrs. Polk) facilitate the exchange of meaningful personal mementos. These modes of visual commerce relied on the new medium of photography for their popular appeal.

After 1843 most of Adams's visits to the daguerreotype studio came after invitations from the photographer or requests by others for a photograph. Between 1844 and 1846, Adams agreed to sit for a number of daguerreotypes designed to facilitate painters' plans for portraits of him. Despite the early suggestion that photography would "ruin" art because the new, so-called pencil of nature would make the hand of the artist obsolete, not only printmakers but fine artists as well took advantage of the opportunities the daguerreotype portrait offered their work. It became common for artists to base portraits on daguerreotypes of the sitter.[89] Of Adams's twenty daguerreotype sittings, his diary reveals that upward of half a dozen daguerreotypes were produced explicitly to be given to painters working on portraits of him.[90]

For example, during the spring of 1844 Adams sat a number of times for the Philadelphia painter James Reid Lambdin, who had made a portrait of Adams in 1841 and wanted to produce an updated one.[91] On April 13 Adams wrote in the diary, "I gave the last sitting of a full hour this morning to Mr Lambdin who finished his third and last portrait of me. He asked me also to stop on Monday morning at Haas's Daguerreotype shop and having a likeness of me taken there for him to which I agreed."[92] A few weeks later, Adams made his way to Haas's after a subsequent written request from Lambdin in which the artist asked for "a full length miniature Daguerreotype for my benefit."[93] After waiting for a less cloudy day and later enduring one failed attempt, on May 3 Adams achieved the image Lambdin had requested: "On my way to the House I stop'd again at Haas's shop, and he took three more Daguerreotype likenesses of me, one of which is for Mr. Lambden [*sic*] at Philadelphia."[94]

Adams understood that painters would find it helpful to work from daguerreotypes of him because he repeatedly indulged their requests to sit for

them. Yet despite this regular exposure to photography, Adams maintained a vexed relationship with the daguerreotype as its own mode of portraiture. In addition to his early dismissal of daguerreotype portraits as "wretched" and "inferior to the silhouette," Adams seemed to believe that the very thing that practitioners hailed as the wonder of the daguerreotype—its fidelity to "nature"—was what made it inferior as portraiture. Recall his complaint that the daguerreotypes he sat for in Utica in August 1843 were "all hideous" and "too true to the original."[95] Similarly, of daguerreotypes he sat for in Washington, DC, with the photography studio of West and Page, Adams wrote, "They are resemblances too close to the reality and yet too shadowy to be agreeable."[96] Unlike a well-formed painted portrait, the daguerreotype was visually excessive: *too* true, *too* shadowy, *too* real, *too much* fidelity in every way. Not visual values he would embrace.

Adams had extensive experience sitting for every kind of portrait one might sit for in the late eighteenth and early nineteenth centuries, and the daguerreotype in its wondrous excessiveness was especially problematic. Yet Adams had a love-hate relationship with portraiture in general, no matter what the medium. Of all the portraits Adams sat for, he claimed in an 1843 diary entry, only a few were actually "worthy of being preserved": "a miniature in a bracelet for my mother, painted at the Hague in 1795 by an Englishman named Parker, now in the possession of my son John's widow—Copley's portrait of 1796—Stuart's head of 1825. And Durand's of 1836 painted for Mr Lumen Read, are the only ones worthy of being preserved, with the busts by Persico, Greenough and Powers."[97] Adams did not list specific criteria for why these images and objects were worthy and others were not, but likely his reasons were closely connected to their value as artifacts of history. In 1839 Adams drafted a list of every portrait he recalled sitting for. Although the list was not complete, Andrew Oliver argued that it nevertheless "confirms his genuine, indeed overriding, interest in preserving, not only for himself and his family but for his country's history, his own likeness."[98] "Nothing else," Oliver continued, "can explain the hundreds of weary hours he gave to the scores of painters who besought them."[99]

Adams's comfort level with the act of sitting for portraits also changed over time. Near the end of his life, the diary reveals that he was horrified, indeed ashamed, by his own physical failures to properly engage the process. By his own account, his failed first daguerreotype sitting, in September 1842, resulted in the ruin of more than half a dozen images. The physical demands of sitting—the need to keep still chief among them—were simply

too much for the congressman. But Adams's nap on that single day seems to have been symptomatic of a more general problem with which Adams wrestled later in life. Writing of a sitting he was doing with painter Franklin White in early August 1843, Adams lamented:

> It must be extremely difficult for any painter to take a favourable likeness of me now—for I cannot sit five minutes or three or even one, without falling into a doze. This propensity which I have long observed grows upon me to such an extent, that I ought to be deeply alarmed at its progress—for its termination may overtake me every day and every hour of my life. It benumbs every faculty of my body and soul. . . . This irresistible spell has made it impossible to take a good daguerreotype likeness of me, and it baffles though not in equal degree the skill of the portrait painter, who cannot give life or animation to a countenance all the muscles of which are all the time lapsing into slumber. It deadens alike all the faculties of the mind, and is a continual warning to me of the decays of my powers native and acquired.[100]

Adams's biographers and the diary itself chronicle several bouts of some-times extended illness in Adams's last years. But it is just as likely that his somnolence was the result of old age and a busy life that left little time for relaxation and made it difficult to sleep.[101] Adams's confession about fall-ing asleep not only related his alarm at the ongoing "decay" of his "powers" but also pointed to an implicit theory of portraiture to which Adams had long subscribed. The creation of a good portrait, his lamentation implied, required bodily agency and active "faculties of the mind" on the part of the sitter. The artist needed an engaged sitter in order to be able to "give life or animation" to the subject. Without that engagement, the artist would not be able to render a rich, full likeness of both the body and soul of the subject. Tensions caused by bodily decline and failure would shape his experience of the daguerreotype's visual values of fidelity and wonder.

"True portraiture of the heart"

What, then, to make of John Quincy Adams and the daguerreotype? He thought this new art was both "wonderful" and "wretched." He saw how it had the capacity to show ourselves to one another, to create visual identi-fication among strangers, but he also recognized its excesses and failures. The new visual values of fidelity and wonder did not measure up to Adams's standards for images of public import and historical permanence. To be valuable as a mode of public portraiture, the daguerreotype would need

to provide not only likenesses but likenesses worthy of preservation. They should be artful but not excessive, offering "life" and "animation" without too much of a dose of reality. During a November 1843 trip to Cincinnati to dedicate the city's new observatory, Adams wrote of yet another visit to a daguerreotypist: "Before returning to the Henry House we stopped at the Daguerreotype office where three attempts were made to take my likeness. I believe neither of them."[102] Adams did not elaborate on what precisely made the images less than believable. But when understood in light of his commentary about the daguerreotype, the remarks about believability come into sharper relief. Reflecting just a few months earlier in the diary on his history of being depicted in portraiture, Adams was blunt: "The features of my old age are such as I have no wish to have transmitted to the memory of the next age. They are harsh and stern beyond the true portraiture of the heart; and there is no ray of interest in them to redeem their repulsive severity."[103] Few portraits—and surely fewer daguerreotypes—could properly communicate the "true portraiture" of what was inside of himself, what lay beyond his own "harsh" and "repulsive" visage. No dose of fidelity and wonder could change his point of view.

Any person who is aging can understand Adams's frustrations at his declining physical condition; as a result, it may be tempting to read Adams's commentary as simply the sad complaints of a disgruntled old man who no longer likes what he sees in the mirror. Yet inside the curmudgeonly ambivalence lies a way of thinking about photography worth thinking through. Adams believed that the power of the daguerreotype lay in the ways that it provided citizens with the opportunity to see others as those others saw themselves. For Adams that opportunity was always conflicted. The daguerreotype may have offered fidelity ("the features of my old age"), but for precisely these reasons it would always fail to achieve "true portraiture of the heart." The daguerreotype might capture one's image for "communication to the memory of the next age," but it did so with a wonder-full excessiveness that might tarnish, rather than burnish, that next age's image of those who had come before. As a public figure who sat for dozens of portraits throughout his life, in nearly every available medium, these issues mattered deeply to Adams. Subject to failure, inevitably always chronicling the decline of the body and mind, and ultimately "unbelievable" as portraiture, this new mode of public subjectivity constituted a dubious art of national memory and history at best.

PART II

The Snapshot President

Handheld Photography and the Halftone Revolution

Photography changed dramatically between John Quincy Adams's bodily struggles with the daguerreotype and the later nineteenth century. The daguerreotype faded in popularity by the mid-1850s, replaced first by other one-of-a-kind images, such as the ambrotype (a non-mirrored, positive image on a glass plate) and its cheaper cousin the tintype, then eclipsed almost entirely by the wide introduction of photographs printed on paper.[1] Paper photographs offered the possibility of endless reproduction, something earlier photographic technologies had not. By the end of the nineteenth century, photography became a mass medium, capable of being printed in newspapers and magazines in ways that brought visual news to the masses. In addition, by the end of the nineteenth century those masses had cameras of their own and began to make their own photographs. Presidential portraiture adapted to these changes, becoming less formal and posed. But presidents struggled with new possibilities that photographers with increasingly portable cameras would force on them in both public and private spaces. As the century progressed, the daguerreotype's visual values of fidelity and wonder made way for the shift to a timely photography made possible by the emergence of handheld cameras and the ability to reproduce photographs in print.

The rise to public prominence of Abraham Lincoln paralleled the earliest of these changes. Before and during his presidency Lincoln was photographed more than 120 times, making him one of the most photographed Americans of the nineteenth century.[2] Harold Holzer writes, "During the five years of his national fame from 1860–65, he unfailingly made himself available to photographers, painters and sculptors even during periods of crisis, strongly suggesting that he personally appreciated, and endorsed, the importance of portraiture in recording his triumphs."[3] The oldest known photograph of Lincoln is a daguerreotype by N. H. Shepherd made in Springfield, Illinois, in 1846 or 1847.[4] By the late 1850s, as the daguerreotype waned in popularity, Lincoln sat instead for the newer photographic technology of the ambrotype as he traveled around Illinois in his unsuccessful bid to become a U.S. senator.[5] During the famous Lincoln-Douglas debates in 1858, for example, Lincoln sat for portraits in towns where the debates took place, including Pittsfield and Macomb, the latter photograph made as a thank-you gift for his local host.[6] Closer to the 1860 presidential election and after, Lincoln was increasingly photographed using glass-plate negatives from which positives would be printed on paper using salt or albumen solutions. One of these glass negatives, made at Lincoln's last official portrait sitting in Washington in February 1865, famously (and, some contend, ominously) cracked during processing; all that remains today is the single, poignant paper print that Alexander Gardner pulled from it before he threw away the plate.[7]

Lincoln's most famous prepresidential photograph was initially encountered by most Americans as an engraving. In February 1860 Lincoln traveled to New York City to give a speech at Cooper Union (also known at the time as Cooper Institute). As Holzer explained, it was Lincoln's "very first speech in the media center of the nation" and "presented him with a great opportunity to convince Easterners that he was more than a frontier debater, and a further chance to produce a document that the New York publishers might reprint and circulate nationwide."[8] To commemorate the candidate's visit and important speech, Lincoln's companions brought him to Mathew Brady's New York City studio to sit for a photograph. Brady was at the height of his fame, his studio as much a place to see and be seen as a place to have one's picture made.[9] What became known as the "Cooper Union photograph" is a three-quarter-length portrait of a beardless Lincoln in a slightly rumpled suit, standing next to a low table and resting his left hand on a pair of books. Brady made the unusual choice to photograph Lincoln

Figure 4.1: Mathew Brady, Abraham Lincoln, candidate for U.S. president, before delivering his Cooper Union address in New York City, 1860. (Library of Congress.)

standing, which no photographer up to that point had done.[10] Lincoln looks directly at the viewer, a serious expression on his face, his full height reflected in the pose. Brady chose to frame Lincoln against a relatively plain backdrop that includes a pillar, which when combined with the books and table gives the image a vaguely civic gravitas. Both the speech and the photograph succeeded in introducing Lincoln to the nation. Holzer writes, "The picture captured Lincoln in all his western vigor, refracted by a new and convincing dignity. It was a work of art. It is no wonder that Lincoln later said: 'Brady and the Cooper Institute made me President.'"[11]

The initial public impact of the image derived not from the photograph itself but from engravings and other nonphotographic reproductions that circulated throughout 1860. Brady's image first circulated widely in May 1860, when *Harper's Weekly* magazine put a head-and-shoulders engraving of it on its cover to commemorate Lincoln's nomination for the presidency.[12] Throughout 1860, popular engravers Currier and Ives issued several versions of the Cooper Union portrait, including a lithograph titled "Our Next President."[13] *Harper's* revisited the Brady photograph again after Lincoln won the election in November. This time the engraver added drapery and a window behind Lincoln; in the distance, buffalo graze on a flat prairie that presumably signified the president-elect's western origins.[14] During the campaign the image was also reproduced on all kinds of memorabilia, such as ribbons and buttons.[15] Eventually, Brady and other photographers issued copies of the photograph as cartes de visite (visiting cards), a new type of paper print glued to cardboard that became popular in the United States immediately following the campaign of 1860. The Cooper Union photograph and subsequent images of President Lincoln would participate extensively in this new mode of visual commerce.

The Visual Commerce in Paper Photography

That visual commerce was fueled by the new ability to reproduce photographs on paper. Paper negatives and positives had existed since the invention of photography. But paper lacked commercial viability, so it remained in the background while the daguerreotype and subsequent related technologies came to dominate U.S. photography. That began to change in the late 1850s. Once it became commercially feasible to expose images from glass negatives onto sensitized paper, the market for paper photographs took off.[16] The process allowed for endless copying of the same image and enabled extended commerce in images like the carte de visite, cabinet card, and stereograph. The carte de visite was invented in France in the 1850s. Originally intended to be a visual calling card, it quickly became more than that.[17] Consisting of images printed on shiny albumen paper glued to heavier cardstock, cartes de visite could be easily mass-produced, collected into albums, and shared via the postal service.[18] A writer for *Art Journal* in 1862 described cartes de visite as the "most felicitous expressions of the photographer's art. They are such true

portraits, and they are so readily attainable, and so easily reproduced, that they may well aspire to become absolutely universal."[19] While cartes de visite were more commonly made for and exchanged with loved ones, they also served as a powerful medium for communicating likenesses of celebrities and political figures.[20] The *Art Journal* writer emphasized this dual role, arguing for cartes de visite as extensions of national portrait galleries like those the daguerreotypists of Washington, DC, and New York constructed in the 1840s and 1850s: "They produce the family portrait of the entire community. They form portrait collections, on a miniature scale, but with an unlimited range and in every possible variety—family collections, collections of portraits of friends, and of celebrities of every rank and order."[21] An 1862 catalog from Mathew Brady illustrated the popularity of celebrity prints, listing hundreds of card photographs for sale, organized into eleven separate categories. Seven of those categories featured celebrated figures in politics, literature, the military, and the stage, and included images of all sixteen presidents to date.[22] Presidents occupied a popular space in carte de visite culture. Take, for example, a carte de visite called "Presidents of U.S.," a composite of portraits of every president up to Ulysses S. Grant. A petite two and a half inches by four inches in size, it likely dates from the mid-1870s, perhaps produced as part of the centennial celebration of the Declaration of Independence.[23] Cartes de visite remained popular until the 1870s, when they were generally replaced by the larger, four-by-six-inch cabinet card or "imperial" carte de visite that used the same formula of paper affixed to card stock.[24]

The stereograph is rare among nineteenth-century photographic technologies in that it successfully made the transition from the glass to the paper age of photography.[25] Made possible by the physical fact of human binocular vision, the stereograph pairs two slightly different images of the same subject that, when viewed through a stereoscope, appear to be one three-dimensional picture.[26] Stereographs served as instruments for acquiring visual knowledge, and they were often sold as themed collections of faraway places one might never be able to visit in person. In a series of essays published in the *Atlantic* in the early 1860s, Oliver Wendell Holmes Sr. touted stereography as a way to see the world from one's armchair.[27] Compared to other photographic technologies, the stereograph had a long life. Scholars estimate that between the late nineteenth century and the 1930s, between three to six million stereograph images were produced.[28]

Figure 4.2: "Presidents of U.S." Carte de visite, ca. 1876. (Collection of the author.)

As a result of its longevity and wide circulation, Simone Natale argues, stereography should be recognized as "the first mass visual medium."[29]

While Americans might collect presidential cartes de visite in albums, or study stereographs of faraway places in their stereoscopes, it was not until well into the 1890s that they would find photographs of presidents accurately reproduced *as photographs* in newspapers and magazines. While news imagery predated the introduction of the halftone printing process,

halftone transformed the public's experiences of the news and marked an important moment in the shift to a new kind of photography oriented toward timeliness.

The Rise of Halftone and the Birth of News Photography

Throughout the final decades of the nineteenth century, printers sought ways to print photographs directly onto the same paper used to produce newspapers, books, and magazines. The first successful experiments with halftone appeared in the early 1880s, beginning with the March 1880 publication of a photograph titled "A Scene in Shanty Town" in the *New York Graphic*. The publishers captioned the halftone image (in all caps) as a "REPRODUCTION DIRECT FROM NATURE," suggesting both their level of excitement about the new process and the extent to which halftone seemed to erase the distance between the photograph and its mode of reproduction.[30] While halftone reproduction developed and became more nuanced over time, at its core the process involved the use of a screen that divided the image into a system of tiny black and white dots. The density of these dots would produce the visual impression of a range of gray tones that appeared as a continuous image.[31] After 1880 it took some time for publishers to catch up with the possibilities of the new technology. By the 1890s the use of halftone in book publishing was common; one historian designated the year 1897 as the moment when halftone came to saturate U.S. newspapers.[32]

While we tend to associate it most with photography, halftone soon came to be the preferred mode for printing all kinds of images. Halftone cost significantly less than traditional engraving; while a woodcut in the early 1890s might cost close to three hundred dollars, a halftone would be closer to twenty.[33] Publishers moved quickly to adopt the new technology, and between 1890 and 1900 the ratio of engravings to halftone in some journals essentially flipped.[34] Weekly magazines also eagerly bought into the new market for visual images.[35]

Halftone changed the viewer's experience of visual illustration, drastically increasing the quantity of images that people encountered in their daily lives.[36] But halftone also changed the *quality* of the images that people engaged. Halftone images looked decidedly different from engravings, and even from the photographs upon which they were based. As a result, viewers needed to learn how to interpret the images.[37] In addition, largely because

of the dots, early halftones were not seen as an aesthetically pleasing mode of image reproduction, especially when compared with exquisitely rendered engravings.[38] Commentators at the time also lamented the impending loss of the art of engraving itself.[39] In 1895 a writer for the *New York Times* observed, "While the half-tone has many advantages, and is perhaps in many respects a more satisfactory medium for the reproduction of picture, portrait, landscape, and incident, making possible much that before was impracticable, still, with the decline of wood engraving, art will be greatly the loser." But for this writer at least, the tradeoff was worth it: "What we lose in the beauty of line we gain in the increased number of the illustrations."[40]

By the dawn of the twentieth century, halftone had become integrated into the visual experiences of media-consuming Americans. If they regularly read a big-city newspaper or subscribed to general weekly magazines such as *Frank Leslie's*, *Harper's*, or *Collier's*, they encountered page after page of halftone photographs. In the newspapers, special Sunday supplements highlighted the week's news by featuring halftone reproductions of photographs representing all topics, from the most important to the silliest. The halftone revolution helped to change photography's relationship to time because it changed photography's relationship to mechanization. Kevin Barnhurst and John Nerone write of this period, "Pictures adopted greater claims to status in the hierarchy of news values. Newspapers advertised scoops—the last picture or the latest picture. That change was accompanied by the loss of image-as-handicraft" as earlier modes for rendering images were "replaced by the supposedly mechanical photograph."[41] Mechanization sped up the number and frequency of photographs Americans encountered and, as a result, changed their expectations for photographs' timeliness.

Handheld Cameras and Camera Fiends

While printers worked out the complexities of how one might faithfully reproduce a photograph in newspapers, books, and magazines, other practitioners focused on making improvements to cameras and processes. These innovations eventually led to the rise of amateur snapshot photography, made possible first by the shift from wet-plate to dry-plate photography and then the subsequent introduction of the handheld camera. As with halftone, these technological changes transformed the average person's relationship to photography. By the end of the nineteenth century,

millions of Americans turned from consumers of photographs into makers of them. But with the rise in the number of camera-wielding Americans came a parallel rise in anxiety about what people might do in public with those cameras, creating a fear of the so-called camera fiend that lasted until well into the twentieth century.

As its name suggests, wet-plate photography required the photographer to coat a glass plate with light-sensitive chemicals just before making an exposure—in other words, while the plate was wet—and then immediately develop it. While this process often produced exquisite images, it also required photographers to develop their own pictures, which limited the practice of photography largely to professionals and highly motivated amateurs.[42] The commercial emergence of dry-plate photography in the 1880s changed this. Dry-plate photography offered precisely what its name suggested: a way to coat chemicals onto plates so that they could be exposed when dry. Photographers could then coat many at once and store them for later use. Eventually photographers did not need to coat their own plates at all, because they could purchase prepared plates from manufacturers. The gelatin coating on the dry plates turned out to be more light-sensitive than what was used in the wet-plate process, another benefit. As a result of increased light sensitivity, exposure times for dry-plate images plummeted, speeding up the entire process.[43]

The shift to dry-plate photography eventually led to the development of roll film and the handheld film camera, two technologies that lasted in some form for more than a hundred years and lost popularity only with the digital revolution. As with most technological developments in photography, however, these changes happened in a series of smaller steps. Because of the greater light sensitivity of the dry plate, cameras now required a shutter, a small door that opened and closed inside the camera, limiting the amount of time the plate inside was exposed to light.[44] Because of sped-up exposure times and the use of a shutter, cameras no longer needed to be as large in order to let the light in. Sometimes called "detective cameras," these smaller cameras were designed primarily for amateurs, who did not require the levels of individual control that professionals wanted. Compared to later box cameras, the detective cameras were still large but nevertheless represented a distinct change from past devices.[45]

Here George Eastman became a prominent part of the story. Eastman started out in Rochester, New York, as a bank clerk with a deep interest

in amateur photography. Like other devoted amateurs of the time, he began with the wet-plate process but later experimented with dry-plate photography.[46] After making many improvements to the process—so successfully that his photographer friends began asking him to prepare their plates too—Eastman went into business for himself.[47] By 1883 Eastman operated his own factories and a profitable international business. He also made experiments with flexible film, which could be coated with the proper chemicals and spooled on a roller, removing the need to exchange glass plates between exposures.[48]

Eastman's successes were only modest until he introduced the first Kodak camera, which combined the small size and portability of the earlier detective cameras with flexible film.[49] Kodak Number One, as it was known, cost twenty-five dollars and came with a roll of film long enough to provide the user with one hundred exposures. In today's terms this would have been the equivalent of about six hundred dollars, or what a farm laborer of the time might have made in a year.[50] Because of the steep price, the cameras did not fly off the shelves. Even so, Eastman's factories in the United States and England produced more than one hundred thousand of them by 1896.[51] Advertised with the slogan "You press the button, we do the rest," the Kodak camera offered amateurs the chance to learn photography without having to worry about developing the pictures. While users could develop the photographs on their own, Kodak encouraged photographers (whom it called "Kodakers") to mail the whole camera back to the company. The film would be unloaded, developed, and the resulting photographs printed. Photographs would then be returned to the customer, along with a new roll of film in the camera, and the process would start all over again.[52]

The first Kodak cameras made truly amateur photography possible and made the medium available to anyone who could afford a camera. Of this period Robert Mensel writes, "The most important cultural consequence of the technological and marketing strategy which produced the Kodak was that it completely changed the conception of who was to practice photography."[53] In large cities like New York, for example, it seemed that photographs suddenly appeared everywhere: "Photographs were sold in a variety of locations, from the attractive shops of successful professional photographers to general junk shops. They were disposed from vending machines, and even given away free in cigarette packs."[54] With such ubiquity came anxiety about the role of cameras in public. In 1885 *Anthony's*

Figure 4.3: Early Kodak advertisement, ca. 1889. (Courtesy of George Eastman Museum; gift of Eastman Kodak Company.)

Photographic Bulletin warned readers, "It behooves every man, woman and child to walk circumspectly while on the streets, for it is impossible to tell when they may be confronted with a photograph showing them in some ridiculous or embarrassing position."[55] Such criticism also extended to the newspapers and magazines that published such images; an 1896 essay in the *North American Review* complained about "the new illustrated journalism, built upon surreptitiously taken photographs."[56] Soon advertisers appropriated uncredited snapshots to sell their products. In 1902 the *New York Times* reported that one woman was shocked to discover an unauthorized photograph of herself in a corset advertisement.[57] A new term emerged as a label for such behavior: "camera fiend" arose during this time to describe amateur photographers who lurked about in public, taking people's photographs without permission.[58] In an 1897 essay called "Confessions of a Camera Fiend," the writer jokingly claimed to "have raised the snapshot to a fine art" and to have developed a "special" skill for photographing celebrities in the water and from behind; neither approach offered much opportunity for consensual, flattering poses.[59] For the *Ladies Home Journal* in 1900, the concern was ultimately one of manners. It urged the magazine's women readers to recognize that "there are those who

have a strong prejudice against being promiscuously 'snapped at' through a camera." All people—even presidents, the magazine suggested—should be able to decline being photographed, and they especially should be allowed to keep their children from being photographed. Not everything, the magazine warned, "may be considered as fair game for their cameras, and . . . no one should interpose objections to being 'snapped.'" While the camera could be a wonderful educational tool, the writer concluded, "it must not be employed in violation of private rights."[60] Women and girls often were framed in these accounts as especially vulnerable. For their part, photographers sought to differentiate their profession from those amateurs who behaved badly. A writer in the British journal *Photography* observed in 1900, "There are, of course, 'cads with cameras' just as there are 'cads on castors.' No hobby, or profession, is free from the all pervading 'bounder,' and there is no reason why we photographers should be exempt. To utter sweeping condemnation of every user of a hand camera because a few have attempted to abuse is neither just nor reasonable."[61]

The public craving for photographs rose exponentially with the introduction of a cheap Kodak camera in 1900. While the first Kodaks eventually came down in price and rose in popularity, it was not until Eastman's introduction of the Kodak Brownie that snapshot photography came into its own. Costing only one dollar, the first Brownie used inexpensive, six-exposure rolls of film that produced two-and-a-quarter-inch-square snapshots.[62] Just as important as its low price was its ease of use. The small box camera required very few photographic choices on the part of the user; even a child could use it. The Brownie, whose name and early advertising was inspired by popular illustrations of a mischievous sprite from Scottish folktales, became an instant financial success.[63] By the end of its first year on the market, more than 150,000 Brownies had been sold. [64] While Kodak primarily advertised the Brownie to children, early ads targeted to adults also appeared in places like *Scientific American*.[65] Nancy Martha West estimates that "adults probably purchased between one-third and one-half of all Brownie cameras" and argues that the success of the Brownie "was largely responsible for the fact that roughly one-third of the U.S. population owned a camera by 1910."[66]

The rise of amateur photography transformed people's relationships to photography. Not only could they now make photographs themselves, but they came to know more intimately the impulse to photograph as they made

pictures of what they encountered in daily life. While photography was still a practice of memory (especially for those encouraged to use their Brownies to make photographs of little ones at home who would soon be grown up), it increasingly became identified with the timely qualities that today we associate with news.[67] As people learned to make their own photographs and consumed a greater quantity of images, the snapshot, the news photograph, and even fears of the "camera fiend" all created new expectations about timeliness. People expected cameras to be where the action was and they wanted pictures of it. Public figures, including presidents, needed to get used to that new impulse.[68]

Photographic Presidents during the Rise of Halftone and Handheld Photography

In 1898 a writer for the British journal the *Photographic News* declared, "The camera and the half-tone block have made the appearances of most of our public men and women so familiar to the eye of the community at large that it might seem a matter of impossibility for a prominent personage to pass through a London thoroughfare without being generally recognised."[69] In the United States things were no different, and presidents needed to navigate the changing expectations for their engagements with photography.

James Garfield was shot by mentally ill office-seeker Charles Guiteau in July 1881, just four months into his presidency. Garfield lingered for weeks after the shooting, and his physical status remained front-page news during that time, which drove up sales of Garfield's image.[70] When Garfield died, a Chicago newspaper reported, "In a few short hours manufacturers, photographers, lithographers, and designers were at work, and in an incredibly short space of time the streets were alive with portraits of Garfield, and Garfield shields, mottoes, and badges. The rage for some memento of the dead President was something wonderful."[71] A photograph dealer reported that although he could not fulfill a request by a wholesaler for "a million 'cheap photographs of Gen. Garfield,'" he still produced "10,000 a day for three months, and couldn't begin to fill the orders."[72] The new impulse for pictures demanded quantity.

Americans voiced interest in the photographic engagements of living presidents too. Some in the press criticized President Chester Arthur for apparently liking photography a little too much. One article that circulated

nationally in 1884 observed, "One of President Arthur's manias is the taking of photographs." The writer noted, "It is said that he has over 100 pictures of himself in various positions." The piece described how Arthur "has an artist to pose him and arrange the surroundings and light and shade" and concluded, tongue firmly in cheek, "Why, let me tell you that there is not a painting of Washington in full uniform, or of the most stately of our chief executives, that is half as impressive as one of the photographs of Arthur in his new spring suit."[73] What was in John Quincy Adams's time a nearly singular, noteworthy, rare event—sitting for a photographic portrait—had forty years later become so routine that when indulged in too much it reflected poorly on the presidential sitter. One needed to be a photographic president, just not *too* photographic. Despite the criticism of Arthur's supposed "mania," however, the demand for photographs of prominent public figures only rose over time. When Benjamin Harrison took office just five years later, sellers of photographs in Philadelphia complained that there were not enough photographs of his wife for sale, speculating that it was because "she was never struck [*sic*] on herself enough to have many taken."[74]

The appearance of amateur photography and the rise of halftone in the late 1880s and early 1890s coincided with Grover Cleveland's two nonconsecutive terms in office. The Clevelands' experiences with photography at the White House included anxiety about images used without permission and the sneaky presence of camera fiends. The White House banned amateur photographers from the grounds because too many crowded outside the mansion trying to get a glimpse of Frances Folsom Cleveland, the president's much younger, beautiful wife, who married Grover Cleveland halfway through his first term.[75] After the marriage the illustrated weeklies quickly put her on their covers and inside their pages. When soon after advertisers of patent medicines, corsets, and cigarettes used Mrs. Cleveland's image without permission to sell their products, "a bill was introduced in the House that would ban the public exhibit of any photograph or likeness of a woman without her consent."[76] Just after Cleveland lost his bid for reelection to Benjamin Harrison in 1888, one writer lamented the loss of a favorite subject: "Mrs. Cleveland has been beyond compare the greatest boon the photographers ever had."[77]

During Cleveland's second term, eager photographers sought out images of the Clevelands' eldest daughter, known popularly as "Baby Ruth." In 1893 a writer for the *American Journal of Photography* noted the child's

popularity with photographers: "The kodak fiends are, of course, trying to get a snapshot at the White House baby." Offering an anecdote about a photographer who "'touched the button' and got his picture as Mrs. Cleveland took [Baby Ruth] out of the carriage" at church, the writer surmised that the president and his wife were not pleased: "Mr. and Mrs. Cleveland have naturally been desirous that the baby's picture should not be circulated, but it can hardly be expected that a kodak fiend would respect their feelings, and doubtless the photograph he stole will be on the market before many days."[78] Even the shakiest of snapshots were coming to be prized for their timeliness as visual news.

Photography changed dramatically during the fifty years between John Quincy Adams's daguerreotype sittings and the end of the nineteenth century. What first appeared as a medium grounded in the visual power of the one-of-a-kind object of fidelity and wonder had transformed into an abundant, often riotous visual chronicle of private and public life produced by both professionals and amateurs. As President William McKinley took office in 1897, the halftone era was in full swing, bringing with it the rise of the amateur snapshot and the introduction of photography in print. These two practices taken together made possible for the first time a truly timely photography. Just how timely would be tested when William McKinley was shot and killed in Buffalo, New York, in 1901.

William McKinley's Last Photographs

William McKinley had antelope eyes. Or so said an unnamed photographer in a 1902 article in *Wilson's Photographic Magazine* that recounted the photographer's experiences capturing the image of "every president since Grant." William Howard Taft reportedly was easy to work with, but Theodore Roosevelt was "an excessively hard man to pose for the camera" because he was "generally stricken with the fidgets." Grover Cleveland had "a decided aversion to the camera," while McKinley "had the most remarkable pair of eyes that I ever saw in a man's head. They were literally as mellow as the eyes of an antelope."[1]

Whether Leon Czolgosz, the would-be anarchist who shot the president while he greeted well-wishers at Buffalo's Pan-American Exposition, thought McKinley's eyes were especially bovine has gone undocumented. What is documented, however, is the assassination's role in a transformative moment in the history of photography. When Czolgosz shot the president on September 6, 1901, McKinley had been shot perhaps hundreds of times in Buffalo already, by cameras. During the day and a half that McKinley spent in Buffalo before being fatally shot, he gave a major speech before a large crowd at the exposition, toured exhibits, and visited Niagara Falls. These and other activities gave photographers of all stripes a number of opportunities to photograph the president as he moved about in public. Both

professional photographers and amateur "camera fiends" photographed the illustrious visitor before his fateful encounter with an assassin, eager to make a snapshot of the visiting president.

Those images took on increased significance (and financial value) almost immediately after the shooting as photographs of McKinley in Buffalo began to circulate in local and national newspapers and magazines. The press closely followed the minute-by-minute drama of McKinley's improving, then rapidly declining, health over the eight long days between the shooting and McKinley's death. Newspapers and magazines reported on and pictured the comings and goings from McKinley's sickbed of family members, Vice President Theodore Roosevelt, and various cabinet secretaries. Photographers revisited all the scenes of the shooting and its aftermath. After the president's death, magazine and newspaper editors peppered their coverage with what they came to call the "last photographs" of President McKinley. They labeled the images with captions such as "McKinley's Last Speech," "Last Picture of McKinley, Day He Was Shot," and "Last Photograph of the President . . . Taken Twenty Min [sic] Before the Shooting." Still other photographs seemed to split fine hairs as far as the claim to "last" was concerned, such as "The Last Photograph Taken at the Request of President McKinley" and "The Last Photograph of President McKinley by His Own Permission." Perhaps most poignant: a photograph of McKinley at Niagara Falls captioned "Last Trolley-Ride."

One might easily tumble down a rabbit hole trying to determine which of the dozen-plus images declared to be McKinley's last photograph really *was* the last photograph of McKinley before he was shot. But that question is less important than the question of why newspapers, magazines, and sellers of photographic images deemed it important to emphasize McKinley's last photographs in the first place. What value—political, financial, or otherwise—did they place on their claims to holding the last photographic representations of a now dead president? Perhaps the obsession with "last" resulted from the shock of yet another presidential assassination; after all, McKinley's assassination constituted the third murder of a U.S. president in just thirty-six years. Yet while all kinds of visual representations depicted and remembered the violence unleashed upon Abraham Lincoln in 1865 and James Garfield in 1881, no similar obsession with last photographs dominated the visual histories of those previous assassinations.[2] What did change was the value that photography now placed on the importance of timely snapshots.

The obsession with the "last photographs" of McKinley was grounded not in anxieties about yet another presidential death but in what Neil Harris has called the "visual reorientation" that Americans experienced after 1885 with the rise of halftone and handheld photography.[3] As chapter 4 argued, by the turn of the twentieth century, photography had a new relationship to time. In the 1840s John Quincy Adams struggled with the lengthy time requirements needed for achieving a properly exposed (and awake) daguerreotype. More than fifty years later, President William McKinley participated in a new shift in the photograph's temporality when the nearly instantaneous amateur snapshot and halftone news image came to dominate the medium. While both the daguerreotype and the snapshot froze their subjects in time, the operations that produced the two kinds of images evolved decidedly different relationships to time itself. The daguerreotype, with its long exposures, tapped into a sense of time as duration, but the snapshot framed time as the force of the opportune moment.[4] By the dawn of the twentieth century, photography became oriented toward the act of capturing the right moment and being ready to make a picture. The snapshot and the news photo stood as exemplars of the new visual value of timeliness.

These technological and social shifts appeared perhaps most visibly and consequentially in the aftermath of McKinley's shooting and death.[5] While the moment of the shooting itself was not captured photographically—perhaps the ultimate failure of the new timely photography—the shooting still played an important role in the visual chronicle of the assassination. It constituted an event that dramatically distinguished "before" from "after" and thus became a key reference point for those seeking to highlight the value of their images. By labeling the many photographs they *did* have as McKinley's "last," photographers and editors attempted to capture the force and power of that moment despite its literal photographic absence. McKinley's was the first presidential assassination to take place after the shift to timely photography and the last presidential assassination to offer no photographic images of the moment of the shooting. As a result, the McKinley assassination offers a unique opportunity to examine up close the tensions that arose when the medium's new claims to timeliness clashed with the absence of images of the event itself.[6] What the McKinley assassination lacked in timely images, it more than made up for with images of literally everything else.

McKinley and the Modern Media

Elected in 1896, William McKinley was the first president to invest in what today we would recognize as "modern" communication methods. Though historians often treat his much-lauded "front porch campaign" of 1896 as a passive approach to campaigning, it in fact relied on a number of new methods for doing politics, such as data gathering and advertising.[7] That advertising included photographs, along with the brand-new medium of motion pictures. McKinley was the first president to appear in a motion picture, doing so as a candidate in 1896.[8] The Biograph film, short yet plodding by today's standards, was revolutionary for its time. Just over one minute long, it depicts McKinley in front of his Canton, Ohio, home with his personal secretary, George Cortelyou, apparently reenacting the moment McKinley received word of his nomination. As they walk together toward the camera, McKinley puts on his stovepipe hat and his glasses and takes some papers from Cortelyou. The two then confer about them, McKinley removes his hat and glasses again, and the two wander slowly from the frame, exiting stage left.[9] Despite what today screens as an uneventful, indeed awkward presentation, the film engaged audiences of the time. One newspaper account of the film's screening reported that when "Major McKinley stepped onto his front lawn, the whole house went wild."[10]

Once elected, McKinley created structures for the management and dissemination of presidential news.[11] He was open and inviting with newspaper reporters and strategic about using communication strategies to his advantage, and his personal secretary, Cortelyou, pioneered the role of what today we would call the White House press secretary.[12] In terms of photography, two aspects of McKinley's time as president stand out. One is the rise of photo agencies. In the fast-moving, turn-of-the-century halftone era, print outlets needed timely photographs faster than their own staff could deliver, and photo agencies emerged to fill that gap. One key player was George Grantham Bain. A New York City photographer, Bain launched his own news service in 1898. In 1899 he connected with President McKinley, joined him on trips, and gained regular access to the White House. In this way Bain collected hundreds of photographs of McKinley for distribution and sale.[13] Such images satisfied not only a president always looking for good

press but also the increasingly voracious appetite for images of celebrities and public figures that agencies like Bain's sought to feed.

In addition to its relationship with the photo agencies, the McKinley White House cultivated relationships with photographers and invited them to travel with him. On his 1901 tour of the United States, for example, a photographer traveled with the press and had his own darkroom aboard the train.[14] Perhaps the most important ongoing relationship McKinley shared with a photographer was that with Washington, DC, photographer Frances Benjamin Johnston. While the job of official White House photographer as we know it today did not exist until much later, Johnston came close to fulfilling that role with McKinley. The daughter of wealthy, connected parents (her mother was a Washington, DC, journalist), Johnston took up photography in the late 1880s; she used one of the earliest Kodak cameras, generously provided by family friend George Eastman.[15] Not long after becoming a photographer, Johnston used her family connections to gain access to both the White House and its inhabitants (her mother was a cousin of Frances Folsom Cleveland). She published her first images of the White House and its grounds in a magazine in 1890 and by 1893 operated her own photography studio in Washington, DC.[16] Throughout her career, Johnston photographed five presidents (Cleveland, Benjamin Harrison, McKinley, Theodore Roosevelt, and Taft), along with their wives and children.[17] She also used her access to the occupants of the White House to photograph other prominent families in government. In 1897, for example, she recorded in her diary on January 4 that she photographed "Mrs. Cleveland" and all the "cabinet ladies."[18] Later, when McKinley took office, she photographed him regularly, including at his inauguration, along with making portraits of his wife, Ida Saxton McKinley, and his cabinet.[19] Fatefully, Johnston was with the president and Mrs. McKinley in Buffalo for the Pan-American Exposition in 1901 and made some of the images that became famous as McKinley's "last" photographs.

McKinley at the Exposition

President McKinley was not supposed to be in Buffalo that September. Originally, he and Mrs. McKinley planned to visit in June as part of an extended western tour that would take them as far as California.[20] But when the first lady, who suffered from various health issues throughout her adult

life, became too ill to do the full trip, a separate trip to Buffalo was planned for September.[21] The president would be tightly scheduled during his two official days in the city, arriving on the evening of Wednesday, September 4. McKinley would keep to a full slate of activities on Thursday, September 5, and Friday, September 6, including a major speech to be delivered to the exposition on the fifth, which was to be declared "President's Day." In its preview of the president's itinerary, the *Buffalo Courier* proclaimed, "Sept. 5th will be one of the greatest days of the entire exposition."[22] The *Courier* noted that the events on the schedule were "each individually planned to draw big crowds," and pronounced confidently that the presidential visit would "bring the Exposition to the zenith of its glory."[23]

The Pan-American Exposition was one of several world's fairs held in the United States in the late nineteenth and early twentieth centuries, each designed to showcase innovation, culture, and commerce. Margaret Creighton writes that these events "flaunted military and industrial power, new technologies, and consumer goods. They became extravagant advertisements for nation states, and, when possible, showcased colonial possessions."[24] Running from May to November of 1901, the Pan-American Exposition announced it would "promote commercial and social interests among the States and countries of the western hemisphere."[25] The exposition's various buildings showcased machinery, transportation, music, art, agriculture, and that exciting form of energy driving many new technologies, electricity. State and so-called foreign buildings highlighted national culture and commerce both below and above the U.S. border, with buildings dedicated to Central and South American nations as well as Canada.[26]

The exposition competed with the memory of the immensely popular Chicago World's Columbian Exposition of 1893. The Pan-American Exposition advertised itself as "second in size only to the World's Fair and far more attractive and unique in many particulars beyond that display in 1893, and thoroughly original in its most distinctive features."[27] One of those "distinctive features" was the "Illumination," a display of electric light achieved by lightbulbs and searchlights choreographed to outline the features of major exposition buildings. The nightly presentation of the power of electric light produced a dramatic view of the exposition that, organizers touted, sent "its gleams for many miles around, embracing in its grand circle the Falls of Niagara and the Canadian Frontier."[28] The exposition's midway, advertised as an "amusement section," continued previous expositions' racist traditions.

Its "African village" and "Old Plantation" exhibits (complete with Black actors performing as slaves) sat alongside a beer hall, a talking horse, and the "Palace of Illusions," which was a house built completely upside-down.[29] Regular parades of the midway's attractions, including Lubin's Picture Machines—a float that would photograph the crowd as it proceeded along the parade route—further called attention to all that the midway had to offer visitors.[30] Yet despite the wide variety of its many attractions and the ceaseless boosterism of city fathers, the exposition never achieved the financial success its organizers hoped for. It cost 7 million dollars to put on but earned only 6 million; organizers later claimed that the death of President McKinley resulted in 1.5 million dollars of lost revenue.[31]

Photography played an important role at the exposition, one that privileged the professional photographer over the Kodak-wielding amateur. Following norms established at the Chicago World's Fair in 1893, the Pan-American Exposition had its own official photographer, photography concession, and specific rules about who could photograph on the grounds with what kinds of cameras.[32] Specific exhibits also featured photographic technologies.[33] Organizers sought to control the visual image of the event as much as possible and to ensure that visitors bought the exposition's official souvenir books and images.[34] Photographer C. D. Arnold had served as the official photographer of the 1893 World's Columbian Exposition in Chicago, and he served again in that same role in Buffalo.[35] Chicago's photography division, led primarily by Arnold, caused controversy for its practices, especially its attempts to limit amateur photography on the grounds.[36] Concerned about the rise of smaller cameras and the seemingly endless number of images they could put into circulation, Arnold tried to ban amateurs entirely, which would force visitors to purchase officially sanctioned images of the fair if they wanted a memento. But after a public outcry, he instead created a scheme of rules and fees designed to impose strict controls on amateurs' photographic activities.[37]

The practice in Buffalo mirrored the rules ultimately put in place in Chicago. Arnold, well known as an architectural photographer, produced the sanctioned images at the exposition. Many of these highlighted the architectural features of the major buildings on the grounds, and Arnold published them in a 1901 souvenir book, *Official Views of Pan-American Exposition*.[38] He also kept a studio on the grounds of the exposition, where he sold officially licensed souvenir copies of his images.[39] As in Chicago,

select professional photographers were allowed to work at the exposition. For example, B. W. Kilburn, a New Hampshire company that held the stereograph concession at Chicago, appears to have held it in Buffalo as well.[40] The Edison Company produced a series of "actuality" films (one-minute nonfiction films) featuring spectacles and snippets of everyday life at the exposition.[41] Photographers working for magazines like *Collier's* and *Frank Leslie's* came to the exposition to cover President McKinley's visit. Frances Benjamin Johnston would make many images during her visit to the fair to document President McKinley's official visit, including some of those that came to be labeled and sold as the president's last. Her specific presence at the exposition would have been no threat to Arnold, however. He had worked closely with her during the run of the Chicago fair, where she served for a time as an official photographer.[42]

As far as amateurs with cameras were concerned, the exposition's official guide set forth specific rules that they must follow in order to have "camera privileges." Camera privileges could "be enjoyed upon payment of 50 cents per day for each instrument and a somewhat less rate when permit is taken out for a week, the only limitations being that no tripods be used and the plates must not be larger than 4 x 5 inches."[43] Translation: visitors with cameras had to pay to bring them onto the exposition grounds, but no one would be allowed to use any equipment with the capacity to produce larger, high-quality images that might compete with the exposition's official photography concession. The Kodak Brownie, introduced just a year before, cost only one dollar, while the fifty-cent fee per camera per day cost the equivalent of roughly $14 in today's dollars. When paid on top of the twenty-five-cent daily admission fee, the cost of the permit likely dissuaded amateur photographers from bringing their cameras to the exposition. Even so, lavish Kodak advertising urged customers to "Take a Kodak with You to the Pan-American Exposition" and suggested that the company's more expensive Folding Pocket Kodak would be ideal for capturing the spectacular sights.[44] Extant images made by amateurs visiting the exposition show that lots of visitors did bring their cameras to make their own snapshot souvenirs.[45]

The official plan slated the president, Mrs. McKinley, and advisers to arrive in Buffalo by train on Wednesday evening, September 4, and make their way to the home of exposition president John Milburn, where they would stay during their time in the city. The *Buffalo Courier* pointed out that

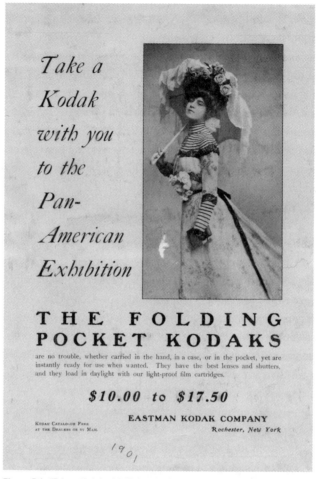

Figure 5.1: "Take a Kodak with You to the Pan-American Exposition," Kodak advertisement, 1901. (Courtesy of George Eastman Museum; gift of Eastman Kodak Company.)

McKinley's first full day in Buffalo would be especially busy. The next morning, Thursday, September 5, the president and his party would be escorted in carriages to the exposition grounds in a military-style parade. Shortly thereafter, President McKinley would make a formal speech outdoors to a large assembled crowd, review the troops, attend a luncheon, and then visit exposition buildings and exhibits. During the evening, he and Mrs. McKinley would view the Illumination. On Friday the sixth, the schedule would be lighter but still busy: a morning trip to Niagara Falls followed later

in the day by a four o'clock public reception at the exposition's Temple of Music.[46]

Local newspapers trumpeted that the McKinleys' first night and day in Buffalo went off without a hitch—save a salute from a welcoming cannon set so close to the tracks that it broke several windows on the McKinleys' train and caused some alarm. Large crowds awaited the president's train on Wednesday night, where a reporter acknowledged the role of the half-tone press in making McKinley recognizable to the locals: "Through the grating of the fence emerged the face of a man known wherever papers are printed—President McKinley. . . . It was a privilege to the people to obtain a close scrutiny of the faces of the President and Mrs. McKinley."[47] That close scrutiny was followed the next day by what the *Courier* called the "proudest day in Buffalo history" as the president visited the exposition, made an hour-long speech, and took in the spectacle of the Illumination.

The next day, citizens of Buffalo and surrounding communities looked forward to opportunities to catch a glimpse of the president and possibly shake his hand at the public reception in the Temple of Music. But first, that morning McKinley and his party traveled from Buffalo to Niagara Falls. They lunched at the International Hotel and visited the falls, where the president reportedly "climbed like a schoolboy to the highest rock formation above the falls."[48] Photographers followed along to capture the scene. A local photographer named Smith made several unposed exposures of the president mingling with his party outside of the International Hotel, which were later produced and sold as cabinet cards.[49] Orrin Dunlap, another local photographer, captured the president and his party at the falls, making at least one image later published in *Frank Leslie's Weekly* after the president's death.[50] Leon Czolgosz, a loner with anarchist leanings, was also at Niagara Falls that day, where he traveled with the intention of shooting the president. Traveling under the alias "Fred Nieman," Czolgosz realized he would have no opportunity to shoot McKinley there and returned to Buffalo.[51] (He later said he had followed McKinley around the exposition the previous day but found no good opportunities to commit his crime.[52]) Back in Buffalo, Czolgosz joined those in line for the public reception later that afternoon, a white handkerchief wrapped around his gun to make it look like he had a hand injury.[53]

After returning from Niagara Falls to the Milburn house in Buffalo, the president freshened up and then rode to the exposition for the public

Figure 5.2: Smith, "The Last Photograph of President McKinley, by his own permission. Taken at the International Hotel, Niagara Falls, N.Y.," 1901. (Library of Congress.)

reception. A stereograph of the exterior of the Temple of Music shows hundreds of people lined up to get a glimpse of the president or possibly a handshake. As President McKinley readied to meet the public, members of the Secret Service and dozens of soldiers, along with his secretary, George Cortelyou, and assorted dignitaries, stood nearby. Scott Miller described the scene at the Temple of Music as the assassin approached the president, who had been shaking hands with an ongoing stream of citizens for about fifteen minutes:

> For a frozen instant, nobody moved. It was too fantastic to believe. From
> the dais where McKinley was shaking hands with the public the sound of

a firecracker echoed. A second report soon followed. A slightly built young man, standing only a few feet from the president, was holding a gun covered in a white handkerchief. A small mushroom cloud of smoke wafted upward. The president clutched at his chest and was beginning to lean forward—his expression, not of pain, nor anger, but one of confusion.[54]

The exact details of what happened next differ across accounts, but the gist of it is this: A man directly in line behind Leon Czolgosz, an African American exposition worker named James Parker, tackled the shooter to the ground, where Secret Service agents and others struggled to subdue him and began to beat him until the president, still conscious, asked them to stop.[55] Czolgosz was taken to another room in the building and later removed to the police station, where crowds gathered outside, shouting for his head. The president was helped to a chair, where he remained until removed from the building by an ambulance and taken to the exposition hospital for surgery to remove the bullets. Working in insufficient, badly lit conditions, doctors were able to remove one bullet but unable to find the second, so they elected to close up the president with the second bullet still inside of him. Later that evening he was returned by ambulance to his lodgings at exposition president John Milburn's house, where arrangements had been hastily made to allow him to recover there under the care of doctors and nurses.[56] Police set up barricades on the street—guarded by an army regiment—and established an ad hoc communications operation, including a telegraph operator and stenographers to draft messages.[57]

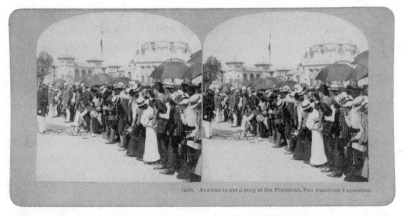

Figure 5.3: B. W. Kilburn, "Anxious to Get a Peep at the President. Pan American Exposition," 1901. (Library of Congress.)

News of the shooting traveled quickly. The *Buffalo Courier* wrote of the scene outside the Temple of Music, "With the remarkable rapidity that the news of a direful calamity spreads, so was the fact of the prisoner's assault disseminated through the 20,000 people who were in one great mob outside the building."[58] The local and national press soon set up camp at the Milburn house and published nearly hour-by-hour updates on the president's condition. The vigil lasted for eight long days. At first the president seemed to be doing well. In its extra noon edition of September 8, the *Buffalo Courier* reported, "The President has passed a good night and his condition this morning was quite encouraging. His mind is clear and he is resting well. The wound was dressed at 8:30 this morning and found in a very satisfactory condition."[59] There were reports that the president asked for a newspaper and wanted to know how his exposition speech had been received.[60] Cabinet members traveled to Buffalo and moved into the nearby Buffalo Club, essentially setting up a temporary White House there; the *Courier* reported that Western Union had strung a direct line between the Buffalo Club and the Milburn house.[61] All day long people streamed in and out of the Milburn house, besieged for comment and photographed at their arrivals and departures. Vice President Theodore Roosevelt, who at the time of the shooting was the guest of the Vermont Fish and Game League at Lake Champlain, hurried across the state to see McKinley, assuring reporters that the president would fully recover.[62] The *Courier* described the buzz of activity during the vigil: "Messenger boys go and come constantly, for the telegrams of sympathy and regret continue to come in what seems to be a never-ending succession. At nearly regular intervals a secretary from the Milburn residence hands a bundle of type-written sheets to the press representatives. They are the official bulletins of the condition of the President. So it goes on in unfailing routine, offering no change or stirring incident to arouse the camp to activity."[63] At first the press tent was occupied by local reporters and national ones already in Buffalo to chronicle the president's visit. But reporters from around the country soon converged on the city, the *Courier* reported in booster-like fashion: "Early Saturday morning the influx of out-of-town newspaper correspondents set in. Immediately upon receipt of the first bulletin announcing the shooting of the President, the papers in the large cities hurried men of their staff to Buffalo. The most brilliant and capable men were sent, accompanied by photographers and

artists. Buffalo is the news center of the world today and the men are not needed at home."[64]

The news media reported every detail of the president's condition during the eight days between his shooting and his death: what he ate, what he drank, who visited him, even the condition of his wound. But while the textual updates in each issue of the newspaper arrived hot off the presses and straight from the front porch of the Milburn house, the options for photographic coverage of the drama were limited. Unlike the period of the Lincoln and Garfield assassinations, where citizens had to content themselves with formal memorial portraits of the stricken presidents or artists' representations of the dramatic moment of the shooting or death, in the halftone era expectations ran higher. Implicit in the breathless news coverage lingered a question: Had anyone photographed the actual assassination?

Assassination Photographs

The *Buffalo Courier* obliquely addressed this question in an article published two days after the shooting under the headline "Amateur Photographs of Czolgosz's Crime." The piece opened by observing, "'Johnny with his camera' got in his work yesterday on everything pertaining to President McKinley."[65] The writer referenced a popular comic song, "Up Came Johnny with His Camera," in which the "Johnny" of the title sneaks around town with his camera, surreptitiously taking snapshots of young women playing leapfrog and riding bicycles.[66] (Johnny surely was a camera fiend if there ever was one.) Like the fictional Johnny, the *Courier* reported, eager Buffalo photographers sought to capture anything related to the event that they could. But there remained the problem of photographs of the actual crime itself: Did any exist? On this point the writer equivocated. First, the article claimed that "two or three self-possessed snap artists were fortunate enough to secure pictures of the President and Czolgoz [*sic*] just after the latter had committed his cowardly attempt at murder." Furthermore, the article explained, the photographs of the crime would certainly become valuable in the future:

> These pictures will be melancholy souvenirs of one of the greatest crimes and news events which has ever startled America. Whether the President lives or dies, they will always be valued highly by those who succeeded in

getting the pictures, and in case death should ensue from the assault their value will increase many fold. This is the first great crime of the sort in this country, if not in the world, which has ever been successfully snap-shotted. Both Lincoln and Garfield, the two presidents previously assassinated, were struck down in the presence of large crowds, but amateur photography was practically unknown twenty years ago.[67]

Yet despite its own claims about "success"—variants of that word appear twice above—the newspaper neither reproduced photographs of the shooting nor offered any information about who the "snap artists" in question might be. Nor did the *Courier* mention them again in its coverage of the events. Furthermore, no such images were later discovered or are known to exist today.[68] If any snapshots of the shooting itself existed, the *Courier* neither appears to have had them nor to know who did.

Curiously, after offering such a surprising headline and claim, the *Courier* then went on to explain that despite the presence of cameras on the exposition grounds, it would have been difficult to secure the very snapshots of the shooting that it claimed had been made:

> The development of amateur photography in the past ten years has made it a popular amusement and the instantaneous film carrying camera an almost necessary adjunct to a successful outing. Hundreds of cameras are brought on the Exposition grounds eveery [sic] day and a few of these hundreds happened to be within the Temple of Music when President McKinley's would-be assassin fired the shots. Still less of them were at such vantage points they could be used, and still less of those were in the hands of operators with sufficient presence of mind to press the button at the crucial moment.[69]

The writer opened the passage broadly (the hundreds of cameras brought onto exposition grounds) and then narrowed the field considerably, by first pointing out that a camera would have had to have been inside the Temple of Music, then that it would have had to have a good view of the scene, and, finally, that it would have required an operator "with sufficient presence of mind" to actually make a picture "at the crucial moment." Theoretically, an alert and knowledgeable photographer would both recognize the timely opportunity posed by the moment *and* act accordingly. But rising to this kind of occasion would have been difficult under the circumstances, as the *Courier* admitted. The writer went on to point out that other complications would have emerged as well, such as "the condition of the light." Observing

that a good picture capturing the moment of the shooting would have had to have been taken "instantaneously," the writer confessed that "the light was very poor for such purposes and this accounts for the number of failures standing out against the two or three good pictures."[70] Indeed, flash photography was in its own infancy during this period, so any amateur photographs would have had to be made by photographers adapting their practice to available light in the space.

What the article said about photographs of the shooting was confusing and contradictory: The *Courier* both declared the triumph of snapshot photography in the McKinley era yet at the same time offered no evidence that the "great crime" had in fact been "successfully snap-shotted." Not only that, but it also explained that the photographs it insinuated did exist would have been nearly impossible to make. Perhaps the writer was cleverly leaving open the slim possibility that someone somewhere might have such photographs and eventually share them. Perhaps the *Courier* heard rumors they existed and wanted to imply to its competitors that the paper might have a scoop. It is impossible to know for sure. Ultimately, however, it appears that the *Courier* claimed such photographs existed because it seemed utterly impossible that they should not. In the United States in 1901, "Johnnys with a camera" seemed to lurk everywhere in public. Thanks to halftone reproduction, photographs now appeared regularly in newspapers, magazines, books, and advertisements. Indeed, just one dollar would buy anyone their own opportunities to make pictures. By emphasizing that exposition visitors *could have* photographed the president at the moment of the shooting, regardless of whether or not they actually *did*, the *Courier* trumpeted the new visual value of timely photography.

By extension, it signaled to readers the importance of *all* of its visual coverage of the events. Even though new images of the two stars of the show—the president and his assassin—were conspicuously absent, it became immediately clear in the days after the shooting that photographs would be important. With no up-to-the-minute photographs of the president or his assailant to share with readers, newspapers and magazines made up for that absence by making hypervisible almost everything else remotely connected to the shooting. The sheer quantity of photographs was dizzying. Newspapers and magazines photographed the Milburn house, where the president was brought to recuperate, along with the numerous dignitaries coming and going from it. And they published photographs of the scene of

the crime, helpfully marking with an "X" the chair in the Temple of Music on which the wounded president had sat immediately following the shooting.[71] Farther down in the same article that proclaimed photographs of the shooting existed, the *Courier* touted the vast scope of its other visual coverage:

> While no pictures of the President could be secured yesterday, everything in any way connected with his visit to Buffalo and with the great crime was photographed many times. It is no exaggeration to say a thousand pictures were taken of the Milburn house. The first photographers appeared on the scene at daybreak. These were for the most part representing local and outside papers, all of which were anxious to give their readers a pictorial representation of the crime at the earliest possible moment. A little later the amateur photographers began to come, and they came all day. . . . The police permitted the camera fiends to stop long enough to take a snap or two. . . . Nothing possible to photograph connected with President McKinley and the all but tragic ending to his visit to the Pan-American Exposition has escaped. When collected and classified later these pictures will form an interesting and authentic history of the greatest crime which ever stirred Buffalo.[72]

With no ability to publish photographs of either the shooting or its famous victim, the press needed to fill in the blanks however it could. If "a thousand pictures" were necessary, then so be it. Barbie Zelizer writes of a similar journalistic problem reporters faced some sixty years later when those riding the press bus did not actually witness firsthand the assassination of President Kennedy: "For journalists who wanted to uphold their status as preferred observers, this situation posed obvious difficulties. . . . The fact that they missed the event raised professional problems."[73] Zelizer points out that their solution was to emphasize their "firsthand" view of events, an approach that effectively obscured the fact that the most of the assembled press had not seen the actual shooting. Captions of photographs published during the period between McKinley's shooting and death revealed a similar approach. Caption writers used "ing" verbs to emphasize that the news was happening in the present of the picture: the texts emphasized McKinley associates "giving" "waiting" reporters the news, reporters "getting [the] latest news" of the president's condition, and visitors "coming" and "going" from the Milburn house.[74]

The visual coverage of the McKinley vigil continued much in the same vein until things took a turn for the worse early in the morning on Friday,

September 13, exactly one week after the shooting. Because doctors were afraid to probe too far for the bullet left inside the president, gangrene had set in. The previous day the president had seemed in good spirits but no longer had an appetite; furthermore, his heart rate had jumped precipitously. Later in the day it was reported that the president could no longer eat solid food.[75] The president's men sent for Vice President Roosevelt. After rumors circulated throughout the evening that the president had died, he finally did succumb to his wounds just after two o'clock in the morning on September 14.[76]

Theodore Roosevelt was sworn in at a friend's house in Buffalo later that day, and funeral planning for the president commenced. William McKinley was publicly memorialized in three separate cities, each event replete with all the pomp and circumstance rightly accorded a president. The first came in Buffalo itself, where McKinley's body was viewed in city hall by more than one hundred thousand citizens who, the *Illustrated Buffalo Express* proclaimed in its headline, "look[ed] their last upon their dead president's calm face."[77] On the morning of the sixteenth, the president's body was loaded onto a train headed for Washington, DC, where it lay in the East Room of the White House that evening and later was transported to the rotunda of the U.S. Capitol for funeral services. Both the new president and Grover Cleveland, the only living former president, accompanied the procession.[78] Finally, the president returned home to Canton, Ohio, where he was laid to rest on September 19.

Newspapers and magazines covered the funeral events as closely as they had covered the events surrounding the shooting, and again the press offered ample photographic views to its readers. In an ad titled "WE PICTURE IT. SEE!" the *Illustrated Buffalo Express* trumpeted the new visual value of timeliness, advertising that its September 22 issue would offer readers a "complete photographic record of the late president's funerals, and scenes incident thereto" and pledged that the coverage would be "artistic—timely—complete."[79] Newspapers and magazines used photographs to reconstruct the last days of McKinley's life by revisiting his trip to Buffalo and republishing pictures from his two days of public events. In their study of news coverage of presidential deaths, Kevin Barnhurst and John Nerone chronicled the various visual motifs that were repeated in news coverage of these events, including the "cross-country train ride," "the grieving widow, the team of doctors, and the body of the president."[80] The visual coverage of the McKinley

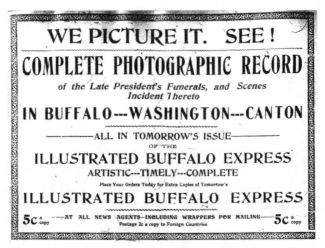

Figure 5.4: "We Picture It. See!" *Illustrated Buffalo Express*, Sept. 21, 1901.

assassination featured these motifs. Barnhurst and Nerone also identified a more self-reflexive motif that they termed "the news of the news." In each case of a presidential death, they write, "the story was itself another story: the way the news spread like contagion through the public and the way the newspeople covered it."[81] In the case of the McKinley assassination, reporters' descriptions of how the news spread across Buffalo and of their vigil outside the Milburn house exemplified this motif. Yet what made McKinley's death visually different from those that came before, and to some extent those that came after, was the media's specific obsession with his "last" photographs.

The Last Photographs of William McKinley

The impulse to collect, publish, and name photographs of McKinley as his "last" highlighted the assassination as a timely news event, one that demanded equally timely photography. However, the absence of photographs of the actual shooting in the Temple of Music produced a problem for those seeking to share or sell timely news of the McKinley assassination: How could one valorize the new visual value of timely photography in the conspicuous absence of photos of the one moment that mattered most? The press responded to this dilemma by framing McKinley's "last" photographs to emphasize their timeliness and the privileged access of a few photographers. As they appeared in newspapers, magazines, and

other photographic items for sale, the photographs and their captions accomplished this framing in three related but distinctive ways.[82] First, editors touted photographs as McKinley's last by captioning them in terms of their temporal relationship to the moment of the shooting. Second, they broadened the notion of "last" to include the last acts of the man himself, especially his last public act of giving a speech at the exposition. Finally, photographers hurriedly copyrighted their own "last" photographs, which underscored the commercial value of images made by photographers with unique and therefore opportune access to the president.

After McKinley was shot, he was not photographed again, at least not in any images that circulated publicly. He did remain visible in death, however. After he died, sculptor Edward Pausch created a death mask of him. In addition, tens of thousands of Americans viewed the president lying in state in order to look "their last upon their dead president's calm face."[83] But the shooting officially marked the moment when President McKinley the man disappeared from public view. Before Czolgosz raised his hand to shoot, the president had been hypervisible at the fair, in his public speech, at Niagara Falls, and—fatefully—at the Temple of Music. Photographers chronicled most of these activities. The shooting thus marked a liminal moment—unphotographed, despite what the *Buffalo Courier* obliquely claimed—in which the "before" of Buffalo's triumphant presidential visit deteriorated into the tragic "after" of a presidential death.

Photographers, newspapers, and magazines marked that liminal moment by reproducing photographs of McKinley in Buffalo in ways that explicitly referenced the shooting itself as a temporal marker. *Collier's* magazine put a photograph of the McKinleys' arrival at the Pan-American Exposition on its September 21 cover, captioning it—erroneously—"President and Mrs. McKinley's Last Appearance before the Shooting."[84] The headline was factually correct only if speaking in the most general terms of their two-day appearance at the exposition. The cover's sub-headline explained more honestly what the photograph depicted: "The photograph represents the arrival of the presidential party at the Exposition grounds on the morning of September 5, the day before the attempted assassination."[85] While the magazine had chosen the week before to feature a formal portrait by Frances Benjamin Johnston on its shooting-related cover, editors chose for the September 21 cover an image that highlighted the very public spectacle of the McKinleys' visit, even though the president and his wife are difficult to pick out in the

picture.[86] *Frank Leslie's* declared that its own photographer had made the "last" photograph of the president and his wife. In its September 28 issue, it reproduced a somewhat blurry snapshot of the president and Mrs. McKinley walking with her doctor and a Secret Service agent, captioning it "The Last Photograph Taken of President and Mrs. McKinley during Their Buffalo Visit."[87] Photographs of McKinley delivering his exposition speech on September 5 also got the "last" treatment by newspapers and magazines. *Collier's* reproduced photographs of McKinley speaking and reviewing the troops "before he was shot by the anarchist, Czolgolsz."[88] Similarly, the *Brooklyn Eagle* twice reproduced photographs of McKinley delivering his speech at the exposition, captioning one "This photograph was taken during the delivery of his last address, on September 5, the day before he was shot."[89] On September 15 the *Illustrated Buffalo Express* reproduced two photographs of the president by Frances Benjamin Johnston, one made "in the Govt building the day before he was shot" and the other noting the historical significance of a photograph of McKinley delivering his speech: "This picture, one of the most characteristic portraits of President McKinley ever made, will always have a peculiar historic interest. It not only shows him the day before he was shot, but in the act of delivering the address."[90] These and other similarly captioned pictures gained news value not for their visible subject matter but rather for the way editors framed their temporal relationship to the event of the shooting itself. Photographs that would have mattered somewhat as records of a successful presidential visit now became historically significant because of the shooting and the president's subsequent tragic death.

That temporal relationship moved even closer to the time of the shooting itself in other "last" photographs of McKinley. While the captions discussed above highlighted a general time period "before" McKinley was shot, another group of captions emphasized a foreshortened time frame of mere hours and minutes before Czolgosz's deadly act. *Frank Leslie's* reproduced a photograph it captioned "The last photograph taken at the request of President McKinley—three hours later he was shot."[91] A few weeks later, after McKinley died, the magazine shared two additional, temporally foreshortened "lasts": a blurry snapshot (apparently by a bystander who copyrighted the image) of McKinley traveling in a carriage that it captioned "The Last Photograph of the President . . . Twenty Minutes before the Shooting" and another higher-quality photograph of McKinley in the same carriage "while driving to the reception at which he was soon after shot."[92] The *Illustrated Buffalo Express* remarked of its own carriage photo

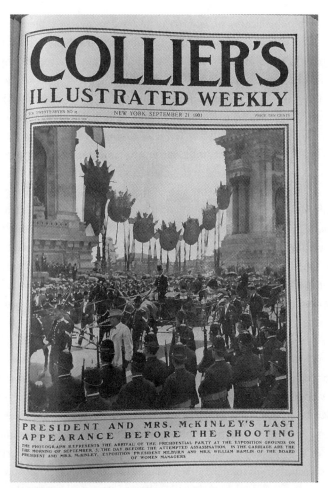

Figure 5.5: "President and Mrs. McKinley's Last Appearance before the Shooting," *Collier's*, Sept. 21, 1901.

(one by Frances Benjamin Johnston that it paid for), "This was taken but a few minutes before the shooting."[93] The *Atlanta Constitution* got into the time-compression game as well, though it (perhaps purposely) erred in doing so, captioning a photograph of McKinley's speech "McKinley making his address at Buffalo just prior to being shot" when he was actually shot the next day.[94] Such captions increased the news value of the images by compressing time in order to place the images closer to the moment of shooting. Pegging such images to the liminal moment of the shooting itself invited those who encountered the photographs to consider the drama of the timely news photo: *this* photographer, *these* subjects, all were *there, at*

that moment, which came *so close* to the fatal moment itself. By framing the photographs in this way, magazines and newspapers invited the viewer to participate in the drama of the shooting itself, to absorb the full impact of the "last" photographs as a knowing observer.

The labeling of McKinley photographs as his "last" not only tied the images to the specific moment of the shooting; it also foregrounded the final earthly acts of the man himself. News photographs initially made to chronicle a presidential visit took on new meaning and visual power after his death. Given that McKinley the man became essentially invisible—reported on but never seen after the shooting—these "last photographs" offered viewers a poignant opportunity to follow the president's final days and hours in public life. They also served the additional function of keeping McKinley visually present even in his bodily absence. A *Frank Leslie's* feature titled "Last Acts in the Life of the Late President" gave McKinley's final activities powerful visual expression, presenting what it called "photographs which have a pathetic interest in the time of our great mourning." The spread included photographs of three McKinley "lasts": the last funeral McKinley attended (in Ohio, during the previous year); McKinley's "last trolley-ride," the morning of the shooting; and McKinley's "last view of the falls of Niagara—taken early on the afternoon of the day he was shot."[95] *Collier's* published a two-page spread that included a page of photographs of McKinley speaking in public, captioning the feature "Last Speeches of President McKinley." Shifting emphasis from the timing of the shooting to McKinley's own personal experiences, these kinds of photographs invited readers to contemplate McKinley's final public activities. Such images delivered what *Frank Leslie's* termed "pathetic interest," because the viewer knew what McKinley himself did not know: this was the last time he would do these activities. While the moment of the shooting still loomed large, these "last" photographs were distinctive for the way they invited the viewer to consider the president's own personal experiences.

Magazines and newspapers published several photographs whose captions emphasized that the president authorized them. *Frank Leslie's* declared that its "special photographer" made "the last photograph taken at the request of President McKinley."[96] Similarly, a photographer named Smith of Niagara Falls, New York, captioned three different images of McKinley as the "Last Photograph of President McKinley by his own permission." (See fig. 5.2.) It is not necessarily clear whether these photographs were in fact made with McKinley's explicit permission; they seem to be snapshots the photographer

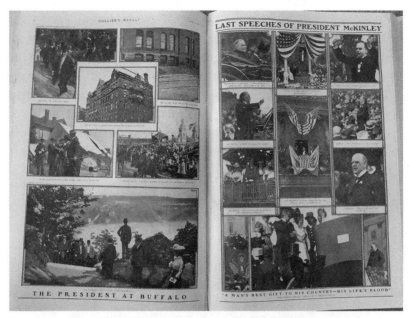

Figure 5.6: "The President at Buffalo/Last Speeches of President McKinley," *Collier's*, Sept. 21, 1901, 6–7.

grabbed as the president was leaving or arriving for lunch at the International Hotel in Niagara Falls on the day of the shooting. Regardless of the facts, the choice to emphasize that photographs were made by McKinley's "request" or with his "permission" should be understood in the context of cultural anxieties about camera fiends. Especially in light of the president's death, editors or sellers of photographs would want to reassure potential readers, viewers, and purchasers of McKinley images that they were not stolen by a stealthy camera fiend. Other, obviously official, images emphasized in their captions that they had been sanctioned; for example, a Frances Benjamin Johnston photograph of McKinley made at the government building the day before the shooting was captioned the "last portrait" of McKinley, emphasizing his choice to consent to and pose for a photograph.[97]

By far the most frequently published images of McKinley's last acts recognized his last speech, delivered on September 5 on the Pan-American Exposition grounds. These photographs depict his final, formal public act as president, the last time he would speak directly to the people. Before radio, television, and the internet, presidents relied on the bully pulpit for communication with citizens. McKinley's speech thus constituted an important final statement on the state of the nation and his ideas about the role of the

United States in the world at the dawn of the twentieth century.[98] Photographs made of McKinley during that speech came to stand more broadly for his beliefs and values as president and therefore those of the nation. All the illustrated news outlets published at least one (often more than one) image of McKinley's "last speech."[99] In a special section of "souvenir pictures of the president," the *Illustrated Buffalo Express* told readers, "Of the portraits of President McKinley, especial attention is directed to the one showing him as he stood in the Esplanade on September 5th, delivering his memorable

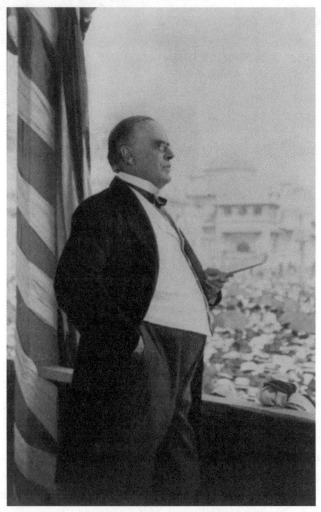

Figure 5.7: Frances Benjamin Johnston, "William McKinley delivering his last address, Buffalo, N.Y., Sept. 5, 1901." (Library of Congress.)

address."[100] Even the *Buffalo Medical Journal*'s October 1901 issue, which discussed the medical issues surrounding the president's shooting and ill-fated recovery, published a photograph of McKinley's speech, captioning it "And thus he began his last speech!"[101] All of the photographs of McKinley's "last acts," but especially those of his last speech, invited viewers into the experience of McKinley's final public activities as president and highlighted both his personal and presidential agency.

Because of their connection to a timely, dramatic news event, McKinley's last photographs quickly became lucrative commodities. In *Collier's*, *Illustrated Buffalo Express*, and other outlets, photo credit was given to photographers such as Frances Benjamin Johnston and O. E. Dunlap, who sold their images of McKinley in Buffalo to these publications.[102] Johnston's skillful handling of her McKinley photographs offers an illustrative example of the post-assassination photographic economy at work. Johnston's photographs of McKinley's last speech got particular play largely because of her unique access as McKinley's personal photographer. Three of her "last photographs" received broad circulation after the shooting: her photograph of McKinley giving his September 5 address, a photograph of McKinley posing with advisers and other attendees at a reception at the government building on the day before he was shot, and a photograph of McKinley and his press secretary, George Cortelyou, in a carriage on the way to the fateful reception at the Temple of Music. Published with captions declaring "Copyright by Frances Benjamin Johnston," the photographs made clear Johnston's claim on the images and granted her prominence as McKinley's specially selected, privileged observer. Johnston sold one McKinley image to the *Illustrated Buffalo Express* for fifteen dollars, a surprisingly high fee for the time.[103] In the days after the shooting, the *Illustrated Buffalo Express* published four of Johnston's photographs.[104] According to Bettina Berch, "Her whole sequence of McKinley photographs suddenly became valuable, as newspapers and wire services vied for the right to reproduce the last images of the president. Johnston's mailbox filled with requests from common people for copies."[105] Johnston also sold prints of her "last speech" photo to average citizens who wrote to request them.[106] The "last speech" photograph, in particular, achieved wide circulation, eventually becoming the model for a statue of William McKinley erected at his memorial site in Canton, Ohio.[107] Johnston appears to have maintained boundaries around her entrepreneurship, however. Several weeks after the shooting, Kodak contacted her for permission to use a Johnston photograph of McKinley in its advertising, because they knew she had used

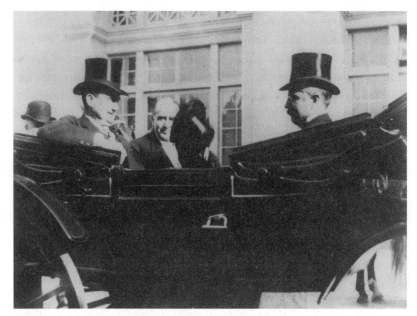

Figure 5.8: Frances Benjamin Johnston, "The last photo ever taken of President McKinley, at Buffalo, N.Y., with John G. Milburn and George B. Cortelyou, on his way [in carriage] to the Temple of Music where he was fatally wounded on Sept. 6, 1901." (Library of Congress.)

one of their cameras. Johnston turned down the offer, though it is unclear whether she was more concerned about exploiting the former president's death or damaging her reputation as an artist by admitting to the use of an "amateur" camera.[108]

By copyrighting their images and charging for their use, photographers like Johnston recognized both the literal and figurative value of the new timely news photograph. Photographers not only protected their work in light of the photographs' status as lucrative commodities in the wake of the president's death but also ensured that their work would live on as historical documents. That Johnston's images from Buffalo live on today in the Library of Congress archive with their captions of "last" intact suggests the historical value the photographs continue to hold as news images of a presidential assassination—even one that wasn't actually photographed by a camera.

Last Photographs and the Visual Value of Timeliness

The complicated story of McKinley's last photographs exemplifies the dramatic changes photography had undergone by the beginning of the

twentieth century. While one could still pose or sit for formal portraits, photography had been taken to the streets in more ways than one. Amateur, handheld cameras put photography into the hands of the masses, which put more cameras in more public places. News photography increasingly put photographs into the pages of newspapers and magazines and, by extension, out onto the streets in print. In this time of mass circulation of photography in every form, the dramatic moment of the McKinley assassination should have been the pinnacle of the new timely photography. With cameras everywhere in public and pictures everywhere in print, this huge news event was ripe for exploiting the possibilities of the timely image. But the assassination is notable for the failure of the new timely photography to capture the ultimate "prize" of an image of the president being shot. Though photographers and editors offered pictures of nearly everything else, photography could not at that moment live up to the demands of the new visual value of timeliness.

Given the absence of photographs of that single moment, the mad scramble for McKinley's last photographs makes sense. As much about upholding photography's new visual value of timeliness as it was about memorializing the slain president, the obsession with his last photographs reveals the new power the timely photograph had brought to the culture by the dawn of the twentieth century—even if that new power was not yet fully realized.

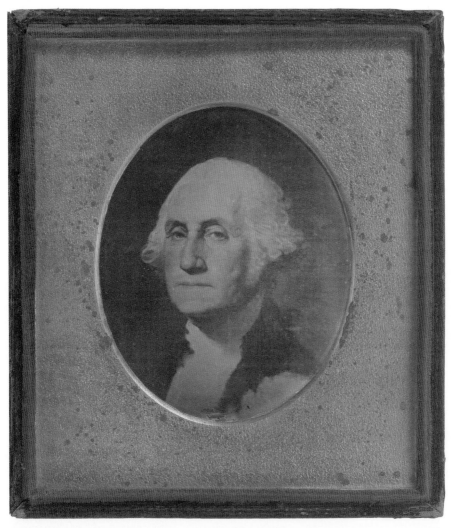

Plate 1 (Figure 1.1): John Adams Whipple, daguerreotype of portrait of George Washington by Gilbert Stuart, 1847. (National Portrait Gallery, Smithsonian Institution; gift of Helen Hill Miller.)

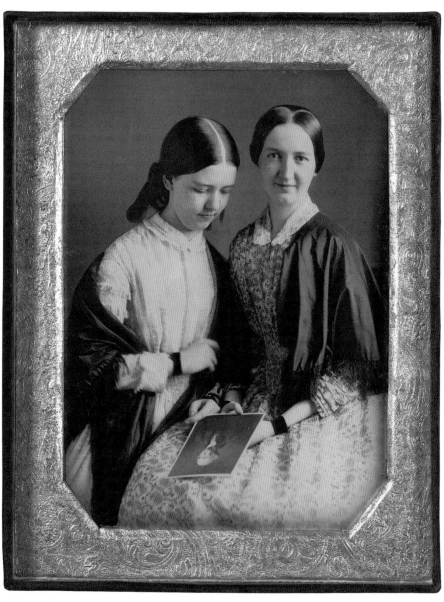

Plate 2 (Figure 1.3): Unknown maker, American mother and daughter with print of George Washington, ca. 1845–1848. Daguerreotype, half-plate, 5 1/2 x 4 1/2 inches (14 x 11.4 cm). (Nelson-Atkins Museum of Art, Kansas City, Missouri; gift of Hallmark Cards Inc., 2005.27.70. © Nelson Gallery Foundation. Image: Thomas Palmer.)

Plate 3 (**Figure 1.6**): George P. A. Healy, Dolley Madison with two presidents on the south portico of the White House, 1846–1847. (Courtesy of George Eastman Museum.)

Plate 4 (Figure 2.2): Philip Haas, daguerreotype of John Quincy Adams, March 1843. (National Portrait Gallery, Smithsonian Institution. Acquired through the generosity of the Secretary of the Smithsonian and the Smithsonian National Board, the Burnett Family Fund, Carl and Marilynn Thoma, Connie and Dennis Keller, Tim Lindholm and Lucy Gaylord Lindholm, Mr. and Mrs. John W. McCarter Jr., Mr. and Mrs. Ronald J. Gidwitz, Ellen G. Miles and Neil R. Greene, Ronnyjane Goldsmith, David D. Hiller, Richard and Janet Horwood, and Mary Martell.)

Plate 5 (Figure 3.2): Auguste Edouart, silhouette of John Quincy Adams, 1841. (National Portrait Gallery, Smithsonian Institution; gift of Robert L. McNeil Jr.)

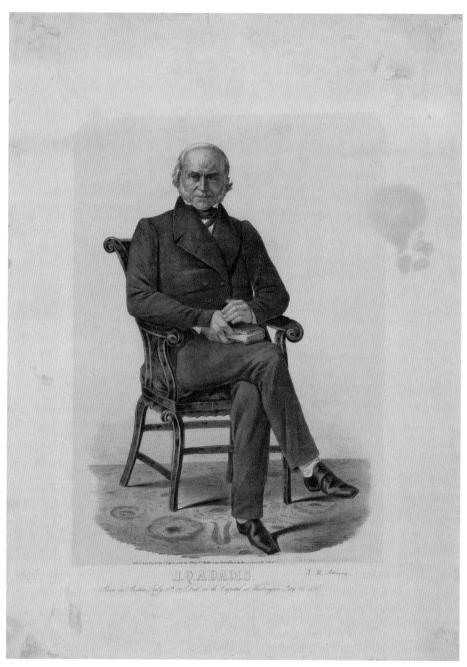

Plate 6 (Figure 3.5): Benjamin Franklin Butler, lithograph of John Quincy Adams after Haas lithograph, 1848. (National Portrait Gallery, Smithsonian Institution.)

Plate 7 (Figure 4.1): Mathew Brady, Abraham Lincoln, candidate for U.S. president, before delivering his Cooper Union address in New York City, 1860. (Library of Congress.)

Plate 8 (Figure 5.2): Smith, "The Last Photograph of President McKinley, by his own permission. Taken at the International Hotel, Niagara Falls, N.Y.," 1901. (Library of Congress.)

14559, Anxious to get a peep at the President, Pan American Exposition.

Plate 9 (Figure 5.3): B. W. Kilburn, "Anxious to Get a Peep at the President. Pan American Exposition," 1901. (Library of Congress.)

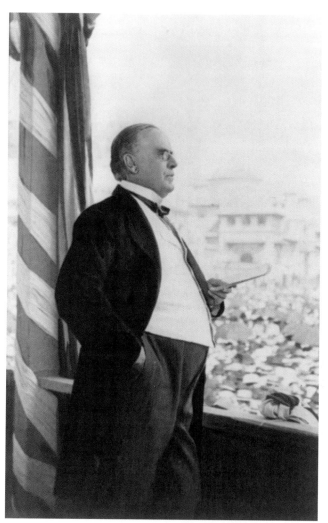

Plate 10 (Figure 5.7): Frances Benjamin Johnston, "William McKinley delivering his last address, Buffalo, N.Y., Sept. 5, 1901." (Library of Congress.)

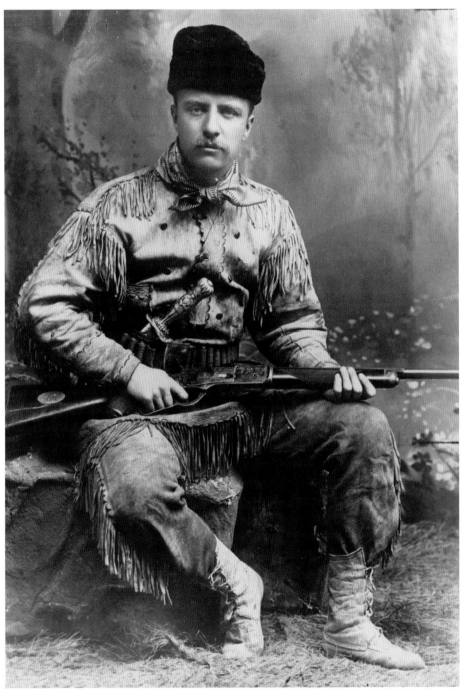

Plate 11 (Figure 6.1): George Grantham Bain, portrait of Theodore Roosevelt, 1885. (Library of Congress.)

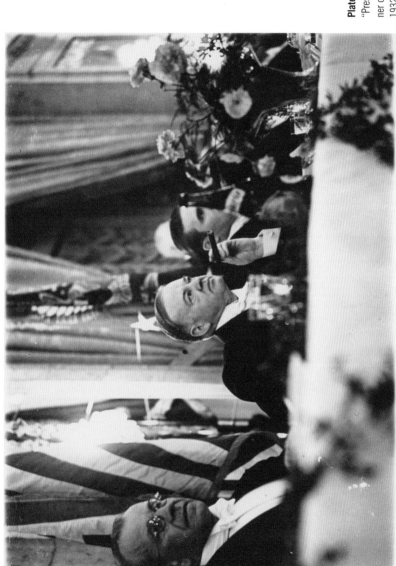

Why the Candid Camera Was BARRED from the WHITE HOUSE

This is the picture that caused many newspaper readers to inquire about the President's health.

by ROSA REILLY

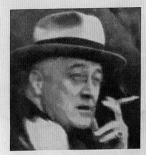

Another candid shot taken during the season's opening baseball game which made the President appear ill.

POPULAR PHOTOGRAPHY'S special correspondent investigates the controversy as to why the miniature camera was barred from use in photographing the President.

THE candid camera is certainly *non grata* in political circles. Months ago, Stephen Early, Press Secretary at the Executive Mansion, barred the minicam from Washington. And more recently, Mr. Early placed a month's ban —which was later reduced to a few days —on two press services because of the

Jefferson Island photographic fracas.

You all recall the melee which followed the Democratic love feast on Jefferson Island, where, in the early summer, Mr. Roosevelt and his followers gathered to relax under the trees and renew political friendships.

Here some unconventional photographs were taken and distributed — pictures which showed the President and his friends in shirt sleeves with handy glasses at their elbows.

POPULAR PHOTOGRAPHY has endeavored to sift the rumors which flew around after this occurence from the truth. The facts in the case are these:

According to R. P. Dorman, General Manager of the Acme News Pictures, Inc., his service and the three other major news syndicates asked for permission to send photographers to Jefferson Island to cover the political picnic. This request was refused, with the result that no photographers attended.

The world was naturally astounded, therefore, to see a few days later four or five pictures of Mr. Roosevelt and his Senators and Congressmen enjoying themselves on Jefferson Island.

The pictures were released by Acme and the Associated Press although they had had no cameramen on the Island.

Where did the pictures come from? Who took the photographs?

Well, the talk around New York and Washington is that several Congressmen or Senators took the unconventional pho-

tographs—which weren't really so unconventional after all—and turned them over to Acme and the Associated Press.

Those in the pictorial "know" also are snickering in their sleeves because they say Acme and AP thoughtfully provided certain of the nation's representatives with photographic equipment so that they could take adequate pictures.

Whether that is true or not cannot be verified. However, some abdominal laughter has been had all around. The President enjoyed himself with a fair

Ammonia - sensitized film enabled newshawk McAvoy to get these candid shots of the President at his desk. Contrary to rumor the pictures in themselves had nothing to do with the candid camera ban.

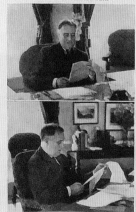

Distribution of these pictures taken by Congressmen caused AP and Acme a bit of trouble.

Plate 13 (Figure 7.8): "Why the Candid Camera Was Barred from the White House," *Popular Photography*, Oct. 1937, 13.

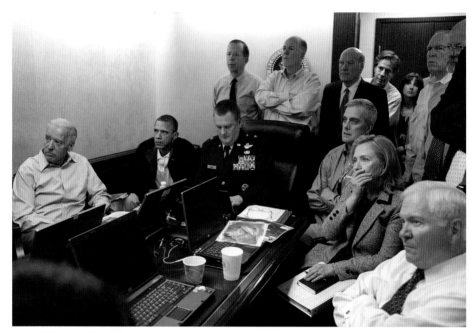

Plate 14 (Figure 9.1): Pete Souza, "President Barack Obama and Vice President Joe Biden, along with members of the national security team, receive an update on the mission against Osama bin Laden in the Situation Room of the White House, May 1, 2011." (Official White House photo via Obama White House Flickr photostream.)

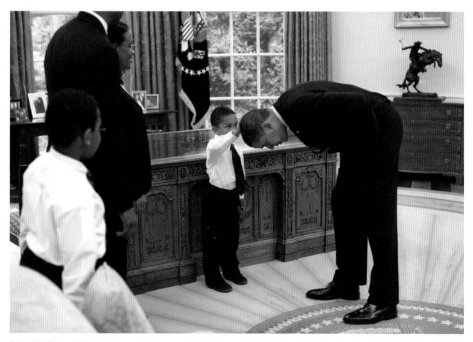

Plate 15 (Figure 9.2): Pete Souza, "A temporary White House staffer, Carlton Philadelphia, brought his family to the Oval Office for a farewell photo with President Obama," May 8, 2009. (Official White House photo via Obama White House Flickr photostream.)

Plate 16 (Figure 9.6): Pete Souza, "President Barack Obama poses for a photo with a patron at Jerry's Family Restaurant, a diner in Mount Pleasant, Iowa," April 27, 2010. (Official White House photo via Obama White House Flickr photostream.)

The Candid Camera Presidents

The Length-Change Transients

Visual News in the Early Twentieth Century

A week after he became president of the United States, Theodore Roosevelt had a public run-in with an amateur photographer in Washington, DC. The *Buffalo Courier*—still very much on the case in the weeks after McKinley's death—reported it on the front page under the headline "CAMERA FIEND REBUKED BY PRESIDENT: Roosevelt hotly resents an attempt to 'snap' him as he leaves church." The story went like this: A young man stood outside the church waiting for the president to emerge, getting his camera in just the right position to photograph the president as he exited. As the *Courier* told it, "Mr. Roosevelt took in the situation as he emerged from the church door. A signal to a policeman and the broad blue back of the officer of the law was before the camera and probably exposed plate. As the President passed the offender he said to him slowly and with considerable force: 'It is a despicable thing to take a man's picture as he is leaving the church.'" Presumably this particular young man was not alone, for the writer then added, "This little incident deterred other camera 'fiends' from leveling their instruments at the President, as with a long, swinging stride he walked down the street."[1]

Theodore Roosevelt maintained few boundaries where cameras were concerned. On this occasion perhaps he was simply surprised and irritated

by the intrusion of the public on what he thought was a private outing. Or, given that it was only weeks since McKinley had been shot in public, the new president might have been unnerved by the approach of strangers with unknown objects in their hands. Yet even as he reportedly "rebuked" and "resented" the cameras of the amateurs, Roosevelt was no stranger to photography's power to build a public image. In 1884, not long after losing both his mother to typhoid and his wife in childbirth on the very same day, a grieving Roosevelt left New York and headed west to his cattle ranch in the Dakota Territory, where he visually reinvented and publicly styled himself as a frontiersman.[2] Portraits made to coincide with the publication of his 1885 book, *Hunting Trips of a Ranchman*, illustrated the transformation. The photograph presented Roosevelt, without his trademark spectacles, dressed in buckskin, wearing a beaver-skin hat, and carrying a Winchester rifle.[3] (The knife tucked into his belt came from Tiffany and Co.[4]) Roosevelt's visual reinvention resulted from real personal changes in his life and outlook. But Ronald Tobias writes that it also "played a critical role in defining his political persona. He loved the camera, and the camera loved him: his persona filled the screen."[5] Roosevelt continued to be deeply invested in his public image throughout the rest of his life.

Roosevelt also recognized the value of the camera as a tool for the public communication of ideas that were important to him, such as conservation and social reform. Though he was not fond of the camera fiends who stalked him, he had no problem with using the camera to stalk animal prey. Roosevelt advocated for the practice of "camera hunting," the activity of photographing wild animals in their natural habitats. Grounded in the idea that hunting with a camera produced the same heightened masculine experience as hunting with guns, camera hunting served as way for Roosevelt to promote public interest in wildlife conservation.[6] Back home on the East Coast, Roosevelt became head of the New York City Board of Police Commissioners. There, his understanding of the camera's power to convey visibility led him to befriend social reformer Jacob Riis, a journalist and activist who used his camera to document the city's poorest citizens and share his findings in vivid public presentations.[7] Roosevelt read Riis's 1890 illustrated book, *How the Other Half Lives*, and was so moved that he wrote to Riis with offers of help. Roosevelt later joined Riis on a few of his expeditions through the city and the two became friends.[8]

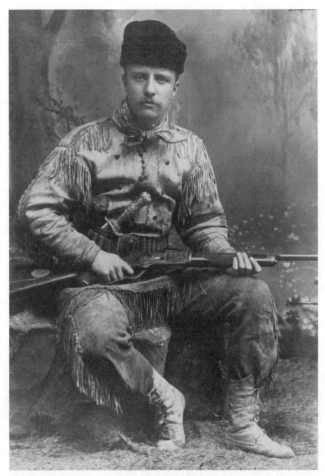

Figure 6.1: George Grantham Bain, portrait of Theodore Roosevelt, 1885. (Library of Congress.)

By the time Theodore Roosevelt inherited the presidency, he was a skilled visual communicator who relied on the camera to construct his political image and recognized the power of the camera to advance his policy agenda. But as the run-in with the camera fiends at church made clear, the new visual values of timely photography often clashed with evolving public norms of decorum. By the time his cousin Franklin ascended to the presidency thirty years later, camera fiends had hardly gone away. In fact, they now wielded new cameras that could make more photographs faster

and less conspicuously. The period between the Roosevelts saw the rise of professionalized visual news and the emergence of more formalized relationships between the White House and the press. Changes in news-gathering techniques, circulation of photographs, and cameras themselves shaped presidents' abilities to get their policy messages to the public.

Photography between the Roosevelts

By the turn of the twentieth century, what Ulrich Keller has called the "constitutive elements of photojournalism" were largely in place.[9] In the years between the Roosevelts, new cameras transformed the production of photographs, new modes beyond the halftone became central to the reproduction of photographs, and photo agencies amplified the circulation of photographs. These three ingredients combined to provide the public with lively and timely visual news.

The rise of photographic reproduction in newspapers ushered in the idea that photography provided readers with not just timely but instant access to news. While instant access was rarely the case, because visual news gathering was only in its infancy, during this period journalism grew increasingly invested in the *narrative* of instantaneousness. Jason Hill points out that it was not the photograph's actual "capacity to freeze an instant" that made photography seem instantaneous so much as it was the institution's "ability to reduce the delay between an event and its newspaper public."[10] That is, the photograph became an important element of news not necessarily because of what it showed but because of how the structure of journalism framed photography.[11] Photojournalism's ethos of instantaneousness came not from freezing a newsworthy moment but from getting photographs of that moment to the public as quickly as possible.

Photographic news agencies served as vehicles for the quick delivery of those newsworthy visual moments. George Grantham Bain was a journalist, writer, and friend of William McKinley who created one of the first photo agencies to provide newspapers and magazines with newsworthy images.[12] Bain recognized the increasingly important role of photographs in newspapers and magazines, and by 1898 he had established the George Bain News Service to provide photographs to news outlets.[13] News agencies themselves had been around since the mid-nineteenth century, but an agency specifically designed for the distribution of pictures was a new idea.[14] Building on Bain's success, other agencies soon emerged.[15]

While pictures became increasingly important as visual news, newspapers and magazines also needed better ways of printing and displaying those photographs. As discussed in chapter 5, halftone photographs were ubiquitous in newspapers and magazines by the turn of the twentieth century. But they often suffered from poor reproduction and had to be presented together on a separate page, apart from the actual story.[16] The introduction of processes such as rotogravure eliminated this problem by allowing for photographs, text, and other visuals to be printed together on the same plate.[17] Produced on round cylinders that used not the dots of halftone but a screen that allowed for a greater variety of tones, rotogravure made it possible to print more photographs of better quality and to do so affordably.[18] During the 1910s, U.S. newspapers began to introduce special rotogravure sections, called "rotos," to attract readers with interesting pictures. The *New York Times*, for example, introduced a regular roto section called *Mid-Week Pictorial* in 1914 (it was later revived as its own picture magazine in the mid-1930s).[19] The rotos did not practice the polished narrative photojournalism found later in mass magazines of the 1920s and '30s.[20] Instead, the reader often encountered densely populated, chaotic layouts containing a dizzying mix of images and topics.[21]

Even so, rotogravure sections remained popular well into the next two decades, and dozens of U.S. newspapers included rotogravure sections in their Sunday issues.[22] Not surprisingly, the demand for pictures grew when celebrities and other public figures appeared in them. For example, when President Warren Harding died while visiting San Francisco in 1923, *Mid-Week Pictorial* ran fifteen pages of photographs.[23] By the 1920s and early 1930s, European magazines had fully embraced the capacity of photogravure and rotogravure, publishing sophisticated and visually complex designs.[24] From World War I until the 1930s, photo magazines and newspaper roto sections brought a new energy to the visual field of news.

Cameras continued to transform during this period. Kodak dominated the amateur camera market. Despite the presence of dozens of other camera manufacturers in the United States, Kodak most successfully exploited the value of selling not just cameras but the dream of photography as well.[25] In the early years of the twentieth century, Kodak heavily marketed itself to travel, tourism, and women's magazines.[26] Kodak advertising targeted women, children, and families with newfound leisure time, the company designing not only the cheap Brownies discussed in previous chapters but also more expensive amateur cameras like the Kodak Vest Pocket, which

offered both the high image quality and portability that camera-happy families required.[27] The continued improvement of portable cameras meant the persistence of anxiety about camera fiends as the culture continued to wrestle with concerns that smaller amateur cameras might record strangers' activities unawares.

For the most part, professional photographers who made the kinds of news photographs sold by agencies like Bain's did not use these smaller cameras. Their jobs required different instruments. The first of the press cameras, the Press Graflex, appeared in 1908, produced by a subsidiary of Kodak. But it was a later Graflex, the Speed Graphic, that became famous.[28] Introduced in the United States in 1913, the Speed Graphic became the go-to camera for photographers needing to capture the busy world of spot news.[29] The Speed Graphic offered multiple viewfinders, two shutters, and allowed the user to change lenses, which provided photographers with flexibility in their picture-taking.[30] Yet the process was no point-and-shoot affair. The Speed Graphic used sheets of film loaded into the camera using film holders, and only a few sheets could fit into a camera at one time. Because the photographer was limited by the amount of film that could fit into the camera, use of the Speed Graphic required the photographer to work accurately and quickly.[31] All told, the camera's operation required the photographer to perform a sequence of four or five discrete steps to make a single photograph and then get ready to make the next one. While a skilled photographer could work fast, the camera itself was comparatively slow and bulky; the camera, flash gun, and holder together weighed just over nine pounds.[32] Even so, news photographers valued the versatility of the Speed Graphic, keeping it as their primary press camera from the early twentieth century well past the introduction of 35 mm photography and on into the 1950s.

Presidents Engage Photography in the Early Twentieth Century

Photography between the Roosevelts was marked by increased interest in visual images as news, wider circulation of photographs across print culture, and better, livelier reproductions of photos themselves. Americans saw and made more photographs than ever before. As photography neared its centenary, the presidency changed along with it. In the nineteenth century, national power was presumed to lie with Congress, not with the executive branch. As a result, the press filled press galleries and back rooms at the U. S.

Capitol, while the White House offered no space to reporters.[33] That began to change near the turn of the twentieth century. Historians and political scientists have chronicled the rise of the "modern presidency," which they describe as involving an increase in the size of the White House staff and the addition of administrators to manage it, more formalized relationships with Congress, a rise in the power of the president, and a new interdependence between the executive branch and media organizations.[34] Though scholars have disputed when precisely the modern presidency emerged, the consensus places its origins in the presidency of William McKinley, who, as we saw in chapter 4, embraced motion pictures and other new media, professionalized the staffing of the White House, and collaborated with photo agencies and photographers like Frances Benjamin Johnston to construct his presidential image. McKinley's secretary, George Cortelyou, who stayed on after the assassination to work briefly in the same capacity for Theodore Roosevelt, arguably should get much of the credit for these early transformations, the core of which remained in place for decades thereafter.[35] Lewis Gould dates the rise of the modern presidency to the years between 1897 and 1921, when the executive branch grew in power during the presidencies of Theodore Roosevelt and Woodrow Wilson.[36]

This growth was especially true in the case of these two presidents' relationships with the press. Roosevelt was the first president to offer a permanent space to reporters covering the White House.[37] He made sure that journalists covering him on trips got good access to him and his events—though to gain access they had to get (and stay) on the sometimes volatile man's good side.[38] As the first celebrity president of the twentieth century, Roosevelt knew the value of his fame.[39] George Juergens writes of Roosevelt, "Publicity was so essential to his style of leadership that he worked constantly to generate it."[40] Roosevelt adeptly manipulated the press through what today are recognized as standard presidential public relations strategies, such as leaks, trial balloons ("floating" policy ideas into the press to gauge public support), carefully planning the release of information, and staging news events for cameras.[41] Less fond of the press than was Roosevelt, Woodrow Wilson nevertheless instituted regular press conferences. In addition, during his administration the White House Correspondents' Association was formed to serve as an organizational bridge between the media and the presidency and in recognition of the fact that the press itself was becoming more professional and institutionalized.[42]

From Theodore Roosevelt through to Taft, Wilson, Harding, and Coolidge, all presidents during this period had to deal with the sometimes unwelcome intrusions of the press photographer. Individual presidents varied considerably in their willingness to pose for photographs or participate in events staged for the cameras. As a result, presidents and their handlers had their own rules about what, who, where, and when photographers could photograph. In the story that opened this chapter, in which President Theodore Roosevelt angrily chastised a young "camera fiend" for photographically accosting him outside of church, the young man with the camera stood accused of stepping across a boundary that he perhaps did not know was in place. Another story about a violation of unwritten rules of photographic decorum came from the pre-presidency of Woodrow Wilson. Just after his election in 1912, Wilson and his family vacationed in Bermuda, where reporters followed along and sought to catch a few words and images of the president-elect. As Wilson and his teenage daughter Jessie returned from a morning of activity on their bicycles, they discovered members of the press camped out on their doorstep. Disheveled from their ride, Wilson asked photographers not to photograph his daughter, reportedly pleading, "Gentlemen, you can photograph me to your heart's content. I don't care how I look. But I request you not photograph my daughter. You know how women feel about such things."[43] Yet at least one photographer refused the president-elect's request. According to New York Times writer Charles Willis Thompson, who chronicled (and perhaps embellished) the incident in his memoir, "Before he [Wilson] could finish the sentence, a cad of a photographer aimed his camera at Jessie Wilson and snapped her." What happened next was dramatic: "Wilson's face turned the color of a strawberry, and the high flush mounted to his eyes. . . . He clenched his fists and rushed on the photographer with the certain intention of punching his head." Catching himself in an impulsive moment of imprudence, the president-elect slung angry words instead: "You're no gentleman!" he cried. "I want to give you the worst thrashing you ever had in your life; and what's more, I'm perfectly able to do it!"[44] The president-elect walked off without following through on the threat, but the incident made news back in the states. The next day, the New York Times published a brief, less detailed piece on the incident with the headline "Wilson Threatens to Beat Camera Man."[45] Having named a firm boundary he did not want photographers to cross, Wilson snapped when the "ungentlemanly" photographer "snapped" his daughter.

As the necessity to pose for the press became more commonplace, presidents made decisions about where to draw the line. One general boundary was drawn around the president's family. While Roosevelt took advantage of his celebrity, he asked that photographers leave his young, energetic family alone.[46] Yet, true to his character, Roosevelt also understood the value of a good picture under controlled circumstances. Rodger Streitmatter notes that "many of Roosevelt's personal activities may have been staged for their publicity benefit," including, ironically, a presidential meet-and-greet with fellow churchgoers after services near his New York home of Sagamore Hill.[47] Streitmatter also claims that Roosevelt may have been the first president to participate in a modern photo opportunity. The president had apparently arranged for a photographer to cover his signing of a Thanksgiving proclamation. When the photographer arrived late, Roosevelt left a meeting with the secretary of state so that he could pose for a photograph of the signing, essentially delaying the work of the presidency for a photo op.[48] Even after he left the presidency, Roosevelt continued to weigh in on issues of image politics. For example, he told President Taft that he should not allow himself to be photographed playing golf, "a rich man's game," for it would fuel the public's impression that the president was not a true man of the people. Roosevelt offered Taft his rules for presidential posing: "photographs on horseback, yes; tennis, no. And golf is fatal."[49] Golf photos or not, Taft rejected the press more generally. Although he was the first president to hold a press conference, he abandoned them soon after and largely hid from the cameras.[50]

Wilson did not welcome photographers. In addition to the incident in Bermuda, he had also threatened to fire his Secret Service head if anyone snuck through to snap a photo of Wilson and new wife, Edith Galt, on their honeymoon. Yet his administration was not above using photography for its own advantage.[51] After his stroke in 1919, Wilson removed himself from the public eye while photographers sought in vain to snap a picture of the recovering president.[52] Months later, under increasing pressure, the White House brought in a photographer to make a photograph of the president at his desk (with his wife by his side) so that Americans could be assured the president was on the job. The resulting photograph arguably showed the opposite, as the first lady appears to be steadying a document the president is reviewing, suggesting not his strength but his infirmity.[53]

The presidents of the 1920s were more willing to pose. A newspaperman himself, Warren Harding generally exhibited warmth toward the press. He affably posed for news photographers and embraced both news photography and newsreels.[54] During the campaign, Harding's staff advocated for the value of up-close, seemingly informal shots of the candidate and his wife, sending out thousands of photo releases and putting ads on billboards and in magazines.[55] After the candidate took office, photographers received lists of Harding's daily events and good access to the president.[56] Furthermore, Harding seemed happy to pose. Stephen Ponder writes, "Taft and Wilson regarded posing for photographers as burdensome and submitted reluctantly. Harding, however, cheerfully walked out into the White House garden to be photographed or filmed with the visitors of the day, whether they were Boy Scouts, Girl Scouts, golfers, printers, delegations from service clubs, or even Albert Einstein."[57] As presidents made themselves more visually accessible, more photographers began to cover the White House. The White House News Photographers Association was formed in 1921 to formally authorize those photographers who could have access to the president.[58]

Rising to the presidency after Harding died, and then elected himself in 1924, Calvin Coolidge similarly embraced photography.[59] One journalist recalled, "He avoided every appearance of publicity seeking, but he probably

Figure 6.2: National Photo Co., "President Harding with pet dog, Laddie, being photographed in front of the White House," June 1922. (Library of Congress.)

was the most photographed man who ever occupied the White House."[60] Coolidge walked a fine and often fuzzy line of presidential decorum. On the one hand, he seemed willing to appear in public in ways that some might deem unpresidential. For example, Coolidge liked to dress up. He infamously wore a headdress while addressing members of the Lakota tribe and dressed as a cowboy (complete with chaps) at a Fourth of July celebration in South Dakota. He received criticism for such displays. One journalist wrote, "Certainly no president has ever been willing to submit to such nauseating exhibitions in the news reels as has Coolidge. . . . Cultured Americans wince at the thought of their president putting on a smock frock to pose while pitching hay and milking a bossy."[61] Despite Coolidge's willingness to pose in ways that some deemed imprudent, he worked to avoid the impression that his photo ops were in fact photo ops. The *Boston Globe* explained Coolidge's unwritten rules in a May 1929 article headlined "Mustn't Photograph Coolidge While He Is Posing for Another." Explaining the now former president's "indignation" that a newsreel operator recorded Coolidge posing for photographers, the *Globe* pointed out that the unwitting man had violated a rule that presidential photographers knew well: "Calvin Coolidge must not be photographed in such a way as to show that other photographers were taking his picture at the same time." Even though the former president's "patience has been seemingly limitless in his compliance with every request of the news photographers," the *Globe* wrote, Coolidge did maintain some boundaries. The president did not like "to be taken unaware."[62] While Coolidge was more than willing to participate in staged photo ops, he was not interested in

Figure 6.3: Rise Studio, "President Coolidge in cowboy outfit, Rapid City, South Dakota," 1927. (Library of Congress.)

having the fact of those photo ops themselves become part of the story. That would be indecorous.

Calvin Coolidge decided not to run for reelection in 1928, paving the way for the landslide election of fellow Republican Herbert Hoover. The man who had been solicitous to photographers and embraced the new media of radio and film—Coolidge delivered the first presidential speech on the radio in 1923 and became the first president to appear in a sound film in 1924—retired from public life just as a new form of photography was ascending in Europe.[63] The so-called candid camera would introduce new visual values to photography that would transform the possibilities for picturing political leaders and challenge the already tenuous space between public and private for both Hoover and Franklin Delano Roosevelt after him.

Herbert Hoover, Franklin Roosevelt, and the Candid Camera

What came to be known as candid camera photography appeared on the scene beginning in the late 1920s, made possible by smaller, more portable cameras that were capable of producing intimate photographs of seemingly unguarded subjects. Variously called "miniature" or "mini" cameras, "hand cameras," or "candid cameras," these small devices allowed photographers to make images of political leaders in a whole new way. Stiff group poses illuminated by obtrusive, exploding flash power could now be replaced by close-ups of diplomats conversing in the quiet corners of meeting rooms or laughing over drinks at the hotel bar. Tapping into some of the same cultural anxieties that emerged after the introduction of amateur cameras in the late nineteenth century but amplifying and expanding them, miniature cameras transformed how photography depicted political leadership and deliberation.

When Herbert Hoover and Franklin Roosevelt encountered the candid camera, they found themselves face-to-face with new visual values that clashed with fragile norms of photographic decorum that had developed since the beginning of the twentieth century. The candid camera brought to the political sphere new visual values of access, intimacy, and energy. These new and seemingly democratic values reframed and, in some cases, collided

with presidents' investments in their political image. And they challenged the public's beliefs about how political leaders should be pictured. In the United States in the late 1920s and '30s, presidents Herbert Hoover and Franklin Roosevelt regularly grappled with, sometimes submitted to, and ultimately were forced to reckon with the candid camera's ways of picturing politics. An exploration of their encounters with the candid camera invites attention to a key period when norms of visual decorum were actively being renegotiated, with implications for both presidents and photographers. The Washington, DC, visits of pioneering German photographer Erich Salomon, known for his skill with the candid camera as "king of the indiscreet," serve as the backdrop for this chapter's discussion of Herbert Hoover. Salomon photographed Hoover twice, the first time by invitation at the White House and the second time at a White House Correspondents' Dinner, where the president was unaware that he was being photographed. Hoover's brief en-counters with Salomon's candid camera—and the ensuing public discussions of Salomon's photographic practices—embodied the tensions inherent in this new mode of photography. The potential intrusiveness of the candid camera offered a seemingly more significant threat to Franklin Roosevelt, who with his advisers sought to limit the visibility of his disability. Although FDR's well-documented investments in "hiding" the extent of his disability have received most of the attention from historians, his relationship with photography was about more than fear of disability disclosure. Unlike Hoover, Roosevelt embraced the same visual values that made the candid camera so popular in the 1930s, though he did so in ways that sought to limit the impact of the candid camera on his political image. In a period when photography increasingly livened coverage of political discourse, the candid camera gave viewers insights into politics in ways previously invisible to them. Yet it also posed risks for politicians needing to adapt to changing assumptions about what was private and what was public.

The Rise of the Candid Camera

In November 1937 *Forum and Century* magazine published an article chronicling the history of candid camera photography. The article's author designated 1928 as the transformative year in which a new kind of photography emerged. Compared to what had come before, the new candid cameras were like an "express rifle had been substituted for a pea shooter."[1]

If photojournalists' old, reliable Speed Graphics were the pea shooters, then the new cameras that first became widely available in Germany in the 1920s were the express rifles. Handheld with fast shutter speeds and a fast lens, cameras like the Ermanox and the Leica were so small compared to the Speed Graphic as to be hardly noticeable, even when mounted on a tripod. Like the Speed Graphic, the Ermanox used sheet film that required frequent loading and unloading. But its portable size and speed made it a very different camera. Advertised with the slogan "What You Can See You Can Photograph," it surmounted technical limitations of larger, slower cameras, making it easier to make photographs using only available light. The Leica appeared on the market alongside the Ermanox in 1924. It originally had been developed before World War I in order to test movie film, but those experiments had to be shelved during the war.[2] The Leica later found its own fame as a still camera. With the same fast shutter speeds and lenses as the Ermanox, but using 35 mm roll film that allowed the photographer to make multiple exposures in quick succession, the Leica quickly became a top-selling "miniature" camera. Production numbers illustrate its popularity. In 1927 one thousand Leicas were manufactured; by 1933 that number was one hundred thousand.[3] It was one of the earliest and most popular 35 mm cameras, a format that dominated photography throughout the twentieth century until the digital age.[4] Ultimately, photographers chose these cameras because they afforded new modes of photographic practice. Robert Hirsch writes, "By eliminating technical obstacles, the hand-camera permitted photographers to be in the flow of events as they unfolded, trapping moments from time, instead of being outside and having to forge happenings for the sake of the camera."[5] In doing so, Hirsch continues, "the miniature camera leveled long-standing societal rules about what was private and what was public."[6]

Early on, the phrase "candid camera" referred to the technology of the new small cameras like the Ermanox or the Leica. But it soon came to connote visual values that quickly gained cultural traction, in both the trade press and the wider public, as the very definition of "candid." Writings of the period reveal that a change was happening not only in the technologies of photography but in the role of photography in public life as well: in the spaces for engagement with photographs, in the relationships that photographers could construct with photographic subjects, and in the visual qualities of the pictures themselves.

Trade publications, newspapers, and popular magazines of the 1930s chronicled the rise of the new visual values of candid photography, those of access, intimacy, and energy. References to access denoted the changing spaces where photography could be practiced. Writers and advertisers repeatedly emphasized that the new cameras were smaller and less obtrusive than larger cameras. This new portability made it possible for photographers to bring their cameras along with them during daily activities, not just when planning to pursue specific photographic assignments. As one advertisement put it, the Leica was "always ready for instant use regardless of place or climate."[7] Small cameras gave photographers access to move about unhindered in their environments; as one writer put it, the new miniature cameras were "perfectly, even wondrously, designed to give absolute freedom in expressing a new idea in photography."[8] Photographers recognized, valued, and even joked about this freedom. As one put it, "They made cameras so small that today when a man reaches into his vest pocket you don't know whether he's going to take your picture or offer you a cigarette."[9]

Better access meant greater intimacy with photographic subjects. Public discourse of the period frequently used terms like "intimate," "unposed," and "revealing" to describe the kinds of photographs the miniature camera could make. Its small size enabled the miniature camera to insinuate itself into situations where other cameras would have been too obtrusive, thus allowing a visual intimacy with its subjects that larger press cameras never could. Writing in *American Photography* magazine, Charles Knapp pointed out that miniature cameras should be valued "for doing what the large camera cannot possibly do . . . that is, picturing a tremendously faster, more complex world in its intimate, frankly realistic moments."[10] Another writer in *American Photography* asserted that there was "one field of photography in which the miniature camera is unquestionably supreme—unposed, revealing, 'candid' photography."[11] Intimacy in these examples was framed as synonymous with "realistic," "unposed" pictures. For these writers, the candid camera offered a closeness, a familiarity, a blurring of the boundaries of public and private that made it possible for subjects to be pictured seemingly without affectation. For a photograph or camera to be "candid" meant in part to achieve a new intimacy with the photographic subject, even if—or perhaps especially if—subjects did not realize that they were being photographed. Yet while the notion of intimacy conjured a sense

of physical closeness between camera and subject, it might also entail an imprudent overstepping of the boundaries between public and private.

Access and intimacy were not all that the candid camera offered, however. Portability (with its resulting freedoms) and unobtrusiveness (with its resulting intimacies) mixed with fast shutter speeds to offer images that looked qualitatively different from other photographs. They bristled with energy—a movement, vividness, and activity that cameras like the Speed Graphic could not capture. Ansel Adams (who with his commitment to large-format photography was by no means a candid camera photographer himself) wrote that "with the advent of the Miniature Camera, photography of the *active moment* became feasible."[12] Charles Knapp concurred that candid photography emerged because there grew "a general boredom with static and often frozen photography." In a passage worth quoting at length, Knapp outlined the character of the candid camera in a way that vividly illustrated the intertwined nature of the candid camera's visual values of access, intimacy, and energy:

> What are the pictures which can be made only with a miniature camera or can be made best with a miniature camera? Obviously they are the close-ups of life, the significant fragments that flash past our eyes, the double-quicks of today's history, the change and evolution which makes even yesterday old stuff and tomorrow the great unknown. They are the brutality of a gangster's face; the surrender in an old, bent back; the grotesqueness of public makeup, public eating, public love-making. They are the pictures of humankind caught up in a network of war, avarice, privation and disease. Pictures of people whose pleasures and sorrows are speeded up to the new tempo. They are sentimental, sardonic, humorous, factual, insulting, complimentary . . . but always they are authentic because the miniature camera can best hold up the mirror to life.[13]

In this passage Knapp rhetorically performed the qualities he ascribed to the candid camera itself. Piling vivid example upon vivid example, Knapp used strategies of accumulation, vivid language, and rhythm to illustrate the sheer detail and variety of what such images offered: access to "significant fragments," "today's history," indeed, to "life." That access was intimate, offering "close-ups" of the details of a face, a body, a pose—the gangster's face, the elderly person's "bent back," the "grotesque" things people do in public when they think they are unobserved. Finally, perhaps for Knapp most importantly, the candid camera offered energy—"fragments that flash

past our eyes," the "double-quicks of today's history," "pleasures and sorrows . . . speeded up to the new tempo." Such language emphasized movement: blurriness, lack of focus, speed.

As understood by practitioners and audiences of the time, then, the candid camera had tremendous capacity to transform the possibilities for photography. It enabled access to different spaces, offered a greater intimacy with photographic subjects, and imbued photographs with an energy that seemed to capture something essential about the whirlwind pace of contemporary life. It seemed both to capture and to create a new visual field for the modern age.

By the mid-1930s, what we might call the rhetoric of the candid camera circulated widely in popular culture. Camera clubs held "candid nights," where photography enthusiasts would get together to make pictures.[14] In 1940 *Life* magazine reported that the Junior Chamber of Commerce in Long Beach, California, had chosen its very own "Miss Candid Camera," at whom eager amateurs could aim their lenses.[15] Movies and novels tapped into the candid camera ethos as well. For example, the 1933 Warner Brothers film *Picture Snatcher* featured James Cagney as a former gangster turned newspaper photographer, and *Jimmie Drury: Candid Camera Detective* presented a young lead character who used his candid camera to solve crimes. One mystery novel series even included photographs in the text itself, promising readers "candid camera clues" in the pictures that would help them solve the mystery.[16] Within ten years of its appearance, the candid camera was more than a photographic technology; it was a permanent feature of 1930s visual culture, familiar to and valued by U.S. audiences for its visual values of access, intimacy, and energy.

Perhaps no photographer's work embodied these values better than one of its earliest and most lauded practitioners, Erich Salomon. The pioneering "candid cameraman," who traveled in circles elite enough to bring him to the United States in the early 1930s to photograph the U.S. president, is recognized today as the first photographer to penetrate previously closed political spaces. In fact, the term "candid camera" purportedly was coined in the *London Graphic* in 1929 to describe his work.[17] Salomon's photographic work in Europe and later in the United States—where he photographed sitting president Herbert Hoover and future president Franklin Roosevelt—moved the new visual values of access, intimacy, and energy into political spaces where they would inevitably clash with ideas about photographic

decorum. The man whose photographic subjects nicknamed him "king of the indiscreet" would use his camera to activate tensions between public and private.

King of the Indiscreet

Erich Salomon came to photography via a circuitous route. Born into a wealthy Jewish family in Berlin, he studied zoology and engineering before completing a law degree at the dawn of World War I.[18] He served in the German army during the war, was captured, and spent four years in a French POW camp. As a result of the war, Salomon's family lost all of its money, so he had to earn a living for himself. After a number of failed ventures, Salomon ended up in 1925 working for the top German publishing company, Ullstein. Among other magazines, Ullstein published the *Berliner Illustrirte Zeitung* (or *BIZ*), recognized today as the first of the picture magazines and one of the primary inspirations for *Life* magazine in the United States.[19] Salomon was put in charge of billboard advertising, and that is when he began making photographs for the first time. Because he felt standard cameras were too heavy, he began to use an Ermanox. He later switched to the Leica in 1932.[20]

Salomon found he preferred operating the smaller camera and that he was good at exploiting its advantages and minimizing its disadvantages. In 1928 he convinced the *BIZ* to let him cover criminal trials for the magazine.[21] Photography was not allowed in courtrooms, but Salomon learned to hide his camera in his hat, cutting out a small hole for the lens, or in a briefcase, where he installed levers that he could manipulate to release the shutter.[22] The photographs he produced of these trials were sensational and popular; no one had seen courtroom drama unfold in a news photograph before. By 1929 Salomon had taken up photography full-time. His specialty quickly became the photography of diplomacy. According to his son Peter Hunter, before Salomon, "photographs of these events were nearly always stiff and posed, devoid of life. The underpaid news photographer, out to get a serviceable shot, usually returned with pictures of rigid diplomats trying to hold a pleasant expression in the midst of an explosive flash of powdered magnesium."[23] By contrast, Salomon made unposed images of unguarded diplomatic conversation, capturing the rhetorical work of men wrestling with the creation of a new world order.

Figure 7.1: Erich Salomon, "British Prime Minister Ramsey MacDonald meets Professor Albert Einstein, Berlin, 1931." (bpk Bildagentur/Berlinische Galerie/Art Resource, New York.)

Salomon fit in at these international events, where he would work quietly around the edges of a room, surreptitiously photographing both major and minor European leaders. It helped that he spoke French fluently from his time in the POW camp and that his family background gave him the bearing of a cosmopolitan gentleman. According to his son, "He always dressed correctly" and "often he would hire a limousine and arrive in the manner of a minor dignitary."[24] Salomon figured out how to time his arrival at events so that no one would scrutinize him too closely. Because he used tools like a remote-release shutter, and because miniature photography did not require the large flashbulbs required of the Speed Graphic, he worked quickly and quietly.

Eventually the statesmen and diplomats figured out what he was doing when his compelling images began to be published in European newspapers, and many embraced him. The diplomats liked Salomon's pictures because they illustrated the behind-the-scenes labor of diplomacy and humanized the stern-faced men leading the discussions. French prime minister Aristide Briand famously labeled Salomon the "king of the indiscreet" and "reportedly once said, 'There are just three things necessary for a League

of Nations conference: a few Foreign Secretaries, a table, and Salomon.'"[25] (Briand liked one of Salomon's candid shots of himself so much that he asked Salomon for six prints of it.[26])

Salomon's early European photographs exemplified the new rhetoric of the candid camera. His ability to blend in, combined with the portability and small size of his technology, gave him unprecedented access to spaces few had seen. His images of diplomatic events regularly featured small groups or pairs of subjects in close conversation, creating the impression that Salomon was in close physical proximity to his subjects, close enough to eavesdrop on their important but informal conversations. Because he made them with a miniature camera using available light and avoided stuffy formal settings, Salomon's photographs embodied the energy of those "double-quicks of today's history" celebrated by Charles Knapp.

The new political photography interested media outlets in the United States. At the height of his fame in Europe, Salomon made his way across the Atlantic on the dime of Henry Luce, publisher of *Time* and *Fortune* magazines. In May 1931 the recently launched *Fortune* published a thirteen-page photo story on William Randolph Hearst, with Salomon's photographs of Hearst, his "castle," and celebrity guests.[27] In November of that same year, *Fortune* published a five-page layout of Salomon's diplomatic images. The piece opened with an encomium to the powers of the candid camera: "As a historic document, FORTUNE presents in the following five pages the premiers of Europe's great powers as they are. None of the pictures was posed. In most of the pictures the subjects were completely unaware that they had been taken at all, for a secret camera was used, requiring no artificial illumination."[28] *Fortune* invoked the rhetoric of the candid camera to highlight Salomon's art: terms like "as they are," "completely unaware," and "secret camera" gave the reader a sense of eavesdropping on political power brokers in action.[29] Throughout 1932, portfolios of Salomon's work appeared in *Fortune* in nearly every issue. Among other topics, he turned his candid camera on residence life at Harvard University, the House Ways and Means Committee, and Washington, DC, social events such as a party at the Italian embassy and the "Bachelor's Cotillion" at the Mayflower Hotel.[30] During this same period, Salomon's candid photographs of American society leaders, politicians, and activists also regularly appeared in other U.S. publications such as the *New York Times* and *Vanity Fair*.[31] *Time* praised his "photographs of the great as they really are, working, talking, eating,

yawning."[32] During that year Salomon took what today is still the only photograph made while the Supreme Court was in session; he purportedly got it by putting his arm in a sling and hiding the camera there.[33]

Those who encountered Salomon's images recognized the distinctiveness of their new visual values and celebrated the way they reframed ideas about public and private. With his elite background and cosmopolitan bearing, he appeared to have come straight from central casting, framed by many who wrote about him as a figure whose reputation for prudence would absolve him of any indecorous photographic behavior. *Fortune* wrote of him: "Dr. Erich Salomon's personality is a touchstone which admits him, without indiscretion, to even the most eminent private sessions. His tiny unseen camera continues to record contemporary history in the making."[34] While the press wrote rapturously about Salomon's camera, regularly describing it not only as "tiny" and "unseen" but also as "secret" and "privy," the impression conveyed of Salomon himself was that of a man above reproach.[35] Even when *Fortune* wrote of his stolen photograph of the U.S. Supreme Court, "Photographs by Dr. Erich Salomon . . . have always been noteworthy as intimate documents of our times," the intimacy Salomon achieved was still cast as somehow discreet in its informative "noteworthiness."[36] Ultimately, those U.S. news outlets that wrote about and published Salomon's photographs walked the fine line of embracing the candid camera's new, sometimes transgressive visual values while at the same time emphasizing the decorousness of their producer. The *New York Times* noted of Salomon's work, "Usually he catches them in moments when they are unaware that the camera's eye is upon them. He seldom takes a posed picture. He gets his subjects in action."[37] While the language of capture ("catching" and "getting") and references to subjects' lack of awareness raised the old specter of the camera fiend, the candid camera's potential for imprudence was framed as somehow tamed by the prudence of the celebrity cameraman himself. Even though Salomon was known for skirting the rules, the "king of the indiscreet" remained somehow above reproach. This quality would help him gain access to the president of the United States.

Herbert Hoover and the Press

Herbert Hoover did not like cameras, whether candid or otherwise.[38] First Lady Lou Hoover apparently was even warier. A White House press

photographer recalled that "Mrs. Hoover had a rule that no photographer could come within fifteen feet of her husband to make a picture." This was because the president wore high collars on his shirt, which she felt made his double chins even more pronounced.[39] Hoover, a devoted fisherman, also famously banned the White House press corps from covering his fishing trips, despite his aides' desperate desire for the president to be shown as a "regular guy."[40]

Herbert Hoover inherited a mature and structured White House press corps, and he adopted what Stephen Ponder labeled an "adversarial" relationship with the press.[41] Photographers and others in the press initially were surprised by President Hoover's reluctance to engage them. When leading food relief efforts after World War I and then in the 1920s as secretary of commerce, Hoover embraced modern publicity methods and maintained good relationships with the press. As commerce secretary, Hoover met routinely with reporters and used a clipping service to follow his mentions in the press.[42] Hoover was also the first president who allowed reporters to quote him directly. Years earlier, the common phrase "White House spokesman" had been invented during Theodore Roosevelt's presidency as a way for reporters to communicate what they learned from the president without attributing the information directly to him in the form of a quote.[43] But contrasts in personality and circumstances challenged Hoover's ability to build a good relationship with the press. The deepening of the Great Depression made that relationship worse. By 1931 whatever positive relationships with the press that might have remained from earlier years frayed amid the devastation of the Depression. Furthermore, that Hoover ascended to the presidency at precisely the moment when miniature photography emerged added additional challenges. Not unlike John Quincy Adams and the daguerreotype, Hoover and the candid camera would not easily mix. Nowhere was this more evident than when the president met Erich Salomon.

President Hoover Meets the King of the Indiscreet

Crisis put Hoover and Erich Salomon together in the same room in October 1931. Throughout that year, European nations had tumbled into economic disaster, which affected hopes for a speedier U.S. recovery. That summer Germany defaulted on its war reparations payments, and Hoover proposed

an eighteen-month moratorium on the payment of war debt to try to avoid a world financial crisis.[44] European nations agreed (the French being the main holdouts), and eventually Congress passed the moratorium (which did not, in fact, do much to avert crisis). After the French signed on in October 1931, French prime minister Pierre Laval visited the United States and met with Hoover. The *Washington Post* reported that Erich Salomon was in town as well; the photographer traveled to Washington from Munich "to get intimate pictures of the two statesmen in conversation."[45] But Hoover turned out to be elusive. The *Post* reported that although Salomon had made "several interesting physiognomic studies" of Laval and others at a Washington luncheon, he was "turned away from the White House on the night of the Hoover-Laval meeting."[46]

Upon learning of the White House's rejection, Laval appealed to Hoover directly to allow Salomon to photograph them at their next meeting. Hoover agreed.[47] As *Time* magazine reported the story:

> Photographer Salomon was led down a corridor. . . . There he found Premier Laval and President Hoover, deep in debt talk. Without disturbing their easy poses, he set up his tripod, took pictures while Premier Laval waggled an excited finger at the President, spoke rapidly in French. Because President Hoover does not thoroughly understand French, Secretary Stimson was present serving as interpreter. Discreet Dr. Salomon, busy with his camera, took pains not to listen to the confidential conversation going on.[48]

"Discreet Dr. Salomon." "Without disturbing their easy poses." "Confidential conversation." *Time*'s account highlighted both the familiar language describing the candid camera and emphasized Salomon's prudential behavior when photographing the two world leaders.

However, Salomon's photographs from that meeting revealed something different. One featured President Hoover, Prime Minister Laval (both seated), Undersecretary of the Treasury Odgen Mills (standing at right), Secretary of State Henry Stimson (seated at right), and French financial expert Adéotat Boissard (standing at left) formally posing for the photographer, nearly everyone looking at the camera except for Laval and Stimson (who, because he was translating for the president, likely needed to watch Laval intently). More experienced with Salomon's candid camera as a result of their encounters in Europe, Laval seemed to have given himself over to the idea that the photographs were supposed to seem unposed. Hoover's

Figure 7.2: Erich Salomon, Prime Minister Pierre Laval with President Herbert Hoover at the White House, 1931. (bpk/Salomon/ullstein bild via Getty Images.)

nearly expressionless gaze offered a stark contrast to Laval's as he met the eyes of the viewer by looking directly into the camera. The body language of the two men varied as well: Laval leaned forward in his chair, hands folded, seemingly eager for conversation, while Hoover sat far back, with a casual but more reserved body stance—legs crossed and shoulders turned not toward his interlocutor but toward the camera. The overall impression the photograph gave was one of wariness, awkwardness, and uptightness—hardly the "easy poses" described in *Time* magazine.

Two other images from the same meeting achieved something closer to the ideal performance of the visual values of the candid camera. Cropped to focus just on the two leaders, one photograph depicted Laval and Hoover smiling at each other, though Hoover's smile was still awkward and forced. While Laval's body position remained unchanged from the previous image, Hoover's right arm moved down, making for a less affected, more casual pose. Most importantly, the gaze between the two men energized the space between them. A third image (referenced in the story from *Time*, above) featured Laval energetically wagging his finger at Hoover, a slightly

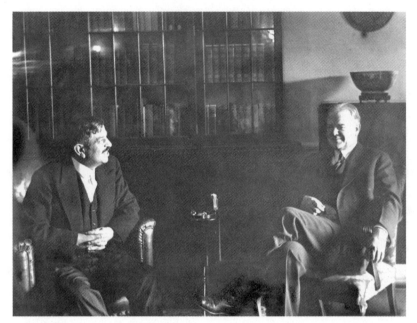

Figure 7.3: Erich Salomon, Prime Minister Pierre Laval with President Herbert Hoover at the White House, 1931. (bpk/Salomon/ullstein bild via Getty Images.)

out of focus hand gesture suggesting he was making an important point mid-conversation. By contrast, Hoover's body remained essentially where it was in the other two photographs, turned politely toward the visiting photographer in a three-quarter view.

Across all of the photographs, Laval seemed to know what he was supposed to do: avoid the photographer's eye and engage with the president in an unposed way. Laval had experience with Salomon's lens; he knew how to perform the visual values of the candid camera. But Hoover did not. Though his carefully moderated body positions and awkward smiles seemed decorous, by embracing a formal mode of portraiture Hoover ironically violated the very values of the candid camera that Salomon's presence at the White House was designed to exploit.

Tellingly, those who circulated the images seemed largely to ignore the content of the photos, claiming instead that the photos of the two men were ideal examples of those visual values. The Hoover-Laval photographs circulated in a number of newspapers and magazines, both in Washington, DC, and nationally. One image appeared on two separate occasions in the *Chicago Tribune*, with different cropping, each accompanied by a caption

that described the photograph as "intimate and informal."[49] Two more photographs, including the "wagging finger" image, appeared alongside *Time* magazine's report of the meeting, but editors cropped out Hoover entirely to share instead only a photograph of Laval. Not surprisingly, given its visual energy and the visit's heated political context, the "wagging finger" photograph seems to have been the most popular. In addition to its appearance in *Time* and Washington, DC's *Evening Star*, it was appropriated for the cover of *Time* a few months later when the magazine named Laval its "Man of the Year." Cropping out Hoover entirely (a telling move in that dark winter of 1931), the magazine appropriated the photograph of Laval's dramatic hand gesture in a painting depicting the French premier in the White House.[50] Captured by Salomon's lens in mid-gesture, Laval emerged in the photo-cum-painting as the candid camera's ideal subject: seemingly unposed, vibrating with bodily energy.

Salomon photographed Hoover again a few months later in March 1932, at the White House Correspondents' Dinner in Washington. According to the *New York Herald Tribune*, the stag gathering of five hundred men included "music, skits, motion pictures made by the reporters, and no speeches."[51] The photograph Salomon made that night captured the president attending to the festivities while smoking a cigar. An open bottle—perhaps a bottle of Prohibition-era wine?—sat in front of him on the dais. By all accounts, Hoover was not aware that he was being photographed. Salomon made the photograph from three feet away, apparently by hiding his camera in a flower arrangement and releasing the trigger by remote control.[52] White House photographers were not pleased with Salomon's appearance at their off-the-record event. The minutes of a 1932 White House News Photographers Association meeting announced the appointment of "a committee of one to investigate the activities of Dr. Salomon, the German photographer who is residing at the Mayflower hotel and making a nuisance of himself at public functions."[53] Framed in so many news accounts as the creator of intimate, secret, but discreet images, Salomon got slapped with a charge of indiscretion.

Despite the complaints, the image is, ironically, one of the best of Hoover as president. He appears focused, thoughtful, and prudent. As a candid camera portrait, it outshines the Hoover-Laval photographs, skillfully mobilizing the visual values of access, intimacy, and energy. Unposed and unaware of the camera, the president nevertheless is fully available to the viewer. As a result, unlike in the previous images, this Salomon photograph offers viewers intimate access to its subject. While it is unclear whether the star

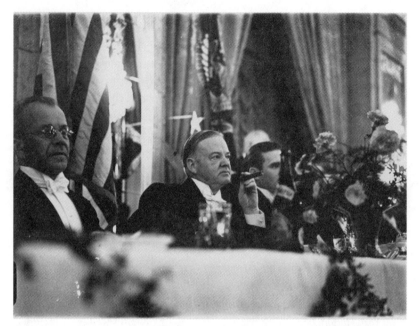

Figure 7.4: Erich Salomon, "President Hoover at the annual dinner of the White House journalists," 1932. (Library of Congress.)

hovering over the president's head was a decoration or a trick of the light, it nevertheless gives the photograph additional energy and interest. Despite the White House press corps' grumblings about Salomon's "nuisance" practices, the photo secretly shot from a flower pot was soon taken up as a positive image of the president. *Fortune* used it in a pro-Hoover story a few months later, tightly cropping it in its July 1932 issue as a full-page image accompanying a long article called "The Case for the Administration." Paired with a pro-Hoover story in a pro-business magazine, the photo of Hoover—with that star even more prominent and glowing above his head— arguably offered a more positive and prudential, if purloined, picture of the president than did other media images.

The candid camera and its new visual values of access, intimacy, and energy enlivened the visual field of photography in ways that challenged, and in some cases upended, norms of decorum. Previously subject to "camera fiends" in public places, presidents in the candid camera age now faced the prospect of becoming the unwilling subject of a photographer's "privy" camera anywhere, at any time, even indoors, in contexts previously off limits or difficult to photograph. At the same time, presidents were expected to

cooperate in the rhetoric of the candid camera by performing these new visual values. Herbert Hoover's awkward engagements with the camera of Erich Salomon embodied the tensions between public and private inherent in these new demands. Unwilling to fully participate as a seemingly unaware photographic subject, Hoover bodily challenged the demands of Salomon's camera at a time when practiced inattention was becoming a dominant way of picturing political leadership. Ironically, at the same time that he rejected the candid camera's ethos, he simultaneously fell victim to its capacity for revealing, engaging portraits.

Salomon's presidential interactions did not end with Hoover. In May 1932 the candid cameraman photographed then governor of New York Franklin Delano Roosevelt as he and his wife, Eleanor, attended boxer Max Schmeling's training camp. News coverage of the presidential candidate's meeting with Schmeling did not mention the presence of the king of the indiscreet, but Salomon and a number of photographers captured the moment when the two men interacted. (Roosevelt pleasantly surprised

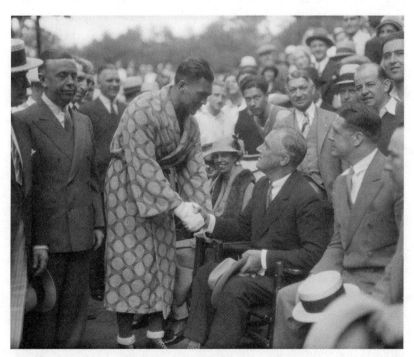

Figure 7.5: Unknown photographer, "Governor Franklin D. Roosevelt of New York, shaking hands with Max Schmeling, the World's Heavyweight Boxing Champion, during the Governor's visit to the Schmeling training camp," May 1932. (Bettmann via Getty Images.)

Schmeling by speaking to him in German.[54]) While Salomon avoided picturing the disabled presidential candidate's lower legs, other photographers were not so discreet. For example, one photograph of Schmeling greeting a seated FDR was framed to reveal just a hint of one of Roosevelt's steel leg braces. While in the photographs Roosevelt appears unaware of the photographers, or more likely had cultivated the practiced inattention that Hoover had not mastered, that hint of a leg brace points to a visual vulnerability that candidate Roosevelt very much sought to surmount. That he famously did so by making himself more publicly visible constituted Roosevelt's mostly successful gamble with the candid camera.

FDR, Visibility, and the Press

The candid camera's visual values of access, intimacy, and energy carried cultural force well into the 1930s. Anxieties about the candid camera went with them too. Physically disabled since 1921 as a result of being infected with the polio virus, Franklin Roosevelt recognized the candid camera as a mounting threat when he returned to a public career after the early years of his illness. As a candidate for New York governor and later as a presidential candidate and president, Roosevelt and his advisers worked hard to divert public attention away from the fact that he could not walk on his own. But the story of FDR's engagements with photography should not be reduced to the well-trod terrain of how he and his advisers worked to "hide" his disability from the public or the extent to which the press colluded with him to accomplish that. For as much as Roosevelt sought to manage the hypervisibility produced by the candid camera's intrusion into political life, he also skillfully appropriated the very visual values the candid camera championed. While he manipulated the role the candid camera would be allowed to play in his relationship with the public, he simultaneously made himself visible to that public in other ways. Ultimately, what Roosevelt did to ensure his visibility was just as important as, or perhaps more important than, what he sought to keep invisible.

Hugh Gallagher's 1985 book, *FDR's Splendid Deception*, argued that Roosevelt's experience with polio significantly affected him every day of his life and should therefore be an integral part of any attempt to understand him and his politics.[55] Until the publication of Gallagher's book, most historians and biographers treated Roosevelt's disability as something over

which he had "triumphed" before becoming a major political figure, if they took it up at all.[56] One question that has dominated discussions of FDR's disability is the question of the extent to which he and his advisers actively sought to deceive the public about polio's impact on him. Not surprisingly, photography played an important role in these assessments. Very few photographs, even fewer that circulated in print during his presidency, depict Roosevelt in a wheelchair, being carried to and from the car, or walking with crutches—despite the fact that all of these things were daily occurrences. The absence of visual reminders of Roosevelt's disability, plus evidence that photojournalists and newsreel cameramen agreed not to photograph FDR at these moments, suggested to some historians the whiff of conspiracy. A survey of photographers and photo editors conducted for a 1946 study, for example, reported that photographers had been asked explicitly not to photograph Roosevelt using crutches or a wheelchair or being carried.[57] Yet scholars disagree about the extent to which it is appropriate to call what FDR and his advisers did a "cover-up." On the one hand, considerable evidence shows that Roosevelt and his advisers sought to squelch rumors about his health and the extent of his disability. On the other hand, the president's health was a topic of public discussion in the media, FDR himself actively and publicly advocated on behalf of those affected by polio, and according to one scholar, arguably he "was more candid about his health than Kennedy was in 1960."[58] Arguing against the extremes of "cover-up" and "everybody knew," Matthew Pressman suggests that it makes more sense "to consider FDR's efforts to control his image as spin, rather than as a cover-up."[59]

Davis Houck and Amos Kiewe offer the most substantive exploration of how candidate Roosevelt worked behind the scenes and in public to address the political impact of whispering campaigns about his health. They point out that these strategies were not so much about what Roosevelt "hid" as what he did in the open to shape and address the inevitable concerns about his fitness for office. They argue that Roosevelt used visual strategies that "took two main forms: an ability to walk or give the appearance that he could walk and extensive travel by automobile, train, and airplane."[60] By combining these strategies with verbal communication emphasizing his own health, Roosevelt sought to make his disability invisible by becoming hypervisible during his campaigns.[61] For example, ahead of the 1932 campaign, he and his advisers commissioned a friendly Republican operative,

Earl Looker, to write an ostensibly objective piece for *Liberty* magazine that addressed the question of whether Franklin Roosevelt was fit enough to be president.[62] (Not surprisingly, he concluded "independently" that FDR was.) During the 1932 campaign, Roosevelt's advertisements then referenced the *Liberty* magazine piece and trumpeted the fact that an insurance company had offered FDR a five-hundred-thousand-dollar life insurance policy as further proof of his good health.[63]

Throughout his political career, but especially in his campaigns for governor and president, Roosevelt traveled extensively and kept to a punishing schedule of appearances. During one campaign trip in 1932, he gave twenty-three speeches across thirteen states.[64] He even broke new ground by being the first presidential nominee to accept the nomination at the convention. With much fanfare Roosevelt flew to Chicago in 1932, communicating energy and vitality with the choice to travel by air.[65] From campaign appearances on the back of a train car (where, leaning heavily on the arm of one of his sons, the smiling candidate appeared to be able to stand on his own) to speeches at specially reinforced lecterns to facilitate standing, Roosevelt literally showed himself to the public so that they could see his vitality and stamina for themselves.[66] Extensive travel helped to create the impression that Roosevelt was not only healthy but also accessible and knowable in ways that previous presidents, especially Hoover, were not.

Roosevelt also used his charisma to great effect with the public and with a press to whom he offered regular access, hosting two press conferences per week during his presidency.[67] Accounts of his relationship with the press frequently mention his informality and friendly demeanor. A *New York Times* account of Roosevelt's very first press conference as president, tellingly headlined "Enjoys Jokes, Allows Cameras," said that the new president spoke "frankly," "laughed heartily," and "looked fresh and fit."[68] Press conferences conveyed the impression of an accessible president and gave Roosevelt opportunities to directly counter his critics in the Republican press as he ingratiated himself with reporters.[69] Photographs revealed the president's energy and charisma as well, especially when compared to his dour predecessor Hoover.[70] Roosevelt's well-known visual expressiveness got a decidedly surrealist treatment in *Vanity Fair* magazine, which in October 1933 published a photo montage slyly called "A Laughing Cavalier." The bizarre image featured a large head shot of FDR grinning at the camera and surrounded by dozens of smaller Roosevelt faces, each with a different,

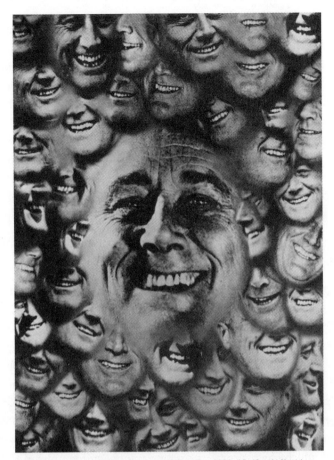

Figure 7.6: "A Laughing Cavalier," *Vanity Fair,* Oct. 1933, 15. (Condé Nast.)

almost maniacally charismatic, smile of its own. Sally Stein suggests the image could be read as a parody of depictions of Roosevelt that focused on his hands and head rather than on his disabled body.[71] At the same time, the fantastical replication of so many Roosevelts arrayed around a central Rooseveltian grin pointed to the kinetic energy and hypervisibility of a new president who dazzled in the candid camera era.

Histories of FDR's media savvy lean heavily on his use of radio, especially the addresses that came to be called "fireside chats." Radio fostered intimacy like no other medium, and Roosevelt took good advantage. When he arrived at the White House, he already had extensive experience with the technology; he had appeared on radio as governor of New York and understood the

value of direct communication with Americans.[72] Roosevelt grounded his radio persona in a narrative of familiarity, famously addressing listeners as "my friends." His voice was often described as the key to his oratorical success. Professors of public speaking declared FDR's voice to be "rich" and "melodious," and one radio director said Roosevelt had "a voice 'like honey syrup oozing through the steel filter that jackets the microphone.'"[73] Just as important, the content of his radio addresses relied on common words and plain speech to communicate complex ideas.[74] The fireside chats—thirty-one of them across his presidency—gave Americans a sense of having an intimate, personal connection with a president who came to them in their homes or cars.

FDR and the Candid Camera

Photography played a key part in both the New Deal and Roosevelt's personal public relations strategies. Through the work of various "alphabet agencies," chief among them the Resettlement Administration, or RA (later renamed the Farm Security Administration, or FSA), led initially by FDR's close adviser the progressive economist Rexford Tugwell, Roosevelt championed the use of photography both to publicize the impact of the Great Depression and to chronicle New Deal efforts to alleviate it. Between 1935 and 1943, photographers working for the Historical Section of the RA/FSA made more than 250,000 documentary images across the United States, many of which have become the most famous photographs in U.S. history.[75] Other agencies, such as the Civilian Conservation Corps (CCC), the National Youth Administration (NYA), and the Works Progress Administration (WPA), regularly publicized their work via photography as well.[76] Roosevelt also embodied faith in visual methods through his own verbal rhetoric. He used visual language repeatedly, such as in his emphasis on the need to "face" and "recognize" the Great Depression in the first inaugural address and his reliance on metaphors of sight in the second inaugural address, including that speech's most famous pronouncement: "I see one third of a nation ill-housed, ill-clad, ill-nourished."[77]

If the Roosevelt administration used photography to make the New Deal more visible, the president's personal engagements with photography were more circumspect. FDR would not hide from the spotlight. He would be seen, but on his terms and according to an ever changing yet firm set of

rules. Roosevelt governed New York when the candid camera arrived and became an increasingly dominant presence in public life. By the mid-1930s both professional and amateur "kings of the indiscreet" relied on the visual access a miniature camera could provide. In response the Roosevelt White House worked to control the environment by implementing an ever tightening set of rules to govern photographers' behavior. Yet visual control could never be absolute. Not all news outlets (especially those run by his political opponents) could be relied on to uphold the gentlemen's agreement to refrain from photographing Roosevelt in ways that made the extent of his disability visible.[78] In addition, anytime the president was out in public, he was vulnerable to the candid cameras of professional and amateur photographers alike. While not all candid photographs of FDR were actually made with the miniature camera, nevertheless the visual values of access, energy, and intimacy that dominated the cultural moment posed a threat, one that required constant vigilance on the part of those seeking to control the president's image. That vigilance was already in place before Roosevelt took office.

Entering his townhouse just days before his first inauguration, Roosevelt declined to turn and "wave his hat for the benefit of photographers," earning praise from the *New York Times* for rejecting the dominance of the news camera. The writer opined, "Camera and sound-machine have brought their own kind of vividness into the news business, but they have also brought with them an element of the artificial, the rehearsed, the posed. There has been adjustment and concession to the requirements of the photographer."[79] While the *Times* did not report how Roosevelt was physically entering the space—was he on crutches, or in a wheelchair, or being carried from a car?—the piece made clear that FDR was going to draw boundaries that other presidents, most notably the notoriously photo-happy Calvin Coolidge, had not. Roosevelt's press secretary, Stephen Early, set the tone by establishing rules for photographic coverage by the White House press corps.[80] As described by Betty Houchin Winfield in *FDR and the News Media*, these rules included the following:

> —photographers would not get exclusive access to the president for pictures; they would instead pool photo coverage so that all organizations had a fair shot at a good picture;
> —photographs of the president with visiting dignitaries could be made "in proper poses only";[81]

—photographers were not allowed to make any "candid pictures . . . not even at the press conferences, without special permission";[82]

—finally, "White House rules . . . prohibited shots taken of the president handling crutches or photos implying he had crutches or was being wheeled in his wheelchair."[83]

While historians tend to emphasize the prohibition of "disability" images, these rules illustrate that anxieties about the candid camera were about more than that. Prohibiting candid images in favor of "proper poses" was one way to protect the president from embarrassments that extended beyond the goal of keeping his disability from the forefront of the public's mind.

Stephen Early's rules evolved over time, often in response to photographic moments that he thought made the president look bad. For example, in early 1935 he announced that photographers would only be allowed to make a picture of the president once Early himself had given permission to shoot. The new restriction was in response to a photo of FDR rubbing his eyes after being subjected to the blinding light of multiple camera flashbulbs going off simultaneously. When the photograph circulated with candid camera–style captions stating that the president was "thinking over the farm problem," the White House balked.[84] Early authorized the Secret Service to implement a similar rule a few months later. After what Early called "some decidedly poor photographs" of the president taken on his yacht, *Sequoia*, appeared, Early directed the Secret Service to keep photographers from making shots of the president until the Secret Service gave the okay.[85]

In 1937 a number of issues related to Roosevelt and the candid camera came to a head. It was a trying year for the president politically. Emboldened by his second-term victory and frustrated by the Supreme Court's rejection of New Deal programs, Roosevelt recommended adding an additional justice to the federal court system for every one justice over the age of seventy. If adopted, what came to be called the "court packing plan" would have given FDR the opportunity to nominate six new Supreme Court justices.[86] Presumably, these Roosevelt appointees would be amenable to the policies and practices of the New Deal. Roosevelt's Republican critics in the media—most notably Robert "Colonel" McCormick, publisher of the *Chicago Tribune*, and Henry Luce, publisher of *Time*, *Fortune*, and *Life*—felt along with many others that the president was making an audacious power grab. Despite the ban on photographing the president in ways that highlighted his disability, in 1937 a handful of publications owned by his critics published photographs of the

president that showed his leg braces, pictured him using crutches, or, in one case, being pushed in his wheelchair.[87] The latter photograph was made on the grounds of the U.S. Naval Hospital when FDR went to visit a member of the cabinet and was taken from so far away as to make the president nearly unrecognizable. Nevertheless, *Life* published the image as part of a two-page photo spread of images of Roosevelt and his family.[88] After the photo appeared in print, Stephen Early wrote to the president's physician, "Here is a picture of the President in his wheelchair—a scene we have never permitted to be photographed."[89] Early demanded to know what steps would be taken at the hospital so that such pictures could not be made again. Later that fall when the president visited Chicago, McCormick's *Tribune* published a photograph of him with Cardinal George Mundelein that clearly showed FDR's leg braces. By contrast, the *New York Times* published a similar photo from that meeting that had been composed or later cropped to cut the two men's legs off at the shins, effectively obscuring the braces.[90]

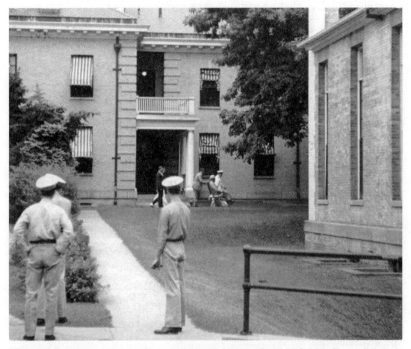

Figure 7.7: Carl Mydans, "Three uniformed men watch American President Franklin Roosevelt as he is wheeled to visit patients," 1937. (The LIFE Images Collection via Getty Images. Originally published as part of "The President's Album," *LIFE*, Aug. 16, 1937.)

However much Stephen Early and other advisers to the president worked behind the scenes to squelch such unusual images, the candid camera remained a matter of more routine concern. In May 1937 *Popular Photography* magazine debuted to capitalize on the ongoing candid camera craze. The cover of its first issue explained that the new publication would offer photography enthusiasts tips about "photo kinks, candid shots, home movies, common errors, tricks exposed," and more.[91] Just a few months later, in October, the magazine published a story titled "Why the Candid Camera Was Barred from the White House." The chatty, sometimes tongue-in-cheek piece written by Rosa Reilly offered readers information about the Roosevelt administration's mercurial relationship with candid camera culture. Speculating on why the Roosevelt White House had recently "barred the mini cam from Washington," Reilly mentioned two potential reasons.[92] First on the list of possible offenders was *Life* magazine photographer Thomas McAvoy, who had made unauthorized candid camera photographs of FDR at his desk in the Oval Office. But when Reilly queried McAvoy, the photographer told her that he had "never received any complaint about them" from anyone at the White House.[93] A second, more plausible cause was a group of "unconventional" photographs taken at a summer 1937 Democratic Party picnic at Jefferson Island, Virginia, including one that showed the president in the act of chewing his food. Reilly reported that major news outlets had requested permission to shoot the event, but they were denied. Yet photographs of the event circulated widely a few days later, raising the question of who had made the unauthorized images. Reilly wrote, "Well, the talk around New York and Washington is that several Congressmen or Senators took the unconventional photographs—which weren't really so unconventional after all—and turned them over to Acme and the Associated Press. Those in the pictorial 'know' also are snickering in their sleeves because they say Acme and AP thoughtfully provided certain of the nation's representatives with photographic equipment so that they could take adequate pictures."[94] Whether the rumors and Reilly's insinuations were correct or whether Democratic congressmen were just eager users of their own candid cameras, the Jefferson Island incident indicated how difficult it could be to control the candid camera anytime the president was out of the White House.[95]

Finally, Reilly's informants fingered as responsible an Associated Press photographer who had photographed the president on baseball's opening day: "An Associated Press photographer caught Mr. Roosevelt as he was

Why the Candid Camera Was

BARRED from the WHITE HOUSE

by ROSA REILLY

This is the picture that caused many newspaper readers to inquire about the President's health.

Another candid shot taken during the season's opening baseball game which made the President appear ill.

POPULAR PHOTOGRAPHY'S special correspondent investigates the controversy as to why the miniature camera was barred from use in photographing the President.

THE candid camera is certainly *non grata* in political circles. Months ago, Stephen Early, Press Secretary at the Executive Mansion, barred the minicam from Washington. And more recently, Mr. Early placed a month's ban—which was later reduced to a few days—on two press services because of the

Distribution of these pictures taken by Congressmen caused AP and Acme a bit of trouble.

Jefferson Island photographic fracas.

You all recall the melee which followed the Democratic love feast on Jefferson Island, where, in the early summer, Mr. Roosevelt and his followers gathered to relax under the trees and renew political friendships.

Here some unconventional photographs were taken and distributed — pictures which showed the President and his friends in shirt sleeves with handy glasses at their elbows.

POPULAR PHOTOGRAPHY has endeavored to sift the rumors which flew around after this occurence from the truth. The facts in the case are these:

According to R. P. Dorman, General Manager of the Acme News Pictures, Inc., his service and the three other major news syndicates asked for permission to send photographers to Jefferson Island to cover the political picnic. This request was refused, with the result that no photographers attended.

The world was naturally astounded, therefore, to see a few days later four or five pictures of Mr. Roosevelt and his Senators and Congressmen enjoying themselves on Jefferson Island.

The pictures were released by Acme and the Associated Press although they had had no cameramen on the Island.

Where did the pictures come from? Who took the photographs?

Well, the talk around New York and Washington is that several Congressmen or Senators took the unconventional pho-

tographs—which weren't really so unconventional after all—and turned them over to Acme and the Associated Press.

Those in the pictorial "know" also are snickering in their sleeves because they say Acme and AP thoughtfully provided certain of the nation's representatives with photographic equipment so that they could take adequate pictures.

Whether that is true or not cannot be verified. However, some abdominal laughter has been had all around. The President enjoyed himself with a fair

Ammonia-sensitized film enabled newshawk McAvoy to get these candid shots of the President at his desk. Contrary to rumor the pictures in themselves had nothing to do with the candid camera ban.

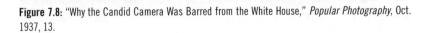

Figure 7.8: "Why the Candid Camera Was Barred from the White House," *Popular Photography*, Oct. 1937, 13.

eating peanuts, rooting, and generally enjoying himself in his own lusty way." But the resulting pictures showed something different: a president looking so tired and drawn that anxious newspaper readers from around the country inquired after the president's health. According to those Reilly consulted, the problem was not so much the photographs per se but that they had been enlarged on the wrong kind of enlarger for miniature nega-tives and later "copied on a regular four by five plate which gave deep blacks and chalky whites to the Chief Executive's face." The Associated Press then sent the images out over the wires, "which produced a set of the pastiest faced photos ever seen" and prompted "another of those perennial scares raised about the President's health."[96] When Reilly queried Stephen Early on the issue, Early stated that although there was no "specific reason" for the ban, he confirmed that seeing the ballpark photos of the president played a part in his decision to ban the small cameras from the White House. In ad-dition, he agreed that enlarging the miniature camera's negatives produced "distortion" that other press camera negatives did not produce. Early also raised the issue of fairness, pointing out that miniature camera operators had an unfair advantage because they could "take dozens of shots where those with larger cameras were getting only a few." Thus, Reilly concluded of Early's position, "It seemed the fair thing was to bar the candid camera while the President was at his desk or in the White House."[97]

While the desire to manage the visibility of FDR's disability no doubt played a role in the Roosevelt White House's control of the candid camera, the *Popular Photography* article illustrated the broader anxieties about pho-tography that circulated during the candid camera era. Access, energy, and intimacy—three visual values that FDR himself eagerly cultivated during the 1930s—could go wrong if it meant circulating photographs of President Roosevelt munching on a hot dog at a picnic or looking poorly in a badly exposed image. It was one kind of problem for a press photographer to make an unsolicited picture of President Roosevelt in public, "lustily" enjoying opening day. But it was a bigger problem to enlarge, print, and circulate that photo in ways that might distort the president's visage and cause public alarm. Similarly, it might not by itself be a problem for Thomas McAvoy to use a small, so-called miniature camera to photograph the president, but it was "unfair" that those using the faster miniature cameras would get more opportunities for such a shot than operators of the bigger, slower press cameras.

Photography at One Hundred

A month after *Popular Photography* published its article on the White House and the candid camera, the *New York Times* reported that Winston Churchill had written a letter to the *Times* of London criticizing the use of the candid camera to photograph political figures. Churchill complained, "While guests are seated eating their dinner . . . photographers stalk about the room taking unexpected close-up shots of well-known people of both sexes which afterward are published by newspapers." Photographers in the U.S. were the worst offenders, Churchill wrote, adding that he "recently saw President Roosevelt with his mouth half open in the act of eating and drinking." Such practices were, according to Churchill, "discourteous" and constituted "effrontery."[98]

Photographer Arnold Genthe echoed Churchill's sentiments two years later at an event celebrating the centenary of photography in 1939. The *New York Herald Tribune* reported that Genthe "took the occasion of the centennial to protest what he called a 'definitely pathological trend' among some photographers, particularly candid camera fans. He accused them of glorifying the ugly. There was need, he said, not so much of a photographic censor as of an Emily Post of photography." One example Genthe gave of this pathological trend was—surprise—photographs of President Roosevelt "in the 'not very beautiful' act of eating a hot dog."[99] The hot dog picture symbolized the limits of the candid camera's decorousness. If Salomon-esque photographs of statesmen doing the engaged work of diplomacy constituted one use of the candid camera, FDR's hot dog constituted quite another. The visual values of the candid camera—access, intimacy, and energy—oscillated perpetually between these extremes.

"Miniature" or 35 mm photography eventually dominated both amateur and professional photography and held that power for seventy-five years. The era of the candid camera was itself much shorter. Complaints about photographs of the president chewing or being pictured with leg braces were one thing, but in Europe the rise of fascism and Nazism made "privy" and "intimate" photographs like those pioneered by Salomon not only breaches of etiquette but patently dangerous as well. Salomon's own tragic story illustrates this fact. He left Germany after Hitler came to power and resettled in his wife's native Netherlands. Colleagues in the United States begged him to come to the U.S., where magazines like *Life* were hiring

German Jews who had pioneered the candid camera and picture magazine. According to his son Peter Hunter, Salomon put off leaving until it was too late. Salomon went into hiding with his family in 1943. A few months later they were discovered and sent to the Auschwitz concentration camp, where he, his wife, and their younger son were murdered in July 1944.[100]

At the same centennial event where Genthe expressed his disdain for the candid camera, ninety-five-year-old William Henry Jackson, a well-known photographer of the late nineteenth-century American West, suggested that photography's evolution was nearly complete: "What more is there to be done? . . . We have color photography, sound synchronized with motion pictures, the transmission of pictures by television, and the taking of a picture in the hundred thousandth part of a second. I don't see what more there is to add, other than to perfect what we have."[101] Coming as they did from a venerable nineteenth-century source, those words would largely hold true until the digital age, when new visual values would again emerge to transform the ways presidents engaged photography.

The Social Media President

Changing Visual Media from the Mid-Twentieth Century to the Digital Age

On the evening of August 8, 1974, President Richard Nixon prepared to deliver a live address to the nation to announce his resignation. The CBS network cameras started rolling before the broadcast was to begin, preserving for posterity about seven minutes of Nixon before he went live on the air.[1] As the video opens, the television crew is readying the room for the live broadcast. One of them sits in the president's chair so that the camera operator can check the lighting. Suddenly the president himself appears in the room and the man leaps up to offer him the seat. "Hey, you're better lookin' than I am; why don't you stay here?" Nixon jokes as he sits down, a copy of his speech in his hands. Then, referencing the man's hair color, he adds, "Blondes, they say, photograph better than brunettes. That true or not?"

Seated now, Nixon asks the production crew whether they have a backup camera (they do), whether they have set the lights properly (they have), and he makes a joke about the brightness of the lights and his aging eyes. The entire scene is understandably awkward. Then Nixon notices something off to his right and says, speaking through a forced smile, "That's enough. Thanks." Nixon turns to the television crew to explain: "My friend Ollie always wants to take a lot of pictures. I'm afraid he'll catch me pickin' my nose." More awkward laughter on the part of the president. (No one

else seems to be laughing.) "Ollie" is Oliver Atkins, the president's official White House photographer. Then Nixon hastily adds, "He wouldn't print that, though, would ya, Ollie? Yeah." Off camera, Atkins's reply is inaudible; presumably he says no, he wouldn't. Then the president gets more serious with his photographer: "No, you can take a long shot, but no, that's enough, really." Next, Nixon runs through the opening of the speech so that the crew can check his sound. Less than a minute later an increasingly strained Nixon addresses his photographer again, making a sweeping gesture with his left hand as if he is clearing off the desk: "Ollie? Now, only the CBS crew now is to be in this room, during this. *Only the crew.*" Off camera, Atkins begins to ask, "Would it be possible if I . . .," but Nixon cuts him off: "No, there will be no picture. No. After the broadcast. You've taken your picture; didn't you take one just now?" Atkins answers, "Yes, sir." Nixon continues: "That's it. Because you know, we don't want to be . . . we didn't let the press take one, so you've taken it, you, just take it right now." Nixon pauses with his script in his hand, serious-faced, consenting to a brief pose. Then, a second later, agitated: "You got it? Come on. OK." The camera clicks several times as Atkins says something inaudible about the TV cameras. Nixon replies, "OK fine, all right, fine." The camera clicks a few more times. Nixon taps his manuscript on the desk and says, his tone even sharper, "I'm gonna make the other photographers mad; I've given you too many. That's *enough*, OK?" Two minutes later, Nixon goes live on the air to announce his resignation.

There is so much that is striking about this moment, but at the core of it is this: literally moments before he became the first U.S. president to resign from office—before he performed the single most consequential act of his long, storied, and controversial career—Richard Nixon chose to spend a full two minutes berating a photographer. This exchange animates key themes of the relationship between presidents and photography in the late twentieth century. Volumes have been written about media and the twentieth-century presidency, research that explores presidents' relationships with the press, presidential campaigning, and presidents' communications operations.[2] Transitioning from the era of the candid camera to that of social media, this chapter examines three topics affecting presidents' relationships with photography in the late twentieth century. Each of these topics emerges vividly in the verbal and visual exchange between Nixon and Atkins. The first of these is presidents' relationships with the visual press. The resignation video offers hints of the push and pull of the

Figure 8.1: Official White House photo, President Nixon announces his resignation, Aug. 8, 1974. (Bettmann via Getty Images.)

relationship between presidents and the press in Nixon's fretting that "I'm gonna make the other photographers mad" that they did not get the photo access that Atkins got. The second of these topics is television. By 1974 television had become the dominant medium of presidential image making, a development that is evident in the entire event of Nixon's resignation, from the television cameras recording him live to his jokes about bright lights and blondes. Finally, the presence of Atkins points to the rise of the role of official White House photographer and Nixon's particular inability to embrace its full possibilities. Nixon's jokes about nose-picking and his irritated declarations of "that's enough" echo previous eras' anxieties about camera fiends and highlight ongoing tensions between publicity and control faced by twentieth-century presidents. Presidents needed media to get their messages out yet simultaneously sought to retain control over the shaping of their presidential image. Moving beyond the politics of the moment, Atkins's relatively passive, yet some might say heroic, attempts to document the historic occasion highlight the role White House photography

was coming to play not only in documenting the president in real time but also in documenting the president for all time. After exploring these three themes, I then turn to the final technological transformation I am treating in this book: the rise of digital photography and social media. Once social media photography emerged, presidents' relationships with the visual press, their reliance on traditional mass media, and the way they used the White House photographer role shifted yet again.

Presidents' Relationships with the Visual Press

After many years of Franklin Roosevelt, photographers covering Harry Truman found him an enthusiastic, active, and affable subject. One Truman biographer observed, "His brisk activity was a noted contrast to the sedentary poses of President Roosevelt to which newsmen had been accustomed for fifteen years."[3] Known for a "good-natured fussiness" with photographers, Truman jokingly referred to photographers as his "One More Club" because they always seemed to be asking for "one more photograph, please."[4] Part of Truman's interest in photographers stemmed from his own interest in the medium itself. As one of the first U.S. presidents to have come of age in the Kodak era, Truman enjoyed making and posing for snapshots, and his youthful interest in photography extended into his presidency.[5] White House news photographers even honored Truman's interest by giving him a movie camera and a Speed Graphic for his birthday.[6]

Dwight Eisenhower was less fond of the pictorial press. Stanley Tretick, who covered the White House for United Press, called Eisenhower "impatient with photographers."[7] Eisenhower faced serious health challenges during his presidency, the most public of which was a 1955 heart attack and subsequent surgery that required weeks of recovery and the delegation of daily responsibilities to others.[8] Because the administration was accused of being less than transparent about Ike's health, White House communication officials welcomed press photographers who could communicate to the public that the president was feeling and looking better. But this openness came only after Tretick and a colleague snuck into the hospital dressed in patients' pajamas and made unauthorized photographs of the president sunning himself on a porch.[9] When most of their photographs were confiscated, the photographers agreed to collaborate with Eisenhower's press secretary, Jim Hagerty, who wanted to control the presentation of

the president to the press after surgery.[10] Like Truman, Eisenhower also practiced photography, but he did so less for its own qualities than to capture images of places he later wanted to paint.[11] Despite his impatience, President Eisenhower played along and was even given an honorary award by the White House News Photographers Association for a photograph he made of the press corps in 1955 with the new Polaroid Land camera, which produced an image instantly after exposure.[12]

Young, photogenic, and media-savvy, John F. Kennedy built his political story in large part on skillfully deployed photographic images of him, his active family, and his attractive wife. The building of Kennedy's pictorial image began well before his political career was launched, calculated by his father, Joseph, who was no slouch at publicity himself.[13] Another key participant in the construction of that narrative was Kennedy's wife. While Jacqueline Kennedy discouraged spontaneous snapshots of the children, Courtney Caudle Travers writes that she was a crucial agent in the visual construction of the Kennedy family and presidency: "She took seriously the visual presentation of the First Family and thought carefully about the means by which" she might do "strategic political work through a cultural agenda."[14] Longtime *New York Times* photographer George Tames recalled of Jacqueline Kennedy, "She had her own favorite photographers and she had her own ideas about what made the best picture of herself."[15] Those photographers included Jacques Lowe, who photographed John F. Kennedy during the campaign and continued doing so regularly after he took office, and Stanley Tretick, who made one of the most famous Kennedy White House pictures: John Junior peeking out through the door of the Resolute desk in the Oval Office.[16] Tames received good early access to Kennedy when he was invited to document a day in the life of the president for a *New York Times Magazine* feature in February 1961, just a few weeks into the Kennedy presidency.[17] Among the published images was one of Kennedy made from behind, the president in silhouette against Oval Office windows, leaning over a table to read a document. While it later became famous as the "Loneliest Job in the World" photograph, the *Times* initially published it with a more prosaic caption and buried it in the middle of the feature. Tames recalled that when Kennedy saw the magazine spread, he remarked of the "loneliest job" photograph, "This should have been on the cover." Tames recalled, "It struck him right off that he knew that was an important picture and that it was not being played properly."[18]

Recalling his relationship with Kennedy's successor, whom he had photographed for years in the Senate, Tames complained, "LBJ used to blame me for every picture that he considered unflattering that ran in the *New York Times*." Lyndon B. Johnson was adamant that he be photographed on his left side and routinely complained to photographers when he didn't like their images.[19] Yet much of the visual trouble LBJ got into was his own fault. While he courted members of the press by inviting them to his ranch and offering impromptu press conferences, these events often did more harm than good.[20] Eager for media exposure, Johnson sometimes went too far. Photographers captured such a moment in 1964 when President Johnson lifted one of his beagles by the ears while meeting with White House visitors (ostensibly to get it to howl). The subsequent press photos of the incident caused public outrage. While Johnson maintained his act was not cruel, the letters and phone calls that flooded the White House proved that many Americans did not agree.[21] Neither did the president do himself any visual favors the following year when he spontaneously lifted his shirt to show members of the press the scar from his gallbladder surgery.[22] In the context of the times, such images seemed emblematic of the troubled Johnson White House more generally and haunted LBJ until he left office.[23]

As the twentieth century drew to a close, spontaneous press photographs of the president and his family became harder to come by, and they could become controversial when they did appear. In 1997, for example, photojournalist John Mottern received criticism when he photographed President Bill Clinton and First Lady Hillary Rodham Clinton walking on the beach in their bathing suits while on vacation on Martha's Vineyard. Accused by some of deploying paparazzi (the modern-day term for "camera fiend") tactics, Mottern maintained there was nothing unethical about his images.[24] He said that the Clintons knew he was making pictures, they did not ask him to stop, and they were photographed on a public beach where dozens of other citizens and members of the Secret Service were also present.[25] Mottern's photographs circulated around the world but quickly came to seem more invasive when just two days later Princess Diana was killed in a car crash in Paris as her drunk driver attempted to outrun the paparazzi.[26] Only a few months after that, in early 1998, new photographs of the Clintons in bathing suits received direct criticism from the White House. The images included photographs of the president and first lady slow-dancing on a beach in the U.S. Virgin Islands. The pictures had been made, as one journalist invoking

camera fiend language described them, by "photographers lurking in bushes about 100 yards away."[27] This time the Clintons were unaware that they had been photographed. When President Clinton was asked about the picture, he said, "I like it quite a lot, but I didn't think I was being photographed."[28] His communications staff was less sanguine, as were some in the press. Some members of the White House press corps argued the photographs were a violation of the first family's privacy and suggested that the mainstream press was behaving just like paparazzi.[29]

The Rise of Television

If presidents could not always control how photojournalists represented them, television offered the dream of direct visual and verbal communication with the public. Television not only transformed how presidents interacted with citizens and presented themselves visually, but it also affected the ways they interacted with the photographic press.[30] By 1956 television had the capacity to reach more than three-quarters of U.S. homes, offering a new and large audience for presidents to reach.[31] Television brought to presidential communication new demands for how a president should look, move, and behave on camera.[32] Although Truman had appeared on television, Eisenhower was the first president to fully embrace professional media training designed to shape the way he appeared on the small screen. The White House hired actor Robert Montgomery to coach Eisenhower on how to speak to the camera. Eisenhower offered the first filmed presidential press conference in 1955 and delivered the first televised Oval Office address.[33] The rise of television also changed the ways press photographers interacted with the White House. George Tames recalled arriving to events in the early days of television and finding television cameras given priority "in a roped off area," while he—as a *New York Times* photographer, who "was usually front and center"—was shunted to the side and forced to scramble for good vantage points.[34]

If Robert Montgomery trained one president to speak to the camera, soon a president emerged who had himself been a Hollywood actor. David Greenberg argues that although Ronald Reagan was "the first president to spend his pre-political career working in the mass media," he was not so much the founder of modern presidential media strategy but "a master of methods that a long string of forbears had incrementally developed."[35]

Well before his career in elected office began in the 1960s, Reagan honed those skills in radio, film, on television, and in thousands of speeches he delivered in conjunction with his job as host of television's *General Electric Theater*.[36] Reagan's presidency notably reduced the value of the presidential press conference and replaced it with the primarily visual, heavily scripted presidential performance of the photo op.[37] Reagan's speeches staged televisual spectacles, from cutaway shots of the Washington Monument and other national landmarks during Reagan's first inaugural address to the skillful placement of the president near the cliffs of Normandy at the fortieth-anniversary commemoration of the D-Day invasion.[38] Of these visual strategies, Reagan White House spokesperson Larry Speakes said, "We learned very quickly that when we were presenting a story or trying to get our viewpoint across, we had to think like a television producer."[39]

If presidents through Reagan lived in the era of three television networks, the George H. W. Bush and Clinton administrations had to deal with two additional challenges: the rise of the twenty-four-hour news cycle and the increased fragmentation of media.[40] As a result, viewers' experiences of politics became more fragmented, partisan, and self-selected—a change that arguably began with the birth of the Fox News Channel in 1996 and increased exponentially with the rise of the internet.[41] Both the George H. W. Bush and Clinton administrations took advantage of this fragmentation. Bush, for example, was interviewed on cable networks such as CBN (Christian Broadcast Network) and BET (Black Entertainment Television), while Clinton took advantage of opportunities to appear on cable talk shows such as CNN's *Larry King Live*, "where he might showcase his gift for more pleasant conversation."[42] As the first baby boomer president, Clinton grew up with television and had internalized its power.[43] The new era of television never fit the elder Bush, however. Writes Lori Cox Han, "Bush's public style . . . would have been better suited for the news media environment of an earlier time like the 1960s, when the national news cycle was more driven by words than by images."[44]

Emergence of the Official White House Photographer

While the visual press and television shaped the image of presidents from the outside looking in, the role of White House photographer emerged in the late twentieth century as an increasingly important countervailing

force. Earlier chapters mentioned presidents who built mutually beneficial relationships with photographers, most notably William McKinley's and Theodore Roosevelt's cooperation with Frances Benjamin Johnston. But the idea of hiring someone to document the president officially, on a daily basis, came later. National Park Service photographer Abbie Rowe was hired during Franklin Roosevelt's third term to document official presidential activities; he worked at the White House into the Johnson administration.[45] Navy photographer Robert Knudsen worked at the White House through five administrations, from Truman to Nixon.[46] Army photographer Cecil Stoughton was assigned to the Kennedy White House in 1961 and made several famous presidential photographs of the era, including the poignant image of Lyndon B. Johnson's swearing-in on Air Force One in Dallas, just hours after President Kennedy was assassinated.[47] In addition to Stoughton, Knudsen, and other White House photo staff, other photographers already mentioned, such as Jacques Lowe and Stanley Tretick, were given exclusive access to President Kennedy and his family at particular times.[48]

A former U.S. Army and U.S. Information Agency photographer, Yoichi Okamoto was hired as the president's personal photographer when Lyndon B. Johnson became president, and "Oke," as he was known, defined the role as it generally has been practiced since.[49] Okamoto was the first photographer to demand of the president the kind of access that would transform the role into one that chronicled the presidency for history. Writes John Bredar, "Okamoto told Johnson that his goal wasn't simply to make portraits but also 'to hang around and try to document history in the making.'"[50] A former photo assistant recalled that Oke "was the first person who basically had unfettered access to Johnson's Presidency. Oke didn't work for anyone except the President. He didn't work for the press office, he didn't work for the special assistant to the President, his secretaries, or anyone else."[51] For his part, Johnson demanded to see and approve all the photographs Okamoto produced and to sign off on every photograph released to the public.[52] *New York Times* photographer George Tames recalled of Johnson's investments in photography, "I got on him about this habit of his having the White House photographers shoot pictures of him all day Monday, and Tuesday morning when he came into his office, they had to have the stack of prints on his desk, shot from the day before." Tames noted that Johnson "was always conscious of pictures."[53] David Hume Kennerly, Gerald Ford's photographer, suggested that Johnson's personal investments in photography grew out of

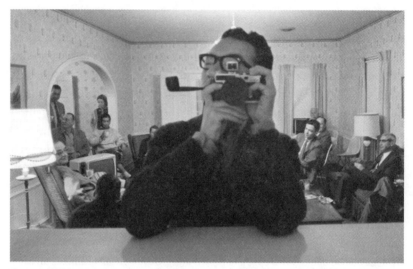

Figure 8.2: Yoichi Okamoto, self-portrait in a mirror at LBJ Ranch, 1964. (Johnson Presidential Library via Wikimedia Commons.)

a combination of envy and a sense of the importance of visual documentation: "L.B.J. wanted pictures like J.F.K. was getting. . . . L.B.J. just let him [Okamoto] in to do whatever he wanted to do. And L.B.J. did that out of a sense of vanity and a sense of history."[54]

Not all presidents welcomed the constant attention of an official White House photographer, however. According to Oliver Atkins, who took the job after working briefly as a photographer for the 1968 campaign, Richard Nixon initially refused the idea of an official photographer but was then convinced of the value of recording activities of the White House for posterity.[55] However, as the opening of this chapter makes clear, Atkins and Nixon had nothing like the relationship Okamoto had with Johnson.[56] He had no security clearances or arrangements that would allow him to cover Nixon in a personal, behind-the-scenes way, and he was required to clear all photo ops with Nixon's press secretary.[57] Jimmy Carter ultimately chose not to hire his own official photographer, though First Lady Roslyn Carter had one and there continued to be White House photographers on staff.[58] Many viewed President Carter's choice as a mistake. Michael Evans, who served as official White House photographer under President Reagan, said of Carter that he "had no understanding of still photographers. . . . He didn't

trust them and Carter suffered enormously because of it."[59] Perhaps not coincidentally, no president has gone without one since.

It is also no coincidence that the presidents who provided the most access to official White House photographers became the most compelling subjects of White House photographs. Political scientists sometimes speak of "reconstructive" presidents, those presidents who substantially transformed the very functions and meanings of the presidency.[60] We might also speak of reconstructive White House photographers: those whose efforts fundamentally transformed official presidential image making. Three fit that label: Yoichi Okamoto, who defined the role; David Hume Kennerly, who had the most intimate access to a president; and Pete Souza, who named Okamoto as a model and transformed presidential photography for the social media age. Okamoto defined the role of president's photographer by demanding complete access and free rein over the image-making process. Kennerly, a Pulitzer Prize–winning war photographer in his twenties at the time of his hiring by Gerald Ford, built extremely close personal relationships with the president and his family.[61] Kennerly's access compared to that of no photographer before him or since, as he was able to move freely not only in the official office spaces of the White House but in the private family quarters as well. His close relationship with the president also gave him opportunities to perform jobs that were not typical for White House photographers. For example, in the spring of 1975, Kennerly asked President Ford for permission to accompany the army chief of staff to Vietnam to make photographs and report back on conditions there.[62] Kennerly used photographs from the trip to brief the president on the impending fall of Saigon; some of them were even hung in the West Wing for other staffers to see. In *Shooter*, his memoir of this period, Kennerly wrote, "My stark, black-and-white photographs of refugees and civilian casualties soon replaced the color prints of dancers, state visits, and similar events that hung in the corridors of the West Wing. My pictures were everywhere you turned, even in the hallway leading to the staff dining room, and many people reportedly couldn't eat after seeing them."[63] As the next chapter details, Pete Souza combined unfettered access with a good personal relationship with the president to transform White House photography for the digital age. His successes were made possible in part by the new opportunities for photographic sharing and connecting afforded by digital photography and Web 2.0.

Digital Photography and the Rise of the Social Media President

The digital transition in photography may be dated to three events: the introduction of the digital camera, the appearance of digital imaging software, and the rise of mobile photography and related applications. Digital cameras first appeared in the early 1970s and emerged commercially after 1988, but only in the early 2000s did they begin to make sustained inroads into journalism and saturate the public market.[64] In 2003 sales of digital cameras outpaced those of analog cameras for the first time.[65] But well before that, digital reproduction played an increasingly important part in the experiences of professional photographers and photojournalists. Beginning in the early 1980s, photographers would turn in images shot on film to be scanned and digitally retouched with complex machines and software.[66] The rise of the personal computer created new markets for commercially available image manipulation software; Adobe's Photoshop appeared in early 1990 to meet that need. Photoshop put tools of photo editing and graphic design into the hands of professionals and amateurs, eventually becoming its own generic verb as the culture began to wrestle with the implications of digital manipulation.[67] Mobile, or cell phone, photography emerged in the late 1990s, its popularity skyrocketing by the introduction of mobile applications, or "apps," for smart phones in the late 2000s.[68] Developments such as these made social media photography possible.

The shift to digital photography was about more than technology, however. Broader transformations in digital culture mattered as well. Presidents both participated in these transformations and took advantage of them. In 1994, three years after the World Wide Web appeared, the Clinton administration introduced the first White House website, whitehouse.gov. In 1999 the Clinton White House released a memo urging federal agencies to adopt email as a regular institutionalized form of communication with citizens.[69] After 2000 what came to be called Web 2.0 emerged, creating avenues for two-way interactive communication on networks.[70] Social networking sites (SNS) and other sites enabling user-generated content soon appeared, their platforms both facilitating interactivity and simultaneously constituting its rules of engagement.[71] The data make clear the dramatic shifts that followed. According to the Pew Research Center, in 2005 only 5 percent of adults surveyed said they used at least one social media site. Just after

Barack Obama's 2008 election, that number rose to 27 percent, and by the end of Obama's two presidential terms, it had skyrocketed to 69 percent. Among adults between the ages of eighteen and twenty-nine, the number was 86 percent.[72] News consumption changed during this period as well. In 2010 journalist Ken Auletta put the changes in perspective: "When George W. Bush was finishing his first term, there was no Facebook, no Twitter, no YouTube; dozens of regional newspapers and TV stations were highly profitable and seemed, at least to themselves, inviolable. Between 2006 and 2008, daily online news use jumped by a third, which meant that one-quarter of Americans were getting the news online."[73]

The social and political implications of the new interactivity began to reveal themselves during the middle of the George W. Bush administration. As always, the White House sought to take advantage of new ways of visually displaying the president and his activities, such as the White House website's "photo of the day" feature and the administration's use of visual backdrops hung at presidential events to highlight the message of the day.[74] At the same time, the rise of the blog and the emergence of online news comments sections offered new, highly visible online spaces for the circulation of criticism.[75] The playful visual-verbal practice of the meme made images of the president especially susceptible to manipulation and appropriation. Heather Woods and Leslie Hahner define memes as "concepts and images that spread virally across culture, largely through social media platforms." They are "rhetorical images that are designed to move audiences and ultimately shape the larger culture."[76] Scores of memes mocked the infamous "Mission Accomplished" banner hung behind President Bush on the deck of the USS *Abraham Lincoln* as he (erroneously) declared the end of hostilities in Iraq in 2003.[77] After Hurricane Katrina brought widespread death and destruction to New Orleans in 2005, an especially biting meme superimposed a photograph of President George W. Bush and his father, George H. W. Bush, fishing and proudly posing with their catch onto an image of a badly flooded New Orleans street.[78]

Not surprisingly, during this period political candidates took increasing advantage of social media communication as new platforms appeared seemingly overnight: MySpace in 2003, Facebook and Flickr in 2004, YouTube in 2005, Twitter in 2006, Tumblr in 2007, Instagram and Pinterest in 2010, and Snapchat in 2011, to name just a few of the most dominant

players of the period.[79] In the 2008 presidential race between Barack Obama and John McCain, both candidates relied on social media for nearly every campaign function, including mobilizing supporters and raising money.[80] Obama's campaign successes in this regard were well-documented, and social media practices became a defining feature of the candidate's brand.[81] The next chapter explores how the Obama White House embraced new visual values of social media photography while at the same time working to carefully control the president's image and message.

CHAPTER 9

Barack Obama and Flickr

As Barack Obama's two terms as president came to a close, media outlets of all sorts ran stories summarizing the key moments of his presidency and speculating about his legacy. The technology blog network *Engadget* declared Obama to be "the most tech-savvy president" and "the White House's first social media ninja."[1] Obama's legacy would always be tied to how he and his administration took advantage of new media technologies of the early twenty-first century. And future presidents would feel the impact of those choices. Terrence O'Brien writes, "After Obama, expectations about how the president interacts with the public have forever changed."[2]

The rise of Barack Obama paralleled the birth of social media, and it is impossible to overestimate the impact of social media on the role of photography in the culture. Numbers tell part of the story. In 2012 *Fortune* magazine reported that "10% of all photos ever taken were taken in 2011."[3] By the time Obama left office in January 2017, Instagram boasted 150 million users per day, and social media giant Facebook dominated the landscape with upward of 1.3 billion daily users.[4] These platforms sold themselves as spaces for sharing, capturing, and connecting, terms that not only echoed the feel-good Kodak moments of the past but also pointed to a fundamental transformation in our relationship to photography. In 2012 Pete Brook argued in *Wired* magazine that "photographs are no longer things; they

are experiences."[5] That is, photographs are not so much records of what happened as they are real-time chronicles where everyone with a camera announces, "This is happening; I am here." These technological and cultural transformations have had profound implications for photography's role in social and political life.

One of the challenges of studying the Obama administration's relationship to photography is that it is difficult to account for the magnitude and diversity of the photographic practices that shaped and were shaped by the Obama presidency. Yet as contrary as it might seem in an era of "spreadable media," official White House photographs of Obama turn out to be a powerful lens through which to tell the story of social media photography.[6] The Obama White House Flickr photostream chronicled Obama's unfolding presidency and operated as an axis around which other social media practices and public debates about photography circulated. Launched just months after Obama's 2009 inauguration and frozen in time at the end of his two terms with 6,668 official White House photographs, the photostream operated as a real-time curated archive, making it an ideal site for exploring the story of social media photography in the Obama era.[7] Furthermore, as of this writing it is the most complete, official, publicly available visual record of the Obama White House. During Obama's presidency, the Flickr photostream functioned simultaneously as a collection for posterity, a real-time public relations effort, a site of contestation over interactive social media, and a playful and politicized space for appropriation and remixing. It reflected broader social media practices that transformed photography in the early twenty-first century as new visual values of sharing and remixing took center stage in ways that directly affected presidential communication. In exploring the case of Barack Obama and Flickr, I ask not what Barack Obama did with social media but what social media did to and with photographic presidents.

The Digital White House

The Obama campaign's branding of its candidate as a social media pioneer extended into the Obama presidency as the administration sought to use every available social media channel to engage the public. A look at the Obama White House's adoption of social media makes this long-term, multiplatform commitment clear:

2007: Senator and presidential candidate Obama launched a Twitter account[8]

2009: Official White House YouTube channel, Flickr photostream, Twitter account, and Facebook feed launched; first Twitter Town Hall[9]

2010: Creation of *West Wing Week*, a short, punchy weekly video summary of the president's activities that week[10]

2012: White House began to use Google Hangouts; 2012 campaign joined Pinterest; Obama did an "Ask Me Anything" session on reddit[11]

2013: White House Vine, Tumblr, and Instagram accounts launched[12]

2014: White House Medium account appeared[13]

2015: Obama added an official presidential Twitter handle (@POTUS) and a personal POTUS Facebook page[14]

2016: White House Snapchat account launched[15]

The Obama White House consistently used all available means to reach twenty-first-century audiences. And those audiences were large. In 2015, for example, the White House Twitter feed boasted more than 6 million followers, Michelle Obama's Instagram feed had 1.8 million, and the White House's Facebook page boasted more than 3.6 million followers.[16]

The demands of social media changed the nature of White House communications work, requiring larger staffs and different modes of engagement than those of previous administrations. In 2010 the full Obama communications operation at that time consisted of a total of sixty-nine people; George W. Bush had fifty-two and Clinton had forty-seven.[17] Historian of the White House communications operation Martha Joynt Kumar reported in 2015 that the White House Office of Digital Strategy alone boasted a staff of fourteen, bigger than the makeup of George W. Bush's whole press office in 2005.[18] The Obama White House created the Office of Digital Strategy to focus on how to get the president's message out in ways that traditional approaches like policy addresses could not.[19] Kate Albright-Hanna, director of new media video in the 2008 Obama campaign, said of the value of social media, "When people are able to tell their own stories directly (even if in reality it is a third party doing the writing) it allows them to construct their own narratives of self and reframe their public presentation. Consumers of this social media feel like they are getting this information directly rather than through a publicist or the perspective of a journalist."[20] Macon Phillips, who served as new media director for the campaign and later at the White House, said that the White House's digital strategy involved

three goals: "publicizing the President's message, increasing the visibility of White House activities for the public, and creating opportunities for citizen input in government."[21] Jason Goldman helped to establish social media platforms such as Blogger, Medium, and Twitter and was later recruited by the White House to become its first chief digital strategy officer. He argued that social media allowed the White House to foster connection and to exert direct control of the message: "It's going direct to individuals, not through intermediaries. And it's [about] purpose, it's about getting folks emotionally involved so that they're ready to act. . . . And all of that's in the context of using our tools and using the platforms that we control to achieve that goal."[22]

Scholarly assessments of the goals of publicity, visibility, and citizen input suggest that while the first two were successful, the administration ultimately failed to foster meaningful, sustained, interactive citizen engagement. What the White House called "citizen engagement" ended up being primarily one-way communication, not the two-way communication fostered by social media. James Katz, Michael Barris, and Anshul Jain argue that at best the Obama administration used social media "to mobilize support and to give the impression of responsiveness."[23] Others suggest that while Obama's first presidential campaign pioneered new media persuasion, the Obama White House was less revolutionary.[24] One example frequently pointed to is the White House petition system called We the People, begun in 2011. Branded with the tag line "Your Voice in the White House," the site invited citizens to exercise their right to petition by promising that the White House would respond to any petition that met the signature threshold of one hundred thousand signatures within thirty days.[25] Katz and colleagues argued that while initiatives like We the People invited participation, it required not a substantive, engaged response on the part of the administration but only "a nominal reaction."[26] In this way, they argue, social media for Obama became more of "a 'broadcast' tool" than a genuine, sustained give-and-take between citizen and government.[27]

If the Obama administration was less successful at creating the give-and-take that Web 2.0 promised, it did succeed at using social media as a tool for dissemination and control of the president's image and message. As Jason Gainous and Kevin M. Wagner write, "Social media alters the political calculus in the United States by shifting who controls information, who consumes information, and how that information is distributed."[28] As a

result, political campaigns began to sidestep traditional media, which were no longer the primary way to get their message out.[29] With social media it was easier to communicate with people directly and shape your political image to your liking.

When Obama first took office in 2009, some in the mainstream media fretted over the dangers of excessive exposure for the new president, concerned that his "sheer visibility" as a "constant of pop culture" might get in the way of accomplishing actual policy goals.[30] Eight months into Obama's presidency, Jennifer Senior wrote in *New York* magazine, "It's a steady beat of press conferences and town halls and YouTube addresses—a communications lollapalooza, rain or shine. It's messaging not just as a means to an end, but as a kind of end itself."[31] What initially emerged as worries about the overexposure of President Obama, however, later evolved into concern about growing polarization among citizens. These anxieties reflected a larger conversation about the role of social media in politics. Recognizing the capacity of social media to create "filter bubbles," in which citizens expose themselves only to ideas that they already support, some journalists raised concerns about the president's capacity to reach all Americans using social media channels. Juliet Eilperin of the *Washington Post* wrote in 2015, "The White House can reach more people without the filter of the traditional media, target its audience with precision and receive almost immediate feedback. But the approach raises the prospect of fostering further political polarization if the president opts to communicate mostly with parts of the electorate that identify with him ideologically or can be helpful politically."[32] In addition to these concerns, the choice to invest deeply in the online space also brought risks, including the unpredictability of the space, the inevitability of racist comments on social media posts, or the possibility of missteps that circulated too quickly to correct. Still, as Obama White House deputy communications director Amy Brundage told the *Washington Post* in 2015, "These platforms just reach so many people, we can't not play in that space."[33]

Pete Souza and the Obama White House Photo Operation

When the White House chose to play in the new space of social media photography, it chose an old hand at presidential photography to make the pictures. Barack Obama named photojournalist Pete Souza as chief White

House photographer just a few weeks before his inauguration in 2009.[34] A seasoned photojournalist who previously worked as a White House photographer during Ronald Reagan's second term, Souza took on a set of tasks that were very different from those of early White House photographers.[35] In the Lyndon Johnson era, Yoichi Okamoto worked for the president and only for him. By 2009 the position had evolved into a 24/7 job in which a chief photographer not only followed the president's every move but also served as director of the White House Photo Office, managed a staff of photographers and editors, collaborated with colleagues in the White House communications operation, and directed visual coverage of every public event related to the president, the vice president, the first lady, and the White House. Souza initially met Obama when the photographer was working as the *Chicago Tribune*'s Washington Bureau photographer. Souza photographed the then junior senator from Illinois as he was sworn in and began to serve in the U.S. Senate in 2005, eventually producing a book of photographs of the senator that was published during the 2008 presidential campaign.[36] He established a good working relationship with Obama, who tapped him to become the chief White House photographer.[37] While Souza's primary job was behind the camera, during the Obama years Souza became a celebrity in his own right, appearing on programs such as *Charlie Rose*, the BBC's *Newsnight*, and CBS's *Sunday Morning*, along with numerous photography podcasts and in White House social media Q & As. In these contexts he shared the stories behind some of his images and talked about what it was like to photograph Obama behind the scenes.[38]

In interviews Souza repeatedly emphasized that his job was to serve as a "visual historian." He told CNN in 2009, "The most important thing is to create a good visual archive for history, so 50 or 100 years from now, people can go back and look at all these pictures."[39] Souza recalled in 2017 that he was inspired by Johnson White House photographer Yoichi Okamoto: "I was determined to take Okamoto's approach and document his [Obama's] presidency. I wanted it to be the best archive that we've ever had of a president. That was my personal mission."[40] Despite Souza's declarations that he was photographing for history, within a few months selections from the already growing body of official White House photographs began to be posted regularly to Flickr, a social media photography site, and shared via a growing number of White House social media accounts. Souza's visual chronicle was more than a collection for posterity; it constituted a living,

growing archive of a presidency. The confluence of Souza's access to Obama, his artfulness with the camera, and the rise of social media photography made possible new and transformative ways of picturing the presidency. No longer were presidents limited to official White House photographs made primarily to be socked away in a museum for later display or bound up with the vagaries of relationships with photojournalists. The social media president could bypass traditional news media to share seemingly sponta- neous, behind-the-scenes images directly with the public. While previous presidential photographers chronicled their bosses for history, Souza and his colleagues in the White House Photo Office also used their images to document a historic presidency nearly in real time.

The shift to digital photography made it easier to shoot more photo- graphs of the president. But during the Obama years it was not so much the quantity of images that increased as it was their real-time public reach. George H. W. Bush's chief photographer, David Valdez, said that he shot sixty-five thousand rolls of film in the four years of Bush's presidency, which comes to roughly 1.5–2 million photographs for Bush 41's single term.[41] Each photographer on Bill Clinton's four-person photography staff shot between ten and twenty rolls of film per day, which meant a maximum of three thou- sand images per day.[42] George W. Bush's chief photographer, Eric Draper, oversaw the shift from analog to digital photography during Bush's second term. Draper estimates that he personally made one million images during the second Bush's presidency, while that number is closer to four million if one includes the rest of the photo staff. This number is consistent with the higher-end estimate of roughly two million photographs produced per term during the analog years of George H. W. Bush and Clinton.[43] Pete Souza estimated that he personally made nearly two million photographs during Obama's two terms, nearly double the number made by Draper alone.[44] A 2010 National Geographic documentary film and companion book on White House photography estimated that the Obama White House was at that time producing between five and twenty thousand images per week.[45] The actual number likely stands somewhere near the middle of those figures. Steven Booth, archivist at the Barack Obama Presidential Library, reports that the Obama audiovisual archive consists of approximately four million photographs, which works out to just under ten thousand photographs per week across the two terms.[46] While the Obama White House does not appear to have made substantially more photographs than other recent

administrations, what did differ was the extent of the public circulation of those images while Obama was in office.

The work of Souza and his colleagues in the photo office was embedded in a much larger communications structure, though as the director of the White House Photo Office, Souza had substantial control over what images would be made public. He and his photo office colleagues would select the images and then run them by the press office before releasing them on Flickr, whitehouse.gov, or other social media sites. In 2017 Souza recalled, "The way it worked was I would ultimately choose whichever photograph would be made public, for whatever reason, and I would show that photograph to someone in the White House press office, and I would say 99.5% of the time they would say, 'that's fine,' and then maybe they might have an objection about something I hadn't thought about."[47] Alice Gabriner, who served as a White House photo editor and deputy director of the photo office, emphasized the importance of recognizing the dual functions of White House photography: "It's so important to be able to think about what we're doing, because we're uploading to the web, we're uploading to Flickr, but we're also creating an archive that's a lasting archive for history."[48] Describing how particular images were selected for public circulation, Gabriner observed that in addition to aesthetic considerations such as light, composition, and color, she was also looking for "an image that I haven't seen before. So it needs to feel fresh, it needs to feel surprising."[49]

In 2015 Souza told the *Photo Brigade* podcast, "This administration happens to sit at this time of history when social media has exploded. It just so happened that it occurred during this administration."[50] Yet the Obama White House's investments in social media photography were not merely happenstance. As this book has demonstrated, presidents are deeply invested in controlling their visual images. As the nation's first African American president, Barack Obama likely recognized that need even more keenly. Despite careful control of candidate Obama's visual image during the campaign, the visual culture at large offered its own mediated, vernacular, and often disturbing images of Barack Obama. Throughout the 2008 campaign, Obama was depicted through the use of disturbing racial stereotypes. The repeated circulation of images of Obama as a terrorist, thug, or monkey, among other racist themes, constituted a complex burden for the candidate to overcome.[51] The prevalence of these characterizations perhaps fueled the administration's early decision to circulate official White House photographs of President Obama more or less in real time.[52]

The Flickr Photostream: An Archive for the Social Media Era

Although the Obama White House continued earlier presidents' practice of posting photos of the day to whitehouse.gov, the administration chose to use a third-party social media photography platform, Flickr, to share official White House photographs with the public. Obama had previously used Flickr during the presidential campaign, most famously circulating an album of 2008 election night photographs by David Katz that was shared widely.[53] Founded in 2004, Flickr initially gained popularity over other photo sites because it allowed both professional and amateur users alike the opportunity to tag and share their photographs, join groups, and comment on other users' images.[54] José van Dijck argues that Flickr emerged at a moment when "digital photography had already begun to shift people's memory practices in a communicative and public direction."[55] Flickr has been called something of a failed platform because it has never been able to decide what its main function is and it could never compete with later behemoths like Instagram. Yet Van Dijck points out that these "vacillating movements" helped Flickr survive, because it offered users "various platform functions: from community site to social network platform, from photo news site to memory service and archival facility."[56] By the time the White House began to use it, Flickr had also gained credibility as a place to share images of developing world events and natural disasters.[57] Other government entities used Flickr to share their image holdings with a broader public. The Library of Congress partnered with Flickr in early 2008 to pilot "The Commons," a project designed to improve access to publicly available photography collections around the world and enable Flickr users to tag and comment on the library's images.[58] Other U.S. public institutions like the Smithsonian Institution soon followed suit.

The White House launched its Flickr photostream in April 2009 to commemorate the president's first one hundred days in office.[59] It contained only photographs produced by Obama White House photographers and selected by White House photo editors. As Pete Souza put it in a 2015 interview, "One thing that people know is if there is a photograph of mine on the White House Flickr feed, there's no mistaking that it's coming from the White House."[60] Until the full visual archive of the Obama presidency is made available to the public, according to rules set by the Presidential Records Act, the Flickr site offers as comprehensive a behind-the-scenes look at the Obama White House as one can get.[61] While I use the term

"archive" in the colloquial sense to describe the Flickr site, it is important to note that it is not an official archive with the kinds of selection, search, and metadata structures created by professional archivists. Rather, it is akin to what in the language of professional archivists might be called a "fond," which the Society of American Archivists defines as a collection of records that have "been created and accumulated as the result of an organic process reflecting the functions of the creator"—in this case, the Obama White House, which built and added to the photostream over time.[62] Because it was frozen in time at the end of Obama's second term and is still usable and searchable in its original form, the Obama Flickr site is not merely a stand-in for the larger Obama visual corpus. It also constitutes a discrete photographic archive, one that chronicled a presidency in real time and captured for posterity social media practices and public debates about photography in the Obama era.

The White House Flickr photostream served four distinct yet overlapping functions that, when taken together, illustrate how social media's new visual values of sharing and remixing transformed presidents' engagements with photography: the photographs offered an official, behind-the-scenes visual history of the activities and events of the Obama administration; they provided opportunities for public relations activities that bypassed traditional media; they served as raw material for appropriation and remixing; and they pointed to social media photography's role as a playful space for vernacular practice and interaction and, after Obama's presidency ended, political resistance. These functions are neither exhaustive of all that photography did in the White House, nor are they mutually exclusive. In fact, they were often in tension with one another.

PRESERVING FOR POSTERITY: THE FLICKR SITE AS A VISUAL HISTORY OF THE PRESIDENCY

The photostream visually chronicled the Obama presidency. In doing so, it built on the traditions of the most engaged White House photographers of the past by offering a behind-the-scenes view of the White House operations, with images that highlighted the work of the presidency and offered glimpses of the president as a person. Souza's regular behind-the-scenes access to the president and the daily operations of the White House authorized the archive's ethos as "authentic" as opposed to staged. Souza's repeated emphasis on the importance of his role as "visual historian"

constitutes what we might call the "posterity" function of the archive and corresponds with the ways many others who have held the job talked about its purpose. As David Hume Kennerly, Gerald Ford's photographer, put it, "I think the historical part is the overriding reason for doing it [the job of White House photographer] and everything else sort of comes along" with that.[63] While no one questioned Souza's commitment to or skill in capturing the president for posterity, some photojournalists did wonder whether "historian" was an appropriate descriptor. A 2009 article in *News Photographer* magazine asked this question of photographers and educators. One respondent said the label of "historian" was not appropriate, given the "gatekeeping and discussion by officials beyond him about what is released."[64] Another suggested that Souza might best be understood as a kind of "embedded photographer" or biographer, while yet another suggested that the term "personal photographer" might be more appropriate.[65] The fact that some were unwilling to let Souza get away with the label "historian" did not, however, mean that they believed his images did not have value as documents of history. Photographer MaryAnne Golon observed, "People don't understand later on how important those images can be; this most powerful position in the world needs to be documented."[66]

The White House cued the historic nature of Obama's presidency with the very first upload of images in April 2009, an album of images called "First Hundred Days." Themes of posterity and history were clearly on the mind of one commenter on the album who wrote, "Thanks for creating this Flickr stream. This will be a wonderful way to share with us a more personalized view of history in the making."[67] That notion of "history in the making" was punctuated in early 2010 when the Schomburg Center for Research in Black Culture exhibited seventy-seven photographs by Pete Souza made during Obama's first year. The press release announced that Souza's photographs, along with images by watercolorist Jerry Pinckney, "are together an excellent introduction to Barack Obama's first year as President and the centuries-long struggles of African Americans that made it possible."[68] The White House began to use the Flickr photostream to offer its own first draft of history via Pete Souza's "Year in Photos," in which Souza would curate seventy-five to one hundred photographs that he felt best represented the year. This album would become an annual and anticipated ritual. In 2015 Souza explained his process: "I not only found key historic moments from the year, but also chose moments that give people a more personal look at

the lives of the President and the First Lady."[69] This combination of "historic moments" and "personal look" served as the dual pillars of the posterity function of the Flickr photostream.

Perhaps no greater example of the power of photographs produced for history is the image known as the "Situation Room."[70] Made during the raid on Osama bin Laden's compound in 2011 and released to the media shortly thereafter, the Situation Room photograph embodied the ethos of visual history espoused by Souza and his predecessors. The photo visually stands in for a singular event in the history of the Obama presidency: the killing of 9/11 mastermind Osama bin Laden. And it does so by showing the key players in that decision tensely watching aspects of the raid unfold, seemingly in real time. The photograph offers the kind of documentary evidence one would expect of such an event, picturing who was in the room at a particular moment on that eventful day. At the same time, it communicates something of what it might have felt like to be in that room. The photograph became the singular image of the event (it even has its own Wikipedia page) and one of Flickr's most viewed images ever.[71]

A key rhetorical function of the photostream was to offer viewers a glimpse of historic events in the making. But not all of the White House

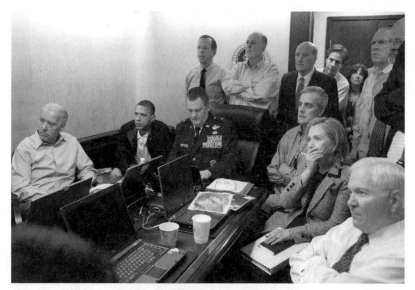

Figure 9.1: Pete Souza, "President Barack Obama and Vice President Joe Biden, along with members of the national security team, receive an update on the mission against Osama bin Laden in the Situation Room of the White House, May 1, 2011." (Official White House photo via Obama White House Flickr photostream.)

images carried the weight of history in so vivid a fashion. By offering re-
peated glimpses into what in Erich Salomon's terms might be called "inti-
mate" moments featuring President Obama, the Flickr site also preserved
for future generations an image of Obama the man. Perhaps the best known
of the photographs which illustrate this component of the archive for his-
tory is that of Jacob Philadelphia, a young boy who asked Obama if he could
touch his hair. The son of a departing staffer, Jacob met President Obama
in the Oval Office in 2009. After the boy asked the president if his own hair
was "just like yours," Obama bent over and told him to feel for himself. The
resulting image embodies nearly everything photography does to capture a
moment for history, a quick snap of the frame that for many encapsulates
the history-making qualities of the Obama presidency: a young African
American boy could not only meet the nation's first Black president but
could also touch him and identify directly, bodily, with him and potentially
see himself in him. It is no wonder that this photo hung on the walls of
the West Wing for Obama's entire presidency and that it, along with the
Situation Room photograph, features prominently in Pete Souza's popular
volume of his White House photographs, *Obama: An Intimate Portrait*.[72] A

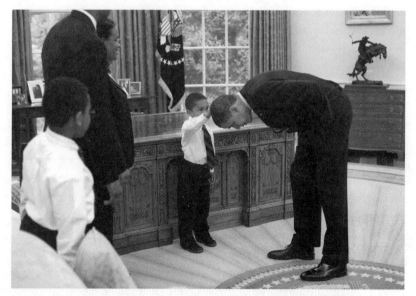

Figure 9.2: Pete Souza, "A temporary White House staffer, Carlton Philadelphia, brought his family to
the Oval Office for a farewell photo with President Obama," May 8, 2009. (Official White House photo via
Obama White House Flickr photostream.)

few years later Jacob's father, Carlton Philadelphia, recalled the cultural importance of the photograph: "It's important for black children to see a black man as president. You can believe that any position is possible to achieve if you see a black person in it."[73]

Photographs like the one with Jacob Philadelphia and the Situation Room made clear the value of having such behind-the-scenes moments preserved for posterity. But unlike previous administrations that distributed fewer official images for public consumption, thousands of these images made for posterity circulated on social media. While the Presidential Records Act mandates that every photograph created by the White House be preserved, the Obama Flickr photostream, curated in real time, showed only the images that Souza and the photo editors in the communications office wanted the public to see.

PUBLICIZING THE PRESIDENCY: THE FLICKR SITE AS PUBLIC RELATIONS EFFORT

As it grew on Flickr and circulated widely beyond it, the Obama White House's visual history served the purposes of the present as well. Social media enabled the administration to shape its own media coverage by producing and circulating content in ways previous presidents had not. Journalist Jennifer Senior acknowledged as much in 2009: "Obama, in fact, lives in a moment when he can finally do what his modern predecessors only dreamed of: go directly over the heads of the mainstream press." Senior called the White House Flickr photostream the best example of this practice, with its photographs "as perfectly composed as an old cover of *Life* magazine."[74] Senior's article in *New York* magazine was accompanied by photo illustrations constructed to highlight the president's visual ubiquity. One image conjured a newsstand with a crowded Times Square in the background. Obama's image appeared everywhere, overpowering the scene on every magazine cover on the newsstand, on every billboard and Broadway marquee, even on the top of a taxicab. In another photo illustration, the stairwell of a stereotypical suburban family house featured a framed gallery of "family photos"—a familiar enough scene, except that this photo gallery featured photographs of the president and his family taken from the White House Flickr feed. The photo illustrations' clever juxtapositions of the public and private Obama underscored both President Obama's direct visual access to the masses as well as the Flickr feed's tantalizing behind-the-scenes glimpses of the president as a person. Because the White House routinely

added to the Flickr photostream—a few times per month early on and later in the second term every few months—the archive grew organically over time. One result of this ongoing growth was that the release of new White House photographs to Flickr became a news event in itself. As online outlets of all kinds responded to the relentless demand for fresh content, blogs and mainstream media sites often reproduced the Flickr images and captions in their entirety, expanding the circulation of the White House's photographs far beyond the boundaries of Flickr's platform. In 2012, for example, *Business Insider* republished thirty of the White House's most recent Flickr photos under the headline "Barack Obama Is Having an Amazing Summer: Check Out the Photos," while the *Baltimore Sun* reproduced without any editorial comment or framing of its own thirteen more.[75] As a real-time public relations effort, the Flickr photostream became a key site from which the administration generated publicity and visual news. At the same time, it became a flash point for a White House press corps that grew increasingly frustrated with its own perceived lack of photo access to President Obama.

The Obama White House used Flickr not only to make behind-the-scenes photographs available to feed the online media beast but also to produce or accompany news. In some cases, White House photos seamlessly circulated in mainstream media, published in topical news stories or opinion pieces alongside photojournalists' images. This created the impression that they were just another kind of news photograph rather than images created by the White House. For example, in June 2009 the *New York Times* published a long essay by Matt Bai on the Obama White House's efforts to lobby Congress on health care reform. The story featured five photographs; the three that included President Obama were all White House photos.[76] Although they were credited as such, the effect of the intermingling of White House photos with photojournalists' images was that photographs circulated for publicity purposes were recast within a neutral photojournalistic frame. Some in the mainstream media took notice. "You don't have to alter photographs to make them misleading," wrote Dana Milbank in a 2013 op-ed in the *Washington Post*, when you can release photos that "go out on the White House's Flickr account and are picked up for free and repackaged by disreputable news services and published by unsuspecting media outlets."[77]

Flickr served not only as a storage site for the building of a real-time White House photo archive but also as a platform for photo releases. Photo

releases are one species of a broader public relations genus known as "hand-outs." Handouts play an important role in any White House communications operation as the administration seeks to get its own messages out and take control of the news cycle. The administration used Flickr to release specific photographs on topics ranging from the killing of Osama bin Laden to official portraits of the Obama family. The Situation Room photograph is by far the most famous example of a photo release. (See fig. 9.1.) Souza's photograph both captured a significant news event and became news itself. The photo gained public traction in part because photographs of bin Laden's corpse were not circulated in public; as a result, the Situation Room photograph came to stand in visually for the whole event, amplifying the president's role as commander in chief in a challenging moment of leadership.[78] Released along with eight other photographs via Flickr on the day after the bin Laden killing, the photo quickly became the subject of public debate, as well as the inevitable creation of memes.[79] Critics weighed in on the visual power of the image, noting how it simultaneously depicted the power of the presidency and showed the president as powerless in the face of an unfolding operation out of his immediate control.[80] They discussed whether Souza's photograph would achieve the status of "icon" as have so many other famous, widely circulated images in U.S. public culture, and analyzed its "accidental" and ambiguous qualities.[81] Viewers asked narrower questions too, such as why Secretary of State Hillary Clinton had her hand clasped over her mouth; was it the shock of seeing bin Laden killed? Clinton claimed she was suffering from allergies and probably suppressing a cough; furthermore, White House officials later clarified that the photograph did not picture the moment of bin Laden's killing, nor did those in the Situation Room see it.[82]

The photograph's caption was also notable. When a document visible on the table in front of Clinton was found to be classified, Souza asked for it to be declassified, but that request was denied. The decision was then made to pixelate the document on the table to blur its content and thus make the photograph viable for public distribution. The photograph was released with a caption explaining the digital alteration: "Please note: a classified document seen in this photograph has been obscured."[83] While there was no widespread public outcry about the digital alteration, the choice to release the photo despite the troublesome document highlighted the White House's investment in circulating a powerful image of a key event in Obama's presidency. Asked by an interviewer in 2014 why he had wanted

to release the photograph despite its classified content, Souza said, "I just felt that it was such an important photograph, as did my colleagues in the Communications Office."[84]

The photojournalists assigned to cover the White House did not openly object to Souza's exclusive on the bin Laden images; given the covert nature of the operation, they could hardly expect to have been invited to cover that moment themselves. Yet photojournalists covering the White House did object to the distribution of photo releases as official records of public events to which they were not given access. On President Obama's second full day in office, Dennis Brack, the president of the White House News Photographers Association, wrote to Obama chief of staff Rahm Emanuel to protest how the White House had handled Obama's "re-swearing in." Chief Justice John Roberts had botched the oath of office on Inauguration Day, causing Obama to transpose words in the oath such that it was deemed prudent to attempt a do-over two days later. While press pool reporters were invited to the short ceremony as witnesses, and *Time* magazine photographer Callie Shell, on special assignment to photograph Obama's first days in office, was also present, White House press photographers were not; a photo handout of the moment as captured by Pete Souza was released instead.[85] That same day, Brack wrote to Emanuel, "In the first days of the Obama administration events have taken place that an open and free press were not able to see." Brack went on to argue that it was not enough to have a photo release from Souza, who was not currently working in the capacity of a news photographer.[86]

Similar issues continued to appear. In March 2010, reporters queried Press Secretary Robert Gibbs about why no press was to be present to cover the signing of an abortion-related executive order.[87] The following exchange ensued:

> **Q:** You also have an event today where you're signing—the President is signing an executive order on abortion that is a pretty big national issue. Why would that be closed press, no pictures?
> **Gibbs:** We'll put out a picture from Pete.
> **Q:** But what about a picture from the actual national media, not from—
> **Gibbs:** Oh, the picture from Pete will be for the actual event.
> **Q:** Right, but what about allowing us in, for openness and transparency?
> **Gibbs:** We'll have a nice picture from Pete that will demonstrate that type of transparency.

Q: Not the same, Robert. Never has been.

Gibbs: I know you all disagree with that. I think Pete takes wonderful photos.[88]

Members of the press were quick to point out that they were not criticizing Souza, but rather the issue was the lack of opportunity to make and circulate photographs without a "government filter."[89]

The accumulation of newsworthy images released directly to Flickr increasingly frustrated photographers in the White House press corps. Things came to a head in late 2013 when close to forty news organizations and journalism associations, including the White House Correspondents' Association and the White House News Photographers Association, collaborated on a letter to White House press secretary Jay Carney to complain about the lack of visual access to the president.[90] The letter noted instances where the White House had not allowed photographers access to presidential activities but then had gone ahead and released its own photographs of the same event later.[91] Examples included a photograph of Obama and his daughter Sasha going for a swim in the Gulf of Mexico to demonstrate that the water was safe after the BP oil spill, a Pete Souza photo of which was later released and widely circulated, and a so-called private meeting between Pakistani activist Malala Yousafzai and the president, first lady, and their daughter Malia, while Souza's photograph of the moment was released to the press.[92] Of these and other moments where press photographers were excluded, the letter to Carney stated, "As surely as if they were placing a hand over a journalist's camera lens, officials in this administration are blocking the public from having an independent view of important functions of the executive branch of government."[93] *New York Times* photographer Doug Mills observed of these practices, "The way they exclude us is to say this is a very private moment. . . . But they're making private moments very public."[94] J. David Ake of the Associated Press invoked the idea of journalism as the first draft of history: "The core issue is the White House uses [Souza's] images and disseminates them to the public, and they become the only historical document of events."[95] Souza was occasionally asked about the controversy in interviews. He pointed out that as someone who had also covered the presidency from the outside, he understood the frustrations. But he disagreed that photographers were not getting access. "This administration has done a really good job of trying to bring photographers in," he said on *Charlie Rose*, mentioning Callie Shell's early access, as well

as that of "a dozen different photographers."[96] While the administration made some concessions and relations with the White House visual press improved (to the extent that they ever can), it also ramped up its own social media activities as new platforms like Instagram offered even more opportunities for circulating the president's visual image.

At the same time they criticized the White House, some journalists also chastised themselves for uncritically circulating White House images. Photographer Stephen Crowley of the *New York Times* argued that the problem was not so much when the media were shut out of an event but when the media willingly used White House handouts.[97] The American Society of Newspaper Editors also weighed in, issuing a letter to its members in late 2013 stating that if they would not run verbatim a White House press release, then they should also stop using White House photographs and videos.[98]

COPYRIGHTING THE PRESIDENCY: FLICKR AS A SITE OF CONTESTATION OVER USE AND INTERACTIVITY

The examples discussed thus far position the Flickr photostream as a broadcast medium—a place to present history in the making and a site for presidential publicity. In both of these instances, the archive function of Flickr was foregrounded. But Flickr served as more than just a virtual photo album; it also emphasized active engagement among users. Thus it should not be surprising that new cultural and legal questions of use, ownership, and interactivity emerged in the context of the Obama Flickr site. When the White House launched the photostream in April 2009, it initially designated the images with a Creative Commons Attribution license, the same type of licensing that the Obama campaign had used for its Flickr site.[99] The Attribution license "lets people reuse, reprint and remix the photos just as long as they credit the original photographers."[100] This designation was the most permissive Creative Commons license available, so it initially appeared as though the Obama administration was going to embrace the spirit of the age and encourage liberal use of and engagement with its images.

Yet the same day the feed was launched, conversations bubbled up from inside of tech blog circles, wondering why the White House's images needed to be licensed at all.[101] As documents produced by the U.S. government, the photographs were in the public domain and therefore could not be copyrighted. The answer to the question quickly emerged: Flickr did not

provide its users with the option to designate their images as public domain images.[102] Writing in another context, Flickr's cofounder Stewart Butterfield explained Flickr's reasons. First, public domain status is difficult to verify, and Flickr did not want to take on potential liability if it turned out that an image declared to be in the public domain was not. In addition, while Creative Commons licenses could be changed, Butterfield pointed out that once declared, a public domain designation could never be revoked.[103] The Electronic Frontier Foundation's Hugh D'Andrade explored the question with regard to the Obama White House and pointed out that Flickr did in fact offer an existing option through its Commons project, where institutions like the Library of Congress and the Smithsonian could designate a photo as having "no known copyright restrictions."[104] D'Andrade suggested, "The White House should reconsider its licensing approach, and work with Flickr to flag these government works in the same way. This Administration is pioneering the use of the Internet to reach out to citizens—and part of the precedent it should set is a clear recognition that publicly funded government works should be free to the public, without the burden of copyright and licensing restrictions."[105]

Just days later, *Wired* magazine reported that Flickr worked with the Obama White House to create a new designation, "U.S. Government Works," for the White House to use, and images on the photostream began to carry that label.[106] Creative works with this designation are "usually produced by government employees as part of their official duties" and therefore do not fall under copyright law, because government works are in the public domain.[107] Presumably this designation better fit the purposes of a visual archive being created by U.S. government staff in real time rather than the museum and archive images for which the "no known copyright restrictions" label was being used.

Issues of use and ownership emerged again in October 2009 when Flickr users noticed that a new, sternly worded statement now appeared on the White House Flickr site, appended to the caption of each image in the photostream: "This official White House photograph is being made available only for publication by news organizations and/or for personal use printing by the subject(s) of the photograph. The photograph may not be manipulated in any way and may not be used in commercial or political materials, advertisements, emails, products, promotions that in any way suggests approval or endorsement of the President, the First Family, or the White House."[108]

Tech writers soon publicly discussed the change. Tim Lee asked on Twitter, "White House Flickr feed says pictures 'may not be manipulated in any way.' Any basis for that?"[109] Mike Masnick of Techdirt.com quoted Lee's tweet and explored the question in a blog post. After recounting the initial licensing issue of attribution versus public domain, Masnick wrote, "It appears that the White House is now trying to claw back some of the rights over these photos that it just doesn't have. . . . The problem is the White House has no right to say that you can't manipulate the photo, since the photo is public domain."[110]

The photostream's new warning gained visibility a few months later after being erroneously interpreted as the White House's response to two incidents that occurred within days of one another in January 2010, when it was revealed that images of the first lady and president had been used in advocacy and advertising campaigns without their permission.[111] People for the Ethical Treatment of Animals (PETA) reproduced Michelle Obama's official first lady photograph (made by Pete Souza) in an anti-fur ad. Included alongside images of celebrities Carrie Underwood, Tyra Banks, and Oprah Winfrey with the headline "Fur-Free and Fabulous!" the image of Mrs. Obama had not been approved by the White House for PETA's use.[112] Around that same time, an Associated Press photograph of the president wearing a Weatherproof Garment Company jacket while visiting the Great Wall of China appeared on a large billboard erected by that clothing company in Times Square.[113] The White House criticized both organizations for using the images without consent. Within days, PETA withdrew the ad and Weatherproof Garment Company agreed to take down the billboard.[114] While the photostream's new warning about use appeared before these high-profile appropriations of the Obamas, and the billboard's image of the president was not a White House photo, the incidents nevertheless seemed to suggest a new wrinkle in the White House's approach to the Flickr photographs.

It appeared that the White House wanted it both ways. By designating the Flickr images "U.S. Government Work," the White House affirmed that the photographs were not subject to copyright. But it also wanted to tap into the few exceptions to that rule, including the norm that images of U.S. government workers and government logos should not be used "in a way that implies endorsement by a government agency, official, or employee."[115] Yet as Lee and Masnick hinted a few months earlier, the

new statement was heavy-handed and did not have legal legs to stand on. First, each image on the White House Flickr photostream was designated "U.S. Government Work," a label that appeared with a direct link to U.S. copyright law declaring that image to be free from copyright restrictions and stating that users could, among other things, "reproduce the work in print or digital form," "create derivative works," "perform the work publicly," and "display the work."[116] The statement allowing the creation of "derivative works" seemed to directly contradict the new warning's prohibition of manipulation "in any way." Second, commentators pointed out that as U.S. Government Work, all of the photos had been paid for with taxpayer money, so it was inappropriate to deny members of the public the opportunity to use what was technically theirs.[117] In addition, as the next section of this chapter vividly illustrates, in the age of memes it was impossible to avoid the inevitable remixing of the Flickr images. Even if the White House wanted to maintain tight control, social media users had other ideas. Finally, even the White House seemed uninterested in enforcing its own warning. In a February 2012 press briefing, ABC news reporter Ann Compton asked Deputy Press Secretary Josh Earnest about an official White House holiday portrait of the Obama family that was appearing in an internet ad for the president's reelection campaign: "Does the campaign buy the rights to photographs from official White House government photographs and video? Does it have free access to all government video and pictures taken of the president?" Earnest asked Compton whether the image in question was "a photo that's available on our Flickr website." Compton confirmed that it was, and then Earnest replied, "What we have found is that a whole lot of people who have access to the Flickr website use these photos for a wide range of reasons—whether to put them on their Facebook page, to send them to their friends because they think they're interesting—." Compton jumped in: "But they cannot be used for commercial—." Earnest replied, "They cannot be used for commercial uses, that's true. But we've also seen a number of political campaigns, certainly in 2010, that used . . . photos off the Flickr website and incorporated them into their television advertisements and other advertisements." After Compton pressed him further, Earnest concluded, "My understanding about the way that that material that's publicly released is, is that with the exception—the commercial uses exception that

you stipulated—that these are basically items in the public domain."[118] Josh Gerstein of Politico described this exchange and reminded readers that the White House Flickr warning on the images was not only about commercial uses. It also referenced "political materials" like those the Obamas had circulated in the online ad that Compton referenced, as well as in another fund-raising email sent in late 2011. For Gerstein, Earnest's admission that the images were in the public domain confirmed that even the White House knew its photo warning was "mostly bluster." If the White House were following its own rules, then the campaign would not be able to use Flickr photographs of the president because of the White House photostream's "ban on political use of the photos."[119]

A final tension regarding use and interactivity emerged during the first year and a half of the Obama administration, but it got less public attention. Call it "The Case of the Disappearing Comments." Flickr's platform aspired to be a space not only for sharing images but also for conversation and interaction. This focus held true for the Obama White House's initial use of the site. At first the photostream allowed user comments. Because Flickr was favored by professional and amateur photographers, many of these comments noted the quality of the shots or asked questions about Souza's camera or the conditions in which the photographs were made. Predictably, other comments offered political approval or disapproval of Obama himself, and some of those ideological conversations got messy.[120] The question of the difference between impassioned political conversation and spam or trolling—always difficult for social media sites to navigate—emerged on the White House photostream early on. Flickr required users to sign in with a Flickr account to be able to participate in the community and comment on images. Perusal of the photostream's comments from 2009 and early 2010 makes it clear that several users likely set up Flickr accounts mainly to criticize the president and his policies. (On the archived Obama site, many of these accounts now show as "deleted," though the comments themselves remain visible.) A few users violated the site's terms of service to such an extent that Yahoo! (which at the time owned Flickr) banned their accounts from the site. A user named Shepherd.Johnson, for example, garnered media attention in June 2009 when Yahoo! banned him from Flickr after he left multiple comments in a row on images from Obama's 2009 trip to Cairo.[121] Johnson claimed that Yahoo! deleted twelve hundred images from

his paid "pro" account after he "protested the Obama administration's policy on torture photos."[122] Yahoo! implied that Johnson's account was removed because he had violated Flickr's community guidelines.[123]

Although the incident did not generate an official response from the White House, the White House eventually elected to eliminate comments altogether. After June 2010 no photographs uploaded to the White House Flickr photostream allowed the option to leave a comment, though users could still flag a photograph as a "favorite." Furthermore, this change went unremarked upon by the White House or the news media at the time. Pete Souza later recalled that he had become increasingly disturbed by the tone of the comments, specifically their use of profanity and derogatory language. He asked the White House counsel's office about whether comments could be moderated or whether they could block users or ask Flickr to do so and was told that First Amendment considerations would preclude that. He explained:

> Meanwhile, the comments kept getting worse. One day I received an email from a middle school civics teacher that the Flickr photo stream had become a great tool for teaching her kids about the Presidency, but she had made a decision (I can't remember if it was a school decision) to not show the photos any more because of the vulgar language. That was the final straw for me. I turned the comments off that day. Then I went to see the White House counsel and told her that I had solved the problem. When I told her what I had done, she smiled and said that she couldn't make an argument that I couldn't do what I did.[124]

Souza's account of turning off the comments illustrates perhaps better than anything the tensions surrounding ownership and interactivity at play with the White House Flickr photographs. The Flickr site's potential educational value to schoolchildren ultimately meant more to Souza than the "anything goes" comments sections that dominated early social media sites. In this way the Obama White House Flickr photostream not only collected photographs; it also captured key debates and conversations about photography in the age of social media. These debates embedded themselves into the photostream itself, in ways both explicit (the addition of the stern but unenforceable warning, the U.S. Government Work designation) and implicit (the disappearing comments). These nonphotographic presences and absences are very much a part of the story of what social media did to photography in the Obama era.

REMIXING THE PRESIDENCY: FLICKR AS RESOURCE
FOR VERNACULAR PLAY AND SITE OF RESISTANCE

While the White House tried to control who might use the photographs it posted to Flickr, social media culture had the last laugh. The photostream lived—and continues to live—in a visual culture of remixing, appropriation, circulation, and play.[125] In fact, most viewers likely encountered the Obama images not by directly accessing them on Flickr but by encountering them as part of listicles, gifs, and memes that remixed the photographs in playful or pointed ways. After Obama left the White House, when Pete Souza began using his Obama images to criticize President Donald Trump, the Flickr feed arguably also became a site of political resistance. If the Obama White House did not always achieve its lofty goals for citizen interactivity, the public nevertheless made good use of its social media imagery. Circulating and appropriating the Obama Flickr images in ways that went far beyond the boundaries of the platform itself, the public embraced photography's new visual values of sharing and remixing.

The push to not just view but also use the images emerged immediately after the site debuted, with one article even using its headline to announce, "Official White House Photos on Flickr, Ready for You to Photoshop."[126] Beginning in the mid- to late 2000s, sites like *Buzzfeed* emerged to produce and circulate viral content online. *Buzzfeed* made regular and repeated use of the Obama Flickr site. In honor of President Obama's fiftieth birthday, in 2011, *Buzzfeed* shared "The 50 Best Photos of President Obama from the White House's Flickr Stream."[127] Features like "Four More Years of Barack and Michelle Being Adorable Together in the White House" (featuring twenty photos of the president and first lady dancing, holding hands, or looking lovingly into each other's eyes) or "All the Times Obama Lost His Chill around Kids" mobilized the White House Flickr photostream to highlight aspects of the president's personal character such as the Obamas' seemingly ideal companionate marriage, his love of children, and his "no drama" personality.[128] These and other social media appropriations of the Flickr site's photographs on Twitter and Tumblr reanimated the visual themes of Souza's behind-the-scenes images and arguably benefited the Obama White House even as it had little control over them.[129] Even material critical of Obama administration policy did not stray far from playful framing. After Edward Snowden leaked classified government data in 2013, *Buzzfeed* participated in the widespread "Obama Is Reading Your Emails"

meme by curating a gallery of Flickr photos of Obama looking at screens that it called "Photos of Obama Reading Your Email."[130] As the Obamas prepared to leave the White House, *Buzzfeed* launched a flurry of Obama-themed collections, including "33 Pictures of the Obamas That Will Restore Your Faith in Love," "44 of the Most Iconic Pictures of President Barack Obama," and, in a video slideshow accompanied by tinkling piano music, "22 Photos That Will Make You Miss Obama."[131] Some beyond the media went much further than simply reproducing the images; *Huffington Post* reported that a Cleveland, Ohio, couple recreated the poses of several of

POLITICS

All The Times President Obama Lost His Chill Around Kids

Can you blame him?

David Mack
BuzzFeed News Reporter

Posted on November 2, 2015, at 1:07 p.m. ET

🐦 Tweet ☐ Share ⊘ Copy

This Halloween, President Obama <u>totally lost it</u> **when he met this little kid dressed up as the pope at the White House.**

Figure 9.3: Screen shot of David Mack, "All the Times President Obama Lost His Chill around Kids," *Buzzfeed*, Nov. 2, 2015.

the best-known White House photographs of the Obamas for their own engagement pictures.[132]

Photographs from the Flickr photostream also regularly appeared in memes. Meme archives such as KnowYourMeme.com document thousands of Obama-related memes, and official images from the White House feature in a number of them. The Situation Room photograph immediately generated memorable memes. One inserted the MTV reality show star "The Situation" into the photograph, while others added superhero costumes to everyone in the picture and Photoshopped in popular culture figures such as Big Bird, Elvis, and Pee Wee Herman.[133] Official White House photographs featuring President Obama and Vice President Joe Biden became regular fodder for memes depicting the so-called bromance between the two leaders. These memes drew upon the president and vice president's well-known deep affection for each other and typically featured Biden as prankster and Obama as straight man.[134] (President Obama even used one of the most popular of these to wish Biden a happy birthday on Twitter.[135]) Not all memes were positive or playful, however. Racist imagery that had appeared during the 2008 campaign followed Obama into the White House and continuously circulated in popular culture; any Google Image search revealed racist memes featuring Obama to be easily accessible.[136]

Figure 9.4: Situation Room photograph meme, 2011, KnowYourMeme.com.

In addition to serving as raw material for memes, in at least one case the photostream featured President Obama participating in a popular meme. During the summer of 2012, gymnast McKayla Maroney infamously offered a disgruntled smirk on the medal stand after having to settle for a silver at the London Olympics. Within hours, photographs of Maroney's smirk circulated in a variety of memes labeled "McKayla is not impressed," including (inevitably) the insertion of her smirk into the Situation Room photo.[137] In November of that year, the U.S. Olympic Gymnastics Team visited the White House. Souza photographed Maroney in the Oval Office with President Obama, each of them mimicking the famous smirk.[138] The photograph, released a few days after the visit, illustrated to some that the president, who had apparently asked Maroney to pose with him doing the "not impressed" face, was delightfully up to speed on popular culture.[139] But Mike Masnick of TechDirt.com noted that Obama's willingness to participate in a meme ironically contradicted the White House photostream's own warning about not appropriating its images. Masnick said the Oval Office photo proved that the warning was "*especially* ridiculous since the *entire reason* the 'McKayla is not impressed' meme became so popular was the memegeneration of putting her displeased face into various other images."

Figure 9.5: Pete Souza, "President Obama jokingly mimics U.S. Olympic gymnast McKayla Maroney's 'Not Impressed' look while greeting members of the 2012 U.S. Olympic gymnastics teams in the Oval Office, Nov. 15, 2012." (Official White House photo via Obama White House Flickr photostream.)

Masnick then concluded his post with a meme of his own that technically violated the White House warning: the Flickr photo of Obama and Maroney doing "not impressed" superimposed over the words of the White House's photo warning.[140]

As "McKayla is not impressed" illustrated, the photostream not only pictured the president and his activities; it also indexed quickly changing social media practices and performances. Another feature of social media performance that the photostream indexed was the rise of selfie culture. The selfie, a self-portrait made with a mobile phone and shared via social media, is not just a portrait; it is also a powerful mode of self-representation.[141] While the practice of self-portraiture had been around since the very beginning of photography (the first daguerreotype produced in the U.S. was a self-portrait by Robert Cornelius[142]), the rise of mobile phone photography and especially the introduction of the front-facing camera fueled the practice.[143] The selfie blurs the boundaries between public and private in that it is explicitly designed to be shared with others while at the same time functioning like a personal snapshot.[144] Often derided as narcissistic, inappropriate, or even deadly, selfies nevertheless became a cornerstone of photography in the social media era.[145] It is no surprise, then, that hints of the rise of selfie culture dotted the White House Flickr photostream. A photograph of President Obama posing for a selfie with a diner patron in Iowa in 2010 showed the woman making the picture with the back-facing camera of a flip-phone; the term "selfie" does not appear in the caption, however, because it was not yet in common use.[146] By 2013 the term itself gained traction; in fact, the selfie had gone mainstream to such an extent that Oxford Dictionaries named it "word of the year."[147] Just a few weeks after this announcement, President Obama himself became embroiled in conversations about the propriety of selfie practices when he and British prime minister David Cameron participated in a selfie made by Danish prime minister Helle Thorning-Schmidt at Nelson Mandela's memorial service in South Africa.[148]

The Obama White House Flickr photostream contains thirteen photographs that include the term "selfie" in the caption, all made between 2013 and 2015. The term first appeared in quotation marks in a caption for a photograph depicting First Lady Michelle Obama making a selfie with the first family's dog, Bo, as part of a *National Geographic* magazine effort to create the world's largest online photo album of animals.[149] The other selfies in the Flickr feed dropped the quotation marks (indicating the newness of

Figure 9.6: Pete Souza, "President Barack Obama poses for a photo with a patron at Jerry's Family Restaurant, a diner in Mount Pleasant, Iowa," April 27, 2010. (Official White House photo via Obama White House Flickr photostream.)

the term had worn off) and consisted primarily of images of the president and first lady posing with high-profile White House visitors (celebrities and athletes) or children. Perhaps the image that best illustrated how the selfie was changing photography was a Pete Souza photograph that did not actually picture the president at all. Made in 2014 in Austin, Texas, the image featured a trio of young women sitting at a restaurant table, posing for a group selfie. Behind them, an older man aimed his own phone camera at something beyond the women, across the room and offscreen. Only by reading the caption would the viewer realize what actually was being pictured: "Patrons pose for a selfie as President Barack Obama greets people at the Magnolia Cafe."[150] While the older man pointed his camera at Obama to get a picture of the president, the young women making the selfie were clearly putting themselves into the picture *with* the president. The photostream not only chronicled the president and first lady's participation in selfies; it also illustrated how the practice of making selfies was changing people's relationship to photography itself.

As the 2016 election came and went and the Obama administration drew to a close, I assumed that the White House Flickr photostream would become old news. What I could not predict was what Pete Souza

Figure 9.7: Pete Souza, "Patrons pose for a selfie as President Barack Obama greets people at the Magnolia Cafe in Austin, Texas," July 10, 2014. (Official White House photo via Obama White House Flickr photostream.)

would do with his newfound freedom as a private citizen. Within days of Trump's inauguration, Souza turned his now personal Instagram feed into an ongoing commentary on the Trump presidency. Significantly, he did so by appropriating and recirculating official Obama photographs to critique the unfolding chaos and daily dramas of the Trump White House. On Trump's first full day in office, after news emerged that Trump had replaced the Obama-era rust-colored drapes in the Oval Office with gold ones, Souza posted a photograph of President Obama in the Oval Office to Instagram with the caption, "I like these drapes better than the new ones. Don't you think?"[151] Subsequent posts quickly grew more political. On January 31, 2017, the day Trump announced Neil Gorsuch as his Supreme Court nominee, Souza posted a photograph of President Obama and his rejected choice for that same seat with the caption "Merrick Garland. Just saying."[152] Souza's posts, perfectly pegged to the news of the day, quickly snagged him close to 2 million Instagram followers (significantly higher than his Obama-era number of 744,000) and earned him the nicknames "Chief Troll" and "King of Instagram Shade."[153] Souza's posts became so popular that Washington, DC, writer Ruth Tam tweeted a tongue-in-cheek quiz to her Twitter followers:

Figure 9.8: Pete Souza, "Merrick Garland. Just saying." Instagram, @Pete Souza, Jan. 31, 2017.

How do you get your news?
 (a) Washington Post
 (b) New York Times
 (c) NPR
 (d) Reading Pete Souza's Instagram captions and working backwards.[154]

Souza's Instagram feed was a surprising mobilization of the Obama archive, yet one completely in keeping with the playful, pointed practices of the social media age. Relying on strategies of antithesis, juxtaposition, and analogy, Souza used the White House visual archive to highlight the personal and policy differences between Trump and Obama. The resulting Instagram narrative effectively turned the Obama White House photographs into a resource for resistance and activism. It also garnered Souza another book deal; in 2018 he published *Shade: A Tale of Two Presidencies*, which paired his Instagram posts and Obama photographs with items from the news and Trump's Twitter feed.[155] Souza's remixing of the Obama images offered more than critique of the new president, however. Especially in the first year or so of Trump's presidency, Souza's Instagram feed kept Obama's visual image present in the public sphere when the former president himself was largely absent. As a result, the Obama presidency was in

effect reanimated each time Souza reposted a visual fragment of it. That renewed visibility capitalized on many of the same aspects of the Flickr site that I have already discussed. Theoretically, anyone could have performed the same visual critique with White House Flickr photostream images, because they are in the public domain. But because it was Souza himself posting the images, they carried the authority of the office and of his previous, high-profile position. Souza's juxtaposition of Trump to Obama also reflected the carefully curated publicity aims of the Obama White House, boosting the Obamas' own visual brand beyond the temporal boundaries of his presidency at the expense of Trump. Finally, it is also worth noting that Souza's Instagram shade operated largely in a vacuum—not only because of the absence of Obama but also because the Trump team could not offer a suitable visual rejoinder to the Obama visual archive. Trump hired a chief photographer, Shealah Craighead, who had worked as Laura Bush's photographer during the second Bush administration.[156] They uploaded photographs to a White House Flickr photostream and posted images in other social media outlets as well. In August 2019, roughly two-thirds of the way through Trump's single term, the Trump White House Flickr photostream surpassed the total number of photographs posted by Souza's team to the Obama site across the full two terms.[157] Ever watchful, Souza marked the occasion on his Instagram feed with a photograph of President Obama on Inauguration Day in 2009 and a note: "So I guess Comrade Minus [his nickname for Trump] has us beat on that."[158] Craighead and her team's access to the president was much more limited than Souza's, and the Trump Flickr site showed none of the thoughtful editing or careful curation that is a hallmark of the Obama site. Michael Shaw wrote in *Columbia Journalism Review* of the Trump Flickr site's early imagery: "What hasn't drawn broader media attention—saturated as we are by social media and the notion today that 'everybody is a photographer'—is the haphazard, do-it-yourself approach to both the marketing and the historical documentation of Trump's presidency."[159] The Trump White House photos were no match for Souza's intimate behind-the-scenes pictures.

By depicting broader cultural performances such as memes and selfies, the Flickr site not only built an archive of the Obama presidency, but it also participated in a culture of remixing and indexed a history of vernacular practices of social media photography. Even years after Obama left office, it has continued to serve as a resource for invention and critique.

What Social Media Did to Photographic Presidents

It may be tempting to understand the Obama Flickr site as simply a product of the new visual values of the social media era. Indeed, it almost perfectly embodies photography culture of the early twenty-first century. We are now able to share and remix seemingly every image that we encounter in an endless series of gifs, memes, and other viral creations. The Obama White House embraced the visual values of sharing and remixing across all of its communications, and the Flickr site serves as an exemplar of the digital practices of the White House's first "social media ninja." Yet, as I have argued throughout this book, new visual values also tend to run up against more established cultural norms. The social media era is no different. As much as the Obama administration embraced the ethos of sharing and remixing, it—like other administrations before it—also sought to carefully control the president's image. In doing so, it created a visual archive that embodied those seemingly contradictory goals. The Obama Flickr site functioned simultaneously as a historical repository, a real-time public relations effort, a chronicle of the challenges of interactivity, an index of vernacular practice, and, after Obama left office, a site of resistance. The story of what social media did to photography in the Obama era is a story of how tensions between control and interactivity played out amid the early twenty-first century's new visual values of sharing and remixing.

Conclusion

The Portrait Makes Our President

I want to conclude by sharing a brief story about the book that I *didn't* write. In the early stages of designing this project, I met with two campus colleagues, the late Nancy Abelmann and Maria Gillombardo, to talk through my idea for a book on presidents and photography. Nancy, as charismatic as she was brilliant, told me that what I *really* should write about was Barack Obama's use of photography. A whole book on Obama, she argued with her characteristic enthusiasm, was what folks would want to read and was a book I was perfectly positioned to write. I told Nancy I didn't want to write that book. She asked me why not. We bantered back and forth on this question for some time. In the end I managed to convince her (or myself, really, for I suspect Nancy had ulterior motives) that I wasn't all that interested in how Barack Obama, or any president, used photography. Rather, I wanted to explore *how presidents became photographic.* In what ways, I wanted to know, did photography shape public experience, and how might studying presidents' engagements with the medium provide insight into those ways? Although I didn't fully understand it at the time, I soon learned that writing about photographic presidents instead of presidential photography would require focusing less on presidents and more on the history of photography and its moments of technological transformation. It would

also require me to entertain the possibility that some presidents who typically have been studied for their image-making prowess, such as Lincoln, Theodore Roosevelt, Kennedy, and Reagan, might need to take a backseat to less visually exciting but more photographically intriguing figures like John Quincy Adams, McKinley, and Hoover. Obama would need to be a central figure in such a book but less for his obvious visual charisma than for what his photographic engagements might tell us about photography in the early twenty-first century.[1]

In 1861 orator and activist Frederick Douglass declared, "The portrait makes our president."[2] He was likely speaking of Mathew Brady's Cooper Union photograph of Abraham Lincoln. Douglass knew a thing or two about the medium. He sat frequently for photographers from the early 1840s until his death in 1895 and lectured widely on the cultural value of photography. While Brady and Cooper Union may have helped Lincoln become president in an instrumental sense, Douglass's point needs to be interpreted more broadly. He understood that photography had the capacity to be more than just a political tool. Douglass knew that photography makes things matter; it shapes our visions of leadership and helps define who we are. In stating that the portrait makes our president (note especially the word *our*), Douglass implied that the story of the Cooper Union photograph was not just about the importance of a presidential photograph. It also chronicled the emergence of a photographic president in the national landscape of visual culture.

What, then, have we learned about photographic presidents by studying them from daguerreotype to digital? First, photographic presidents are shaped by the modes of representation that dominate their era. All media were once new media, and photography is no exception. From daguerreotypes and snapshots to candid images and social media, technological changes in the medium transform the ways presidents visually engage. In addition, because of their elite status and role as symbols of the nation, photographic presidents often serve as the visual equivalent of canaries in the coal mine. That is, while all of us confront and adapt (or don't) to new kinds of photography as they emerge, presidents often do it first and always do it more publicly—even if, like Washington and McKinley, they are not present in body. Photographic presidents are also challenged by and required to adapt to new visual values that emerge at moments of photography's technological transformations. Their encounters with photography across

its history affirm that photography is not only a medium, a science, an art, a technology, and a rhetoric, but also a site of tension where new visual values emerge and play out over time. In my stories of the daguerreotype presidents (Washington and Adams), the snapshot president (McKinley), the candid camera presidents (Hoover and FDR), and the social media president (Obama), I have chronicled how these visual values emerged and were activated through presidents' engagements with photography.

The daguerreotype's new visual values of *fidelity* and *wonder* made it possible to "photograph" Washington while at the same time raising questions about the new medium's capacity to present a stable image of national character. John Quincy Adams's experiences of sitting for daguerreotypes were marked by frustration, failure, and disappointment. Privileging fidelity to "nature" but with a touch of magic, the daguerreotype promised a faithful reproduction of sitters. For Adams, however, this was precisely the problem. That very fidelity operated in tension with the norms of republican portraiture. While photography promised to photograph people as they were, Adams wanted portraits of them as they should be. The desire for "true portraiture" clouded Adams's engagements with photography.

The amateur snapshot and news photograph privileged the visual value of *timeliness*, raising expectations for photography's capacity to capture events instantaneously. Faster, smaller cameras and new spaces for reproduction and circulation of images seemed to satisfy the demand for a timely photography that could capture newsworthy moments. McKinley's visit to the Pan-American Exposition should have been a testament to the value of these new visual capacities. Yet when McKinley was shot, photography could not keep up. The nagging absence of an actual photograph of McKinley's assassination illustrated how timeliness could be thwarted by unstable situational and technological factors. Despite photographers' best efforts, some events just could not be "successfully snapshotted."

The candid camera's visual values of *access*, *intimacy*, and *energy* introduced new ways of picturing leadership. Photographers like Erich Salomon exploited the new, small, portable cameras as ways to infiltrate political spaces previously closed to everyday people. As a result, political leaders were forced to confront the implications of such photographic intrusions. To be a "candid" president opened one to being captured informally, in ways that would provide viewers new insight into one's character. While Hoover largely failed at the performance of "candid," Roosevelt skillfully performed

it while simultaneously seeking to control it. The candid camera thus amplified early twentieth-century cultural and political tensions regarding what was public and what was private.

The social media photograph emphasizes the visual values of *sharing* and *remixing*. While the Obama White House sought to participate in the Web 2.0 culture of interactivity, it also needed to control the president's visual message. As a real-time archive of the Obama presidency that spawned a million memes, the Flickr photostream embodied tensions between control and interactivity as the Obama White House sought both to participate in and manage a largely unmanageable visual culture.

We tend to treat photography as if it is a coherent medium, but photography is not and never has been only one thing. What we call "photography" is a diverse set of technologies, tools, practices, and performances that change over time in ways that transform not only the medium but also the basis on which we evaluate visual experience itself. If, to paraphrase Douglass, photography makes our president, then this book has also shown the reverse: that the president makes our photography. That is, exploring photography's changing visual values through the lens of photographic presidents offers the opportunity to see the history of photography with fresh eyes.

Notes

Introduction

1. Vanessa B. Beasley, *You the People: American National Identity in Presidential Rhetoric* (College Station: Texas A&M University Press, 2004); Mary E. Stuckey, *Defining Americans: The Presidency and National Identity* (Lawrence: University Press of Kansas, 2004). See also Anne Norton, "The President as Sign," in *Republic of Signs: Liberal Theory and American Popular Culture* (Chicago: University of Chicago Press, 1993), 87–121.

2. One exception is Robert A. Mayer, "Photographing the American Presidency," *Image* 27, no. 3 (1984): 1–36. Mayer wrote this survey, which features the George Eastman Museum's collection of presidential photographs, to accompany a 1984 exhibit by the same name.

3. Harold Holzer, *Lincoln Seen and Heard* (Lawrence: University Press of Kansas, 2000); Richard S. Lowry, *The Photographer and the President: Abraham Lincoln, Alexander Gardner, and the Images That Made a Presidency* (New York: Rizzoli, 2015); David M. Lubin, *Shooting Kennedy: JFK and the Culture of Images* (Berkeley: University of California Press, 2003); Cara A. Finnegan, "Picturing Presidents: Visual Politics Inside the Obama White House," in *The Rhetoric of Heroic Expectations: Establishing the Obama Presidency*, ed. Justin Vaughn and Jennifer Mercieca, 209–234 (College Station: Texas A&M University Press, 2014).

4. Dennis Brack, *Presidential Picture Stories: Behind the Cameras at the White House* (self-pub., Dennis Brack Inc., 2013); George Tames, *Eye on Washington: The Presidents Who've Known Me* (New York: HarperCollins, 1990); Kenneth T.

Walsh, *Ultimate Insiders: White House Photographers and How They Shape History* (New York: Routledge, 2018); Pete Souza, *Obama: An Intimate Portrait* (New York: Little, Brown, 2017).

5. George Juergens, *News from the White House* (Chicago: University of Chicago Press, 1981); Stephen Ponder, *Managing the Press: Origins of the Media Presidency, 1897–1933* (New York: St. Martin's Press, 1998); David Greenberg, *Republic of Spin: An Inside History of the American Presidency* (New York: W. W. Norton, 2016); Martha Joynt Kumar, *Managing the President's Message: The White House Communications Operation* (Baltimore: Johns Hopkins University Press, 2007).

6. Kiku Adatto, *Picture Perfect: Life in the Age of the Photo Op* (Princeton, NJ: Princeton University Press, 2008); Roderick P. Hart, *The Sound of Leadership: Presidential Communication in the Modern Age* (Chicago: University of Chicago Press, 1989); Kathleen Hall Jamieson, *Packaging the Presidency: A History and Criticism of Presidential Campaign Advertising*, 3rd ed. (New York: Oxford University Press, 1996); Robert Hariman, "Framing the Presidency: The Evolution of the Campaign Image," *Aperture* 192 (Fall 2008): 44–51; Paul Martin Lester, *On Floods and Photo Ops: How Herbert Hoover and George W. Bush Exploited Catastrophes* (Oxford: University Press of Mississippi, 2010).

Chapter 1. Photographing George Washington

1. "Remarkable Invention," *Boston Daily Advertiser*, Feb. 23, 1839, 1, http://www.daguerreotypearchive.org/texts/N8390007_BOST_DAILY_ADVERT_1839-02-23.pdf. See also Marcy Dinius, *The Camera and the Press: American Visual and Print Culture in the Age of the Daguerreotype* (Philadelphia: University of Pennsylvania Press, 2012), 16–17.

2. Floyd Rinhart and Marion Rinhart, *The American Daguerreotype* (Athens: University of Georgia Press, 1981), 15.

3. Ibid., 22. See also Keith Davis, *The Origins of American Photography, 1839–1885* (New Haven, CT: Yale University Press, 2007), 18; Robert Taft, *Photography and the American Scene: A Social History, 1839–1889* (Mineola, NY: Dover, 1938), 8.

4. Geoffrey Batchen, "'Some Photographic Experiments of Mine': The Early Photographic Experiments of Samuel Morse," *History of Photography* 15, no. 1 (1991): 37–42.

5. Rinhart and Rinhart, *American Daguerreotype*, 16. See also Sarah Kate Gillespie, *The Early American Daguerreotype: Cross-Currents in Art and Technology* (Cambridge: MIT Press, 2016), 15–55.

6. Rinhart and Rinhart, *American Daguerreotype*, 22.

7. Ibid., 18.

8. Mark Osterman, "How to See a Daguerreotype," *Image* (Autumn 2005): 13. See also Davis, *Origins*, 64–66.

9. Osterman, "How to See," 14.

10. While we don't necessarily know whether Whipple photographed the original painting or a copy, given its location and potential accessibility, plus the

unfinished bottom right corner of the image visible in the daguerreotype, it is reasonable to assume that he photographed the portrait itself.

11. Rinhart and Rinhart, *American Daguerreotype*, 101. See also M. Grant, "John A. Whipple and the Daguerrean Art," *Photographic Art-Journal*, Aug. 1851, 94–95; Marcus Aurelius Root, *The Camera and the Pencil* (Philadelphia: M. A. Root, J. B. Lippincott and Co., 1864), 364–65.

12. *Boston Directory, 1848–9* (Boston: James French and Charles Stimpson, 1848), 304.

13. Ibid., 11. The small steam engine Whipple installed in his studio enabled him to polish plates automatically rather than time-consumingly by hand; in addition, the steam engine powered a fan to keep those sitting for portraits cool in the midday heat of a Boston summer.

14. Rinhart and Rinhart, *American Daguerreotype*, 101.

15. Ibid., 102–103; Grant, "John A. Whipple," 95.

16. On daguerreotypists' early interest in making copies of art, see Gillespie, *Early American Daguerreotype*, 70–72, 81–89.

17. The print is held at the George Eastman Museum in Rochester, New York. See http://collections.eastman.org/objects/333420/statue-with-two-figures-holding -pitchers?ctx=e1853300-2c12-4905-82dd-60c218f3979f&idx=17.

18. Merry A. Foresta, *American Photographs: The First Century* (Washington, DC: Smithsonian Institution Press, 1996), 16.

19. *Homes of American Statesmen, with Anecdotal, Personal, and Descriptive Sketches by Various Writers* (New York: G. P. Putnam and Co., 1854).

20. Ibid., iv.

21. Barbara E. Lacey, *From Sacred to Secular: Visual Images in Early American Publications* (Newark: University of Delaware Press, 2007), 134.

22. Wendy Wick Reaves, *George Washington, An American Icon: The Eighteenth-Century Graphic Portraits* (Washington, DC: Smithsonian Institution Press, 1982), 4.

23. For more on the image of Washington as Cincinnatus, the reluctant farmer-turned-leader, see Garry Wills, *George Washington and the Enlightenment* (London: Robert Hale, 1984); Maurie D. McInnis, "Revisiting Cincinnatus: Houdon's George Washington," in *Shaping the Body Politic: Art and Political Formation in Early America*, ed. Maurie D. McInnis and Louis P. Nelson, 128–61 (Charlottesville: University of Virginia Press, 2011); Maurie D. McInnis, "George Washington: Cincinnatus or Marcus Aurelius," in *Thomas Jefferson, the Classical World, and Early America*, ed. Peter S. Onuf and Nicholas P. Cole, 128–70 (Charlottesville: University of Virginia Press, 2011).

24. Hugh Howard, *The Painter's Chair: George Washington and the Making of American Art* (New York: Bloomsbury Press, 2009), 14. Matthew Fox-Amato points out that some of those portraits depicted Washington "with a slave on the margins of the canvas," a choice that embodied "the foundation of white identity—of mastery, racial power, freedom, and wealth"; see Fox-Amato, *Exposing Slavery:*

Photography, Human Bondage, and the Birth of Modern Visual Politics in America (New York: Oxford University Press, 2019), 23.

25. Howard, *Painter's Chair,* 13.

26. Maurie D. McInnis and Louis P. Nelson, "Introduction," in McInnis and Nelson, *Shaping the Body Politic,* 8. On sculptures and busts of George Washington, see Anne L. Poulet, *Jean-Antoine Houdon: Sculptor of the Enlightenment* (Washington, DC: National Gallery of Art, 2003); H. Nichols Clark, "An Icon Preserved: Continuity in the Sculptural Images of Washington," in *George Washington: American Symbol,* ed. Barbara J. Mitnick, 39–54 (New York: Hudson Hills Press, 1999).

27. Barry Schwartz, *George Washington: The Making of an American Symbol* (New York: Free Press, 1987), 194.

28. On apotheosis images of Washington, see Phoebe Lloyd Jacobs, "John James Barralet and the Apotheosis of George Washington," *Winterthur Portfolio* 12 (1977): 115–37. See also William Ayres, "At Home with George: Commercialization of the Washington Image, 1776–1876," in Mitnick, *George Washington: American Symbol,* 95. Later, images of Washington joining angels to bring Lincoln into heaven appeared after the latter's assassination; see Merrill D. Peterson, *Lincoln in American Memory* (New York: Oxford University Press, 1994), 27.

29. Davis, *Origins,* 86; Gregory Pfitzer, *Picturing the Past: Illustrated Histories and the American Imagination* (Washington, DC: Smithsonian Institution Press, 2002); Keith Beutler, "Emma Willard's 'True Mnemonic of History': America's First Textbooks, Proto-Feminism, and the Memory of the Revolution," in *Remembering the Revolution: Memory, History, and Nation Making from Independence to the Civil War,* ed. Michael A. McDonnell, Claire Corbould, et al. (Amherst: University of Massachusetts Press, 2013), 166.

30. According to Keith Davis, the leading lithography firm in Hartford, Connecticut made three thousand to four thousand prints per day, and George Washington was its most popular subject; see Davis, *Origins,* 86.

31. Ayres, "At Home with George," 100.

32. For a discussion of how the Athenaeum portrait reappeared and recirculated in different aesthetic contexts during the twentieth century, see Adam Greenhalgh, "'Not a Man but a God': The Apotheosis of Gilbert Stuart's Athenaeum Portrait of George Washington," *Winterthur Portfolio* 41, no. 4 (2007): 269–304.

33. Pfitzer, *Picturing the Past,* 31.

34. Ayres, "At Home with George," 100.

35. Qtd. in Wick Reaves, *George Washington,* xxi.

36. Egon Verheyen, "'The Most Exact Representation of the Original': Remarks on Portraits of George Washington by Gilbert Stuart and Rembrandt Peale," *Studies in the History of Art* 20 (1989): 138.

37. Ibid., 132.

38. Charles Henry Hart, "Original Portraits of Washington," *The Century* (April 1889): 865.

39. David Meschutt, "Life Portraits of George Washington," in Mitnick, *George Washington: American Symbol*, 33.

40. Howard, *Painter's Chair*, 206, 246; Meschutt, "Life Portraits," 35.

41. Howard, *Painter's Chair*, 198–200. The Lansdowne portrait is now owned by the National Portrait Gallery of the Smithsonian.

42. Howard, *Painter's Chair*, 196–97; Meschutt, "Life Portraits," 35.

43. "George Washington Portrait by Gilbert Stuart," *George Washington's Mount Vernon*, https://www.mountvernon.org/george-washington/artwork/george-washington-portrait-by-gilbert-stuart.

44. Wick Reaves, *George Washington*, xxi.

45. Paul Staiti, "Gilbert Stuart's Presidential Imaginary," in McInnis and Nelson, *Shaping the Body Politic*, 175.

46. Meschutt, "Life Portraits," 35.

47. By "finished" I mean a copy where the artist—possibly Stuart but possibly also someone in his studio—seems to have added shoulders, a body, and a dark background to the unfinished head of the original.

48. The most recent and complete catalog of the work of Southworth and Hawes is Grant B. Romer and Brian Wallis, *Young America: The Daguerreotypes of Southworth and Hawes* (Rochester, NY: George Eastman House and International Center of Photography, 2005). The catalog lists six Southworth and Hawes daguerreotypes of the Athenaeum portrait, three whole-plate daguerreotypes and three half-plate (476–78).

49. Grant B. Romer, "'A High Reputation with All True Artists and Connoisseurs': The Daguerreian Careers of A. S. Southworth and J. J. Hawes," in Romer and Wallis, *Young America*, 50.

50. Ibid.

51. Ibid., 36.

52. Marcus Aurelius Root, "A Trip to Boston—Boston Artists," *Photographic Art-Journal*, Aug. 1, 1855, 246.

53. Ibid. In describing the Washington painting as an "original portrait," Root seems to suggest that Southworth and Hawes photographed the actual painting; as with Whipple's Athenaeum, we may not know for sure. In their discussion of the studio's Washington daguerreotypes, Sobieszek and Appel suggest that Southworth and Hawes photographed the actual painting using a special lens that Hawes had developed "for copying two-dimensional works"; see Robert A. Sobieszek and Odelle M. Appel, *The Spirit of Fact: The Daguerreotypes of Southworth & Hawes, 1843–1862* (Rochester, NY: International Museum of Photography, 1976), 126.

54. Wendy Wick Reaves and Sally Pierce point out the Southworth and Hawes Athenaeum daguerreotypes were studied by engraver Thomas B. Welch, who used them for his print of Washington; see Wick Reaves and Pierce, "Translations from the Plate: The Marketplace of Public Portraiture," in Romer and Wallis, *Young America*, 98.

55. John Stauffer suggests that there is in fact not an eyeline match and questions whether perhaps the image might be interpreted as "an acknowledgement that women were not included as citizens and were therefore denied access to the Founders as a source for their own rebirth and regeneration." Given what I have established here about Washington's iconicity, Southworth and Hawes's own repeated use of the Athenaeum image, and other photographers' use of women and children in worshipful poses, I am less persuaded by this interpretation. See Stauffer, "Daguerrotyping the National Soul: The Portraits of Southworth and Hawes, 1843–1860," in Romer and Wallis, *Young America*, 68.

56. The half-plate daguerreotype, by an unknown photographer, is in the collection of the Nelson-Atkins Museum of Art in Kansas City, Missouri. See Davis, *Origins*, 122–23, 320.

57. On Harrison, see Grant B. Romer, "Poetic Daguerrean," *Image* 22 (1979): 8–18. Harrison is today most famous for photographing Walt Whitman multiple times, including the jaunty, full-frontal image that became the frontispiece of the first edition of *Leaves of Grass* (17).

58. S. J. Burr, "Gabriel Harrison and the Daguerrean Art," *Photographic Art-Journal*, 1, no. 3 (1851): 169–77.

59. Laura Wexler, "Techniques of the Imaginary Nation: Engendering Family Photography," in *Looking for America: The Visual Production of the Nation and Its People*, ed. Ardis Cameron (Malden, MA: Blackwell, 2005), 103–107.

60. Sobieszek and Appel, *Spirit of Fact*, 57. Stauffer states that Southworth and Hawes may have used the Washington painting as a "studio prop," but this claim is not substantiated textually by Stauffer, nor are there other images in the catalog of extant images by Southworth and Hawes that show any of it besides this one. See Stauffer, "Daguerreotyping," 68.

61. Davis, *Origins*, 122–23; Stauffer, "Daguerreotyping," 68; Wexler, "Techniques," 107.

62. Burr, "Gabriel Harrison," 176.

63. Robert A. Mayer, "Photographing the American Presidency," *Image* 27 (1984): 3. See also T. B. Thorpe, "Webster, Clay, and Jackson: How They Sat for Their Daguerreotypes," *Harper's New Monthly*, May 1869, 787–89; Clifford Krainik, "Face the Lens, Mr. President: A Gallery of Photographic Portraits of 19th-Century U.S. Presidents," *White House History* 16 (2005): 24–25.

64. Madison's biographer Catherine Allgor writes, "One version of the legend holds that Dolley herself cut the portrait out of its frame with a butcher knife; some later illustrations even depict Dolley fleeing the burning White House, the canvas flapping behind her as she runs through the street." See Allgor, *A Perfect Union: Dolley Madison and the Creation of the American Nation* (New York: Henry Holt, 2006), 4–5. For an example of one of these dramatic accounts, see "Scenes of the Last War: Mrs. Madison's Flight from Washington," *Cleveland Herald*, May 22, 1849, Nineteenth Century U.S. Newspapers database. Most scholars now believe that at most Madison may have ordered slaves to remove the portrait, which was

not an original but a copy of the original Stuart Lansdowne portrait (featuring, of course, the Athenaeum head). See Allgor, *Perfect Union*, 5; Elizabeth Dowling Taylor, *A Slave in the White House: Paul Jennings and the Madisons* (New York: St. Martin's Press, 2012), 51.

65. Allgor, *Perfect Union*, 6.

66. Mayer, "Photographing the American Presidency," 5; Clifford Krainik, "'A Dark Horse' in Sunlight and Shadow: Daguerreotypes of James K. Polk," *White House History* 2 (1997), https://www.whitehousehistory.org/a-dark-horse-in -sunlight-and-shadow.

67. I explore the Anthony and Edwards project more fully in chapter 3, where I discuss John Quincy Adams's experiences with the daguerreotype.

68. "The National Miniature Gallery," *National Intelligencer*, March 3, 1845, Nineteenth Century U.S. Newspapers database.

69. John Lockwood, "The Men—and the Women—Who Built the Washington Monument," *Prologue* (Spring 2016): 7–9, https://www.archives.gov/files/ publications/prologue/2016/spring/monument.pdf.

70. Frederick L. Harvey, *History of the Washington National Monument and of the Washington National Monument Society* (Washington, DC: Norman T. Elliott Printing Co., 1902), 47.

71. Ibid., 39. See also "National Washington Monument: Order of Procession," *National Intelligencer*, July 3, 1848, Nineteenth Century U.S. Newspapers database.

72. Harvey, *History of the Washington National Monument*, 44–45.

73. Lockwood, "Men—and the Women," 9.

74. "The Washington Monument Procession," *National Intelligencer*, July 7, 1848, Nineteenth Century U.S. Newspapers database.

75. "List of Articles Deposited in the Corner Stone of the Washington National Monument on the Fourth Day of July, 1848," *National Intelligencer*, July 7, 1848, Nineteenth Century U.S. Newspapers database. John Grubb was an active Virginia daguerreotypist into the 1850s, with a studio in Richmond in the years 1850–1852. See "Grubb, John S.," *Craig's Daguerreian Registry*, http://craigcamera .com/dag.

76. The painting by Stuart was commissioned by Samuel Parkman as a gift to the City of Boston in 1806. It hung in Faneuil Hall until replaced later in the century with a copy made by Stuart's daughter Jane. The original now hangs in the Museum of Fine Arts in Boston. See "Washington at Dorchester Heights," Museum of Fine Arts, Boston, https://collections.mfa.org/objects/30879.

Chapter 2. Early Daguerreotypes in the U.S. and the Nation's Capital

1. Robert Taft, *Photography and the American Scene: A Social History, 1839–1889* (Mineola, NY: Dover, 1938, 15).

2. Floyd Rinhart and Marion Rinhart, *The American Daguerreotype* (Athens: University of Georgia Press, 1981), 31. See also Marcy J. Dinius, *The Camera*

and the Press: American Visual and Print Culture in the Age of the Daguerreotype (Philadelphia: University of Pennsylvania Press, 2012), 23–24.

3. "The Daguerreotype," *New-York Commercial Advertiser*, Dec. 14, 1839, 2, America's Historical Newspapers database.

4. "The Daguerreotype Again," *Madisonian* (Washington, DC), Dec. 28, 1839, 2, America's Historical Newspapers database.

5. Gouraud mentions these and other cities on his U.S. tour in a letter to the editor reproduced in "The Daguerreotype," *Charleston Courier*, Jan. 17, 1840, 2, America's Historical Newspapers database.

6. "The Daguerreotype," *New-York Commercial Advertiser*, Feb. 6, 1840, 2, America's Historical Newspapers database.

7. Beaumont Newhall, *The Daguerreotype in America* (New York: Duell, Sloan, and Pierce, 1961), 31. On charging for lessons, see Keith Davis, *The Origins of American Photography, 1839–1885* (New Haven, CT: Yale University Press, 2007), 20. On Gouraud's importance to early daguerreotypy in the United States, see Taft, *Photography and the American Scene*, 42–43.

8. Numerous successful daguerreotypes already had been made by late 1839; see Sarah Kate Gillespie, *The Early American Daguerreotype: Cross-Currents in Art and Technology* (Cambridge: MIT Press/Smithsonian Institution, 2016), 137–42.

9. Rinhart and Rinhart, *American Daguerreotype*, 40. See also Davis, *Origins*, 15–20.

10. Rinhart and Rinhart, *American Daguerreotype*, 38–40.

11. Ibid., 29.

12. Qtd. in Gillespie, *Early American Daguerreotype*, 61.

13. Rinhart and Rinhart, *American Daguerreotype*, 38; Gillespie, *Early American Daguerreotype*, 17, 31. On Wolcott and Johnson's careers more generally see François Brunet, "Woolcott, Alexander Simon and John Johnson," in *Encyclopedia of Nineteenth Century Photography*, vol. 2, ed. John Hannavy, 1501–1502 (New York: Routledge, 2008).

14. Davis, *Origins of American Photography*, 18.

15. Rinhart and Rinhart, *American Daguerreotype*, 53.

16. Ibid.

17. "Advertisements: Daguerreotypes," *Frederick Douglass's Paper*, July 9, 1852, 19th Century African American Newspapers database.

18. Dinius, *Camera and the Press*, 25–33.

19. Ibid., 28.

20. Frederick Douglass, "Pictures and Progress," in *Picturing Frederick Douglass: An Illustrated Biography of the Nineteenth Century's Most Photographed American*, ed. John Stauffer, Zoe Trodd, and Celeste-Marie Bernier (New York: Liveright Publishing, 2015), 165. Douglass regularly sat for portraits beginning in 1841 and became the nineteenth century's most photographed American. Later in his career he toured the lyceum circuit and gave lectures on photography. See Stauffer, Trodd, and Bernier, *Picturing Frederick Douglass*.

21. Cara A. Finnegan, *Making Photography Matter: A Viewer's History from the Civil War to the Great Depression* (Urbana: University of Illinois Press, 2015), 64, 65. See also Dinius, *Camera and the Press*, 28–29.

22. Alan Trachtenberg, "Photography: The Emergence of a Keyword," in *Photography in Nineteenth Century America*, ed. Martha A. Sandweiss (Fort Worth: Amon Carter Museum, 1991), 17.

23. Dinius, *Camera and the Press*, 32.

24. "A Day and a Night in 'Uncle Tom's Cabin,'" *Frederick Douglass's Paper*, March 4, 1853. 19th Century African American Newspapers database.

25. "Daguerreotype," *National Intelligencer*, March 12, 1840, Nineteenth Century U.S. Newspapers database.

26. "The Daguerreotype," *National Intelligencer*, March 14, 1840, Nineteenth Century U.S. Newspapers database.

27. "Daguerreotype Likenesses," *National Intelligencer*, June 29, 1840, Nineteenth Century U.S. Newspapers database; "Closes on Tuesday Evening," *National Intelligencer*, July 20, 1840, Nineteenth Century U.S. Newspapers database.

28. "The Daguerreotype, or Pencil of Nature," *National Intelligencer*, Jan. 30, 1841, Nineteenth Century U.S. Newspapers database. On Moore and Ward, see Thomas M. Weprich, "The Pencil of Nature in Washington, D.C.: Daguerreotyping the President," *Daguerreian Annual* (1995): 116–17. See also entries on each in *Pioneer Photographers from the Mississippi to the Continental Divide: A Biographical Dictionary, 1839–1865*, ed. Peter E. Palmquist and Thomas R. Kailborn (Stanford, CA: Stanford University Press, 2005), 447, 611.

29. "We Understand," *National Intelligencer*, March 13, 1841, Nineteenth Century U.S. Newspapers database.

30. "Daguerreotype Portraits at Washington," *Philadelphia Inquirer and Daily Courier*, March 6, 1841, Nineteenth Century U.S. Newspapers database. On the Harrison daguerreotype, see also Weprich, "Pencil of Nature," 116.

31. William Garrett Piston, *Portraits of Conflict: A Photographic History of Missouri in the Civil War* (Fayetteville: University of Arkansas Press, 2009), 2. See also Palmquist and Kailborn, *Pioneer Photographers*, 447, 611.

32. Diary of John Quincy Adams, vol. 43, April 29 and May 1, 1843, Massachusetts Historical Society, http://www.masshist.org/jqadiaries/php; referred to hereafter as "JQA Diary."

33. *Washington D.C. Directory*, 1843, 39. Haas is listed as "lithographer."

34. See JQA Diary, March 8, 1843; March 15, 1843; March 16, 1843; May 2, 1845; May 3, 1845.

35. Rob Brunner, "How an Eerie, Ultra-Rare Photo of John Quincy Adams Went from a Desk Drawer to the Smithsonian," *Washingtonian Magazine*, Feb. 2, 2018, https://www.washingtonian.com/2018/02/02/how-an-ultra-rare-photo-of-john-quincy-adams-went-from-a-desk-drawer-to-the-national-portrait-gallery.

36. Ibid.

37. On the daguerreotype's discovery and sale, see also Jennifer Schuessler, "Found: Oldest Known Photo of a U.S. President (Socks and All)," *New York Times*,

Aug. 16, 2017, C2; Jeanne Schinto, "John Quincy Adams Daguerreotype Sells to National Portrait Gallery for $360,500," *Maine Antique Digest*, Oct. 5, 2017, https://www.maineantiquedigest.com/stories/john-quincy-adams-daguerreotype-sells-to-national-portrait-gallery-for-360500/6618; "Sotheby's: Photographs," *Art News*, https://www.artsy.net/artwork/philip-haas-john-quincy-adams; Marielba Alvarez and Ellen Skochdopole, "Welcome to the Portrait Gallery, John Quincy Adams," *National Portrait Gallery Blog*, Oct. 12, 2017, http://npg.si.edu/blog/welcome-portrait-gallery-john-quincy-adams.

38. Clifford Krainik, "Face the Lens, Mr. President: A Gallery of Photographic Portraits of 19th-Century U.S. Presidents," in *White House History: Collection 3 (Numbers 13 through 18)*, ed. William Seale (Washington, DC: White House Historical Association, 2008), 226.

39. As of March 2020 there are five recognized extant daguerreotypes of John Quincy Adams: two at the National Portrait Gallery from March and August 1843, respectively; one copy daguerreotype of an 1843 daguerreotype at the Metropolitan Museum of Art in New York; one at the Missouri Historical Museum; and one at the Smithsonian National Museum of American History; see "Sotheby's: Photographs."

Chapter 3. John Quincy Adams and National Portraiture

1. John Quincy Adams, *The Diaries of John Quincy Adams: A Digital Collection* (Massachusetts Historical Society), Aug. 1, 1843, http://www.masshist.org/jqadiaries/php; hereafter referred to as "JQA Diary."

2. Ibid.

3. "John Q. Adams and the Colored People of Utica," from the *Utica Gazette* as reported in the *Daily Atlas* (Boston), Aug. 5, 1843, Nineteenth Century U.S. Newspapers database.

4. JQA Diary, Aug. 1, 1843.

5. Ibid. The *New York Herald* followed Barnum's amusements and attractions closely. In mid-July it reported that Barnum's star attraction, General Tom Thumb, would soon leave the city for a tour that would take him "to Albany on Monday, and thence to Saratoga Springs, the Canadas, and so on to England." A couple of weeks later, the paper reported that Barnum and his entourage, including General Tom Thumb, were in Albany and later in Saratoga and Niagara Falls, putting him in the vicinity of Adams's own travels during the same period. See "Grand Gala Day at the American Museum," *New York Herald*, July 15, 1843; "Theatrical and Musical," *New York Herald*, July 24, 1843; and "Saratoga Correspondence," *New York Herald*, Aug. 1, 1843; all in Nineteenth Century U.S. Newspapers database. On P. T. Barnum's life and career, see James W. Cook, *The Arts of Deception: Playing with Fraud in the Age of Barnum* (Cambridge, MA: Harvard University Press, 2001).

6. JQA Diary, Aug. 1, 1843.

7. Ibid.

8. "John Quincy Adams," *Cleveland Daily Herald*, Aug. 3, 1843, Nineteenth Century U.S. Newspapers database. See also "Hon. John Quincy Adams at Utica, N.Y.," *Daily Atlas* (Boston), Aug. 2, 1843, Nineteenth Century U.S. Newspapers database.

9. For recent biographical treatments of John Quincy Adams, see Fred Kaplan, *John Quincy Adams: American Visionary* (New York: Harper, 2014); James Traub, *John Quincy Adams: Militant Spirit* (New York: Basic Books, 2016).

10. "Hon. John Quincy Adams," *National Intelligencer* (Washington, DC), Aug. 4, 1843, Nineteenth Century U.S. Newspapers database.

11. Andrew Oliver, *Portraits of John Quincy Adams and His Wife* (Cambridge, MA: Harvard University Press, 1970), 4, 37–41, 73–89. This count does not include photographs or popular prints.

12. JQA Diary, Aug. 15, 1843.

13. For example, Adams mentions evening visits with Greenough and King in his entries for both March 28, 1843, and April 6, 1843. On Greenough's career and work with Adams, see Oliver, *Portraits*, 148–53. On King's portraits of Adams, see Oliver, *Portraits*, 91–105. During his trip to western New York in the summer of 1843, Adams mentioned visiting the "splendid mansion" of one John Graig of Canandaigua, where he enjoyed the owner's "handsome library and fine collections of paintings, engravings, ancient coins, and shells." JQA Diary, July 28, 1843.

14. For my numbers, I rely on accounts in Adams's diaries of his visits to photographers. His diary entries enabled me to quantify both the number of sittings and the rough number of daguerreotypes made at each sitting. While we cannot know for sure whether Adams accounted for every visit to a photographer in his diary, the thoroughness with which he kept the diary suggests its accounting is likely reliable. Similarly, Adams's mentions of the number of images made per visit is sometimes specific and sometimes more vague (i.e., he might say "several," which I conservatively take to mean more than two).

15. JQA Diary, Aug. 2, 1843.

16. Ibid., Aug. 15, 1843.

17. Ibid., Aug. 2, 1843.

18. Ibid., March 4, 1840.

19. On Adams's engagements with science and technology, see Marlena Portolano, *The Passionate Empiricist: The Eloquence of John Quincy Adams in the Service of Science* (Albany: SUNY Press, 2009).

20. Traub, *John Quincy Adams*, 472–81. In 1839 Africans who had been kidnapped in Africa and illegally sold into slavery rebelled and took over the Spanish ship *Amistad*, which was carrying them toward Cuba. After the ship was taken into custody outside of New York City, the Africans' legal status became the subject of controversy. Eventually the case landed at the U.S. Supreme Court, where Adams argued that the Africans were not Spanish property but persons and that therefore

certain treaties did not apply. On Adams's arguments in the *Amistad* case, see A. Cheree Carlson, "John Quincy Adams' 'Amistad' Address: Eloquence in a Generic Hybrid," *Western Journal of Speech Communication* 49 (Winter 1985): 14–26; Patricia Roberts-Miller, "John Quincy Adams's *Amistad* Argument: The Problem of Outrage; or, the Constraints of Decorum," *Rhetoric Society Quarterly* 32, no. 2 (2002): 5–25.

21. Traub, *John Quincy Adams*, 428–35. On violence in Congress in 1842 regarding antislavery petitions, see also Joanne Freeman, "The Violence at the Heart of Our Politics," *New York Times*, Sept. 9, 2018, SR4.

22. JQA Diary, Sept. 20, 1842.

23. Ibid.

24. Christopher Lukasik, *Discerning Characters: The Culture of Appearance in Early America* (Philadelphia: University of Pennsylvania Press, 2011), 134.

25. Garry Apgar, "Silhouette," Grove Art Online database.

26. On the various devices used to make silhouettes with mechanical help, see Penley Knipe, "Paper Profiles: American Portrait Silhouettes," *Journal of the American Institute for Conservation* 41, no. 3 (2002): 215–17.

27. Ibid., 207.

28. Apgar, "Silhouette."

29. Sarah L. Thwaites, "Daguerreotypy, Democratizing, and the Fall of Light," *Journal of Design History* 26, no. 3 (2013): 249; Mark Osterman, "How to See a Daguerreotype," *Image* (Autumn 2005): 15.

30. On 1809 silhouettes of Adams, see Oliver, *Portraits*, xxi. On Adams's lifetime of being the subject of silhouette portraits, see Oliver, *Portraits*, 48–50, 144–47, 212–16, 236. On Edouart's fame and skill, see Knipe, "Paper Profiles," 208.

31. "For a Short Time Only," *National Intelligencer*, Jan. 29, 1841, Nineteenth Century U.S. Newspapers database.

32. JQA Diary, March 11, 1841. According to Knipe, Edouart made two copies of each silhouette he produced and always kept one for himself for his own collection. Edouart apparently worked by hand, drawing the subject in white chalk and then performing the cutout with scissors. Knipe, "Paper Profiles," 208–209. The Harrison silhouette by Edouart is in the National Portrait Gallery of the Smithsonian, listed in its *Catalog of American Portraits* as NPG.91.126.89.A.

33. Oliver, *Portraits*, 216.

34. The *National Intelligencer* reported on February 12 that Edouart had met President-Elect William Henry Harrison and managed to make "one of the most striking likenesses, in profile, of the person and countenance of the General that we have ever seen." See "City News," *National Intelligencer*, Feb. 12, 1841, Nineteenth Century U.S. Newspapers database. It may be a copy of this silhouette that Edouart gave to Adams at their meeting.

35. Knipe, "Paper Profiles," 209–210.

36. JQA Diary, June 11, 1841.

37. Ibid., June 15, 1841.

38. Ibid., July 12, 1843. Edouart must have summered in Saratoga to take advantage of the tourist trade there. See "For a Short Time Only," which describes Edouart as "late of Saratoga, New York, etc."

39. JQA Diary, April 3, 1843.

40. Alan Fern and Milton Kaplan, "John Plumbe, Jr. and the First Architectural Photographs of the Nation's Capital," *Quarterly Journal of the Library of Congress*, 31, no. 1 (1974): 11. See also Robert Taft and Clifford Krainik, "John Plumbe, America's First Nationally Known Photographer," *Daguerreian Annual* (1936/1994): 49–57.

41. Records indicate "that by 1842 Plumbe had practiced daguerreotypy in Boston, Philadelphia, and probably New York, as well as Washington." Taft and Krainik, "John Plumbe," 52. By late November 1840, Plumbe was advertising himself as "a manufacturer of daguerreotype miniatures" on Court Street in Boston. Taft and Krainik, "John Plumbe," 53. In July 1842 Plumbe was listed in the *Daily Atlas*, a Boston newspaper, as selling a "daguerreotype apparatus." *Daily Atlas*, July 13, 1842, Nineteenth Century U.S. Newspapers database.

42. Fern and Kaplan, "John Plumbe, Jr.," 11.

43. Clifford Krainik, "John Plumbe," *Iowa Heritage Illustrated* 89 (Spring/Summer 2008): 52, 55. See also Taft and Krainik, "John Plumbe," 52.

44. "Plumbe's Daguerrian Gallery of Patent Colored Photographs," *Boston Courier*, Feb. 13, 1843, Nineteenth Century U.S. Newspapers database.

45. JQA Diary, Sept. 21, 1842; Sept. 22, 1842; Sept. 24, 1842.

46. Ibid., Sept. 27, 1842.

47. Marcy Dinius, *The Camera and the Press: American Visual and Print Culture in the Age of the Daguerreotype* (Philadelphia: University of Pennsylvania Press, 2012), 16.

48. John Quincy Adams, *Lectures on Rhetoric and Oratory*, vol. 2 (Cambridge, MA: Hilliard and Metcalf, 1810), 258–59.

49. Portolano, *Passionate Empiricist*, 41.

50. JQA Diary, Sept. 27, 1842.

51. Sculptor Horatio Greenough wrote of Adams, "Mr. Adams is very agreeable as a sitter; he talks all the while, has seen much of art and artists, and remembers everything" (qtd. in Oliver, *Portraits*, 149).

52. See, for example, JQA Diary Sept. 27, 1842; March 15, 1843; May 2, 1844; June 19, 1846.

53. Grace Sieberling, *Amateurs, Photography, and the Mid-Victorian Imagination* (Chicago: University of Chicago Press, 1986), ix.

54. Taft, *Photography and the American Scene*, 40.

55. Thwaites, "Daguerreotypy," 241.

56. JQA Diary March 7, 1843; March 15, 1843; May 2, 1844. On the complexities of the ways that daguerreotypists harnessed the "agency of light" to make their images, see Thwaites, "Daguerreotypy," 253.

57. Bob Zeller, "Haas, Philip," in *Encyclopedia of Nineteenth Century Photography*, vol. 2, ed. John Hannavy (New York: Routledge, 2008), 631.

58. *Washington D.C. Directory*, 1843, 39. Of Haas, Zeller writes, "He was among the first resident daguerreians in the nation's capitol." "Haas, Philip," 631. Others included West and Page, whom Adams visited a few weeks later. George West, whose studio with Charles Page Adams would visit in Washington a few weeks later, is listed in the 1843 city directory as "Photographer." *Washington D.C. Directory*, 1843, 95.

59. JQA Diary, March 7, 1843.

60. Ibid., March 8, 1843.

61. On the camera obscura and its use by artists, see Jenny Carson and Ann Shafer, "West, Copley, and the Camera Obscura," *American Art* 22, no. 2 (2008): 24–41.

62. Dinius, *Camera and the Press*, 6.

63. Ibid.

64. Osterman, "How to See," 13.

65. JQA Diary, March 11, 1843.

66. Ibid., March 15, 1843.

67. Ibid., March 16, 1843.

68. Ibid.

69. The Everett daguerreotype bought at auction by the Smithsonian included on the back an "address leaf . . . inscribed to Everett and signed by Adams with characteristic flourish" and "a bookplate with the Everett family crest [that] is annotated 'Presented by J. Q. A. to his Kinsman H. E. 1843.'" See "Sotheby's: Photographs," *Art News*, https://www.artsy.net/artwork/philip-haas-john-quincy-adams.

70. Gunther Kress and Theo van Leeuwen, *Reading Images: The Grammar of Visual Design* (New York: Routledge, 2006), 123–30.

71. Beaumont Newhall, "A Daguerreotype of John Quincy Adams by Philip Haas," *Metropolitan Museum Journal* 12 (1977): 151.

72. See, for example, Robert A. Mayer, "Photographing the American Presidency," *Image* 27 (1984): 2. Mayer states that the image was likely made in Adams's home in Quincy, Massachusetts. Andrew Oliver also assumes it was produced in Quincy rather than in Washington; see Oliver, *Portraits*, 285–87. The Mayer assertion is unfortunate because his essay was published many years after Newhall's new information about the daguerreotype was available. On the 1939 catalog's original error about Quincy, see Newhall, "A Daguerreotype," 152.

73. Newhall, "A Daguerreotype," 153.

74. Ibid., 152.

75. "John Quincy Adams / Taken from a Daguerreotype by P. Haas," Library of Congress Prints and Photographs Division, http://www.loc.gov/pictures/item/2013645252. Bob Zeller argues that this lithograph may represent the first

time a lithograph was made directly from a daguerreotype. Zeller, "Haas, Philip," 631.

76. See Nancy Finlay, "Introduction: Taking a Fresh Look at Nineteenth-Century Lithography," in *Picturing Victorian America: Prints by the Kellogg Brothers of Hartford, Connecticut, 1830–1880*, ed. Nancy Finlay and Kate Steinway (Middletown, CT: Wesleyan University Press, 2009), 6.

77. See, for example, Oliver, *Portraits*, 60, 82, 107, and 111.

78. Finlay, "Introduction," 2.

79. Benjamin Franklin Butler, lithograph of John Quincy Adams, Smithsonian Institution National Portrait Gallery, object no. NPG.80.60, http://npg.si.edu/object/npg_NPG.80.60.

80. JQA Diary, March 16, 1843.

81. On collective portraits and the role of daguerreotypes in producing these popular prints, see Michael Leja, "Fortified Images for the Masses," *Art Journal* 70, no. 4 (2011): 60–83.

82. JQA Diary, March 16, 1843.

83. Ibid., April 12, 1844. When Tyler became president after the untimely death of William Henry Harrison, Adams wrote in his diary that Tyler had "vices of slavery rooted in his moral and political constitution, with talents not above mediocrity." JQA Diary, April 4, 1841.

84. The figure of John Quincy Adams may be found fourth from the left in the background of the U.S. Senate Chamber print. A solo engraved portrait of Adams by Thomas Doney offers a nearly identical profile, suggesting that both engravings are likely based on one of the Anthony and Edwards daguerreotypes the congressman sat for in 1844. See Oliver, *Portraits*, 289–90.

85. Leja, "Fortified Images," 65.

86. The engraving was roughly thirty by forty inches, and an 1847 edition of it is archived in the Library of Congress. See https://www.loc.gov/item/2003666712.

87. JQA Diary, March 27, 1945.

88. Ibid., May 2, 1845.

89. Gillespie, *Early American Daguerreotype*, 64.

90. Adams's diary mentions two sittings with Philip Haas in 1844 for the painter James Reid Lambdin and one sitting at Plumbe's studio in Washington for George P. A. Healy in 1846. See JQA Diary, May 1 and May 2, 1844, and July 20, 1846.

91. On Lambdin's portraits of Adams, see Oliver, *Portraits*, 217–21.

92. JQA Diary, April 13, 1844.

93. Oliver, *Portraits*, 219.

94. JQA Diary, May 3, 1844.

95. Ibid., Aug. 1–2, 1843.

96. Ibid., April 29, 1843.

97. Ibid., Aug. 15, 1843. See also Oliver, *Portraits*, 2.

98. Oliver, *Portraits*, 2.

99. Ibid., 4.

100. JQA Diary, Aug. 9, 1843.

101. On Adams's late life illnesses, see Traub, *John Quincy Adams,* 391–92, 441. Adams wrote regularly about his health complaints in the diary during the 1840s, and those complaints sometimes included insomnia.

102. JQA Diary, Nov. 13, 1843.

103. Ibid., Aug. 15, 1843.

Chapter 4. Handheld Photography and the Halftone Revolution

1. On various forms of post-daguerreotype, pre–dry plate photography, see Robert Taft, *Photography and the American Scene: A Social History 1839–1889* (Mineola, NY: Dover, 1938), 123–335; Keith Davis, *The Origins of American Photography, 1839–1885* (New Haven, CT: Yale University Press, 2007).

2. On the complexities of counting Lincoln photographs, see Cara A. Finnegan, *Making Photography Matter: A Viewer's History from the Civil War to the Great Depression* (Urbana: University of Illinois Press, 2015), 193–94n5.

3. Harold Holzer, "The Photograph That Made Lincoln President," *Civil War Times,* Nov./Dec. 2006, 24.

4. On this daguerreotype and its subsequent discovery and publication in 1895, see Finnegan, *Making Photography Matter,* 51–60.

5. Ambrotypes are one-of-a-kind negatives produced on glass plates and then backed with black backing to make the negative image appear positive. On the ambrotype, see Mark Osterman, "Introduction to Photographic Equipment, Processes, and Definitions of the 19th Century," in *Focal Encyclopedia of Photography,* 4th ed., ed. Michael R. Peres, 40–41 (New York: Elsevier, 2007).

6. The Library of Congress holds the original ambrotype of Lincoln made by photographer Calvin Jackson, in Pittsfield, Illinois, on October 1, 1858; see http://www.loc.gov/pictures/item/2009632130. The Macomb portrait was made by photographer William Judkins Thompson on October 11, 1858. The Library of Congress holds a print, and the original ambrotype is in the collection of the Smithsonian National Portrait Gallery; see http://www.loc.gov/pictures/item/2009630670 and https://npg.si.edu/object/npg_NPG.82.52.

7. On the "cracked plate" photograph, see Richard S. Lowry, *The Photographer and the President: Abraham Lincoln, Alexander Gardner, and the Images That Made a Presidency* (New York: Rizzoli, 2015), 140–44. The print made by Gardner is in the collection of the Smithsonian's National Portrait Gallery.

8. Harold Holzer, "The Campaign of 1860: Mathew Brady, Cooper Union, and the Campaign of Words and Images," in *Lincoln Revisited: New Insights from the Lincoln Forum,* ed. John Y. Simon, Harold Holzer, and Dawn Vogel (New York: Fordham University Press, 2007), 59. For analyses of the speech, see Michael C. Leff and Gerald P. Mohrmann, "Lincoln at Cooper Union: A Rhetorical Analysis of the Text," *Quarterly Journal of Speech* 60 (1974): 346–58; Michael Leff, "Lincoln at Cooper

Union: Neo-classical Criticism Revisited," *Western Journal of Communication* 65, no. 3 (2001): 232–48.

9. On Brady's photographic career, see Robert Wilson, *Mathew Brady: Portraits of a Nation* (New York: Bloomsbury, 2013).

10. Holzer, "Photograph That Made Lincoln President," 24.

11. Holzer, "Campaign of 1860," 64.

12. *Harper's Weekly*, May 26, 1860.

13. "Our Next President," Library of Congress, https://www.loc.gov/resource/pga.09104. See also "Hon. Abraham Lincoln: Republican Candidate for Sixteenth President of United States," Nov. 1860, https://www.loc.gov/item/2002695898.

14. *Harper's Weekly*, Nov. 10, 1860.

15. Holzer, "Photograph That Made Lincoln President," 24. See also Holzer, "Campaign of 1860," 65. Holzer reproduces a number of examples of Cooper Union memorabilia and images in "Campaign of 1860."

16. Reese Jenkins, *Images and Enterprise: Technology and the American Photographic Industry, 1839 to 1925* (1975; Baltimore: Johns Hopkins University Press, 1987), 48–50.

17. Darcy Grimaldo Grigsby, *Enduring Truths: Sojourner's Shadows and Substance* (Chicago: University of Chicago Press, 2015), 2. See also E. Anne McCauley, *A.A.E. Disdéri and the Carte de Visite Photograph* (New Haven, CT: Yale University Press, 1985), 1–3.

18. Albumen paper uses egg whites to bind chemicals to paper. On the use of albumen paper for cartes de visite and cabinet cards, see Taft, *Photography and the American Scene*, 144–47; 355–56.

19. *Art Journal*, "Cartes de Visite," *Humphrey's Journal* 8, no. 21 (1862): 326, Nineteenth Century Collections Online database.

20. Grigsby, *Enduring Truths*, 5–7; McCauley, *A.A.E. Disdéri*, 221–22.

21. *Art Journal*, "Cartes de Visite," 327.

22. Mathew B. Brady, *A Catalogue of Brady's Photographic Views of the Civil War* (Watkins Glen, NY: Century House, 1862). The list of presidential photographs appears on page 6, Nineteenth Century Collections Online database.

23. For an example of a similar, centennial-themed image of presidents, see http://lincolncollection.tumblr.com/post/121051559509/our-presidents.

24. On carte de visite albums and cabinet cards, see Nicholas Yablon, "Posing for Posterity: Photographic Portraiture and the Invention of the Time Capsule, 1876–89," *History of Photography* 38, no. 4 (2014): 342; see also Taft, *Photography and the American Scene*, 143; 355.

25. On the history of stereography, see Laura Burd Schiavo, "From Phantom Image to Perfect Vision: Physiological Optics, Commercial Photography, and the Popularization of the Stereoscope," in *New Media, 1740–1915*, ed. Lisa Gitelman and Geoffrey B. Pingree (Cambridge: MIT Press, 2003), 113. See also Jonathan Crary, *Techniques of the Observer: On Vision and Modernity in the Nineteenth Century* (Cambridge: MIT Press, 1990), 116–27.

26. William Darrah, *The World of Stereographs* (Nashville: Land Yacht Press, 1997), 1–3. See also Jenkins, *Images and Enterprise*, 50–51.

27. Holmes's stereography essays were published together along with other pieces in *Soundings from The Atlantic* (Boston: Ticknor and Fields, 1864). See also Finnegan, *Making Photography Matter*, 33–35.

28. Judith Babbitts, "Stereographs and the Construction of a Visual Culture in the United States," in *Memory Bytes: History, Technology, and Digital Culture*, ed. Lauren Rabinovitz and Abraham Geil (Durham, NC: Duke University Press, 2004), 129. See also Darrah, *World of Stereographs*, 6. A big part of stereographs' longevity was the result of their use as educational tools in schools. See Babbitts, "Stereographs," 139–44; Elizabeth Ann Wiatr, "Seeing American: Visual Education and the Making of Modern Observers, 1900–1935" (PhD diss., University of California–Irvine, 2003); Brenton J. Malin, "Looking White and Middle-Class: Stereoscopic Imagery and Technology in the Early Twentieth-Century United States," *Quarterly Journal of Speech* 93, no. 4 (2007): 403–24. Although most scholars place the heyday of the stereograph between the late nineteenth century and the 1930s, stereograph collector and expert David Eisenman of Champaign, Illinois, kindly shared with me stereographs made in the late 1940s featuring President Harry Truman (Eisenman, personal visit, March 1, 2016).

29. Simone Natale, "Photography and Communication Media in the Nineteenth Century," *History of Photography* 36, no. 4 (2012): 455.

30. On the "shanty" photo and the early beginnings of halftone, see Neil Harris, *Cultural Excursions: Marketing Appetites and Cultural Tastes in Modern America* (Chicago: University of Chicago Press, 1990), 306; Taft, *Photography and the American Scene*, 432–40; Michael Carlebach, *The Origins of Photojournalism in America* (Washington, DC: Smithsonian Institution Press, 1992), 163; Estelle Jussim, "'The Tyranny of the Pictorial': American Photojournalism from 1880 to 1920," in *Eyes of Time: Photojournalism in America*, ed. Marianne Fulton, 43–45 (Boston: Little, Brown, 1998). See also William Gamble, *The Beginning of Half-Tone: A History of the Process* (New York: Edward Epstean, 1927).

31. Michael Ayers Trotti, "Murder Made Real: The Visual Revolution of the Halftone," *Virginia Magazine of History and Biography* 111, no. 4 (2003): 399. See also David Rudd Cycleback, "Half-tone Printing," in *Encyclopedia of Nineteenth Century Photography*, vol. 1, ed. John Hannavy (New York: Routledge, 2008), 632.

32. Harris, *Cultural Excursions*, 314. See also Christopher Harris, "The Halftone and American Magazine Reproduction, 1880–1890," *History of Photography* 17, no. 1 (1993): 77.

33. Frank Luther Mott, *A History of American Magazines, 1741–1930*, vol. 4 (Cambridge, MA: Belknap Press, 1957), 5.

34. Edward W. Earle, *Halftone Effects: A Cultural Study of Photographs in Reproduction, 1895–1905* (Riverside: California Museum of Photography, 1989), 4.

35. David Clayton Phillips, "Art for Industry's Sake: Halftone Technology, Mass Photography, and the Social Transformation of Print Culture" (PhD diss., Yale University, 1996), 38.

36. Ulrich Keller, "Photojournalism around 1900: The Institutionalization of a Mass Medium," in *Shadow and Substance: Essays on the History of Photography in Honor of Heinz K. Henisch*, ed. Kathleen Collins (Bloomfield Hills, MI: Amorphous Institute Press, 1990), 283, citation on 286.

37. Harris, *Cultural Excursions*, 306.

38. Gerry Beegan, *The Mass Image: A Social History of Photomechanical Reproduction in Victorian London* (New York: Palgrave Macmillan, 2008), 189, 196–97.

39. Taft, *Photography and the American Scene*, 444.

40. "The Passing of the Wood Engraver," *New York Times*, April 23, 1895, 4, ProQuest Historical Newspapers database. Reproduced also (without attribution to *NYT*) as "Art Notes," *American Journal of Photography* (June 1, 1895): 279, American Periodicals Online database.

41. Kevin G. Barnhurst and John Nerone, "The President Is Dead: American News Photography and the New Long Journalism," in *Picturing the Past: Media, History, and Photography*, ed. Bonnie Brennen and Hanno Hardt (Urbana: University of Illinois Press, 1999), 89.

42. For a discussion of the history of wet-plate photography by one of its most accomplished contemporary practitioners and teachers, see Mark Osterman, "The Technical Evolution of Photography in the Nineteenth Century," in *The Concise Focal Point Encyclopedia of Photography*, ed. Michael Peres, 11–14 (New York: Focal Press, 2008).

43. See Taft, *Photography and the American Scene*, 362–69, for a detailed technical discussion of the evolution of the dry-plate method. Taft points out that despite these benefits, dry-plate was slow to emerge because (1) the plates cost more than the wet process, where photographers made their own plates with cheaper materials, and (2) because the additional sensitivity of the gelatin produced problems for photographers with light leaking into their cameras and fogging the unexposed plates (372–73). For these reasons, professionals were slower to adopt it.

44. Taft, *Photography and the American Scene*, 374.

45. Ibid., 377. On so-called detective cameras, see also Tom Gunning, "Embarrassing Evidence: The Detective Camera and the Documentary Impulse," in *Collecting Visible Evidence*, ed. Jane M. Gaines and Michael Renov, 46–64 (Minneapolis: University of Minnesota Press, 1999).

46. Taft, *Photography and the American Scene*, 378–81.

47. Ibid., 381–83. See also Mary Warner Marien, *Photography: A Cultural History*, 3rd ed. (Upper Saddle River, NJ: Prentice Hall, 2011), 168–69.

48. Taft, *Photography and the American Scene*, 383.

49. Carlebach, *Origins*, 154. Kodak itself is a meaningless word, invented by Eastman for its "strong, incisive" "K" sound. See Taft, *Photography and the American Scene*, 388–89.

50. Taft, *Photography and the American Scene*, 388; Nancy Martha West, *Kodak and the Lens of Nostalgia* (Charlottesville: University Press of Virginia, 2000), 23.

51. Michael Carlebach, *American Photojournalism Comes of Age* (Washington, DC: Smithsonian Institution Press, 1997), 19.

52. West, *Kodak*, 21–22; Carlebach, *American Photojournalism*, 18. An 1899 instruction book for the Kodak No. 4 lists nine separate steps for loading the film properly into the camera and another nine separate steps to unload it once the roll was exposed. Thus, even apart from the messiness of developing, one can see why the company might have encouraged customers to avoid mistakes and simply send everything back to them. While the manual says, "We recommend everyone to do their own developing," it also pointed out that if the "Kodaker prefers to have us 'Do the Rest,' he can send his exposures to us by mail. We have larger and better facilities for developing and printing and more skilled operators than anyone else, and it is in our interest to get the *best results from every negative*." See *The Bulls-Eye Kodak No. 4 Instruction Book* (Rochester, NY: Eastman Kodak, 1899), 21; italics in original text.

53. Robert E. Mensel, "'Kodakers Lying in Wait': Amateur Photography and the Right of Privacy in New York, 1885–1915," *American Quarterly* 43, no. 1 (1991): 28.

54. Ibid., 32.

55. Qtd. in Carlebach, *American Photojournalism*, 18.

56. Qtd. in Harris, *Cultural Excursions*, 315.

57. Mensel, "Kodakers," 33.

58. For example, a Google Books Ngram Viewer search of the phrase shows that the term "camera fiend" more or less appeared around 1885 and spiked in frequency around 1898, a rise roughly parallel to that of amateur photography during this same period. While the Ngram Viewer uses only those texts archived in the Google Books database, it still offers a useful metric for tracking the general rise and fall in print culture of cultural terms and references. On the origins of the Google Ngram Viewer and its potential value for research, see Jean-Baptiste Michel et al., "Quantitative Analysis of Culture Using Millions of Digitized Books," *Science*, Dec. 16, 2010. On its limitations, see Eitan Adam Pechenick, Christopher M. Danforth, and Peter Sheridan Dodds, "Characterizing the Google Books Corpus: Strong Limits to Inferences of Socio-Cultural and Linguistic Evolution," *PLOS ONE* 10, no. 10 (2015), https://journals.plos.org/plosone/article?id=10.1371/journal.pone.0137041.

59. "The Confession of a Camera Fiend," *Photographic Times and American Photographer* 29, no. 1 (1897), 52+, Nineteenth Century Collections Online database.

60. "'Kodak Manners,'" *Ladies' Home Journal*, Feb. 1900, 16, American Periodicals Series database.

61. "Camera Fiends," *Photographer*, Feb. 1900, 629.

62. Bob Rose, "The History of the Twentieth-Century Camera," in *The Focal Encyclopedia of Photography*, 4th ed., ed. Michael R. Peres (Amsterdam: Focal Press, 2007), 772. Rose points out that the Brownie endured for decades; the last model was produced as late as 1986.

63. Palmer Cox was a French-Canadian poet and illustrator. See Marc Olivier, "George Eastman's Modern Stone-Age Family," *Technology and Culture* 48, no. 1 (2007): 4–6. On the use of Cox's brownies in Kodak advertising, see also West, *Kodak*, 95–100.

64. West, *Kodak*, 75.

65. "Brownie Cameras (advertisement)," *Scientific American*, April 14, 1900, 240.

66. West, *Kodak*, 75.

67. On Kodak's emphasis on photography by and of children, see West, *Kodak*, 74–108.

68. On the rise of celebrity photojournalism and snapshot culture at the turn of the twentieth century in Great Britain, see Ryan Linkof, *Public Images: Celebrity, Photojournalism, and the Making of the Tabloid Press* (London: Bloomsbury, 2018), 19–62.

69. "Photography and Public Recognition," *Photographic News*, Aug. 12, 1898, 505, Nineteenth Century Collections Online database.

70. Carlebach, *American Photojournalism*, 25.

71. "Curiosities of Public Mourning," *Daily Inter Ocean* (Chicago), Sept. 26, 1881, 4, Nineteenth Century U.S. Newspapers database.

72. Qtd. in Carlebach, *American Photojournalism*, 25.

73. "President Arthur's Photographs," *Milwaukee Daily Journal*, May 31, 1884, 2. See also "One of Arthur's Manias," *New Mississippian* (Jackson), June 3, 1884, 2, Nineteenth Century U.S. Newspapers database.

74. Carlebach, *American Photojournalism*, 25; "Mrs. Harrison's Photographs Scarce," *Photographic Times and American Photographer*, Dec. 7, 1888, 585, American Periodicals Series database.

75. Mensel, "Kodakers," 33.

76. Ibid., 33–34. The bill died quickly. See also Annette Dunlap, *Frank: The Story of Frances Folsom Cleveland, America's Youngest First Lady* (Albany: SUNY Press, 2009), 42. On the role of patent medicines in advertising to women, see Jillian Klean Zwilling, "The Euphemistic Rhetoric of Birth Control Advertising in the Comstock Era: The Lysol Douche as a Case Study" (PhD diss., University of Illinois, 2017).

77. "Public Men Look Pleasant," *Daily Inter Ocean* (Chicago), Sept. 8, 1890, 6, Nineteenth Century U.S. Newspapers database.

78. "Photographic Scissors and Paste: Bombarded by Cameras," *American Journal of Photography*, July 1, 1893, 332, American Periodicals Series database.

Chapter 5. William McKinley's Last Photographs

1. "How Presidents Pose for their Photographs," *Wilson's Photographic Magazine*, March 1, 1913, 107.

2. One possible exception is the "cracked plate" print of Abraham Lincoln mentioned in chapter 4.

3. Neil Harris, *Cultural Excursions: Marketing Appetites and Cultural Tastes in Modern America* (Chicago: University of Chicago Press, 1990), 307.

4. These two types of time have been known from the classical period as *chronos* and *kairos*, respectively. Sharon Crowley and Debra Hawhee write, "The Greeks had two concepts of time. They used the term *chronos* to refer to linear, measurable

time, the kind . . . that we track with watches and calendars. But the ancients used *kairos* to suggest a more situational kind of time, something close to what we call 'opportunity'"; see Sharon Crowley and Debra Hawhee, *Ancient Rhetorics for Contemporary Students*, 4th ed. (New York: Prentice Hall, 2009), 45. Photographer Chan-fai Cheung links photography to *kairos* through Henri Cartier-Bresson's famous notion of "the decisive moment." What makes photography *kairotic* for Cheung is "the clicking of the shutter by the conscientious photographer"; see Chan-fai Cheung, *Kairos: Phenomenology and Photography* (Hong Kong: Chinese University of Hong Kong, 2009), v.

5. Kevin Barnhurst and John Nerone studied news coverage of all four presidential assassinations (Lincoln, Garfield, McKinley, and Kennedy) in order to explore shifting news norms and to identify repeating visual motifs in assassination coverage; see Kevin G. Barnhurst and John Nerone, "Civic Picturing vs. Realist Photojournalism: The Regime of Illustrated News, 1856–1901," *Design Issues* 16, no. 1 (2000): 59–79; Kevin G. Barnhurst and John Nerone, "The President Is Dead: American News Photography and the New Long Journalism," in *Picturing the Past: Media, History, and Photography*, ed. Bonnie Brennen and Hanno Hardt, 60–92 (Urbana: University of Illinois Press, 1999). In her study of photographs that picture "the moment at which individuals are about to die," Barbie Zelizer discusses engravings that illustrated the moment of McKinley's shooting, emphasizing how the McKinley images, like the Garfield imagery before it, did not offer "realistic depiction of the act of the assassination." Zelizer focused on engraved images from the McKinley assassination rather than the photographs I engage here; see Zelizer, *About to Die: How News Images Move the Public* (Chicago: University of Chicago Press, 2010), 2, 30.

6. On the Kennedy assassination, the first presidential assassination to produce visual evidence of the actual shooting itself in the form of the Abraham Zapruder film, see David M. Lubin, *Shooting Kennedy: JFK and the Culture of Images* (Berkeley: University of California Press, 2003), 163–92; Ned O'Gorman, *The Iconoclastic Imagination: Image, Catastrophe, and Economy in America* (Chicago: University of Chicago Press, 2015), 65–101.

7. R. Hal Williams, *Realigning America: McKinley, Bryan, and the Remarkable Election of 1896* (Lawrence: University Press of Kansas, 2010), 137. See also William D. Harpine, *From the Front Porch to the Front Page: McKinley and Bryan in the 1896 Presidential Campaign* (College Station: Texas A&M University Press, 2005).

8. Lewis L. Gould, *The Presidency of William McKinley* (Lawrence: Regents Press of Kansas, 1980), 11.

9. "William McKinley at Home, Canton Ohio (1896)," https://www.youtube.com/watch?v=pRVj3yeTNgo.

10. Jonathan Auerbach, "McKinley at Home: How Early American Cinema Made News," *American Quarterly* 51, no. 4 (1999): 805, 811. On McKinley and film, see also Charles Musser, "Rethinking Early Cinema: Cinema of Attractions and

Narrativity," in *The Cinema of Attractions Reloaded*, ed. Wanda Strauven, 391–416 (Amsterdam: Amsterdam University Press, 2006); David Greenberg, *Republic of Spin: An Inside History of the American Presidency* (New York: W. W. Norton, 2016), 26–27. Greenberg notes that McKinley's brother Abner was an investor in the Biograph company, which produced this film.

11. Kevin Phillips, *William McKinley* (New York: Henry Holt, 2003), 30.

12. Ibid., 38, 58; Greenberg, *Republic of Spin*, 30–34. See also Stephen Ponder, "The President Makes News: William McKinley and the First White House Press Corps, 1897–1901," *Presidential Studies Quarterly* 24 (Fall 1994): 823–36.

13. Keller, "Photojournalism around 1900," 290.

14. Stephen Ponder, *Managing the Press: Origins of the Media Presidency, 1897–1933* (New York: St. Martin's Press, 1998), 14.

15. Maria Elizabeth Ausherman, *The Photographic Legacy of Frances Benjamin Johnston* (Tallahassee: University Press of Florida, 2009), 20–21. See also Paula M. Pierce, "Frances Benjamin Johnston: Mother of American Photojournalism," *Media History Digest* 5, no. 1 (1985): 55–56.

16. Ausherman, *Photographic Legacy*, 29. See also Bettina Berch, *The Woman Behind the Lens: The Life and Work of Frances Benjamin Johnston* (Charlottesville: University Press of Virginia, 2000).

17. Ausherman, *Photographic Legacy*, 35.

18. Frances Benjamin Johnston diary, Jan. 4, 1897. Frances Benjamin Johnston personal papers, Library of Congress.

19. See, for example, Johnston diary entries for Jan. 11, 1900; Feb. 26, 1901; March 4, 1901. Frances Benjamin Johnston personal papers, Library of Congress.

20. Phillips, *William McKinley*, 30.

21. Carl Sferrazza Anthony, *Ida McKinley: The Turn-of-the-Century First Lady through War, Assassination, and Secret Disability* (Kent, OH: Kent State University Press, 2013), 225–40.

22. "Plans for Greeting the President," *Buffalo Courier*, Aug. 31, 1901, 2.

23. Ibid.

24. Margaret Creighton, *The Electrifying Fall of Rainbow City: Spectacle and Assassination at the 1901 World's Fair* (New York: W. W. Norton, 2016), 4. See also Scott Miller, *The President and the Assassin: McKinley, Terror, and Empire at the Dawn of the American Century* (New York: Random House, 2011).

25. *Official Catalogue and Guide Book to the Pan-American Exposition* (Buffalo, NY: Charles Ahrhart, 1901), 5.

26. Ibid., 10–34.

27. Ibid., 4.

28. Ibid., 13. An Edison company short film of the Pan-American Exposition's Illumination may be found at https://upload.wikimedia.org/wikipedia/commons/1/16/Pan-American_Exposition_by_Night_%281901%29.webm. Several other Edison films featuring the exposition may be found at the Library of Congress.

See, for example, "A Trip around the Pan-American Exposition," https://www.loc
.gov/item/00694338.

29. *Official Catalogue*, 42–46.

30. Creighton, *Electrifying Fall*, 49.

31. Ibid., 260.

32. On photography at the World's Columbian Exposition (Chicago World's
Fair 1893), see James Gilbert, "Fixing the Image: Photography at the World's
Columbian Exposition," in *Grand Illusions: Chicago's World's Fair of 1893*, ed. Neil
Harris, 101–132 (London: Sewell, 1993).

33. "Printing and Allied Arts: All Branches to be Illustrated at the Buffalo Ex-
position," *Washington Post*, Nov. 4, 1900, 17.

34. Annie Schentag, "Photography at the World's Fairs: Constructing 'Official'
Images," http://rmc.library.cornell.edu/Architourism/exhibition/Construcing%
20Official%20Images%20Photography%20at%20the%20Worlds%20Fairs/index
.html.

35. John M. Bewley, "C. D. Arnold, Photographer of the Pan-American Exposi-
tion," https://digital.lib.buffalo.edu/items/show/91878.

36. Peter Bacon Hales, "Photography and the World's Columbian Exposition,"
Journal of Urban History 15, no. 3 (1989): 255.

37. Ibid., 268.

38. C. D. Arnold, *Official Views of Pan-American Exposition* (Buffalo, NY: C. D.
Arnold, 1901).

39. Bewley, "C. D. Arnold."

40. Based with a factory in New Hampshire, B. W. Kilburn became a success-
ful producer and dealer of stereographs beginning in the late 1870s; see William
Darrah, *The World of Stereographs* (Nashville: Land Yacht Press, 1997), 45–46.

41. On the history of Edison films, see *Edison: The Invention of the Movies:
1891–1918* (New York: Kino Lorber, 2005), 4 DVD set.

42. On Johnston at the Chicago World's Fair, see Berch, *Woman Behind the Lens*,
32–36. On Johnston photographing McKinley at the Buffalo Exposition, see ibid.,
71. On Johnston at Chicago, see Ausherman, *Photographic Legacy*, 42–50.

43. *Official Catalogue*, 40.

44. Nancy Martha West, *Kodak and the Lens of Nostalgia* (Charlottesville: Uni-
versity Press of Virginia, 2000), plate 1 (between pages 108 and 109). The ad
pointed out that this camera sold for between ten and eighteen dollars.

45. Exposition visitors made images and assembled scrapbooks of their trips
to Buffalo. The Seaver Center for Western History Research at the Natural His-
tory Museum of Los Angeles County, for example, has Pan-American Exposition
scrapbooks among its holdings.

46. "Plans for Greeting the President," 2.

47. "Salutes of Cannon, Tooting of Whistles and Cheers of Thousands Welcome
President M'Kinley to the Exposition," *Buffalo Courier*, Sept. 5, 1901, 1.

48. Miller, *President and the Assassin*, 300.

49. The undigitized cabinet cards may be found in the McKinley collection of the Presidential File in the Library of Congress. Each of the three images is captioned "The Last Photograph of Pres. McKinley by his own permission. Taken at the International Hotel, Niagara Falls, N.Y., Sept. 6, 1901."

50. "President McKinley's Last View of the Falls at Niagara—Taken Early on the Afternoon of the Day on which he was Shot," *Frank Leslie's*, Oct. 5, 1901, 322.

51. Miller, *President and the Assassin*, 300.

52. Creighton, *Electrifying Fall*, 87.

53. Miller, *President and the Assassin*, 301.

54. Ibid.

55. Parker's role was later erased by other accounts that emphasized the valor of the Secret Service agents and negated the important contribution of an African American citizen and exposition worker in stopping the shooter. See Creighton, *Electrifying Fall*, 125–26, 150–52.

56. Miller, *President and the Assassin*, 301–304, 312–14; Creighton, *Electrifying Fall*, 95–99.

57. Miller, *President and the Assassin*, 315.

58. "Prisoner Is Removed from the Exposition," *Buffalo Courier*, Sept. 7, 1901, 2.

59. "President Better," *Buffalo Courier*, Sept. 8, 1901 (noon extra), 1.

60. Miller, *President and the Assassin*, 316.

61. "Cabinet Has Established Headquarters," *Buffalo Courier*, Sept. 8, 1901, 23.

62. Miller, *President and the Assassin*, 316; Creighton, *Electrifying Fall*, 101–103.

63. "Scenes about Milburn Home," *Buffalo Courier*, Sept. 8, 1901, 10.

64. "Night Scenes in Press Tent," *Buffalo Courier*, Sept. 9, 1901, 4.

65. "Amateur Photographs of Czolgosz's Crime," *Buffalo Courier*, Sept. 8, 1901, 23.

66. A vintage Edison cylinder recording of the tune by popular singer Will F. Denny, plus lyrics, is available at https://www.youtube.com/watch?v=btBhgXzAW84.

67. "Amateur Photographs," 23.

68. In the spring of 2017 I contacted the William McKinley Presidential Library and Museum in Canton, Ohio, and shared with them the *Buffalo Courier* article that obliquely suggested that snapshots of the shooting existed. A researcher there confirmed that the museum knows of no snapshots of the shooting. Email from Judith Pocock to the author, April 14, 2017.

69. "Amateur Photographs," 23.

70. Ibid.

71. See, for example, *Buffalo Courier*, Sept. 15, 1901 (Sunday supplement), 1–3.

72. "Amateur Photographs," 23.

73. Barbie Zelizer, *Covering the Body: The Kennedy Assassination, the Media, and the Shaping of Collective Memory* (Chicago: University of Chicago Press, 1992), 52.

74. See, for example, "Watching Over the Stricken President," *Collier's*, Sept. 21, 1901, 10.

75. Creighton, *Electrifying Fall*, 133; Miller, *President and the Assassin*, 319.

76. Creighton, *Electrifying Fall*, 136. After McKinley died, doctors who treated him publicly discussed the president's treatment, in some cases accusing one another of bad practices; see Miller, *President and the Assassin*, 323–24. See also articles by McKinley's various doctors published in a special issue of the *Buffalo Medical Journal*, Oct. 1901, 226+.

77. *Illustrated Buffalo Express*, Sept. 16, 1901, 1.

78. "Funeral in Washington," *Illustrated Buffalo Express*, Sept. 22, 1901, 2.

79. "We Picture It" (advertisement), *Illustrated Buffalo Express*, Sept. 21, 1901.

80. Barnhurst and Nerone, "President Is Dead," 68–69.

81. Ibid., 69.

82. My examples are drawn primarily from four heavily illustrated local and national publications that covered the shooting and McKinley's death extensively: the *Buffalo Courier*, the *Illustrated Buffalo Express*, *Frank Leslie's Weekly*, and *Collier's Weekly*.

83. "Death-Mask Taken," *Illustrated Buffalo Express*, Sept. 16, 1901, 2.

84. On James "Jimmy" Hare, see Lewis L. Gould and Richard Greffe, *Photojournalist: The Career of Jimmy Hare* (Austin: University of Texas Press, 1977).

85. *Collier's*, Sept. 21, 1901.

86. *Collier's*, Sept. 14, 1901.

87. "The Last Photograph Taken of President and Mrs. McKinley During Their Buffalo Visit," *Frank Leslie's Weekly*, Sept. 28,1901, 294.

88. "President McKinley at the Pan-American Exposition," *Collier's*, Sept. 14, 1901, 6.

89. "William McKinley's Last Speech Delivered at Buffalo September 5," *Brooklyn Eagle*, Sept. 14, 1901, 9.

90. "The President Addressing the Throng at the Exposition on President's Day," *Illustrated Buffalo Express*, Sept. 15, 1901, 4, 1.

91. "The Last Photograph Taken at the Request of President McKinley," *Frank Leslie's Weekly*, Sept. 9, 1901, n.p.

92. "The Shooting of the President," *Frank Leslie's Weekly*, Sept. 21, 1901, 262; "Happy Mood of President McKinley on the Day of the Tragedy," *Frank Leslie's Weekly*, Sept. 21, 1901, 267.

93. "The Latest Portrait of the President," *Illustrated Buffalo Express*, Sept. 15, 1901, 1.

94. "Hope Rises That Chief Will Soon Pass Peril Point," *Atlanta Constitution*, Sept. 9, 1901, 1.

95. "Last Acts in the Life of the Late President," *Frank Leslie's Weekly*, Oct 5, 1901, 322.

96. "Last Photograph Taken," n.p.

97. "Last Portrait of McKinley, Buffalo, NY, Sept. 5, 1901," Frances Benjamin Johnston collection, Library of Congress Prints and Photographs Division, http://www.loc.gov/pictures/item/2001703933.

98. William McKinley, "President McKinley's Last Public Utterance to the People in Buffalo, New York," Sept. 5, 1901. Online by Gerhard Peters and John T. Woolley, *The American Presidency Project*, https://www.presidency.ucsb.edu/documents/president-mckinleys-last-public-utterance-the-people-buffalo-new-york.

99. See, for example, *Buffalo Courier*, Sept. 22, 1901; *Illustrated Buffalo Express*, Sept. 15, 1901; *Collier's*, Sept. 21, 1901, 7; *Brooklyn Eagle*, Sept. 14, 1901; *Frank Leslie's Weekly*, Sept. 15, 1901; *Buffalo Medical Journal*, Oct. 1901.

100. "Souvenir Pictures of the President," *Illustrated Buffalo Express*, Sept. 15, 1901, 1.

101. "The Assassination of President McKinley," *Buffalo Medical Journal*, Oct. 1901, 229.

102. See, for example, "The President at Buffalo," *Collier's*, Sept. 21, 1901, 6, 8; "Incidents and Scenes of the Day," *Buffalo Courier*, Sept. 21, 1901, 3.

103. Ausherman, *Photographic Legacy*, 36.

104. See *Illustrated Buffalo Express*, Sept. 15, 1901, 1, 2, 4.

105. Berch, *Woman Behind the Lens*, 71.

106. See, for example, letters to Johnston from George Millard Benson, Dec. 14, 1901; Citizens Club of Fulton, NY, Nov. 23, 1901; Harvey R. Keeler, Nov. 27, 1901; all in Frances Benjamin Johnston personal papers, Library of Congress.

107. Sculptor and Ohio native Charles Henry Niehaus created the statue based on Johnston's photograph. He had also created two statues of another assassinated president from Ohio, James Garfield, during the 1880s. On Niehaus, see https://en.wikipedia.org/wiki/Charles_Henry_Niehaus.

108. Ausherman, *Photographic Legacy*, 36.

Chapter 6. Visual News in the Early Twentieth Century

1. "Camera Fiend Rebuked by President," *Buffalo Courier*, Sept. 23, 1901, 1.

2. H. W. Brands, *TR: The Last Romantic* (New York: Basic Books, 1997), 150–75.

3. On Roosevelt's physical and public transformation in the Dakotas, see Ronald Tobias, *Film and the American Moral Vision of Nature: Theodore Roosevelt to Walt Disney* (East Lansing: Michigan State University Press, 2011), 29–30.

4. Ibid., 29.

5. Ibid., 31.

6. See Matthew Brower, *Developing Animals: Wildlife and Early American Photography* (Minneapolis: University of Minnesota Press, 2011), 26, 58. See also Finis Dunaway, "Hunting with the Camera: Nature Photography, Manliness, and Modern Memory, 1890–1930," *Journal of American Studies* 34, no. 2 (2000): 210–17.

7. On Riis's photography, see Reginald Twigg, "The Performative Dimension of Surveillance: Jacob Riis' *How the Other Half Lives*," *Text and Performance Quarterly* 12, no. 4 (1992): 305–328; Bruce E. Gronbeck, "Jacob Riis and the Doubly Material Rhetorics of His Politics," in *Rhetoric, Materiality, and Politics*, ed. Barbara Biesecker and John Louis Lucaites, 131–60 (New York: Peter Lang, 2009); Maren Stange,

Symbols of Ideal Life: Social Documentary Photography in America, 1890–1950 (New York: Cambridge University Press, 1989).

8. On Riis's relationship with Roosevelt, see Ferenc M. Szasz, Ralph F. Bogardus, and Ralph H. Bogardus, "The Camera and the American Social Conscience: The Documentary Photography of Jacob A. Riis, *New York History* 55, no. 4 (1974): 408–436. See also Brands, *TR: The Last Romantic*, 272–78.

9. Ulrich Keller, "Photojournalism before 1900: The Institutionalization of a Mass Medium," in *Shadow and Substance: Essays on the History of Photography in Honor of Heinz K. Henisch*, ed. Kathleen Collins (Bloomfield Hills, MI: Amorphous Institute Press, 1990), 286.

10. Jason E. Hill, "Snap-shot: After Bullet Hit Gaynor," in *Getting the Picture: The Visual Culture of the News*, ed. Jason E. Hill and Vanessa R. Schwartz (London: Bloomsbury, 2015), 195.

11. Ibid., 193.

12. Michael Carlebach, *Bain's New York: The City in News Pictures, 1900–1925* (Mineola, NY: Dover Publications, 2011), viii.

13. Ibid., xiv; xvii.

14. Zeynep Devrim Gursel, "A Short History of Wire Service Photography," in Hill and Schwartz, *Getting the Picture*, 206; Carlebach, *Bain's New York*, xviii. On the history of news agencies and wire services, see also Richard A. Schwarzlose, "Cooperative News Gathering," in *American Journalism: History, Principles, Practices*, ed. W. David Sloan and Lisa Mullikin Parcell, 153–61 (Jefferson, NC: McFarland, 2002).

15. Keller, "Photojournalism," 293.

16. Keith R. Kenney and Brent Unger, "The Mid-Week Pictorial," *American Journalism* 11, no. 3 (1994): 244.

17. Andrés Mario Zervigón, "Rotogravure and the Modern Aesthetic of News Reporting, in Hill and Schwartz, *Getting the Picture*, 199. On rotogravure, see also Richard Benson, *The Printed Picture* (New York: Museum of Modern Art, 2008), 236–39.

18. Kenney and Unger, "Mid-Week," 244; Benson, *Printed Picture*, 236.

19. Kenney and Unger, "Mid-Week," 244.

20. Benson, *Printed Picture*, 238. On the rise of Sunday supplements and rotogravure sections in newspapers, see also Cara A. Finnegan, *Picturing Poverty: Print Culture and FSA Photographs* (Washington, DC: Smithsonian Books, 2003), 170–71.

21. Benson, *Printed Picture*, 238. See also Kenney and Unger, "Mid-Week," 243.

22. "The Rotogravure Process and the Use of Pictorials in Newspapers," American Memory Collection, Library of Congress, http://memory.loc.gov:8081/ammem/collections/rotogravures/rotoprocess.html.

23. Kenney and Unger, "Mid-Week," 247.

24. Zervigón, "Rotogravure," 197.

25. Nancy Martha West, *Kodak and the Lens of Nostalgia* (Charlottesville: University Press of Virginia, 2000), 20.

26. Ibid., 31–32.

27. Bob Rose, Todd Gustavson, and Hiroshi Yano, "The History of the Twenti-eth-Century Camera," in *Focal Encyclopedia of Photography*, 4th ed., ed. Michael R. Peres (New York: Elsevier, 2007), 773.

28. Todd Gustavson, *Camera: A History of Photography from Daguerreotype to Digital* (New York: Sterling Innovation, 2009), 206.

29. Jodie Hauptman, "FLASH! The Speed Graphic Camera," *Yale Journal of Criticism* 11, no. 1 (1998): 131.

30. John Durniak, "Camera; The Old Speed Graphic Is Alive and Clicking," *New York Times*, June 15, 1986, http://www.nytimes.com/1986/06/15/arts/camera-the-old-speed-graphic-is-alive-and-clicking.html?mcubz=0.

31. Hauptmann, "FLASH," 131.

32. On the Speed Graphic in the U.S. press, see Marianne Fulton, *Eyes of Time: Photojournalism in America* (Boston: Little, Brown, 1998), 115. See also Michael L. Carlebach, *American Photojournalism Comes of Age* (Washington, DC: Smithsonian Institution Press, 1997), 159–60. On the Speed Graphic weighing nine pounds fully loaded, see Hauptman, "FLASH," 131.

33. David Greenberg, *Republic of Spin: An Inside History of the American Presidency* (New York: W. W. Norton, 2016), 5.

34. Lewis L. Gould, *The Modern American Presidency*, 2nd ed. (Lawrence: University Press of Kansas, 2009), xiii-xiv. See also Stephen Ponder, *Managing the Press: Origins of the Media Presidency, 1897–1933* (New York: St. Martin's Press, 1998).

35. Gould, *Modern American Presidency*, 9.

36. Lewis L. Gould, "Theodore Roosevelt, Woodrow Wilson, and the Emergence of the Modern Presidency: An Introductory Essay," *Presidential Studies Quarterly* 19, no. 1 (1989): 41. See also Ponder, *Managing the Press*, xiv-xvi.

37. George Juergens, *News from the White House* (Chicago: University of Chicago Press, 1981), 15. See also Rodger Streitmatter, "Theodore Roosevelt, Public Relations Pioneer," *American Journalism* 7, no. 2 (1990): 110.

38. See Juergens, *News from the White House*, 17–20. Charles Willis Thompson writes that Roosevelt understood the work of journalists and their deadlines and would tip them ahead of time whether what he said was likely to make news; see Thompson, *Presidents I've Known and Two Near Presidents* (Freeport, NY: Books for Libraries Press, 1929), 142–43.

39. Streitmatter, "Theodore Roosevelt," 99.

40. Juergens, *News from the White House*, 27.

41. Streitmatter, "Theodore Roosevelt," 96. See also Juergens, *News from the White House*, 41–62.

42. Juergens, *News from the White House*, 140–51. On the White House Correspondents' Association, see also Thomas A. Hughes, "White House Correspondents' Association," in *History of the Mass Media in the United States*, ed. Margaret Blanchard (Chicago: Fitzroy Dearborn, 1998), 696.

43. Thompson, *Presidents I've Known*, 295. See also Charles Willis Thompson, "Coolidge Has Learned the Art of Publicity," *New York Times*, Aug. 7, 1927, 22, where Thompson recounts the same story; Juergens, *News from the White House*, 133.

44. Thompson, *Presidents I've Known*, 295.

45. "Wilson Threatens to Beat Camera Man," *New York Times*, Nov. 23, 1912, 4. ProQuest Historical Newspapers database.

46. Juergens, *News from the White House*, 36. See also Ponder, *Managing the Press*, 30–32.

47. Streitmatter, "Theodore Roosevelt," 104.

48. Ibid., 105.

49. Juergens, *News from the White House*, 101.

50. Ponder, *Managing the Press*, 58.

51. Dennis Brack, *Presidential Picture Stories: Behind the Cameras at the White House* (self-pub., Dennis Brack Inc., 2013), 7.

52. Ibid., 5–6.

53. Ibid., 7–8.

54. Stephen Ponder, "That Delightful Relationship," *American Journalism* 14, no. 2 (1997): 171. See also Brack, *Presidential Picture Stories*, 10–12.

55. Greenberg, *Republic of Spin*, 132.

56. W. Richard Whitaker, "Harding, Warren G., and the Press," in *History of Mass Media: An Encyclopedia*, ed. Margaret A. Blanchard (Chicago: Fitzroy Dearborn Publishers, 1998), 250.

57. Ponder, "Delightful Relationship," 171. See also Ponder, *Managing the Press*, 114.

58. Ponder, "Delightful Relationship," 171.

59. Greenberg, *Republic of Spin*, 164. See also Ponder, *Managing the Press*, 122.

60. Greenberg, *Republic of Spin*, 165.

61. Ibid.

62. Dan Rossiter, "Mustn't Photograph Coolidge When He Is Posing for Another," *Boston Globe*, May 12, 1929, A37.

63. Greenberg, *Republic of Spin*, 157–63.

Chapter 7. Herbert Hoover, Franklin Roosevelt, and the Candid Camera

1. H. L. Smith, "The News Camera on Trial," *Forum and Century*, Nov. 1937, 267.

2. Mary Warner Marien, *Photography: A Cultural History*, 3rd ed. (Upper Saddle River, NJ: Prentice Hall, 2011), 237.

3. Gisèle Freund, *Photography and Society* (Boston: David R. Godine, 1980), 130.

4. On the history and eventual dominance of 35 mm photography, see Peter Wollheim, "Towards a Critical History of the 35mm Still Photographic Camera in North America, 1896 to 1980" (PhD diss., McGill University, 1990); Roger William Hicks, *A History of the 35mm Still Camera* (New York: Focal Press, 1984).

5. Robert Hirsch, *Seizing the Light: A History of Photography* (Boston: McGraw-Hill, 2000), 301.

6. Ibid.

7. "Are You Looking for a New Thrill in Photography?" Nesster, Leica Advertising, Flickr.com, https://www.flickr.com/photos/nesster/sets/72157625698006770.

8. Charles Sanford Knapp, "Toy or Tool? Challenge to the Miniature Cameraist," *American Photography* 30, Feb. 1936, 80.

9. Ibid.

10. Ibid; ellipsis in the original text.

11. Harrison Fisk, "Uses and Abuses of the Miniature Camera," *American Photography*, May 1936, 327.

12. Ansel Adams, "The Expanding Photographic Universe," in *Miniature Camera Work: Emphasizing the Entire Field of Photography with Modern Miniature Cameras*, ed. Willard D. Morgan and Henry M. Lester (New York: Morgan and Lester Publishers, 1938), 73; emphasis in the original text.

13. Knapp, "Toy or Tool," 82; ellipsis in the original text.

14. "Speaking of Pictures," *Life*, March 15, 1937, 6–7.

15. "Sailorman's Daughter Chosen Miss Candid Camera of 1940," *Life*, April 22, 1940, 83.

16. "Picture Snatcher," TCM Database, http://www.tcm.turner.com/tcmdb/title/86672/Picture-Snatcher. The film includes a scene in which Cagney uses a hidden miniature camera to surreptitiously photograph an execution, a scene mimicking the real-life case of the execution of Ruth Snyder photographed in 1928. (Thanks to Vanessa Schwartz for pointing me to this film.) On the Snyder execution photo, see Richard Meyer, "Public Execution, Sing Sing Prison, 1928," in *Getting the Picture: The Visual Culture of the News*, ed. Jason E. Hill and Vanessa R. Schwartz (London: Bloomsbury, 2015); Marien, *Photography*, 237. Examples of candid camera mystery novels include David O'Hara, *Jimmie Drury: Candid Camera Detective* (New York: Grosset and Dunlap, 1938); and Van Wyck Mason, *The Castle Island Case: A Candid Clue Mystery* (New York: Reynal and Hitchcock, 1937).

17. Peter Hunter, *Erich Salomon: Aperture History of Photography Series* (New York: Aperture, 1978), 5.

18. Ibid., 6.

19. Ibid., 7. On the *Berliner Illustrirte Zeitung*, see Sherre Lynne Paris, "Raising Press Photography to Visual Communication in American Schools of Journalism, with Attention to the Universities of Missouri and Texas, 1880s–1990s" (PhD diss., University of Texas, 2007), 116–17; Lutz Koepnick, "Face/Off: Hitler and Weimar Political Photography," in *Visual Culture in Twentieth-Century Germany: Text as Spectacle*, ed. Gail Finney, 214–34 (Bloomington: Indiana University Press, 2006).

20. Hunter, *Erich Salomon*, 7.

21. For more on Salomon's early work, see Freund, *Photography and Society*, 119–24.

22. Hunter, *Erich Salomon*, 8.

23. Ibid., 6.

24. Ibid., 9.

25. Daniel H. Magilow, "Photo of Kellogg-Briand Pact Meeting, Paris, 1931," in Hill and Schwartz, *Getting the Picture*, 53.

26. Erich Salomon, *Portrait of an Age* (New York: Macmillan, 1967), 21.

27. "Hearst at Home," *Fortune*, May 1931, 56–68.

28. "Statesmen of Europe," *Fortune*, Nov. 1931, 143.

29. Ibid.

30. "Harvard University: A Portfolio by Dr. Erich Salomon," *Fortune*, Jan. 1932, 82–93; "Salomon's Eyes on Washington," *Fortune*, Feb. 1932, 54–55.

31. See, for example, Frederick T. Birchall, "Europe Makes the Conference a Habit," *New York Times*, Dec. 11, 1932, SM 7, 17; Anne O'Hare McCormick, "Preparing for 'The New Deal,'" *New York Times*, Jan. 15, 1933, SM 1, 14; "These Dry Hands Shall Not Falter," *Vanity Fair*, July 1932, 15.

32. "Roi des Indiscrets," *Time*, Nov. 9, 1931, 21.

33. Hunter, *Erich Salomon*, 9. See also "The Supreme Court Sits," *Fortune*, Oct. 1932, 60.

34. "Dr. Salomon's Faces," *Fortune*, April 1932, 41.

35. On Salomon's camera as "secret," see, for example, L. H. Robbins, "Secret Snapshots of Current History," *New York Times*, June 19, 1932, 4; "Statesmen of Europe," 143. Salomon's camera is described as "privy" in "Salomon's Eyes on Washington," 53.

36. "Supreme Court Sits," 60.

37. Robbins, "Secret Snapshots of Current History," 4.

38. Dennis Brack, *Presidential Picture Stories: Behind the Cameras at the White House* (self-pub., Dennis Brack Inc., 2013), 15.

39. Ibid., 16.

40. Ibid., 17. See also Stephen Ponder, *Managing the Press: The Origins of the Media Presidency, 1897–1933* (New York: St. Martin's Press, 1998), 151.

41. Ponder, *Managing the Press*, 148.

42. Louis W. Liebovich, *Bylines in Despair: Herbert Hoover, the Great Depression, and the U.S. News Media* (Westport, CT: Praeger, 1994), 35. See also Ponder, *Managing the Press*, 127–55.

43. Glen Jeansonne, *The Life of Herbert Hoover* (New York: Palgrave Macmillan, 2012), 384. On presidents refusing to be quoted directly, see also Ponder, *Managing the Press*, 79; George Juergens, *News from the White House* (Chicago: University of Chicago Press, 1981), 20; Louis M. Lyons, "1964: Calvin Coolidge and the Press," *Nieman Reports* (Winter 1999/Spring 2000): 35.

44. See Jeansonne, *Life of Herbert Hoover*, 330–33.

45. Harold T. J. Horan, "The Diplomatic Pouch," *Washington Post*, Oct. 25, 1931, M7.

46. Ibid.

47. Salomon, *Portrait of an Age*, 170–71. See also "The First Candids," *New York Times*, March 9, 1958, SM21.

48. "I Am Happy," *Time*, Nov. 9, 1931, 13.

49. "When President and French Premier Conversed," *Chicago Tribune*, Nov. 8, 1931, 5; "America's President and France's Premier Confer at the White House," *Chicago Tribune*, Nov. 15, 1931, G3.

50. "Man of the Year," *Time*, Jan. 4, 1932. During World War II, Laval became a fascist sympathizer and served in several positions in Nazi-occupied France. He was tried and executed by the Allies in 1945. On Laval's trial, see J. Kenneth Brody, *The Trial of Pierre Laval: Defining Treason, Collaboration, and Patriotism in World War II France* (New Brunswick, NJ: Transaction Publishers, 2010).

51. "President Guest of White House Newspaper Men," *New York Herald Tribune*, March 6, 1932, 9.

52. Salomon, *Portrait of an Age*, 172. See also Hunter, *Erich Salomon*, 9.

53. Brack, *Presidential Picture Stories*, 18.

54. "Gov. Roosevelt Greets Schmeling in German; Compliments the Champion at Training Camp," *New York Times*, May 31, 1932, 23.

55. Hugh Gregory Gallagher, *FDR's Splendid Deception: The Moving Story of Roosevelt's Massive Disability and the Intense Efforts to Conceal it from the Public*, rev. ed. (St. Petersburg, FL: Vandamere Press, 1999). First published 1985 by Dodd, Mead.

56. Ibid., 210. For one recent example of the "triumph" narrative, see David Greenberg, *Republic of Spin: An Inside History of the American Presidency* (New York: W. W. Norton, 2016), 195.

57. William McKinley Moore, "F.D.R.'s Image: A Study in Pictorial Symbols" (PhD diss., University of Wisconsin, 1946), 473–77.

58. Christopher Clausen, "The President and the Wheelchair," *Wilson Quarterly* 29 (Summer 2005): 29. See also Anne Norton, *Republic of Signs: Liberal Theory and Popular Culture* (Chicago: University of Chicago Press, 1993), 103–110. For a litany of the chronic illnesses that pained Kennedy for most of his life, see John M. Murphy, *John F. Kennedy and the Liberal Persuasion* (East Lansing: Michigan State University Press, 2019), 28–29; and David Blumenthal and James A. Morone, *The Heart of Power: Health and Politics in the Oval Office* (Berkeley: University of California Press, 2010), 133–37.

59. Matthew Pressman, "Ambivalent Accomplices: How the Press Handled FDR's Disability and How FDR Handled the Press," *Journal of the Historical Society* 13, no. 3 (2013): 328.

60. Davis W. Houck and Amos Kiewe, *FDR's Body Politics: The Rhetoric of Disability* (College Station: Texas A&M University Press, 2003), 10.

61. Ibid.

62. Ibid., 65–76. See also Earle Looker, "Is Franklin D. Roosevelt Physically Fit to Be President?" *Liberty Magazine*, July 25, 1931, 6–10.

63. Houck and Kiewe, *FDR's Body Politics*, 96.

64. Ibid., 107. See also Gould, *Modern American Presidency*, 82.

65. Houck and Kiewe, *FDR's Body Politics*, 83.

66. See ibid., 45–52, 93, 98; Pressman, "Ambivalent Accomplices," 330–31, Robert E. Gilbert, "Disability, Illness, and the Presidency: The Case of Franklin D. Roosevelt," *Politics and the Life Sciences* 7, no. 1 (1988): 35; and Sally Stein, "FDR's Two Bodies: Stagings and Restagings of FDR and the New Deal Body Politic," *American Art* 18, no. 1 (2004): 36.

67. Greenberg, *Republic of Spin*, 192.

68. "Enjoys Jokes, Allows Cameras," *New York Times*, March 9, 1933, 3.

69. Betty Houchin Winfield, *FDR and the News Media* (Urbana: University of Illinois Press, 1990), 33.

70. Betty Houchin Winfield, "FDR's Pictorial Image: Rules and Boundaries," *Journalism History* 5, no. 4 (1978–79): 110.

71. "A Laughing Cavalier," *Vanity Fair*, Oct. 1933, 15; Stein, "FDR's Two Bodies," 39–40.

72. Winfield, *FDR and the News Media*, 104.

73. Ibid., 105; Earnest Brandenburg and Waldo W. Braden, "Franklin Roosevelt's Voice and Pronunciation," *Quarterly Journal of Speech* 38, no. 1 (1952): 24.

74. Winfield, *FDR and the News Media*, 105. See also Amos Kiewe, *FDR's First Fireside Chat: Public Confidence and the Banking Crisis* (College Station: Texas A&M University Press, 2007).

75. Cara A. Finnegan, *Picturing Poverty: Print Culture and FSA Photographs* (Washington, DC: Smithsonian Books, 2003), xi.

76. On New Deal government photography projects, see Merry A. Foresta, Maren Stange, Sally Stein, and Pete Daniel, *Official Images: New Deal Photography* (Washington, DC: Smithsonian Institution Press, 1987). Photographers working with the RA/FSA included Walker Evans and Dorothea Lange, the latter of whom made what is generally believed to be the most famous photograph of the era, "Migrant Mother." On Lange and "Migrant Mother," see Carol Quirke, *Dorothea Lange, Documentary Photography, and Twentieth-Century America: Reinventing Self and Nation* (London: Taylor & Francis, 2019); Finnegan, *Picturing Poverty*, 94–119, 136–45.

77. On FDR's use of visual language, see Finnegan, *Picturing Poverty*, ix–xi; Mary Stuckey, "FDR, the Rhetoric of Vision, and the Creation of a National Synoptic State," *Quarterly Journal of Speech* 98, no. 3 (2012): 297–319. On the term "one third of a nation," see Cara A. Finnegan, *Making Photography Matter: A Viewer's History from the Civil War to the Great Depression* (Urbana: University of Illinois Press, 2015), 150–51.

78. Pressman, "Ambivalent Accomplices," 348–51.

79. "Words and Pictures," *New York Times*, March 3, 1933, 16. See also Winfield, "Picturing FDR," 111.

80. Winfield, *FDR and the News Media*, 111–12.

81. Ibid., 112.

82. Ibid.

83. Ibid., 114.

84. Ibid., 113. See also Winfield, "FDR's Pictorial Image," 111; Moore, "F.D.R.'s Image," 464–65. See also Smith, "News Camera on Trial," 268–69.

85. Winfield, *FDR and the News Media*, 113.

86. On the court-packing scheme, see Donovan Bisbee, "Driving the Three-Horse Team of Government: *Kairos* in FDR's Judiciary Fireside Chat," *Rhetoric & Public Affairs* 21, no. 3 (2018): 489.

87. Winfield, *FDR and the News Media*, 114.

88. "The President's Album," *Life*, Aug. 6, 1937, 27.

89. Winfield, *FDR and the News Media*, 114.

90. Ibid.; Moore, "F.D.R.'s Image," 635–37; "President Lunches with Cardinal," *Chicago Tribune*, Oct. 6, 1937, 3; "President Visits a Friend and Dedicates Bridge in Chicago," *New York Times*, Oct. 6, 1937, 16.

91. Phil Mistry, "*Popular Photography* Is Dead after 80 Years as a Top Photo Magazine," *PetaPixel*, March 7, 2017, https://petapixel.com/2017/03/07/popular -photography-dead-80-years-top-photo-magazine.

92. Rosa Reilly, "Why the Candid Camera Was Barred from the White House," *Popular Photography*, Oct. 1937, 13.

93. Ibid., 14.

94. Ibid., 13. See also Winfield, *FDR and the News Media*, 113.

95. On the Jefferson Island controversy, see also Moore, "F.D.R.'s Image," 467–69.

96. Reilly, "Why the Candid Camera Was Barred," 86.

97. Ibid., 87.

98. "Candid Camera Shots Assailed by Churchill," *New York Times*, Nov. 13, 1937, 20. Ryan Linkof terms such images "humiliating photographs" and describes the 1930s as the "fruition of the humiliating press photograph." While Linkof's study focuses on Great Britain, he notes that "the vogue for embarrassing photographs took hold perhaps most soundly in the United States"; see Linkof, *Public Images: Celebrity, Photojournalism, and the Making of the Tabloid Press* (London: Bloomsbury, 2018), 67.

99. "Photographers Hail Centenary of Invention of Daguerreotype," *New York Herald Tribune*, Jan. 8, 1839, 14.

100. Hunter, *Erich Salomon*, 12. For a substantive discussion of German Jews who left Europe and later figured prominently in U.S. mass magazine and film culture, see C. Zoe Smith, "Émigré Photography in America: Contributions of German Photojournalism from Black Star Picture Agency to *Life* Magazine, 1933–1938" (PhD diss., University of Iowa, 1983).

101. "Photographers Hail Centenary," 14.

Chapter 8. Changing Visual Media from the Mid-Twentieth Century to the Digital Age

1. "CBS News Vault: 1974 Nixon Resignation," Aug. 7, 1974, https://www.you tube.com/watch?v=_e9Ot63lSiw. John Bredar offers a brief account of this exchange in *The President's Photographer: Fifty Years inside the Oval Office* (Washington, DC: National Geographic, 2010), 124. See also Kenneth T. Walsh, *Ultimate Insiders: White House Photographers and How They Shape History* (New York: Routledge, 2017), 87.

2. For an overview of key scholarship on presidential communication, see Allan D. Louden, "Presidential Communication," in *Encyclopedia of Presidential Communication,* ed. Lynda Lee Kaid and Christina Holz-Bacha, 632–39 (Thousand Oaks, CA: Sage, 2008). See also Martha Joynt Kumar, *Managing the President's Message: The White House Communications Operation* (Baltimore: Johns Hopkins University Press, 2007); Roderick P. Hart, *The Sound of Leadership: Presidential Communication in the Modern Age* (Chicago: University of Chicago Press, 1989); Kathleen Hall Jamieson, *Packaging the Presidency: A History and Criticism of Presidential Campaign Advertising,* 3rd ed. (New York: Oxford University Press, 1996); Doris A. Graber and Johanna Dunaway, *Mass Media and American Politics,* 10th ed. (Washington, DC: CQ Press, 2017); Samuel Kernell, *Going Public: New Strategies of Presidential Leadership* (Washington, DC: CQ Press, 2006); Jeffrey K. Tulis, *The Rhetorical Presidency,* new ed. (1987; Princeton, NJ: Princeton University Press, 2017); Karlyn Kohrs Campbell and Kathleen Hall Jamieson, *Presidents Creating the Presidency: Deeds Done in Words* (Chicago: University of Chicago Press, 2008).

3. Herbert Lee Williams, *The Newspaperman's President: Harry S. Truman* (Chicago: Nelson-Hall, 1984), 86.

4. Ibid.

5. Franklin Mitchell, *Harry S. Truman and the News Media: Contentious Relations, Belated Respect* (St. Louis: University of Missouri Press, 1998), 152.

6. Mitchell, *Harry S. Truman and the News Media,* 154–55.

7. Stanley Tretick, "I Shoot the Big Shots," *Saturday Evening Post,* March 15, 1958, 83.

8. On Eisenhower's heart health, see Clarence G. Lasby, *Eisenhower's Heart Attack: How Ike Beat Heart Disease and Hung on to the Presidency* (Lawrence: University Press of Kansas, 1997); David Blumenthal and James Morone, *The Heart of Power: Health and Politics in the Oval Office* (Berkeley: University of California Press, 2010), 108.

9. See, for example, Russell Baker, "President Poses for Photographs," *New York Times,* Oct. 26, 1955, 1, 20.

10. Tretick, "I Shoot the Big Shots," 84.

11. Dennis Brack, *Presidential Picture Stories: Behind the Cameras at the White House* (self-pub., Dennis Brack Inc., 2013), 51. On Eisenhower as a painter, see Sister Wendy Beckett, "President Eisenhower: The Painter," *White House History* 21 (2007): 30–39. Eisenhower even produced his own version of Stuart's Ath-

enaeum portrait of George Washington, which appears in Beckett, "President Eisenhower," 39.

12. "Ike Takes Up Camera, Snaps Photos at Farm," *Washington Post and Times-Herald*, Jan. 9, 1955, A19; John Leland and Darcy Everleigh, "Ike? They Liked," *LENS: The New York Times Photo Blog*, May 10, 2014, https://lens.blogs.nytimes .com/2014/05/10/ike-they-liked. See also Peter Buse, *The Camera Does the Rest: How Polaroid Changed Photography* (Chicago: University of Chicago Press, 2016), 40.

13. David Lubin, *Shooting Kennedy: JFK and the Culture of Images* (Berkeley: University of California Press, 2003), 6, 43–44.

14. Courtney Caudle Travers, "Jacqueline Kennedy and the Politics of Popularity" (PhD diss., University of Illinois at Urbana–Champaign, 2015), 59. On Jacqueline Kennedy's critiques of press photography of her children, see Brack, *Presidential Picture Stories*, 59–61; "Kennedys Ban Photographs of Caroline at Play," *Washington Post and Times-Herald*, April 8, 1961, A4.

15. George Tames, oral history interview with Donald Ritchie, Jan. 30–May 16, 1988, Interview #2, 44, https://www.archives.gov/legislative/research/special -collections/oral-history/senate-program/tames/interview-1.html.

16. On Lowe, see Susan Kismaric, *American Politicians: Photographs from 1843 to 1993* (New York: Museum of Modern Art, 1994), 39. On Tretick, see Nick Ravo, "Stanley Tretick, 77, Photographer of Kennedy at the White House" (obituary), *New York Times*, July 20, 1999, http://www.nytimes.com/1999/07/20/us/stanley -tretick-77-photographer-of-kennedys-at-the-white-house.html. Tretick made the most famous photographs of the Kennedy children in the Oval Office in October 1963, when Jackie was out of town; these ended up in a ten-page feature in *Look* magazine that was on the newsstands when Kennedy was assassinated. Lubin, *Shooting Kennedy*, 269, 272.

17. "A Day with John F. Kennedy," *New York Times*, Feb. 19, 1961, 204–207.

18. George Tames, oral history interview with Donald Ritchie, Jan. 30–May 16, 1988, Interview #5, 168. The photo appears in "A Day with JFK," 206. See also Brack, *Presidential Picture Stories*, 58–59.

19. George Tames, oral history interview with Donald Ritchie, Jan. 30–May 16, 1988, Interview #3, 100; see also Brack, *Presidential Picture Stories*, 70.

20. Kathleen German, "Visual Images and Presidential Leadership: A Case Study of LBJ and His Beagles," *Journal of the Communication, Speech & Theatre Association of North Dakota* 21 (2008): 24–25.

21. Ibid., 25–26; Brack, *Presidential Picture Stories*, 72–73.

22. Carroll Kilpatrick "A Man of Impulse, Carefully Planned," *Washington Post*, Nov. 2, 1965, A12. See also Brack, *Presidential Picture Stories*, 73–74; German, "Visual Images and Presidential Leadership," 26.

23. German, "Visual Images and Presidential Leadership," 27.

24. On the history of the paparazzi and celebrity photography more generally, see Kim McNamara, *Paparazzi: Media Practices and Celebrity Culture* (Cambridge,

UK: Polity, 2016). For a broader theory of media, celebrity, and the public, see Sharon Marcus, *The Drama of Celebrity* (Princeton, NJ: Princeton University Press, 2019).

25. John Mottern, "The Right Thing to Do? AFP Freelancer Discusses His Coverage of Vacationing Clintons," *News Photographer*, Nov. 1997, 12–13.

26. Ibid., 12.

27. Elizabeth Shogren, "Candid Clinton Photos Hit, Hailed," *Los Angeles Times*, Jan. 6, 1998, https://www.latimes.com/archives/la-xpm-1998-jan-06-mn-5394-story.html.

28. Qtd. in Kelvin Childs, "Private Moment or Photo Op?" *Editor & Publisher*, Jan. 17, 1998, 21.

29. Shogren, "Candid Clinton Photos." See also "News Media Chastised," *News Photographer*, 53, no. 2 1998): 19.

30. On the role of television in late twentieth-century presidential politics, see Kathleen Hall Jamieson, *Eloquence in an Electronic Age: The Transformation of Political Speechmaking* (New York: Oxford University Press, 1988); Roderick P. Hart, *The Sound of Leadership: Presidential Communication in the Modern Age* (Chicago: University of Chicago Press, 1989); Kathleen Hall Jamieson, *Packaging the Presidency: A History and Criticism of Presidential Campaign Advertising*, 3rd ed. (New York: Oxford University Press, 1996); Roderick P. Hart, *Seducing America: How Television Charms the Modern Voter* (Thousand Oaks, CA: Sage, 1998).

31. Craig Allen, "Our First 'Television' Candidate: Eisenhower over Stevenson in 1956," *Journalism Quarterly* 65, no. 2 (1988): 352.

32. David Greenberg, *Republic of Spin: An Inside History of the American Presidency* (New York: W. W. Norton, 2016), 297.

33. Ibid., 296–300; see also James E. Pollard, "Eisenhower and the Press: The First Two Years," *Journalism Quarterly* 32, no. 3 (1955): 286.

34. George Tames, oral history interview with Donald Ritchie, Jan. 30–May 16, 1988, Interview #4, 125.

35. Greenberg, *Republic of Spin*, 408. On Reagan and the media, see also Timothy Raphael, *The President Electric: Ronald Reagan and the Politics of Performance* (Ann Arbor: University of Michigan Press, 2009); Reed Welch, "The Great Communicator: Rhetoric, Media, and Leadership Style," in *A Companion to Ronald Reagan*, ed. Andrew L. Johns, 74–95 (New York: Wiley Blackwell, 2015).

36. Welch, "Great Communicator," 75–78.

37. Greenberg, *Republic of Spin*, 410.

38. On the Pointe du Hoc speech at Normandy, see Allison M. Prasch, "Reagan at Pointe du Hoc: Deictic Epideictic and the Persuasive Power of 'Bringing before the Eyes,'" *Rhetoric & Public Affairs* 18, no. 2 (2015): 247–76. On Reagan's use of televisual media in general, see Greenberg, *Republic of Spin*, 410–15.

39. Qtd. in Welch, "Great Communicator," 83.

40. On the rise of twenty-four-hour news, see Greenberg, *Republic of Spin*, 419; Jeffrey E. Cohen, *The Presidency in the Era of 24-Hour News* (Princeton, NJ: Princ-

eton University Press, 2008), 14–15. See also Lori Cox Han, *A Presidency Upstaged: The Public Leadership of George H. W. Bush* (College Station: Texas A&M University Press, 2011), 52–54; Shawn Parry-Giles and Trevor Parry-Giles, *Constructing Clinton: Hyperreality and Presidential Image-Making in Postmodern Politics* (New York: Peter Lang, 2002).

41. Greenberg, *Republic of Spin*, 422.

42. Joseph Hayden, *Covering Clinton: The President and the Press in the 1990s* (Westport, CT: Praeger, 2001), 8.

43. Ibid., 9.

44. Cox Han, *Presidency Upstaged*, 48.

45. Walsh, *Ultimate Insiders*, 6. Walsh mentions that, like Roosevelt, Rowe himself had a disability as the result of polio. See also "Abbie Rowe Dies at 61; Lensman of Presidents," *Washington Post*, Apr. 19, 1967, B10.

46. "Robert Knudsen Dies; Photographer was 61," *New York Times*, Jan. 31, 1989, D22. I am grateful to Pete Souza for alerting me to the role of this less publicly recognized photographer. Histories of White House photography seem to underplay Knudsen's decades of work; Kenneth Walsh describes him as a "deputy" of Cecil Stoughton, and John Bredar refers to Knudsen briefly as "another photographer" with whom Stoughton shared an office. See Walsh, *Ultimate Insiders*, 50–51; Bredar, *President's Photographer*, 51. Yet Cecil Stoughton's oral history for the John F. Kennedy Library suggests that the two worked as peers during the Kennedy administration to cover both the West Wing and the social events taking place at the White House. See Cecil W. Stoughton, recorded interview by Vicki Daitch, Sept. 18–19, 2002, 9–10, John F. Kennedy Library Oral History Program.

47. Margalit Fox, "Cecil Stoughton Dies at 88; Documented White House," *New York Times*, Nov. 6, 2008, https://www.nytimes.com/2008/11/06/arts/design/06stoughton.html. See also Stoughton, John F. Kennedy Library oral history interview.

48. Bredar, *President's Photographer*, 250; see also Walsh, *Ultimate Insiders*, 33–60.

49. Okamoto was hired twice because the mercurial LBJ fired then rehired him when a January 1964 *Newsweek* story questioned what appeared to be Johnson's obsession with photographs of himself. The story goes that right after Johnson fired him, Okamoto just kept on making pictures of the president, much to Johnson's surprise. See Bredar, *President's Photographer*, 89. See also James Pomerantz, "Yoichi Okamoto, Lyndon Johnson's Photographer," *New Yorker*, March 28, 2012, https://www.newyorker.com/culture/photo-booth/yoichi-okamoto-lyndon-johnsons-photographer. For an overview of Okamoto's relationship with Johnson, see Walsh, *Ultimate Insiders*, 61–72.

50. Bredar, *President's Photographer*, 85.

51. Qtd. in ibid., 86.

52. Bredar, *President's Photographer*, 90.

53. George Tames, oral history interview with Donald Ritchie, Jan. 30–May 16, 1988, Interview #1, 18.

54. Qtd. in James Estrin, "Photographing the White House from the Inside," *New York Times Lens* (blog), Dec. 10, 2013, https://lens.blogs.nytimes.com/2013/12/10/photographing-the-white-house-from-the-inside.

55. Walsh, *Ultimate Insiders*, 74.

56. Ibid., 73–75.

57. Bredar, *President's Photographer*, 123. For a more sanitized discussion of Nixon's relationship with Oliver Atkins, see Julie Nixon Eisenhower, *Eye on Nixon: A Photographic Study of the President and the Man* (New York: W. Clement Stone, 1972), 122–23.

58. George Tames of the *New York Times* claimed that he was initially offered the role and was prepared to take it "until I found out that Carter didn't want to give me the title. He didn't want the Imperial Presidency, so he said." See Tames, Interview #3, 105–106. On Roslyn Carter's photographer, Mary Anne Fackelman, see Frank Breithaupt, "The Second 'First Lady' in the White House," *News Photographer*, April 1980, 18–23. See also Walsh, *Ultimate Insiders*, 103–104.

59. Paula Winslow, "A New Sense of Openness: A President's Photographer Returns to the White House," *News Photographer*, March 1981, 17. See also Walsh, *Ultimate Insiders*, 103–106.

60. Stephen Skowronek coined this phrase. See Skowronek, *Presidential Leadership in Political Time*, rev. ed. (New Haven, CT: Yale University Press, 2011).

61. On Kennerly's White House work, see Walsh, *Ultimate Insiders*, 93–106; Bredar, *President's Photographer*, 128–36.

62. David Hume Kennerly, *Shooter* (New York: Newsweek Books, 1979), 169. See also David Hume Kennerly, *Photo Op* (Austin: University of Texas Press, 1995), 56–103.

63. Kennerly, *Shooter*, 174. See also Kennerly, *Photo Op*, 78–83.

64. On transformations in cameras and the rise of digital photography, see Bob Rose, Todd Gustavson, and Hiroshi Yano, "The History of the Twentieth-Century Camera," in *Focal Encyclopedia of Photography*, 4th ed., ed. Michael R. Peres (New York: Elsevier, 2007), 782. See also Gretchen Garner, "Photography and Society in the 20th Century," in Peres, *Focal Encyclopedia*, 187–98.

65. Garner, "Photography and Society," 191.

66. Mia Fineman, *Faking It: Manipulated Photography Before Photoshop* (New York: Metropolitan Museum of Art/Yale University Press, 2012), 39.

67. Ibid., 41–43. On early anxieties about digital manipulation, see William J. Mitchell, *The Reconfigured Eye: Visual Truth in the Post-Photographic Era* (Cambridge: MIT Press, 1992).

68. On the rise of mobile phone technology, see Jon Agar, *Constant Touch: A Global History of the Mobile Phone* (London: Icon Books, 2013).

69. James E. Katz, Michael Barris, and Anshul Jain, *The Social Media President: Barack Obama and the Politics of Digital Engagement* (New York: Palgrave Macmillan, 2013), 22–25.

70. José Van Dijck, *The Culture of Connectivity: A Critical History of Social Media* (New York: Oxford University Press, 2013), 5. On the concept and history of Web 2.0, see also Jason Gainous and Kevin M. Wagner, *Tweeting to Power: The Social Media Revolution in American Politics* (New York: Oxford University Press, 2014), 2. See also Henry Jenkins, Sam Ford, and Joshua Green, *Spreadable Media: Creating Value and Meaning in a Networked Culture* (New York: New York University Press, 2013).

71. Van Dijck, *Culture of Connectivity*, 6–8.

72. Pew Research Center, "Fact Sheet: Social Media Use Over Time," http://www.pewinternet.org/fact-sheet/social-media.

73. Ken Auletta, "Non-Stop News," *New Yorker*, Jan. 25, 2010, https://www.newyorker.com/magazine/2010/01/25/non-stop-news. On the rise of internet news, see David Tewksbury and Jason Rittenberg, *News on the Internet: Information and Citizenship in the 21st Century* (New York: Oxford University Press, 2012).

74. On official White House photography in the George W. Bush administration, see Elisabeth Bumiller, "Glimpses of a Leader, Through Chosen Eyes Only," *New York Times*, July 13, 2003, https://www.nytimes.com/2003/07/13/us/glimpses-of-a-leader-through-chosen-eyes-only.html. On the Bush White House communications operation, see Martha Joynt Kumar, "Communications Operations in the White House of George W. Bush: Making News on His Terms," *Presidential Studies Quarterly* 33, no. 2 (2003): 366–93; Jeremy D. Mayer, "The Presidency and Image Management: Discipline in Pursuit of Illusion," *Presidential Studies Quarterly* 34, no. 3 (2004): 620–31; John Anthony Maltese, "Communications Strategies in the Bush White House," in *Assessing the George W. Bush Presidency: A Tale of Two Terms*, ed. Andrew Wroe and Jon Herbert, 216–38 (Edinburgh: Edinburgh University Press, 2009).

75. The blog *BagNews Notes*, later renamed *Reading the Pictures*, gained attention as an early critic of Bush-era visual politics. See, for example, posts from 2004–2005 at https://www.readingthepictures.org/category/bush-focus/page/14.

76. Heather Suzanne Woods and Leslie A. Hahner, *Make America Meme Again: The Rhetoric of the Alt-Right* (New York: Peter Lang, 2019), 2, 6. On the history, logic, and rhetoric of memes, see also Ryan M. Milner, *The World Made Meme: Public Conversations and Participatory Media* (Cambridge: MIT Press, 2016).

77. On the "Mission Accomplished" debacle, see Douglas Kellner, "9/11, Spectacles of Terror, and Media Manipulation," *Critical Discourse Studies* 1, no. 1 (2004): 58–59; Mayer, "Presidency and Image Management," 630; Maltese, "Communications Strategies," 224.

78. Eileen R. Meehan, "Hurricane Katrina and Bush's Vacation," *Critical Studies in Media Communication* 23, no. 1 (2006): 85–90.

79. Van Dijck, *Culture of Connectivity*, 7.

80. Katz, Barris, and Jain, *Social Media President*, 31.

81. Ibid., 33; See also Alan Steinberg, "Exploring the Adoption and Use of New Media in the Obama Presidency: Is White House 2.0 Really Just White House 1.5?" *White House Studies* 12, no. 4 (2013): 343–60.

Chapter 9. Barack Obama and Flickr

1. Terrence O'Brien, "Obama's Legacy: The Most Tech-Savvy President," *Engadget*, Jan. 21, 2017, https://www.engadget.com/2017/01/21/obamas-legacy-the-most-tech-savvy-president. See also Nathan Ingraham, "President Obama Is the White House's First Social Media Ninja," *Engadget*, Jan. 12, 2016, https://www.engadget.com/2016/01/12/president-obama-social-networking-the-white-house/?guccounter=1.

2. O'Brien, "Obama's Legacy."

3. Qtd. in Pete Brook, "Photographs Are No Longer Things; They Are Experiences," *Wired*, Nov. 15, 2012, https://www.wired.com/2012/11/stephen-mayes-vii-photography.

4. Data on Instagram, Twitter, and Facebook were accessed on Nov. 2, 2017. See, respectively, https://www.statista.com/statistics/657823/number-of-daily-active-instagram-users; https://www.omnicoreagency.com/twitter-statistics; and https://www.omnicoreagency.com/facebook-statistics.

5. Brook, "Photographs Are No Longer Things." See also José van Dijck, "Digital Photography: Communication, Identity, Memory," *Visual Communication* 7, no. 1 (2008): 57–76.

6. On spreadable media, see Henry Jenkins, Sam Ford, and Joshua Green, *Spreadable Media: Creating Value and Meaning in a Networked Culture* (New York: New York University Press, 2013). See also Henry Jenkins, *Convergence Culture: Where Old and New Media Collide* (New York: New York University Press, 2006).

7. The Obama White House Flickr photostream is still intact on Flickr, frozen in time at the end of Obama's presidency and available at https://www.flickr.com/photos/obamawhitehouse. Previous scholarship on Obama and Flickr includes Julian Stallabrass, "Obama on Flickr," *Journal of Visual Culture* 8, no. 2 (2009): 196–201; Elizabeth Losh, "Channelling Obama: YouTube, Flickr, and the Social Media President," *Comparative American Studies* 10, nos. 2–3 (2012): 255–68; Cara A. Finnegan, "Picturing Presidents: Visual Politics Inside the Obama White House," in *The Rhetoric of Heroic Expectations: Establishing the Obama Presidency*, ed. Jennifer Mercieca and Justin Vaughn, 209–34 (College Station: Texas A&M University Press, 2014); Petra Bernhardt, "Image-Making/Image Management: White House Photos and the Political Iconography of the Obama Presidency," *The Poster* 4, nos. 1–2 (2017): 145–72.

8. Barack Obama, Twitter, https://twitter.com/BarackObama.

9. "Barack Obama on Social Media," Wikipedia, https://en.wikipedia.org/wiki/Barack_Obama_on_social_media; Keith Axline, "Presidential First: White House Floods Flickr," *Wired*, April 29, 2009, https://www.wired.com/2009/04/presidential-first-white-house-floods-flickr; Obama White House YouTube channel, https://www.youtube.com/channel/UCDGknzyQfNiThyt4vg4MlTQ/videos.

10. Arun Chaudhary, "West Wing Week," April 2, 2010, Obama White House Archives, https://obamawhitehouse.archives.gov/blog/2010/04/02/west-wing-week.

11. "President Obama's Google+ Hangout," Jan. 30, 2012, Obama White House Archives, https://obamawhitehouse.archives.gov/photos-and-video/video/2012/01/30/president-obama-s-google-hangout; Colin Jones, "President Obama Joins Pinterest," *New York Daily News*, March 28, 2012, https://www.nydailynews.com/news/politics/president-obama-joins-pinterest-article-1.1051750; "I Am Barack Obama, President of the United States—AMA," reddit.com, Aug. 29, 2012, https://www.reddit.com/r/IAmA/comments/z1c9z/i_am_barack_obama_president_of_the_united_states.

12. Lorenzo Franceschi-Bicchieri, "White House Publishes First Vine," *Mashable*, April 22, 2013, https://mashable.com/2013/04/22/white-house-first-vine; Elizabeth Flock, "White House Joins Tumblr," USNews.com, April 26, 2013, https://www.usnews.com/news/blogs/washington-whispers/2013/04/26/white-house-joins-tumblr---complete-with-gifs-vines-and-bo; Kasie Coccaro, "See the White House through a New Lens," June 26, 2013, Obama White House Archives, https://obamawhitehouse.archives.gov/blog/2013/06/26/see-white-house-through-new-lens.

13. Lindsay Holst and Kori Schulman, "The White House Joins Medium," Oct. 9, 2014, Obama White House Archives, https://obamawhitehouse.archives.gov/blog/2014/10/09/white-house-joins-medium.

14. Alex Wall, "Introducing @POTUS: President Obama's Twitter Account," May 18, 2015, Obama White House Archives, https://obamawhitehouse.archives.gov/blog/2015/05/17/introducing-potus-presidents-official-twitter-account; Kori Schulman, "President Obama: 'Hello Facebook!,'" Nov. 9, 2015, Obama White House Archives, https://obamawhitehouse.archives.gov/blog/2015/11/09/president-obama-hello-facebook.

15. Joshua Miller, "We're on Snapchat: Add White House," Jan. 11, 2016, Obama White House Archives, https://obamawhitehouse.archives.gov/blog/2016/01/11/whitehouse-joins-snapchat.

16. Juliet Eilperin, "Risks Stream with Rewards in a New Media Presidency," *Washington Post*, May 27, 2015, A01.

17. Ken Auletta, "Non-Stop News," *New Yorker*, Jan. 25, 2010, https://www.newyorker.com/magazine/2010/01/25/non-stop-news.

18. Qtd. in Eilperin, "Risks Stream with Rewards," A01.

19. Julia Hirschfeld Davis, "A Digital Team Is Helping Obama Find His Voice Online," *New York Times*, Nov. 9, 2015, A15.

20. Qtd. in James E. Katz, Michael Barris, and Anshul Jain, *The Social Media President: Barack Obama and the Politics of Digital Engagement* (New York: Palgrave Macmillan, 2013), 147.

21. Ibid., 16. Phillips served as new media director for the campaign and early administration but left the White House in 2013.

22. Tanya Somanader, "Q&A with the First-Ever White House Chief Digital Officer: People with Purpose, Puff Daddy, and the Hulk," April 13, 2015, Obama White House Archives, https://obamawhitehouse.archives.gov/blog/2015/04/13/

qa-first-ever-white-house-chief-digital-officer-people-purpose-puff-daddy-and
-hulk.

23. Katz, Barris, and Jain, *Social Media President*, 108; emphasis mine.

24. Alan Steinberg, 'Exploring the Adoption and Use of New Media in the Obama Presidency: Is White House 2.0 Really Just White House 1.5?" *White House Studies* 12, no. 4 (2013): 346.

25. "About We the People," *We the People*, https://petitions.obamawhitehouse
.archives.gov/about/#terms.

26. Katz, Barris, and Jain, *Social Media President*, 108.

27. Ibid., 120.

28. Gainous and Wagner, *Tweeting to Power*, 1.

29. Ibid., 11.

30. Auletta, "Non-Stop News."

31. Jennifer Senior, "The Message Is the Message," *New York Magazine*, July 31, 2009, http://nymag.com/news/politics/58199.

32. Eilperin, "Risks Stream with Rewards," A01. See also Julie Hirschfeld Davis, "Injecting Personality into @POTUS," *New York Times*, Nov. 9. 2015, 15. The term "filter bubble" was coined by Eli Pariser, *The Filter Bubble: How the New Personalized Web Is Changing What We Read and How We Think* (New York: Penguin, 2011).

33. Qtd. in Eilperin, "Risks Stream with Rewards," A01.

34. "A Front-Row View of Obama's White House," *NPR*, January 15, 2009, http://
www.npr.org/2009/01/15/99353598/a-front-row-view-of-obamas-white-house.

35. Pete Souza, *Images of Greatness: An Intimate Look at the Presidency of Ronald Reagan* (Chicago: Triumph Books, 2004).

36. Stephen Wolgast, "Tenacity, Foresight, and Luck: Pete Souza Had Access from the Early Days," *News Photographer*, Sept. 2008, 23–29. See also Anna Diamond, "How Pete Souza Fits into the Storied History of Presidential Photography," *Smithsonian Magazine*, Nov. 15, 2017, https://www.smithsonianmag.com/
history/how-pete-souza-changed-publics-relationship-president-180967201; Pete Souza, *The Rise of Barack Obama* (Chicago: Triumph Books, 2008).

37. For a wide-ranging discussion of Souza's work during the Obama administration that touches on some issues examined in depth in this chapter, see Kenneth Walsh, *Ultimate Insiders: White House Photographers and How They Shape History* (New York: Routledge, 2018), 163–80.

38. Pete Souza on *Charlie Rose*, Dec. 19, 2014, https://charlierose.com/videos/
23047; *BBC Newsnight*, June 9, 2016, https://www.youtube.com/watch?v=wZSy
LJYR8Xk; Bill Plante, *CBS Sunday Morning*, "White House Photog Pete Souza," Jan. 15, 2017, https://www.cbsnews.com/video/white-house-photographer
-pete-souza; David Walker, "Pete Souza on His Long-Term Partnership with President Barack Obama," *Photo District News*, Oct. 22, 2013, 1–4; Robert Caplin, *Photo Brigade* podcast, Episode 065, March 24, 2015, http://thephotobrigade
.com/2015/03/photo-brigade-podcast-65-pete-souza; "Open for Questions: Pete Souza," Obama White House Archives, https://obamawhitehouse.archives.gov/

photos-and-video/video/2010/10/28/open-questions-pete-souza. Beginning in late 2017, after Souza published his book of Obama White House photographs, *Obama: An Intimate Portrait* (New York: Little, Brown, 2017), Souza went on an extensive book tour and media blitz; see a partial listing with links at https://www.petesouza.com/content.html?page=10.

39. Qtd. in Rico Pucci, "Photographing Power," *News Photographer*, Aug. 2009, 40. See also Aamer Madhani, "Shooting History as White House Photographer," *National Journal*, Dec. 13, 2010, n.p.

40. Pete Souza, "Portrait of a Presidency: Pete Souza's Photography of the Obama Years," John F. Kennedy School of Government, Harvard University, Sept. 20, 2017, https://www.youtube.com/watch?v=SfyVUXMMKic.

41. Walsh, *Ultimate Insiders*, 124.

42. Ibid., 143.

43. Ibid., 155, 151. See also Eric Draper, *Front Row Seat: A Photographic Portrait of the Presidency of George W. Bush* (Austin: University of Texas Press, 2013).

44. Dan Amira, "Pete Souza Didn't Miss a Thing," *New York Times*, Dec. 13, 2017, https://www.nytimes.com/2017/12/13/magazine/pete-souza-didnt-miss-a-thing.html; Alex Cooke, "Pete Souza Reflects on His Eight Years with Former President Barack Obama, Offers Photography Advice," *Fstoppers*, Dec. 23, 2017, https://fstoppers.com/photojournalistic/pete-souza-reflects-his-eight-years-former-president-barack-obama-offers-209075.

45. John Bredar, *The President's Photographer: Fifty Years inside the Oval Office* (Washington, DC: National Geographic, 2010), 179; Jodi Lenkoski, *The President's Photographer: Fifty Years Inside the Oval Office*, DVD, directed by Jodi Lenkoski, National Geographic Television, 2010.

46. Steven Booth, email to the author, March 2, 2018.

47. Souza, "Portrait of a Presidency."

48. Qtd. in Lenkoski, *President's Photographer*.

49. Ibid.

50. Qtd. in Caplin, *Photo Brigade* podcast.

51. Dora Apel, "Just Joking? Chimps, Obama, and Racial Stereotype," *Journal of Visual Culture* 8 (2009): 134–42; Pearl K. Ford, Angie Maxwell, and Todd Shields, "What's the Matter with Arkansas? Symbolic Racism and 2008 Presidential Candidate Support," *Presidential Studies Quarterly* 40, no. 2 (2010): 286–302; Spencer Piston, "How Explicit Racial Prejudice Hurt Obama in the 2008 Election," *Political Behavior* 32 (2010): 431–51; Catherine Squires, "Reframing the National Family: Race Mixing and Re-telling American History," *Black Scholar* 39 (2009): 41–50; Ralina Joseph, "Imagining Obama: Reading Overtly and Inferentially Racist Images of Our 44th President, 2007–2008," *Communication Studies* 62, no. 4 (2011): 389–405; James Alexander McVey, "Memeing the Black Presidency: Obama Memes and the Affective Ambivalence of Racialized Policing," *Rhetoric Review* 36, no. 4 (2017): 302–311. Michael Shaw regularly chronicled examples of such images on his site *BagNews Notes* (now called *Reading the Pictures*). See, for ex-

ample, "Beyond Reverend Wright," https://www.readingthepictures.org/2012/05/beyond-reverend-wright-deconstructing-the-ricketts-smiley-obama-storyboard; "Your Turn: Stereotypes from the White Corporate Media—Part 2," https://www.readingthepictures.org/2008/05/your-turn-stereotypes-from-the-white-corporate-media-part-2; and "Obama's Not Human," https://www.readingthepictures.org/2008/07/obamas-not-human.

52. Finnegan, "Picturing Presidents," 209–34.

53. Barack Obama, BarackObamaDotCom Flickr Photostream, https://www.flickr.com/photos/barackobamadotcom/sets/72157608716313371/with/3008257421. For a collection of behind-the-scenes images of the pre-presidential Barack Obama, see David Katz, *Barack before Obama: Life before the Presidency* (New York: Ecco Press, 2020).

54. On Flickr's earliest months, see Daniel Terdiman, "Photo Site a Hit with Bloggers," *Wired*, Dec. 9, 2004, http://www.wired.com/culture/lifestyle/news/2004/12/65958. Flickr was later sold to Yahoo! and, in 2018, Smugmug; see Dan Fromer, "Flickr Has Been Sold after 13 Years at Yahoo. Can Flickr Be Relevant Again?" *Recode*, April 20, 2018, https://www.vox.com/platform/amp/2018/4/20/17264274/flickr-smugmug-yahoo-oath-verizon-deal-photo-sharing-service-mobile-instagram.

55. José van Dijck, *The Culture of Connectivity: A Critical History of Social Media* (New York: Oxford University Press, 2013), 95.

56. Ibid., 91. See also José van Dijck, "Flickr and the Culture of Connectivity," *Memory Studies* 4, no. 4 (2010): 401–415.

57. Van Dijck, *Culture of Connectivity*, 96.

58. See Flickr blog, "Many Hands Make Light Work," Jan. 16, 2008, https://blog.flickr.net/en/2008/01/16/many-hands-make-light-work.

59. "White House Releases Photos on Flickr," *CNN Politics Political Ticker* (blog), April 29, 2009, http://politicalticker.blogs.cnn.com/2009/04/29/white-house-releases-photos-on-flickr; Axline, "Presidential First: White House Floods Flickr." For two of my early discussions about what Flickr provided the Obama White House, see Cara Finnegan, "Obama's Photographic Firsts," *First Efforts* (blog), Jan. 14, 2009, https://caraf.blogs.com/caraf/2009/01/obamas-photographic-firsts.html; Cara Finnegan, "Presidential Flickr-ing," *First Efforts* (blog), Nov. 1, 2009, https://caraf.blogs.com/caraf/2009/11/presidential-flickring.html.

60. Qtd. in Catlin, *Photo Brigade* podcast.

61. For a discussion of how the Presidential Records Act (PRA) works, see National Archives, *Guidance on Presidential Records* (Washington, DC: National Archives and Records Administration, 2016), 12, https://www.archives.gov/files/presidential-records-guidance.pdf. For the first five years after a president leaves office, the public has no access to presidential records. Based on the provisions of the PRA, the Obama records will be available to the public only through Freedom of Information Act requests starting in January 2022. By the time twelve years have passed since a president left office, all previously unrestricted presidential

records should be made available to the public. (Some restrictions, of course, will inevitably apply.) On the Presidential Records Act, see also Mary E. Stuckey, "Presidential Secrecy: Keeping Archives Open," *Rhetoric & Public Affairs* 9, no. 1 (2006): 138–44.

62. "Fonds," SAA Glossary, Society of American Archivists, https://www2 .archivists.org/glossary/terms/f/fonds.

63. Qtd. in Eileen McMenamin, "A VIP Seat to History: Photographer David Hume Kennerly," *Huffington Post*, Aug. 6, 2009, https://www.huffpost.com/entry/ a-vip-seat-to-history-pho_b_225457.

64. Rino Pucci, "Photographing Power," *News Photographer* 64, no. 8 (2009): 41.

65. Ibid.

66. Qtd. in ibid.

67. Comment by Mim Eisenberg, Obama White House Flickr Photostream, https://www.flickr.com/photos/obamawhitehouse/3483994905/in/album -72157617357737487.

68. "Schomburg Center Celebrates Obama First Anniversary with Souza and Pinckney Exhibitions," press release, Feb. 2, 2010, https://www.nypl.org/press/ press-release/2010/02/02/schomburg-center-celebrates-obama-first-anniversary -souza-and-pinkney. See also "Photo Exhibit of Obama's First Year," *Associated Press State and Local Wire*, Feb. 1, 2010.

69. Pete Souza, "Behind the Lens: 2015 Year in Photographs," *Medium*, https:// medium.com/@ObamaWhiteHouse/behind-the-lens-2015-year-in-photographs -b5064a44df4a.

70. Pete Souza writes about this image and shares related images from that day in Souza, *Obama: An Intimate Portrait*, 130–35. Critical analyses of the Situation Room photograph and related topics include Liam Kennedy, "Seeing and Believing: On Photography and the War on Terror," *Public Culture* 24, no. 2 (2012): 261–81; Ryan Croken, "Obama [*sic*] bin Laden: How to Win the War on Terror #LikeABoss," in *Covering Bin Laden: Global Media and the World's Most Wanted Man*, ed. Susan Jeffords and Fahed Al-Sumait, 161–82 (Urbana: University of Illinois Press, 2015); Megan D. McFarlane, "Visualizing the Rhetorical Presidency: Barack Obama in the Situation Room," *Visual Communication Quarterly* 23 (Jan.–March 2016), 3–13; Liam Kennedy, "The Situation Room, Washington, DC, 2011," in *Getting the Picture: The Visual Culture of the News*, ed. Jason E. Hill and Vanessa R. Schwartz, 100–102 (London: Bloomsbury, 2015); Walsh, *Ultimate Insiders*, 168. I moderated a discussion panel of academics and photojournalists on the capture of bin Laden for *Reading the Pictures*; we discussed this image at length. See "The Fall of Bin Laden," *BagNews Notes*, May 23, 2011, https://www.readingthepictures. org/2011/05/salon-bin-laden. The discussion of the Situation Room photograph begins fifty-seven minutes in.

71. McFarlane, "Visualizing the Rhetorical Presidency," 3. "Situation Room (photograph)," Wikipedia, https://en.wikipedia.org/wiki/Situation_Room_(pho-tograph).

72. Souza, *Obama: An Intimate Portrait*, 38, 130. Souza reports in the book that the Jacob Philadelphia photograph was briefly taken down in 2012, but staffers asked that it be put back up because it was a popular stop when they would give West Wing tours (38).

73. Qtd. in Jackie Calmes, "When a Boy Found a Familiar Feel in a Pat of the Head of State," *New York Times*, May 23, 2012, https://www.nytimes.com/2012/05/24/us/politics/indelible-image-of-a-boys-pat-on-obamas-head-hangs-in-white-house.html.

74. Senior, "Message Is the Message."

75. Grace Wyler, "Barack Obama Is Having an Amazing Summer," *Business Insider*, Aug. 10, 2012, https://www.businessinsider.com.au/obama-michelle-obama-white-house-photos-2012–8#-1. For another typical example, see Stokely Baksh, "White House Flickr Photostream in May: President Obama Supports Same-Sex Marriage, Visits Afghanistan, Throws a Football," *The Darkroom (Baltimore Sun)*, June 13, 2012, http://darkroom.baltimoresun.com/2012/06/white-house-flickr-photostream-in-may-president-obama-supports-same-sex-marriage-visits-afghanistan-throws-a-football/#1.

76. Matt Bai, "Taking the Hill," *New York Times Magazine*, June 2, 2009, https://www.nytimes.com/2009/06/07/magazine/07congress-t.html.

77. Dana Milbank, "Picture Perfect," *Washington Post*, Nov. 27, 2013, A15.

78. Philip Gourevich, "Don't Release the Photos," *New Yorker*, May 3, 2011, https://www.newyorker.com/news/news-desk/dont-release-the-photos.

79. McFarlane, "Visualizing the Rhetorical Presidency," 3. Another kind of Photoshopping occurred as well when *Di Tzeitung*, a Yiddish-language newspaper published in New York City, digitally removed the two women in the photo, including Secretary of State Hillary Clinton, before they published it. Editors cited the paper's policy never to publish images of women, because that would promote immodesty. They later apologized—not for the sexism but for violating the White House's instructions that its Flickr photos not be digitally altered. See "Orthodox Jewish Newspaper Apologises for Hillary Clinton Deletion," *The Guardian*, May 10, 2011, https://www.theguardian.com/world/2011/may/10/jewish-paper-apologises-hillary-clinton.

80. Jason Horowitz, "The Powerlessness of the Powerful Caught on Camera," *Sunday Independent (South Africa)*, May 8, 2011, 9.

81. See Tom Sutcliffe, "The Accidental Art of a Lasting Image," *The Independent (U.K)*, May 6, 2011, 2; Ken Johnson, "Situation: Ambiguous," *New York Times*, May 7, 2011, https://www.nytimes.com/2011/05/08/weekinreview/08johnson.html.

82. Barry Moody, "Clinton: Allergy, Not Anguish, in My Bin Laden Photo," *Reuters Politics*, May 5, 2011, https://www.reuters.com/article/us-binladen-clinton-allergy/clinton-allergy-not-anguish-in-my-bin-laden-photo-idUSTRE7442C420110505; Michael Winter, "Panetta: Obama Did Not See Bin Laden Being Killed," *USA Today*, May 3, 2011, http://content.usatoday.com/communities/ondeadline/post/2011/05/panetta-obama-did-not-see-bin-laden-being-killed/1#

.XS907vJKip0. The White House's caption for the photograph read in part that the president and those in the room were receiving "an update on the mission against Osama bin Laden." See Obama White House Flickr Photostream, May 1, 2011, https://www.flickr.com/photos/obamawhitehouse/5680724572.

83. Obama White House Flickr Photostream, May 1, 2011, https://www.flickr.com/photos/obamawhitehouse/5680724572.

84. Pete Souza on *Charlie Rose*, Dec. 19, 2014, https://charlierose.com/videos/23047.

85. Erica Gonzales, "Barack Obama's White House Photographer Trolls Donald Trump's First 100 Days in Office," *Harper's Bazaar*, April 25, 2017, https://www.harpersbazaar.com/culture/features/news/a22228/barack-obama-donald-trump-100-days. Shell, who had previously served as Vice President Al Gore's official photographer during the Clinton administration, covered Obama's political rise and received special access to the White House during Obama's first one hundred days. See Callie Shell, *Hope, Never Fear: A Personal Portrait of the Obamas* (San Francisco: Chronicle Books, 2019).

86. Dennis Brack, letter to Rahm Emanuel from White House News Photographers Association (WHNPA), Jan. 22, 2009, linked from Clint Hendler, "No Handouts: White House Photographers Bridle at Restricted Access," *Columbia Journalism Review*, March 25, 2010, https://archives.cjr.org/campaign_desk/no_handouts.php.

87. Hendler, "No Handouts."

88. The White House, "Briefing by White House Press Secretary Robert Gibbs, 3/24/10," https://obamawhitehouse.archives.gov/realitycheck/the-press-office/briefing-white-house-press-secretary-robert-gibbs-32410. See also Hendler, "No Handouts."

89. Qtd. in Hendler, "No Handouts." Hendler pointed out that in 2005 the WHNPA lodged similar protests at the George W. Bush administration, leading to a "near-boycott" of photo handouts by wire services that led to an agreement by the Bush White House to reduce the number of photo releases.

90. James Rainey, "Nearly 40 News Outlets Accuse Obama Administration of Limiting Access," *Los Angeles Times*, Nov. 26, 2013, https://www.latimes.com/nation/la-xpm-2013-nov-26-la-na-white-house-photographers-20131127-story.html. See also Walsh, *Ultimate Insiders*, 175–77.

91. Mark Landler, "Limit on Access Stirs Tensions between White House Photographer and Press Corps," *New York Times*, Nov. 30, 2013, https://www.nytimes.com/2013/12/01/us/politics/limit-on-access-stirs-tensions-between-white-house-photographer-and-press-corps.html.

92. "President Barack Obama and daughter Sasha swim at Alligator Point in Panama City Beach, Fla., Saturday, Aug. 14, 2010," Obama White House Flickr Photostream, https://www.flickr.com/photos/obamawhitehouse/4891369859/in/photolist-8sexR6; "President Barack Obama, First Lady Michelle Obama, and their daughter Malia meet with Malala Yousafzai, the young Pakistani schoolgirl

who was shot in the head by the Taliban a year ago, in the Oval Office, Oct. 11, 2013," Obama White House Flickr Photostream, https://www.flickr.com/photos/obamawhitehouse/10216265403.

93. Qtd. in "News Media Protest White House Press Access Limits," Associated Press, AP in the News, Nov. 21, 2013, https://www.ap.org/ap-in-the-news/2013/news-media-protest-white-house-press-access-limits.

94. Qtd. in Mark Landler, "Photographers Protest White House Restrictions," *New York Times*, Nov. 21, 2013, https://www.nytimes.com/2013/11/22/us/politics/photographers-protest-white-house-restrictions.html. See also C-SPAN, "Q&A: Doug Mills," Dec. 30, 2013, https://www.c-span.org/video/?316954-1/qa-doug-mills.

95. Qtd. in Landler, "Limits on Access."

96. Pete Souza on *Charlie Rose*, Dec. 19, 2014, https://charlierose.com/videos/23047. For a similar discussion see Caplin, *Photo Brigade* podcast.

97. "The Debate over White House Photo Access," *Reading the Pictures Salon*, Jan. 21, 2014, https://www.readingthepictures.org/2014/01/bagnews-salon-the-debate-over-white-house-photo-access.

98. Rainey, "Nearly 40."

99. Cameron, "President Elect Barack Obama CC-Licensed behind the Scenes Photos on Flickr," Creative Commons blog, Nov. 7, 2008, https://creativecommons.org/2008/11/07/president-elect-barack-obama-cc-licensed-behind-the-scenes-photos-on-flickr.

100. Ryan Singel, "Flickr Creates New License for White House Photos," *Wired*, May 11, 2009, https://www.wired.com/2009/05/flickr-creates-new-license-for-white-house-photos.

101. Fbenenson, "Why Did the White House Choose Attribution and Not Public Domain?" Creative Commons blog, April 29, 2009, https://creativecommons.org/2009/04/29/why-did-the-white-house-choose-attribution-and-not-public-domain; Marshall Kilpatrick, "Why Obama's Flickr Photos Aren't in the Public Domain," *readwrite* (blog), April 29, 2009, https://readwrite.com/2009/04/29/why_obamas_flickr_photos_arent_in_the_public_domai.

102. Flickr changed its policy in 2015 to offer both public domain and what is known as "CC-zero" options, the latter allowing the owner of the image to allow any use of it at all with no rights reserved. See Rajiv Vaidyanathan, "Flickr Now Offers Public Domain and CC0 Designations," Flickr blog, March 30, 2015, https://blog.flickr.net/en/2015/03/30/flickr-now-offers-public-domain-and-cc0-designations/?linkId=13226047. The Trump White House chose to use the "public domain" designation on its Flickr site.

103. Stewart Butterfield, "Oh—and the Reasons We Don't Have a PD Option," Flickr Help Forum, n.d., https://www.flickr.com/help/forum/en-us/7332/#reply36373. See also Kilpatrick, "Why Obama's Flickr."

104. Hugh D'Andrade, "White House Photos—Does the Public Need a License to Use?" *Electronic Frontier Foundation*, May 1, 2009, https://www.eff.org/deeplinks/2009/05/white-house-photos.

105. Ibid.

106. Singel, "Flickr Creates New License."

107. "About Government Works," usa.gov, https://www.usa.gov/government-works.

108. The Searcher, "Am I Allowed to Freely Use Photos from the Official White House Photostream?" Flickr Help Forum, Oct. 14, 2009, https://www.flickr.com/help/forum/en-us/109400.

109. Timothy Lee, @binarybits, tweet on Nov, 5, 2009, https://twitter.com/binarybits/statuses/5463979663.

110. Mike Masnick, "Does the White House Have Any Legal Right to Demand No Modifications to Its Photos?" Techdirt blog, Nov. 6, 2009, https://www.techdirt.com/articles/20091106/0222346823.shtml.

111. See, for example, Kathy Gill, "White House Makes Full Copyright Claim on Photos," *The Moderate Voice* (blog), Feb. 6, 2010, https://themoderatevoice.com/white-house-makes-full-copyright-claim-on-photos.

112. Lindsay Barnett, "Fur-Free, Fabulous, and Fuming: White House Objects to PETA's Image of Michelle Obama in New Anti-Fur Ad," *L.A. Unleashed* (*Los Angeles Times* blog), January 5, 2010, https://latimesblogs.latimes.com/unleashed/2010/01/furfree-fabulous-and-fuming-white-house-objects-to-petas-image-of-michelle-obama-in-new-antifur-ad.html.

113. Stephanie Clifford, "Coatmaker Transforms Obama Photo into Ad," *New York Times*, Jan. 6, 2010, https://www.nytimes.com/2010/01/07/business/media/07garment.html.

114. Frank James, "PETA Pulls Michelle Obama Anti-Fur Ad," *National Public Radio*, Jan. 12, 2010, https://www.npr.org/sections/thetwo-way/2010/01/peta_pulls_michelle_obama_anti.html; Mark Silva, "Weatherproof Garment Co. Agrees to Remove Times Square Billboard Featuring President Barack Obama," *Chicago Tribune*, Jan. 9. 2010, https://www.chicagotribune.com/news/ct-xpm-2010-01-09-chi-talk-obama-billboard-folojan09-story.html.

115. The current usa.gov statement on this point is followed by this sentence: "For example, you can't use a photo of a government official wearing your product in an ad." I do not believe that this specific sentence appeared on usa.gov in 2009–2010. "About Government Works," https://www.usa.gov/government-works.

116. Ibid.

117. Gill, "White House Makes Full Copyright Claim."

118. White House, "Press Briefing by Principal Deputy Press Secretary Josh Earnest," Feb. 24, 2012, https://obamawhitehouse.archives.gov/the-press-office/2012/02/24/press-briefing-principal-deputy-press-secretary-josh-earnest-22412.

119. Josh Gerstein, "Obama Campaign Web Ads Flout White House Photo Warning," *Politico*, Feb. 25, 2012, https://www.politico.com/blogs/under-the-radar/2012/02/obama-campaign-web-ads-flout-white-house-photo-warning-115548. On the December 2011 fund-raising email featuring the same Flickr photo, see Zeke Miller, "White House Holiday Photo Appears in Campaign Email," *Business Insider*, Dec. 22, 2011, https://www.businessinsider.com/obama-campaign

-misuses-white-house-picture-for-political-purposes-2011-12. The article was later updated with the information that "the image was purchased by the campaign, and not just copied off the Flickr website."

120. For just a few examples of comments on White House Flickr Photostream images, see https://www.flickr.com/photos/obamawhitehouse/4074700585/in/album-72157622593716998 and https://www.flickr.com/photos/obamawhitehouse/4753132441/in/album-72157624332927216. Although the site has been frozen in time since Obama left office, Flickr members are still able to add comments on the photographs that allowed for comments before July 2010.

121. While the comments that apparently violated Flickr's terms of service appear to have been removed, the Cairo album today still contains two comments from user Shepherd.Johnson that appear to date from this period in 2009. See https://www.flickr.com/photos/obamawhitehouse/3610757033 and https://www.flickr.com/photos/obamawhitehouse/3610754817.

122. Nicholas Carson, "Yahoo Bans Anti-Obama Flickr Commenter," *Business Insider*, June 10, 2009, http://www.businessinsider.com/yahoo-bans-anti-obama-flickr-commenter-2009-6. See also Ryan Tate, "Yahoo Nukes Man's Photos over Obama Comments," June 9, 2009, *Gawker*, https://gawker.com/5285064/yahoo-nukes-mans-photos-over-obama-comments.

123. Carson, "Yahoo Bans."

124. Pete Souza, email to the author, Aug. 27, 2019.

125. For an extended study of how images of Obama circulated broadly in the period's visual culture, see the analysis of Shepard Fairey's Obama "Hope" poster in Laurie E. Gries, *Still Life with Rhetoric: A New Materialist Approach for Visual Rhetorics* (Logan: Utah State University Press, 2015).

126. Dan Frommer, "Official White House Photos on Flickr, Ready for You to Photoshop," *Business Insider*, April 29, 2009, https://www.businessinsider.com/official-white-house-photos-on-flickr-ready-for-you-to-photoshop-2009-4.

127. Jack Moore, "The 50 Best Photos of President Obama from the White House's Flickr Stream," *Buzzfeed*, Aug. 4, 2011, https://www.buzzfeednews.com/article/jpmoore/happy-birthday-mr-president-the-50-best-photos-0.

128. Whitney Jefferson, "Four More Years of Barack and Michelle Being Adorable Together in the White House," *Buzzfeed*, Nov. 7, 2012, https://www.buzzfeed.com/whitneyjefferson/four-more-years-of-barack-and-michelle-being-adora; David Mack, "All the Times President Obama Lost His Chill around Kids," *Buzzfeed*, Nov. 2, 2015, https://www.buzzfeednews.com/article/davidmack/dad-in-chief.

129. See, for example, the "President Obama with Babies," Tumblr, https://presidentobamawithbabies.tumblr.com; and the Twitter feed @ObamaPlusKids, https://twitter.com/obamapluskids.

130. Benny Johnson, "Photos of Obama Reading Your Email," *Buzzfeed*, June 10, 2013, https://www.buzzfeednews.com/article/bennyjohnson/photos-of-obama-reading-your-email. See also "Obama Is Checking Your Email," Tumblr, 2013–

2019, https://obamaischeckingyouremail.tumblr.com; "2013 NSA Surveillance Scandal," *Know Your Meme*, https://knowyourmeme.com/memes/events/2013 -nsa-surveillance-scandal.

131. Gabriel Sanchez, "33 Pictures of the Obamas That Will Restore Your Faith in Love," *Buzzfeed*, Jan. 18, 2017, https://www.buzzfeed.com/gabrielsanchez/ michelle-barack; Gabriel Sanchez, "44 of the Most Iconic Pictures of President Barack Obama," *Buzzfeed*, Jan. 14, 2017, https://www.buzzfeed.com/gabriel sanchez/the-most-iconic-pictures-of-president-obama?bfsource=relatedauto; Ricky Sans, "22 Photos That Will Make You Miss Obama," July 2016, *Buzzfeed*, https://www.buzzfeed.com/watch/video/2450.

132. Jamie Feldman, "Couple Recreates the Obamas' Best Photos for their Own Romantic Engagement Shoot," *Huffington Post*, July 17, 2017, https://www.huff post.com/entry/engagement-shoot-obamas_n_596cb4d6e4b03389bb18d369.

133. "The Situation Room," *Know Your Meme*, https://knowyourmeme.com/ memes/the-situation-room.

134. Rachel Leishman, "Here, Remember the Good Old Days of Obama and Biden Memes," *The Mary Sue*, Oct. 30, 2018, https://www.themarysue.com/remember -remember-obama-biden.

135. Ryan Schocket, "18 Times Barack Obama and Joe Biden Were #Friend-shipGoals," *Buzzfeed*, Nov. 21, 2017, https://www.buzzfeed.com/ryanschocket2/ eigteen-times-barack-obama-and-joe-biden-were-besties?bfsource=relatedauto.

136. For a collection of images featuring one common racist theme, see Abe Sauer, "Primate in Chief: A Guide to Racist Obama Monkey Photoshops," *The Awl*, April 19, 2011, https://www.theawl.com/2011/04/primate-in-chief-a-guide -to-racist-obama-monkey-photoshops.

137. "McKayla Is Not Impressed," *KnowYourMeme*, https://knowyourmeme.com/ memes/mckayla-is-not-impressed.

138. "President Obama Jokingly Mimics U.S. Olympic Gymnast McKayla Maroney's 'Not Impressed' Look While Greeting Members of the 2012 U.S. Olympic Gymnastics Teams in the Oval Office, Nov. 15, 2012," Obama White House Flickr Photostream, https://www.flickr.com/photos/obamawhitehouse/8191317327.

139. Dan Loumena, "President Obama, McKayla Maroney Strike 'Not Impressed' Pose," *Los Angeles Times*, Nov. 17, 2012, https://www.latimes.com/sports/la-xpm -2012-nov-17-la-sp-sn-obama-maroney-not-impressed-20121117-story.html.

140. Mike Masnick, "President Obama Is Not Impressed with Your Right to Modify His Photos," TechDirt.com, Nov. 20, 2012, https://www.techdirt.com/ articles/20121120/03173221098/president-obama-is-not-impressed-with-your -right-to-modify-his-photos.shtml (emphasis in original).

141. Theresa M. Sneft and Nancy K. Baym, "What Does the Selfie Say? Investigating a Global Phenomenon," *International Journal of Communication* 9 (2015): 1589.

142. Marcy J. Dinius, "The Long History of the 'Selfie'," *J19: The Journal of Nineteenth-Century Americanists* 3, no. 2 (2015): 445–51; Alec Mackenzie, "The Age of the Selfie," *RPS Journal* 154, no. 5 (2014): 289.

143. Anne Quito, "Front-Facing Cameras Were Never Intended for Selfies," *Quartz*, Oct. 26, 2017, https://qz.com/1104742/front-facing-cameras-were-never -intended-for-selfies.

144. Michael James Walsh and Stephanie Alice Baker, "The Selfie and the Trans-formation of the Public-Private Distinction," *Information, Communication, and Society* 20, no. 8 (2017): 1189.

145. For studies that address these various caricatures of selfies, see Sneft and Baym, "What Does the Selfie Say?" 1588–1606; Jessica Maddux, "'Guns Don't Kill People . . . Selfies Do': Rethinking Narcissism as Exhibition in Selfie-Related Deaths," *Critical Studies in Media Communication* 34, no. 3 (2017): 193–205; James Meese, Martin Gibbs, Marcus Carter, Michael Arnold, Bjorn Nansen, and Tamara Kohn, "Selfies at Funerals: Mourning and Presencing on Social Media Platforms," *International Journal of Communication* 9 (2015): 1818–31.

146. "President Barack Obama poses for a photo with a patron at Jerry's Fam-ily Restaurant," April 27, 2010, Obama White House Flickr Photostream, https:// www.flickr.com/photos/obamawhitehouse/4608620827.

147. Silvia Killingsworth, "And the Word of the Year Is . . .," *New Yorker*, Nov. 19, 2013, https://www.newyorker.com/culture/culture-desk/and-the-word-of -the-year-is.

148. Matthew Bellinger, "Bae Caught Me Tweetin': On the Representational Stance of the Selfie," *International Journal of Communication* 9 (2015): 1806–817; Kate M. Miltner and Nancy K. Baym, "The Selfie of the Year of the Selfie: Re-flections on a Media Scandal," *International Journal of Communication* 9 (2015): 1701–715.

149. Caitlin McDevitt, "Michelle Obama Posts 'Selfie' with Bo," Aug. 11, 2013, *Politico*, https://www.politico.com/blogs/click/2013/08/michelle-obama-posts -selfie-with-bo-170355; see "Chuck Kennedy Photographed the First Lady as She Takes a 'Selfie' with Bo, the Obama Family Dog," April 11, 2013, White House Flickr Photostream, https://www.flickr.com/photos/obamawhitehouse/11665287863.

150. "Patrons pose for a selfie as President Barack Obama greets people at the Magnolia Cafe, July 10, 2014," Obama White House Flickr Photostream, https:// www.flickr.com/photos/obamawhitehouse/14992525257.

151. Pete Souza, Instagram, @Pete Souza, Jan. 21, 2017, https://www.instagram .com/petesouza/p/BPjUHO6B3eB.

152. Pete Souza, Instagram, @Pete Souza, Jan. 31, 2017, https://www.instagram .com/p/BP81bFLBP_G/?hl=en.

153. D. L. Cade, "Pete Souza Is Using His Obama Photo Archives to Troll Trump," *Petapixel*, Feb. 8. 2017, https://petapixel.com/2017/02/08/pete-souza -using-obama-photo-archives-troll-trump; Katie Rogers, "Obama's Photographer Gains a New Following, and a Book Deal," *New York Times*, April 26, 2017, https:// www.nytimes.com/2017/04/26/us/politics/pete-souza.html. As of August 2019, Souza's White House account listed 744,000 followers; see Pete Souza (Archived), Instagram, @PeteSouza44, https://www.instagram.com/petesouza44/?hl=en.

154. Ruth Tam, "How do you get your news?" Twitter, @ruthetam, Feb. 19, 2018, https://twitter.com/ruthetam/status/965604527079673856?lang=en.

155. Pete Souza, *Shade: A Tale of Two Presidents* (New York: Little, Brown, 2018). In the fall of 2020, a documentary on Souza was released; see *The Way I See It*, directed by Dawn Porter (Los Angeles, CA: Focus Features, 2020).

156. D. L. Cade, "Shealah Craighead Is Officially Trump's Chief White House Photographer," *Petapixel*, Jan. 27, 2017, https://petapixel.com/2017/01/27/shealah-craighead-officially-trumps-chief-white-house-photographer.

157. As of August 29, 2019, the Trump White House Flickr Photostream contained 6,864 photographs. See https://www.flickr.com/photos/whitehouse. By November 2020, that number was over 14,000.

158. Pete Souza, Instagram, @petesouza, Aug. 25, 2019, https://www.instagram.com/p/B1lxejllBKm.

159. Michael Shaw, "Eleven Images That Show How the Trump Administration Is Failing at Photography," *Columbia Journalism Review*, April 25, 2017, https://www.cjr.org/politics/trump-photography.php.

Conclusion

1. Many thanks to Davis Houck for suggesting this approach to writing my conclusion chapter.

2. Frederick Douglass, "Age of Pictures," in *Picturing Frederick Douglass: An Illustrated Biography of the Nineteenth Century's Most Photographed American*, ed. John Stauffer, Zoe Trodd, and Celeste-Marie Bernier (New York: Liveright, 2015), 143.

Selected Bibliography

Archives

National Portrait Gallery, Smithsonian Institution, Washington, DC
Prints and Photographs Division, Library of Congress, Washington, DC

Online Archival Collections

The Diaries of John Quincy Adams: A Digital Collection, Massachusetts Historical Society
Frances Benjamin Johnston personal papers, Library of Congress, Washington, DC
George Tames, oral history interviews with Donald Ritchie, Senate Oral History Program
Obama White House Flickr photostream

Books

Beasley, Vanessa B. *You the People: American National Identity in Presidential Rhetoric*. College Station: Texas A&M University Press, 2004.
Benson, Richard. *The Printed Picture*. New York: Museum of Modern Art, 2008.
Brack, Dennis. *Presidential Picture Stories: Behind the Cameras at the White House*. Self-published: Dennis Brack Inc., 2013.
Bredar, John. *The President's Photographer: Fifty Years Inside the Oval Office*. Washington, DC: National Geographic, 2010.

Brennan, Bonnie, and Hanno Hardt, eds. *Picturing the Past: Media, History, and Photography*. Urbana: University of Illinois Press, 1999.

Carlebach, Michael. *American Photojournalism Comes of Age*. Washington, DC: Smithsonian Institution Press, 1997.

———. *The Origins of Photojournalism in America*. Washington, DC: Smithsonian Institution Press, 1992.

Collins, Kathleen, ed. *Shadow and Substance: Essays on the History of Photography in Honor of Heinz K. Henisch*. Bloomfield Hills, MI: Amorphous Institute Press, 1990.

Davis, Keith. *The Origins of American Photography, 1839–1885*. New Haven, CT: Yale University Press, 2007.

Finnegan, Cara A. *Making Photography Matter: A Viewer's History from the Civil War to the Great Depression*. Urbana: University of Illinois Press, 2015.

———. *Picturing Poverty: Print Culture and FSA Photographs*. Washington, DC: Smithsonian Books, 2003.

Gainous, Jason, and Kevin M. Wagner. *Tweeting to Power: The Social Media Revolution in American Politics*. New York: Oxford University Press, 2014.

Gould, Lewis L. *The Modern American Presidency*, 2nd ed. Lawrence: University Press of Kansas, 2009.

Greenberg, David. *Republic of Spin: An Inside History of the American Presidency*. New York: W. W. Norton, 2016,

Gustavson, Todd. *Camera: A History of Photography from Daguerreotype to Digital*. New York: Sterling Innovation, 2009.

Harris, Neil. *Cultural Excursions: Marketing Appetites and Cultural Tastes in Modern America* Chicago: University of Chicago Press, 1990.

Hill, Jason E., and Vanessa R. Schwartz, eds. *Getting the Picture: The Visual Culture of the News*. London: Bloomsbury, 2015.

Holzer, Harold. *Lincoln Seen and Heard*. Lawrence: University Press of Kansas, 2000.

Houck, Davis W., and Amos Kiewe. *FDR's Body Politics: The Rhetoric of Disability*. College Station: Texas A&M University Press, 2003.

Hunter, Peter. *Erich Salomon. Aperture History of Photography Series*. New York: Aperture, 1978.

Juergens, George. *News from the White House*. Chicago: University of Chicago Press, 1981.

Katz, James E., Michael Barris, and Anshul Jain. *The Social Media President: Barack Obama and the Politics of Digital Engagement*. New York: Palgrave Macmillan, 2013.

Lowry, Richard S. *The Photographer and the President: Abraham Lincoln, Alexander Gardner, and the Images That Made a Presidency*. New York: Rizzoli, 2015.

Lubin, David M. *Shooting Kennedy: JFK and the Culture of Images*. Berkeley: University of California Press, 2003.

McInnis, Maurie D., and Louis P. Nelson, eds. *Shaping the Body Politic: Art and Political Formation in Early America*. Charlottesville: University of Virginia Press, 2011.

Mercieca, Jennifer, and Justin Vaughn, eds. *The Rhetoric of Heroic Expectations: Establishing the Obama Presidency*. College Station: Texas A&M University Press, 2014.

Miller, Scott. *The President and the Assassin: McKinley, Terror, and Empire at the Dawn of the American Century*. New York: Random House, 2011.

Mitnick, Barbara J., ed. *George Washington: American Symbol*. New York: Hudson Hills Press, 1999.

Oliver, Andrew. *Portraits of John Quincy Adams and His Wife*. Cambridge, MA: Harvard University Press, 1970.

Ponder, Stephen. *Managing the Press: Origins of the Media Presidency, 1897–1933*. New York: St. Martin's Press, 1998.

Rinhart, Floyd, and Marion Rinhart. *The American Daguerreotype*. Athens: University of Georgia Press, 1981.

Romer, Grant B., and Brian Wallis. *Young America: The Daguerreotypes of Southworth and Hawes*. Rochester, NY: George Eastman House and International Center of Photography, 2005.

Salomon, Erich. *Portrait of an Age*. New York: Macmillan, 1967.

Souza, Pete. *Obama: An Intimate Portrait*. New York: Little, Brown, 2017.

———. *Shade: A Tale of Two Presidents*. New York: Little, Brown, 2018.

Stauffer, John, Zoe Trodd, and Celeste-Marie Bernier, eds. *Picturing Frederick Douglass: An Illustrated Biography of the Nineteenth Century's Most Photographed American*. New York: Liveright Publishing, 2015.

Stuckey, Mary. *Defining Americans: The Presidency and National Identity*. Lawrence: University Press of Kansas, 2004.

Taft, Robert. *Photography and the American Scene: A Social History, 1839–1889*. Mineola, NY: Dover, 1938.

Thompson, Charles Willis. *Presidents I've Known and Two Near Presidents*. Freeport, NY: Books for Libraries Press, 1929.

Traub, James. *John Quincy Adams: Militant Spirit*. New York: Basic Books, 2016.

Van Dijck, José. *The Culture of Connectivity: A Critical History of Social Media*. New York: Oxford University Press, 2013.

West, Nancy Martha. *Kodak and the Lens of Nostalgia*. Charlottesville: University Press of Virginia, 2000.

Winfield, Betty Houchin. *FDR and the News Media*. Urbana: University of Illinois Press, 1990.

Index

CARA A. FINNEGAN is a professor of communication at the University of Illinois at Urbana-Champaign. She is the author of *Making Photography Matter: A Viewer's History from the Civil War to the Great Depression* and *Picturing Poverty: Print Culture and FSA Photographs*.

The University of Illinois Press
is a founding member of the
Association of University Presses.

———————————————

Composed in 10.25/14 Chaparral Pro
with Trade Gothic LT Std display
by Lisa Connery
at the University of Illinois Press

University of Illinois Press
1325 South Oak Street
Champaign, IL 61820-6903
www.press.uillinois.edu